The Absolute Beginner's Big Book of Drawing and Painting

More Than 100 Lessons in Pencil, Watercolor and Oil

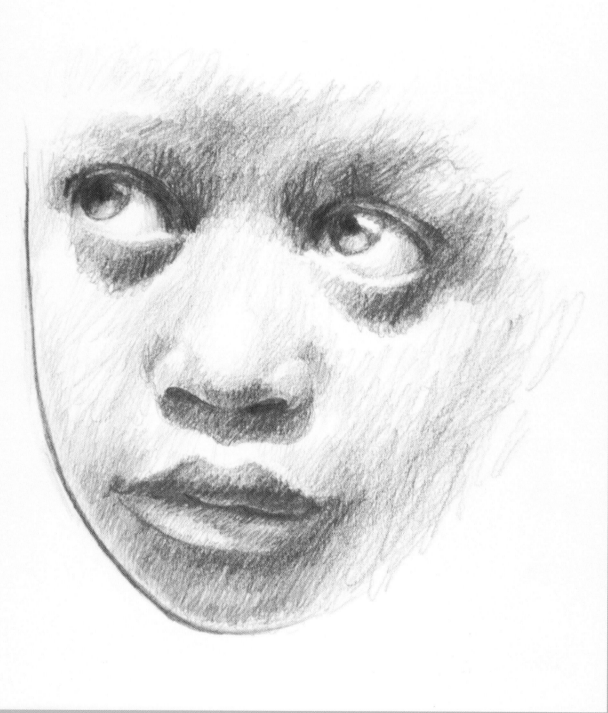

Eyes of Innocence
graphite pencil on drawing paper
9" × 7" (23cm × 18cm)

the absolute beginner's big book of
Drawing & Painting

More Than 100 Lessons in Pencil, Watercolor and Oil

Mark and Mary Willenbrink

NORTH LIGHT BOOKS
CINCINNATI, OHIO
www.artistsnetwork.com

Contents

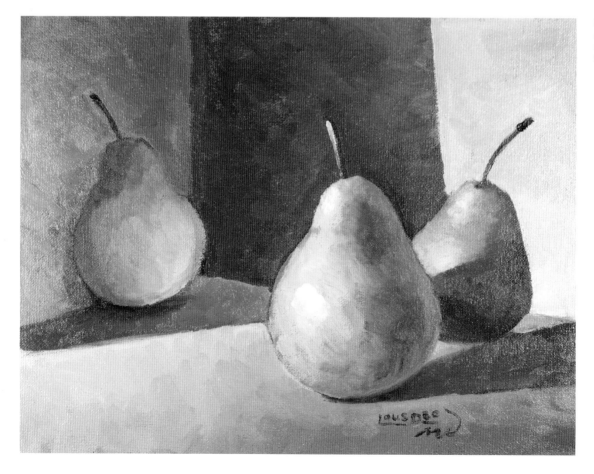

Still Life With Pears
oil on canvas mounted on board
9" × 12" (23cm × 30cm)

What You Need

Here's a list of everything you really need to make your way through each part of this book. Setting aside time in your schedule to draw and paint really helps you focus on your artwork and achieve your goals. Make the most of that time by making sure you have everything you need before you start.

For Drawing

Papers

9" × 12" (23cm × 30cm) fine-tooth, medium-tooth and rough-texture drawing papers

9" × 12" (23cm × 30cm) light gray and medium gray medium-tooth drawing papers

9" × 12" (23cm × 30cm) fine- or medium-tooth sketch paper

transfer and tracing papers

Pencils

2B, 4B, 6B and 8B graphite pencils

2B charcoal pencil

black and white pastel pencils

light gray pastel pencil

medium gray pastel pencil

Other Supplies

blending stump, facial tissue

hole punch, scissors

kneaded and plastic/white vinyl erasers

lightbox

ruler

slip sheet

value scale

Optional Supplies

angled ruler

divider or sewing gauge

drawing board

eraser shield

folding stool

masking tape

mirror

pencil sharpener, pencil extender

spray fixative

tote box

For Watercolor

Papers

watercolor paper: 140-lb. (300gsm) hot-pressed; 140-lb. (300gsm) and 300-lb. (640gsm) cold-pressed (see demonstrations for dimensions)

graphite, sketch and tracing papers

Watercolors

Alizarin Crimson, Brown Madder, Burnt Sienna, Burnt Umber, Cadmium Orange, Cadmium Red, Cadmium Yellow (professional-grade), Cerulean Blue, Hooker's Green, Prussian Blue, Sepia, Yellow Ochre

Brushes

1-inch (25mm) flat; 3-inch (76mm) hake; nos. 2, 6 & 10 round; large bamboo

Other Supplies

2B graphite pencil

kneaded eraser

craft knife

palette

rag, sponge, cotton balls

reference material as needed

table salt

scraps of watercolor paper

straightedge

spray bottle, water container

value scale and color wheel

white latex house paint

Optional Supplies

foam shapes (cube, sphere and cone)

mat board, mounting board

pencil sharpener

Plexiglas book holder

rubbing alcohol

sealing tape, masking tape

sewing gauge

toothbrush, comb, hair dryer

For Oil Painting

Surfaces

canvas on board, stretched and primed canvas, canvas pad (see demonstrations for dimensions)

Oil Paints

Burnt Sienna, Burnt Umber, Cadmium Orange Hue, Cadmium Red Hue, Cadmium Yellow Hue, Cadmium Yellow Light, Cadmium Yellow Medium, Cerulean Blue, Dioxazine Purple, French Ultramarine, Lemon Yellow, Magenta, Payne's Gray, Permanent Rose, Phthalo Blue (Red Shade), Phthalo Green (Blue Shade), Prussian Blue, Sap Green, Titanium White, Ultramarine Blue, Yellow Ochre

Brushes

no. 10 or ¾-inch (19mm), no. 8 or ½-inch (12mm), no. 4 or 5/16-inch (8mm) and no. 2 or ¼-inch (6mm) filberts; no. 12 or 1-inch (25mm), no. 10 or ¾-inch (19mm), no. 8 or ½-inch (12mm), no. 4 or 5/16-inch (8mm) and no. 2 or ¼-inch (6mm) flats; no. 4 rigger; nos. 2 and 4 round

Other Supplies

2B graphite pencil or charcoal pencil

adjustable desk lamp

brush wash with water

drawing pad or sketchbook

easel, palette, palette knife, kneaded eraser, paper towels, rags

spray fixative

Optional Supplies

gesso, mahlstick, medium, observational tools, outdoor painting supplies, palette cups, reference material as needed, smock or apron, thinner, value scale and color wheel

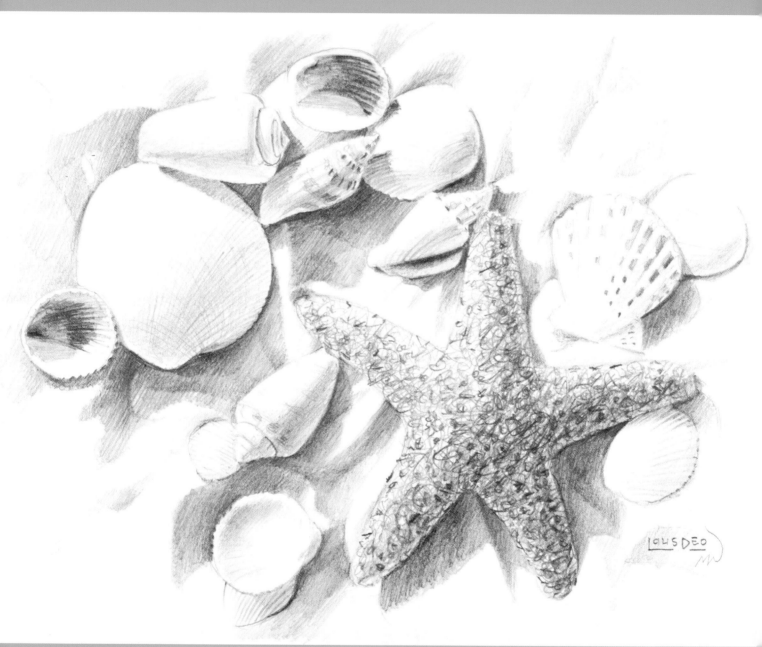

Shells Along the Beach
graphite pencil on drawing paper
9" × 12" (23cm × 30cm)

Part 1 **Drawing**

1 Gather the **Materials**

The materials used for drawing can be as simple as a pencil and paper, or you may choose a more elaborate outfit. However you choose to equip yourself, it is always good to understand the materials you are using.

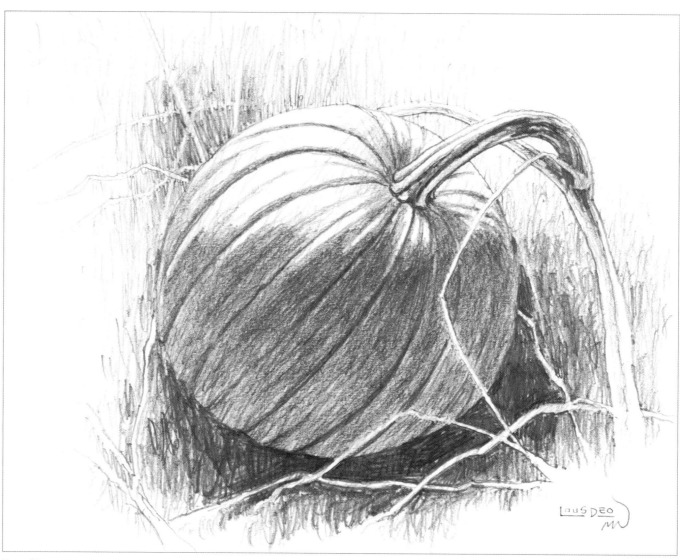

Pumpkin
graphite pencil on drawing paper
8½" × 11" (22cm × 28cm)

Pencils

There are many different types of pencils. Perhaps the most common *drawing pencil* has a core of graphite, carbon or charcoal encased in wood. Though pencils are not made from lead, the core is commonly referred to as *lead*.

Graphite, Carbon and Charcoal

Graphite goes down smooth, but never gets truly black. If you want a really black color, use a *carbon* or *charcoal pencil*, but they can smear easily.

Woodless graphite pencils are made of a cylinder of graphite coated with lacquer. These pencils can make wide or thin strokes but can break in two if they are not handled with care. *Graphite* and *charcoal sticks* have no outer casing. Use the sides to make broad strokes, or use the ends for narrower strokes.

Colored Pencils

Standard *colored pencils* can be waxy and hard to erase. Erasable and *pastel chalk colored pencils* offer similar results but with more versatility than standard colored pencils.

Mechanical Pencils

Mechanical pencils are an alternative to traditional wood pencils. Though convenient, most mechanical pencils can produce only very thin strokes. *Lead holders* are mechanical pencils that grip a single piece of lead at a time. The graphite is about 1/16 inch (2mm) in diameter, wider than other mechanical pencil leads.

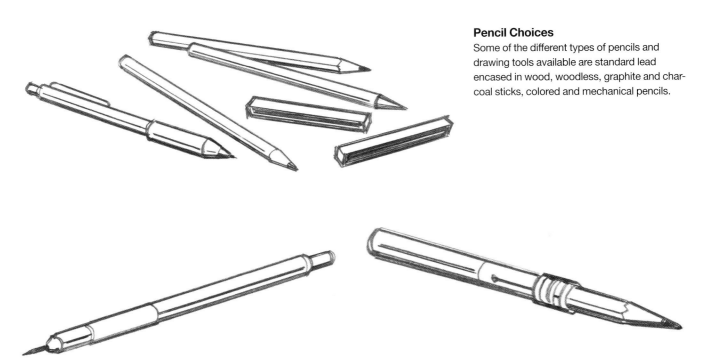

Pencil Choices
Some of the different types of pencils and drawing tools available are standard lead encased in wood, woodless, graphite and charcoal sticks, colored and mechanical pencils.

Lead Holders
Though characteristically similar to a wood pencil, the lead in a lead holder is prone to breaking if excessive pressure is applied to the tip.

Extended Use
Wood pencils that are too short to hold can be made useful with the help of a *pencil extender*.

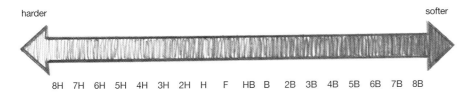

harder softer

8H 7H 6H 5H 4H 3H 2H H F HB B 2B 3B 4B 5B 6B 7B 8B

The Hard (and Soft) Reality
The rating of the hardness of pencil lead is usually stamped on the pencil. H leads are hard compared to B leads, which are soft. F and HB leads are in between. Hard leads can't make rich darks like the soft leads; however, they hold a sharp point longer than soft leads.

Paper

Paper for sketching and drawing varies in weight, size, surface texture, content and color.

Weight

Sketch paper usually has a paper weight of 50 to 70 lbs. (105gsm to 150gsm), commonly thinner than *drawing paper*, which usually weighs 90 lbs. (190gsm) or more. The heavier weight paper is intended for finished drawings and will withstand heavy pencil pressure and erasing better than thinner papers.

Size

Small pads are handy and portable for quick sketches. Bigger pads can also be used for quick sketches or finished drawings.

Surface Texture

Surface texture, or *tooth*, may vary according to individual paper. The tooth of a paper identifies the roughness or smoothness of the paper and can be decided upon by the type of pencil used and desired results. Paper with a rough surface works well with soft pencils such as charcoal, while smooth paper lends itself to graphite pencils for more detailed results.

Content

Sketching and drawing papers are made from wood pulp, cotton or a combination of the two. Cheaper paper may use wood pulp, which has an acid content, causing the paper to yellow over time. With this in mind, for finished drawings it's best to use acid-free paper.

Color

You can use colored drawing paper for different effects. On neutral-colored paper, the drawing already has a middle value, so you can add both darks and lights instead of just darks. Colored drawing paper is available in individual sheets.

Sketching and Drawing Pads
Paper *pads* can be used as is, or you can remove individual sheets for use on a drawing board.

Copier Paper
If you have a fear of wasting a good piece of paper, try sketching on less expensive *copier paper*. Though this type of paper may not hold up over time, it may seem less intimidating for quick, loose observational sketches.

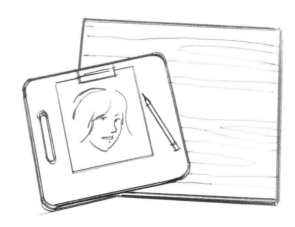

Drawing Boards
A *drawing board* placed behind a sheet of drawing paper provides a smooth, hard surface to control the amount of pressure applied with the pencil. Drawing boards come in different sizes and are made of Masonite or lightweight wood.

Additional Supplies

In addition to the basic supplies, there are other tools that will make your drawing experience go smoothly.

Pencil Sharpeners

Sharpening a pencil can be done using a pencil sharpener or by trimming your pencil by hand with a craft knife and sandpaper pad.

Erasers

Sometimes it may be necessary to erase pencil lines when drawing. Of the different types of erasers, the two most common types are kneaded and plastic.

Avoid using the eraser at the end of a pencil. It won't give you the same results.

Handheld Pencil Sharpeners
Small, handheld pencil sharpeners may look different but perform the same task—trimming the pencil to a point.

Trim With a Craft Knife
Trimming by hand may be the only way to sharpen pastel and charcoal pencils.

To trim a pencil by hand, hold the pencil firmly with one hand and hold the craft knife in the other, with the blade away from your thumb and against the tip of the pencil. Create leverage by pushing the thumb holding the pencil against the thumb holding the knife. Trim a section of wood around the lead. Position the pencil for another cut and continue the process until the wood is trimmed completely around the lead.

Sharpen With a Sandpaper Pad
To sharpen the lead, drag the lead up and down over the surface of the sandpaper pad to form a point.

Sharpen the Lead of Lead Holders
With a section of the lead exposed from the holder, sharpen it using a rotary sharpener. Slip the lead holder down into the sharpener and spin the top around to form the lead to a point.

Kneaded Erasers

Kneaded erasers are soft and have a consistency like putty. They are less abrasive than other erasers and are less likely to roughen up the surface of the paper. Some erasing can be done by pressing the kneaded eraser to the paper surface and lifting.

Plastic Erasers

Plastic erasers may be white or black and characteristically leave behind strings rather than crumbs of the spent eraser.

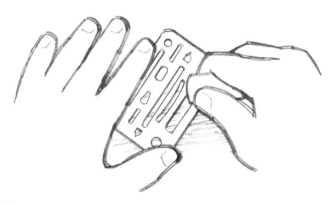

Eraser Shield

This thin piece of metal or plastic is used to isolate an area of the paper for controlled erasing.

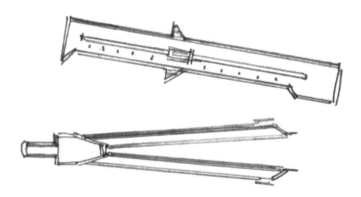

Proportioning Devices

Dividers are a compass-like device used for proportioning and comparing sizes for drawing. Use when working from photographs. A *sewing gauge* is a measuring device that can be used for proportioning photos or real-life subject matter.

Angle Ruler

This clear plastic *angle ruler* can pivot in the middle allowing it to fold at various angles. Use it like a standard ruler to measure and proportion, but it can also be used to transpose angles.

Blending Stump

Made of rolled paper, use a *blending stump* to smooth the linework of a drawing by gently rubbing the end of it across the surface of the paper.

Lightbox

A *lightbox* is used to trace a previously drawn structural sketch onto drawing paper, thus avoiding unwanted pencil lines and excessive erasing on the drawing paper. To do this, tape a sheet of drawing paper over the structural sketch, then place it on the lighted lightbox and trace the image onto the drawing paper.

Transfer Paper

Another method for transferring an image onto drawing paper is to use *transfer paper*, also called *graphite paper*.

The process involves taping the initial sketch to the surface of drawing paper graphite-side down, placing a sheet of transfer paper between the sketch and drawing paper, then redrawing the image with a hard lead pencil. This presses the graphite from the transfer paper onto the drawing paper, transferring the sketch onto the drawing paper.

Transfer paper can be purchased ready for use or can be made by covering one side of a sheet of tracing paper with soft graphite, then wiping across the surface with a cotton ball slightly dampened with rubbing alcohol to bind the graphite to the tracing paper.

Spray Fixative

Fixative is used to bond the linework to the paper surface and can prevent the smearing of soft lead pencils such as charcoal or pastel. Fixative should only be sprayed onto artwork in an area that is well ventilated.

Masking Tape

Masking tape is used to adhere one piece of paper to another. We use name brand masking tape because it grips firmly yet releases with minimal concern for tearing the paper.

Drawing Indoors and Outdoors

When we draw indoors, it's usually accomplished by looking at photographs, whereas the act of drawing outdoors involves observing the actual "live" subject. Both settings have advantages and drawbacks. Combine the two processes by making observational sketches and photographs of the subject outdoors, then completing the drawing inside using your previous sketches and photographs for reference.

Drawing Indoors

Drawing indoors offers a comfortable work environment with all tools ready at hand. The subject matter is provided through reference photos and preliminary sketches.

Drawing Outdoors

Drawing outdoors allows for firsthand observation of the subject however the lighting and form of the subject may constantly be changing.

Indoor Setup

A large work surface and good lighting are important factors to have when drawing indoors. The supplies include reference photos and sketches, drawing board and paper, pencil sharpener, erasers and pencils.

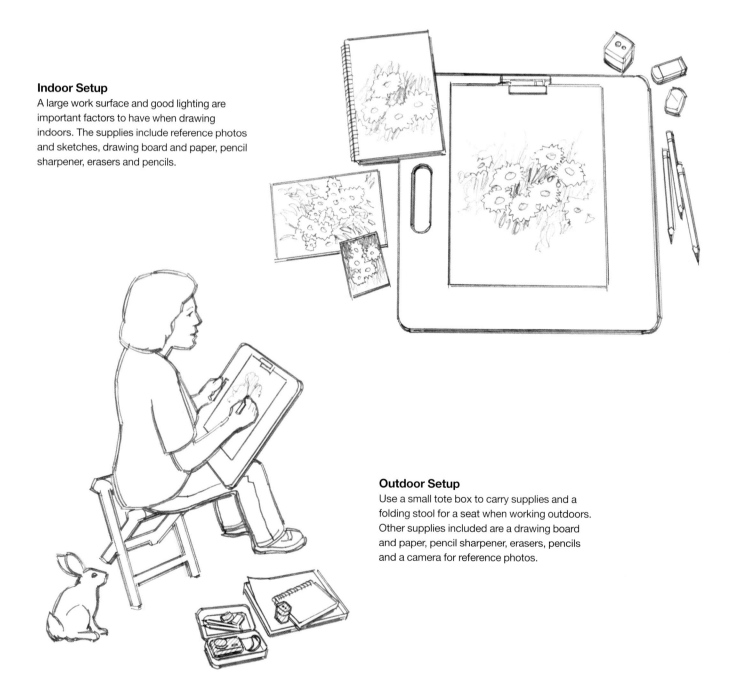

Outdoor Setup

Use a small tote box to carry supplies and a folding stool for a seat when working outdoors. Other supplies included are a drawing board and paper, pencil sharpener, erasers, pencils and a camera for reference photos.

Setup Tips

Here are some tips for setting up your work station, whether you choose to draw from photos or from life.

Drawing From Photographs

Drawing from photographs allows you to study your subject in a two-dimensional form. In some ways, it may be easier to draw from photos because the subject is flat and unchanging. However, the personality or different aspects of the subject are more likely to be captured by drawing from life.

Drawing From Life

Drawing from a live subject or on location offers you the experience of capturing the personality of the subject or aspects of a scene in the moment. However, not everyone will remain still (or everything stay the same) for a long enough period to be drawn. For this reason, you may want to keep a camera on hand to photograph the subject or scene and then complete the drawing from photos.

Be Intentional About Lighting Subjects

An adjustable desk lamp or photography lamp can control the lighting of your subject to help you create interesting results.

Some artists prefer to draw while standing, using an easel to prop the drawing board and paper. By standing, the artist can experience more freedom of movement.

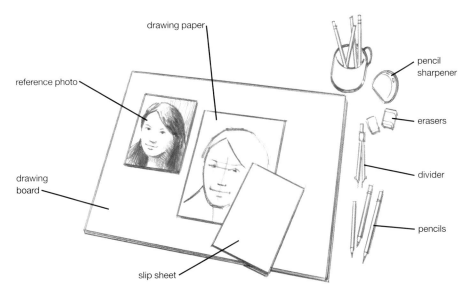

Drawing From Photographs

Among the obvious supplies of pencils, pencil sharpener, erasers, drawing paper and drawing board, also included are the reference photo, divider and slip sheet to rest your hand without smearing pencil lines.

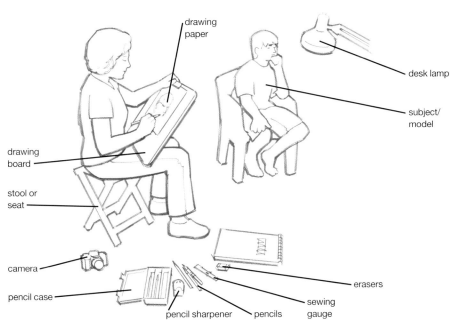

Setup for Drawing From a Live Model

Choose someone who is willing to sit as long as needed, or photograph the person in process to complete the drawing from photographs.

Protecting Your Work

Proper presentation will make your artwork look even better and also preserve and protect it from aging for years to come.

Spraying With Fixative

Fixative may be sprayed over the surface of the artwork to prevent smearing, which is more of a concern with charcoal or pastel drawings than with graphite. Make sure the artwork is free of dust and follow the instructions on the can for applying the spray. Make sure you do it in a well-ventilated area.

Finishing Your Artwork

The right frame and mat will enhance your drawing and give it a professional look. With glass in the front and a sheet of craft paper to cover the back, the artwork will be more protected. Frames and mats should complement the art and express the general theme without distracting from the art itself.

Some artists include a nameplate on the front of the frame that states the title of the art piece as well as their name. Bumpers keep the frame from resting directly against a wall and allow air to circulate around the painting to prevent mold. You may also want to place a sticker stating the artist's information on the back.

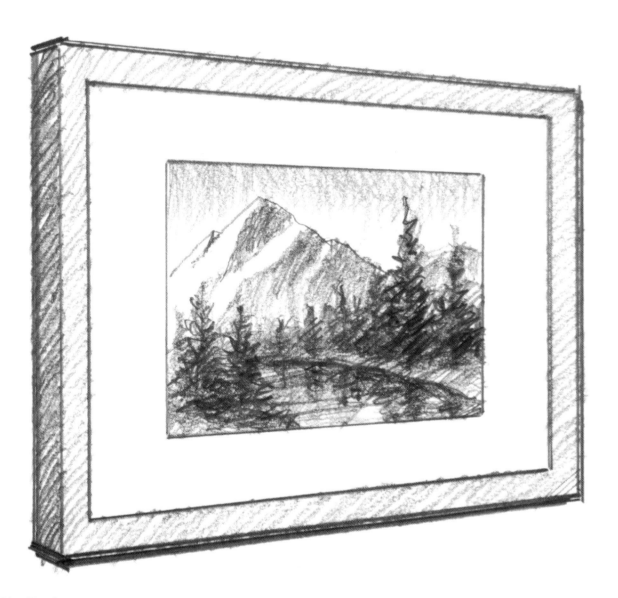

Finishing Touches
Now your artwork is ready to be displayed. Hang your artwork with an attractive mat and frame.

Ash Cave Waterfall
graphite pencil on drawing paper
8½" × 5" (22cm × 13cm)

2 Practice the **Techniques**

As you sketch, you will be studying different aspects of your subject, capturing your observations through your sketches. A drawing is the culmination of the experience you gain as you study your subject by sketching.

Sketching and drawing can be thought of as two different activities. A *sketch* is a study or a work in progress. The process of sketching helps you to understand the structure and lights and darks of a subject. *Drawing* is the activity of producing a finished piece of art. As a beginner, if you are trying to do more drawings than sketches, then you may be putting too much pressure on yourself. Loosen up and enjoy learning how to express yourself.

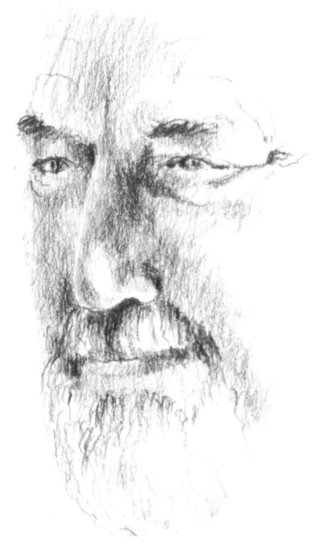

T.R.
graphite pencil on drawing paper
8" × 5" (20cm × 13cm)

Structure + Values = Drawing

Most of the drawings and demos included in this part of the book are completed through a two-stage process. The first stage is the structural sketch. The second stage is adding the *values*, or lights and darks of the subject. This chapter will better describe these terms as well as other techniques and principles.

Bright Idea
Work out the structural sketch on sketch paper, then trace by using a lightbox or transfer with graphite paper onto the drawing paper. By doing this, you will avoid much of the erasing on the drawing paper.

1 **Start With Structure**
The structural sketch is the foundation of the subject with basic lines.

2 **Add the Values**
After completing the structural sketch, add the values.

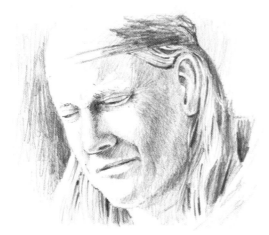

The Finished Drawing
Through this process you'll create the finished drawing by combining both the structure and values of the subject.

Pencil Grips and Strokes

The way the pencil is held, the amount of pressure applied and the materials used all affect the linework of your art.

Different grips achieve different results, from long, loose or sketchy lines to short, tight lines. The grip can also influence the angle of the pencil to the paper, which affects the line width. When the pencil is held upright, only the point of the lead is in contact with the paper, producing narrow lines. When the pencil is tilted flat against the paper, the lead has more contact with the paper and produces wide lines.

As you sketch and draw, you will probably intuitively do what feels natural and hold your pencil in the manner needed to produce the pencil lines you want.

For Wide, Loose Lines
Grip the pencil with your thumb and fingers so the pencil rests under your palm. Position the pencil lead flat against the paper surface. Make loose, fluid line strokes by moving your entire arm instead of just your hand and wrist.

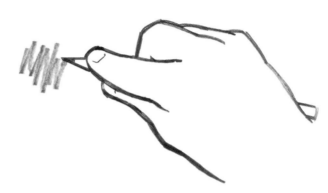

For Wide, Short Lines
Hold the pencil closer to the tip, allowing for more pressure on the lead. Movement comes from the forearm, while the hand and wrist are kept rigid against the paper surface.

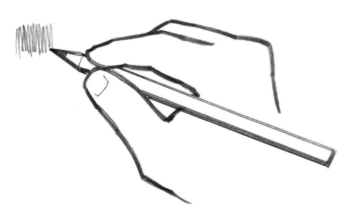

For Narrow, Short Lines
This is like a handwriting grip, with the pencil angled in relation to the paper to make narrow lines. Movement comes from your hand rather than your arm and wrist, making for more controlled pencil strokes.

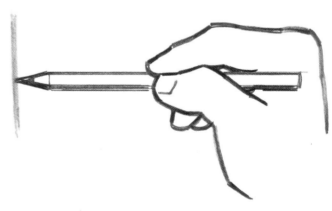

For Long Lines
This also uses a handwriting grip but with the pencil held farther from the tip. Movement comes from your hand while it rests on the paper. The angle of the pencil to the paper and the sharpness of the lead influence the width of the pencil strokes.

Shading and Texture

The lead, the grip of the pencil and the paper surface can all influence the shading and texture of a drawing.

Shading

Shading displays the values (lights and darks) of the subject and is done through pencil strokes that can add patterns and direction to the artwork. There are many different ways to create shading. Some types of shading will feel more natural to you than others. Try experimenting with these techniques or make up some of your own to best express the subject you are drawing.

Parallel Lines
This type of shading places parallel lines next to each other as a pattern.

Crosshatching
Overlapping parallel lines create a crosshatching effect.

Graduating Lines
Graduating lines can be made by going heavy to light with every stroke or by changing the amount of pressure gradually with a group of back-and-forth strokes.

Scribbling
Sharp linework and pointed or round linework are just two examples of scribbling that can be used to imply texture.

Implying Texture

The texture of a subject can be implied through the application of the pencil interacting with the surface of the paper.

Rock Texture
Soft lead graphite applied to the coarse surface of medium-tooth paper implies the rock's bumpy appearance.

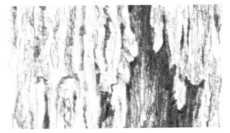

Tree Bark Texture
Tree bark can be drawn using soft and hard lead pencils applied to medium-tooth paper, making wide and narrow lines with lots of contrast.

Fur Texture
Short, narrow pencil lines placed on smooth paper create the feel of a squirrel's fur.

Feather Texture
A bird's feathers can be drawn using soft and hard lead pencils applied to smooth paper for contrasting values.

Combining Approaches

As stated at the beginning of the chapter, we'll use structural sketches as the beginning stage of more finished drawings that have had values added to them for the final result. Having a structural foundation underneath your drawing can make it easier to study other aspects of your subject and combine different approaches to sketching and drawing.

traced or transferred onto the drawing paper. Tracing the structural sketch onto the drawing paper reduces the need to erase unwanted lines on the drawing paper. Erasing on drawing paper can damage the delicate surface of the paper.

Tracing uses a lightbox or window; transferring uses transfer paper. Both procedures are detailed in the first chapter.

Trace or Transfer the Structural Sketch

The structural sketch can be directly on the drawing paper for the finished drawing or on a separate sheet of paper and then

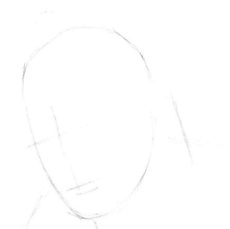
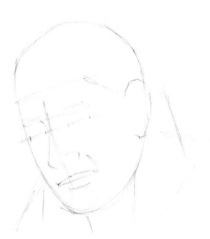
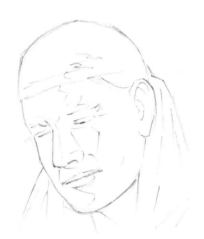

Making a Structural Sketch

The structural sketch is the foundation for the finished drawing. Start by sketching the basic overall proportions and placement of features. Next add the features, then add more detail to the features. You can include lines indicating the regions of shadows.

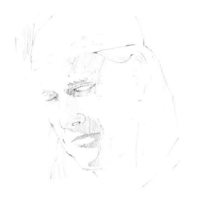
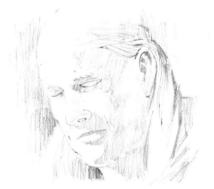
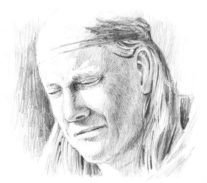

Making a Drawing With Values

Add values over the structural sketch for a finished drawing. Build up the lighter values with a series of lines. Add darks throughout the process or at the end.

Understanding Values

Values are lights and darks that give form and depth to a subject. Observing the wide range of values that make up your subject will give you a better understanding of how to complete your drawing.

Using Contrast: More or Less?

The way you use contrast affects the appearance of the subject. More contrast makes for a broader range of values: The features are sharper and more distinct, and the drawing is more dramatic. With less contrast, the range of values is narrower. The overall feeling is softer and with less depth.

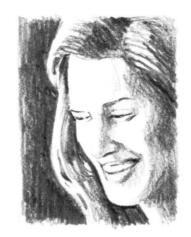 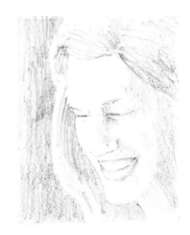

Values Appear Relative

Values can appear different depending on their surroundings. A silhouette of a person in a gray value may seem dark when placed on a white background. That same silhouette seems lighter when placed against a darker background.

Using a Value Scale

A value scale is used by holding it against the subject and comparing the values with those of the drawing.

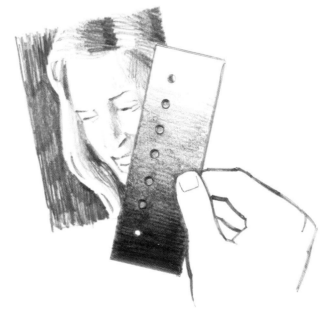

Making a Value Scale
MINI-DEMONSTRATION

A *value scale* is a strip of paper or cardboard that has a range of values from white to black. The purpose of the value scale is to identify the values of the subject and compare those with the drawing. Cardboard value scales are available at art stores or you can make one with pencils and drawing paper.

Materials

4" × 8" (10cm × 20cm) medium-tooth drawing paper

2B graphite pencil

8B graphite pencil

hole punch

ruler

scissors

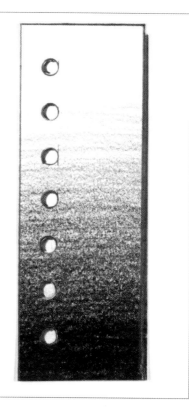

1 Draw a Rectangle
Use a pencil to draw a 2" × 6" (5cm × 15cm) rectangle on the drawing paper.

2 Shade the Lower Half
With a 2B pencil, darken the paper with graphite, gradating the graphite light to dark, keeping the top portion white.

3 Finish Shading and Punch Holes
Continue to darken the drawing paper with an 8B pencil so the bottom is fully dark. Trim the 2" × 6" (5cm × 15cm) rectangle with scissors and punch out a line of holes with a hole punch.

Light and Shadow

Good drawing involves awareness of the lighting of a subject. The play of light and shadow can drastically affect the appearance of a subject. The placement and intensity of the light source affects the lights, darks and shadows of the subject. Understanding the light in relation to the subject will influence the depth and mood of your drawing. The aspects of lighting include highlights, form and cast shadows, and reflected light.

Light Source

The *light source* is the origin of light that influences the lights, darks and shadows of a scene. Most light sources (whether natural or artificial) are above a subject. A scene may have more than one light source.

Highlight

A *highlight* is a bright spot where light reflects off an object.

Form Shadow

A form shadow appears on an object, displaying the form of the object.

Cast Shadow

Typically darker than form shadows, a *cast shadow* is caused by an object casting a shadow onto another surface.

Reflected Light

Reflected light is light that is bounced from one surface onto another. Typically, reflected light is not as bright as the primary light source. It may throw subtle light onto an area that would have otherwise been dark.

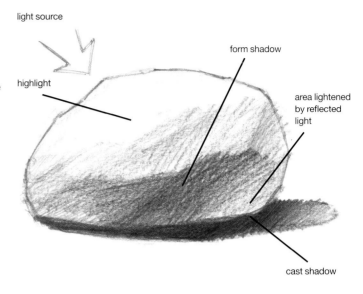

light source
form shadow
highlight
area lightened by reflected light
cast shadow

Light and Shadow
The lights, darks and shadows of a scene are influenced by the light source.

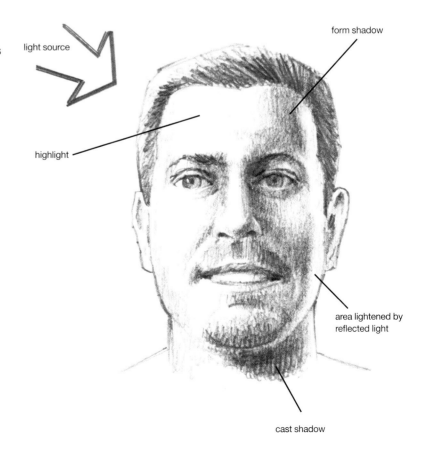

light source
form shadow
highlight
area lightened by reflected light
cast shadow

Observing Light Effects With a Plaster Cast or Mannequin

Facial light effects can be observed with a plaster cast face or a Styrofoam mannequin head that you can find at art or hobby stores.

Proportioning, Comparing and Transposing

The basic shapes of the structural sketch need to be accurate to be believable. Proportioning, comparing and the transposing of lines are practices that need to be developed to make a sketch accurate.

Proportioning

Proportioning involves the comparing of elements such as comparing the height of an object to its width. This information is then applied to the sketch. Different tools can be used for proportioning, including a divider, sewing gauge or a pencil.

Determine a Unit of Measurement
For this subject, the distance of the height of the cactus is used as a unit of measurement.

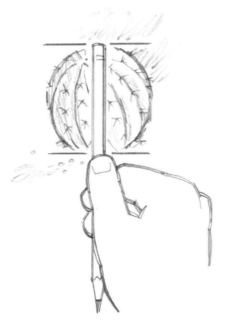

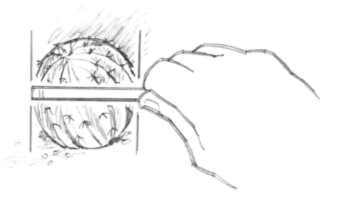

Compare the Size
The distance of the height when compared to the width is the same.

Proportioning a Distant Subject

With this technique of proportioning, a pencil is held in the hand, straight up and down at arm's length. The distance between the top of the pencil and the top of the thumb is used as a unit of measurement when viewed against the subject in the distance. The arm must be kept straight for consistency. A sewing gauge can be used instead of a pencil with this technique.

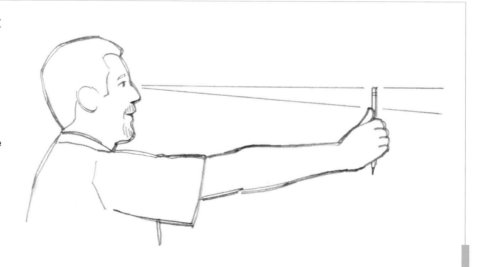

Line Comparisons

A straight tool, such as a pencil, can be used to study the placement of elements by their relationship to one another.

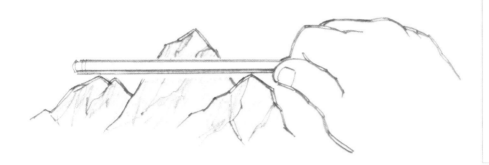

Using a Pencil for Line Comparison
By holding a pencil horizontally, you can see that two of the mountain peaks line up and are the same height as one another.

Transposing Angled Lines

The angled lines of a subject can be transposed to a sketch with a pencil or an angle ruler.

Using a Pencil to Check Angled Lines
Align the pencil so that it is alongside the subject. With the pencil held firmly in your hand, keep the angle as you move your hand over the paper and adjust the line of your sketch.

Using an Angle Ruler to Check Angled Lines
Holding the stem of an angle ruler either horizontally or vertically, align the angle of the ruler to that of the subject. Move the ruler over to the paper. With the stem of the angle ruler parallel to the paper's edge, sketch the angled line.

Linear Perspective

Linear perspective implies depth through the size and placement of the elements. Closer elements appear larger to the viewer. Vanishing points and horizon are features of linear perspective, though they may not be as noticeable in nature as with an environment that includes man-made elements.

Understanding and applying the principles of linear perspective will add depth through the structure of your drawing.

Closer Elements Appear Bigger
Assuming all of the trees are the same size, the trees closer to the viewer will appear bigger.

Parallel Elements Appear to Converge
The parallel sides of the river visually converge in the distance, making or creating a vanishing point. The vanishing point in this scene rests on the horizon.

Vanishing Points and Horizon May Be Hidden
Though hidden behind trees and mountains, the vanishing point and horizon still influence the elements in this scene.

Overlapping Elements Express Depth
Another way that depth is expressed is through the overlapping of elements. In this example, the overlapping tree appears closer.

Atmospheric Perspective

Also called *aerial perspective*, *atmospheric perspective* displays depth through values and definition. The closer elements have contrasting values and well-defined features. As elements become more distant, their values become neutral and may appear hazy. The elements will be less defined.

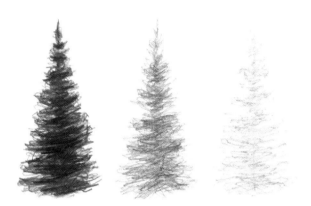

Atmospheric Perspective
Atmospheric perspective expresses depth through values. Elements appear to fade into the distance with atmospheric perspective.

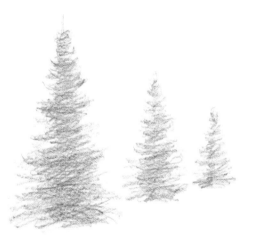

Linear Perspective
Linear perspective expresses depth through size and placement of the elements. The elements appear smaller as they become more distant with linear perspective.

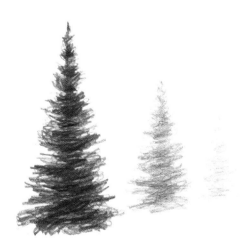

Atmospheric and Linear Perspectives Combined
Depth is expressed through value changes, as well as the size and placement of objects when atmospheric and linear perspectives are used together in a scene.

Composition

Composition is the arrangement of elements in a drawing and is an aspect of all art. Good composition is usually the result of thought and planning by the artist, involving the right balance to feel complete.

Design Elements

Design elements are the pieces that make up a composition. Some of the elements include size, shape, line and values. Color is another element, but this part of the book only pertains to black, white and grays.

Design Principles

Design principles refer to the application of elements. Some of the principles include balance, unity, dominance and rhythm.

Balancing the Elements

Balance in composition can be symmetrical or asymmetrical.

Numbers of Elements

The number of elements in a composition can affect the feel of a composition. In general, odd numbers of elements are more interesting than even numbers of elements.

Leading the Eye

Elements can be placed in a composition to lead the eye of the viewer and create a sense of motion. Using motion while alternating different elements can create a sense of rhythm.

Symmetrical Composition
The elements in a symmetrical composition are evenly distributed from side to side, giving a formal appearance.

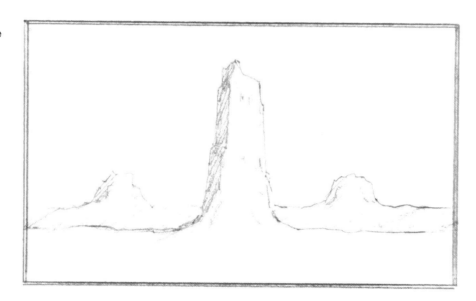

Asymmetrical Composition
The elements in an asymmetrical composition may be placed in an informal manner but maintain a balanced appearance.

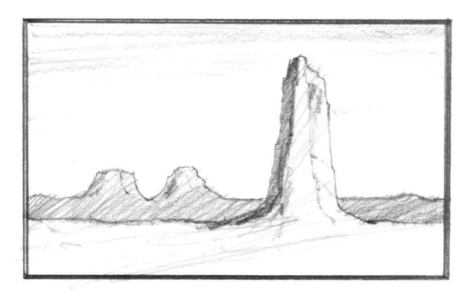

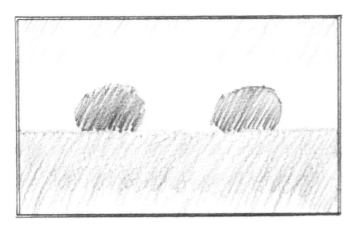

Even Numbers Are Predictable

A composition can seem predictable and lack interest, especially with only two elements to focus on.

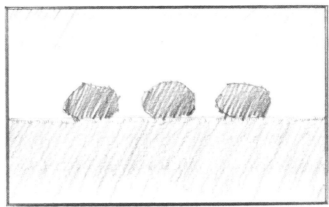

Odd Numbers Add Interest

Having three elements can be more interesting than just two, but this symmetrical composition can still be improved upon.

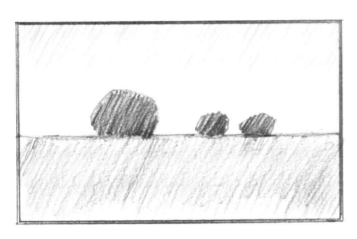

Changing the Balance

By changing the size and spacing of the elements, the composition is now balanced asymmetrically. Though there is unity through the shape of the elements, the larger one is more dominant than the two smaller elements, adding interest to the scene.

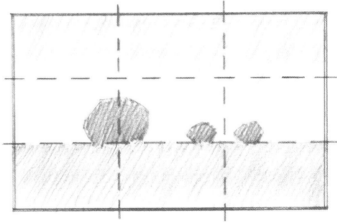

Using the Rule of Thirds

One method to make an appealing composition is to use a grid to divide the drawing into thirds, three high by three across, then place the elements in correspondence to the grid lines.

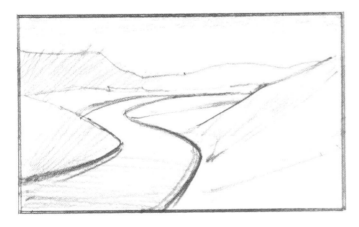

Leading With Line

The eye of the viewer can be led through the composition with the use of line as if to point the way.

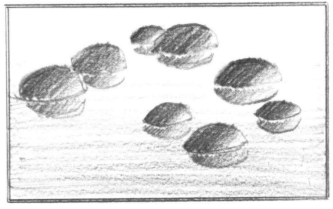

Leading With Shape

Shapes can be used to lead the eye of the viewer through a composition just like stepping stones.

3 Let's Draw **Portraits**

If you have gone through the previous two chapters, you are ready to tackle a demonstration. Remember to refer to those chapters if you get stuck on a specific subject. We'll focus on individual features first, then complete portraits.

You can do each of these demos in one of two ways: You can work out the structural sketch directly onto the drawing paper, or you can draw the structural sketch on a separate piece of paper, then trace it with a lightbox or transfer it with graphite paper onto the drawing paper. The latter method reduces the amount of erasing you'll do on the drawing paper. If you work directly on the drawing paper, remember to sketch your foundation lightly so any erasing won't rough up the surface of the drawing paper.

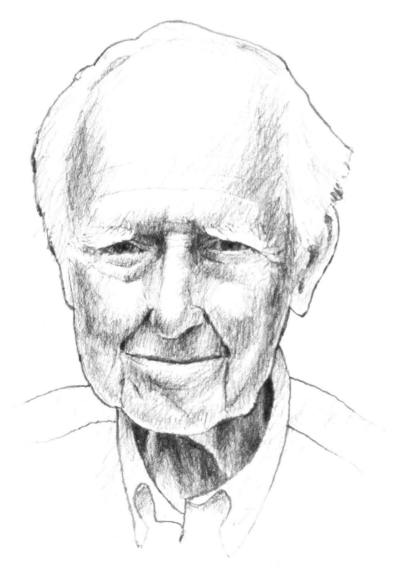

Great Expectations!

Don't be surprised if, at the beginning, your sketch looks nothing like the person you are trying to draw. Persevere! It is in the final stages that you will add the details to make your person unique.

T.C.
graphite pencil on drawing paper
8" × 6" (20cm × 15cm)

Proportioning

Facial proportions are generally the same from person to person. However, there are subtle differences in the size and placement of features that make each of us unique.

Proportioning involves examining and comparing the size and placement of features. You'll make adjustments to the sketch when comparing and measuring proportions.

As you work on your proportioning, remember to start with a light touch so you can make adjustments without having to erase any more than you have to. A sewing gauge is a good tool for measuring. A divider can also be used when working from a photograph.

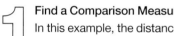

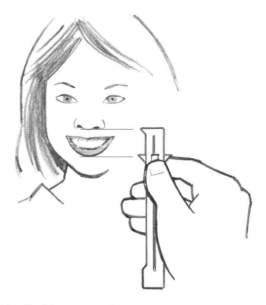

1 Find a Comparison Measurement
In this example, the distance from the eyes to the base of the nose will be the unit of measurement.

2 Use the Measurement
This unit of measurement happens to be equal to the distance from the base of the nose to the bottom of the lower lip.

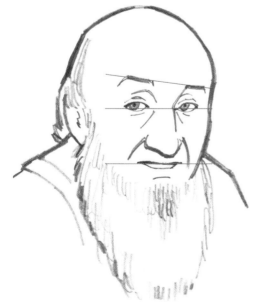

Lining up Features
Look to see which features line up or are angled when compared to one another. The horizontal lines representing the mouth and eyes are parallel, while the eyebrows are angled in comparison.

Proportions Made Easy
Hold up a piece of drawing paper alongside the subject to visually line up the features horizontally, showing the placement of the features. This is especially useful when drawing profiles.

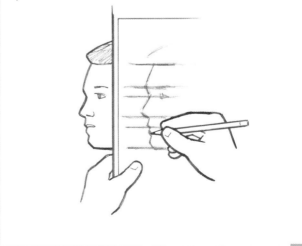

The Eye
MINI-DEMONSTRATION

The eyes express personality and emotion and are perhaps the most important feature of a portrait. The individuality of eyes involves not only the pupil and iris, but also the eyelids, brow, crease and wrinkles. How deeply the eye is set affects the shadows and may darken the white of the eye. Children's eyes are clear and bright with big irises and soft shading. An elderly person's eyes may be set deep in their sockets. The eyes may also have a watery appearance, and a cloudiness to the irises and pupils.

This is a young man's eye, with full eyebrow and few wrinkles.

Materials
8" × 10" (20cm × 25cm) sketch paper

2B pencil

kneaded eraser

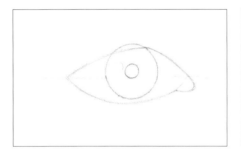

1 Sketch the Basic Shape, Iris, Pupil and Highlight
Beginning with a horizontal guideline, sketch the top and bottom eyelid lines to make the shape of an opened eye. Pay attention to the width and height for accurate proportions. Notice how the lids curve according to the shape of the eyeball.

Sketch a full circle for the shape of the iris. The part of the circle above the top lid can be erased later. Sketch the pupil and highlight.

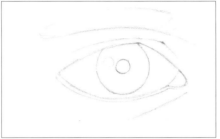

2 Sketch the Lower Brow, Eyelid Crease, Lines, Brow and Detail Lines
Sketch the shape of the lower (underneath) part of the eyebrow. This is formed as a recession by the eye socket. Add the top eyelid crease and lines below the eye.

Sketch the shape of the brow and add detail lines around the lower eyelid. Erase unwanted lines.

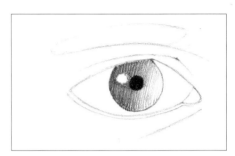

3 Start Adding Values
Start adding the values beginning with the pupil and iris, considering the direction of light and its effects. Keep the highlight white to show reflected light on the cornea. The clear cornea may cause the side of the iris opposite the light source to appear lighter.

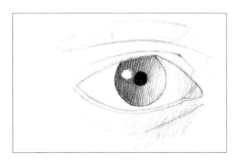

4 Add Values on and Around the Eye
Add values to the white areas of the eye as well as to the areas around the eye, such as the upper and lower lids.

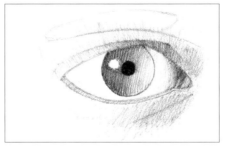

5 Add More Values
Add more values on and around the eye, giving more form to the ball shape of the eye.

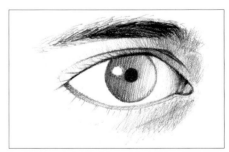

6 Add Final Darks and Details
Darken as needed including the crease on the upper lid, and add details including the brow hairs and eyelashes.

The Nose
MINI-DEMONSTRATION

Noses are narrow at the top and wide at the bottom, with their proportions and forms unique to the individual. Drawing noses from the front can be challenging because most of the form is shown by subtle variations of lights and darks rather than outlines.

 This is an older man's nose and is characteristically long and large. As with all features, be conscious of where the light source is coming from. In this drawing, the light is coming from the upper right, causing highlights on the right side of the nose and dark regions on the left and bottom.

Materials
8" × 10" (20cm × 25cm) sketch paper

2B pencil

kneaded eraser

1 Sketch a Center Line, Eye Line and Bottom Line
Sketch a vertical line representing the center of the nose. Sketch a horizontal line where the eyes would line up at the nose bridge. Sketch a line for the bottom of the nose.

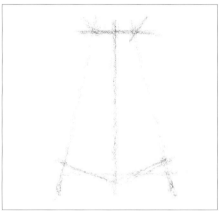

2 Sketch Sides, Brows and Nostril Lines
Sketch the sides as well as part of the brows that intersect at the eye line. Sketch two lines at the bottom for the placement of the nostrils.

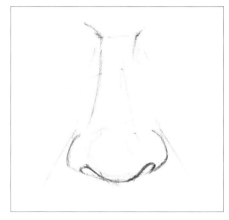

3 Develop the Structural Lines and Shadow Lines
Develop the structural lines and rounding lines, and add detail to the nostrils. Add a circle toward the bottom to develop the shape of the lower part of the nose and the nostrils. Add lines for wrinkles and placement of shadows. Erase unwanted lines in the process.

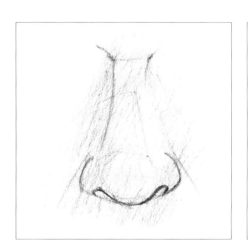

4 Start Shading
Start shading with a light overall value. Highlighted areas can be shaded around or erased later.

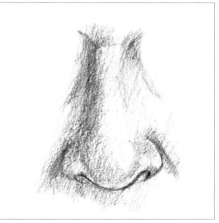

5 Add Darker Values
Add darker values, mostly on the left side since the light is from the right. In this example, the lower part of the nose is ball-shaped and can be shaded like a ball.

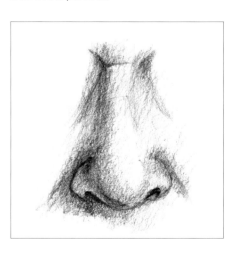

6 Finish With Darks and Highlights
Add darks in the shadowed areas including the nostrils. Create highlights by pressing the kneaded eraser onto those areas to remove graphite.

The Mouth
MINI-DEMONSTRATION

Mouths can express a person's age, gender, origin and, of course, emotion. Lips can be different shapes. Large full lips are recognized as youthful; thin lips look aged. Since the light source is usually from above, the top lip will be shadowed and the lower lip will receive more light. Adult teeth may appear as a group of teeth defined by their bottom or top edges rather than their individual outlines. As the teeth recede into the mouth, they appear more shadowed. Children's teeth are smaller and less developed than adult teeth and are seen as individual teeth.

This woman's mouth indicates youth and beauty with full lips and white teeth. The soft smile indicates contentment.

Materials
8" × 10" (20cm × 25cm) sketch paper

2B pencil

kneaded eraser

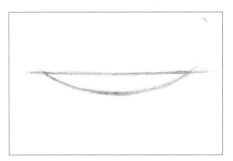

1 Sketch the Basic Shape
Sketch the basic shape of an opened mouth with a horizontal top line and a curved bottom line that connect at the sides.

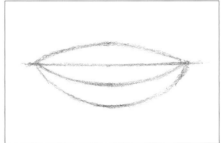

2 Sketch the Lip Shapes
Sketch curved lines for the upper and lower lips.

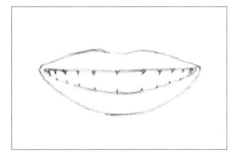

3 Develop the Lips and Teeth
Develop the shape of the lips. Add lines for teeth and gums. Erase unwanted marks.

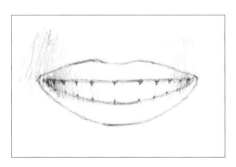

4 Start Shading
Start shading with lighter values. The back teeth appear darker than the front teeth and should be shaded accordingly.

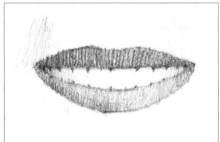

5 Add Shading to the Lips
Shade in the lips. The light source is from above, causing the top lip to be shadowed and slightly darker than the bottom lip.

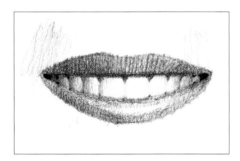

6 Add Darks and Highlights
Add darks to the corners of the mouth and under the top lip, and subtle darks to both lips to show form. Erase part of the lower lip to create a highlight.

The Ear
MINI-DEMONSTRATION

Ears are unique to each person and are a characteristic feature for identification. The size and shape of an adult's ears stay consistent until about the age of sixty, when they lengthen due to a loss of elasticity. Ears have distinct edges and also subtle contours. The deepest, most recessed parts are shadowed and dark.

This mini-demo is of a middle-aged male's ear, specifically my own ear. If you meet me in public, you will be able to recognize me by my ear!

Materials
8" × 10" (20cm × 25cm) sketch paper

2B pencil

kneaded eraser

1 Determine the Height and Width
Sketch horizontal lines for the height and vertical lines for the width of the ear, creating a rectangle.

2 Sketch the Outer Shape of the Ear
Sketch the outer shape of the ear, making the top portion wide and the bottom portion narrow.

3 Sketch the Outer Folds
Sketch the folds and edges that are closest to the outer form of the ear.

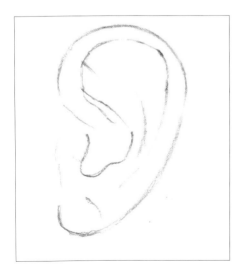

4 Sketch Inner Folds and Erase Unwanted Lines
Sketch the folds that make up the inner region of the ear. Erase unwanted lines.

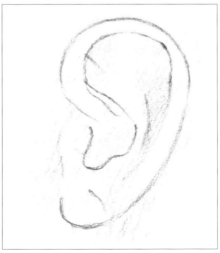

5 Start Shading
Start shading with lighter values.

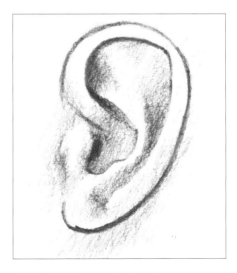

6 Add Darks and Lighter Areas
Add darks and erase graphite to create lighter areas and give depth to the folds.

Hair
MINI-DEMONSTRATION

Straight, wavy, curly, kinky, thick, thin, short and long, there are many types of hair. Draw hair using different types of pencil strokes. For short, curly hair draw with a series of small, scribbly strokes. For straight, silky hair draw with long pencil strokes.

This mini-demo is of a male teen with straight hair. Because his hair is lying flat, it has a sheen or glossy appearance.

Materials

8" × 10" (20cm × 25cm) sketch paper

2B pencil

kneaded eraser

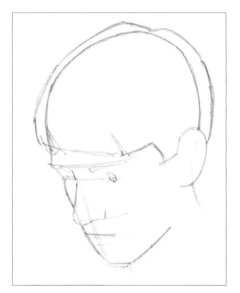

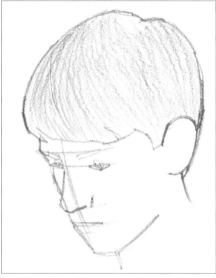

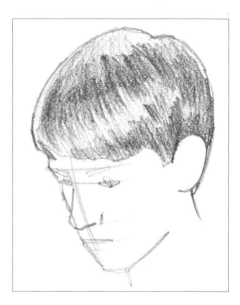

1 Sketch the Shape of the Head and Form the Hair

Sketch the shape of the head as a three-quarter view. Form the hairline around the contour of the head.

2 Erase Unwanted Lines and Add Lighter Values

Erase the line shaping the head, which would now be covered by the hair. Sketch the lighter values overall, following the direction of the hair with long pencil strokes.

3 Add Middle Values

Add the middle values, smoothly transitioning into the lighter values in the central area.

4 Finish With Dark Values

Add dark values and lighten some areas by gently dabbing with the kneaded eraser to give a sheen to the hair.

Hands

Hands can add expression to a portrait, giving it emotion and personality. Hands can tell us about a person, even more than a face can by itself. Men's hands may seem bulky compared to women's hands, which are more slender.

One Shape at a Time
When drawing hands, I first draw the basic shapes, then I add lines for the thumb and fingers, and finally I refine the form.

The Hand
MINI-DEMONSTRATION

With the way his hand is placed over his mouth, this subject looks as if he is talking under his breath.

Materials
8" × 10" (20cm × 25cm) sketch paper
2B pencil
kneaded eraser

 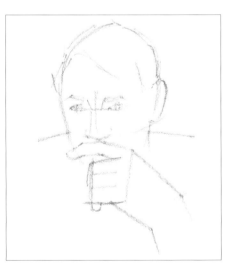 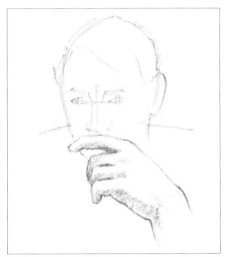

1 Sketch the Head and the Basic Shape of the Hand
Sketch the head from the front. Add a line for the top of the index finger, paying attention to its placement in relation to the face. Sketch the basic overall shapes of the fingers and hand.

2 Add the Fingers and Wrist
Sketch the individual fingers and the basic shape of the wrist.

3 Develop the Form and Add Values
Develop the form of the fingers, hand and wrist. Add the values.

Hats

Adding a headpiece to a portrait can speak volumes about a person's character. And they're fun!

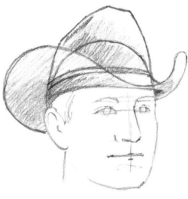
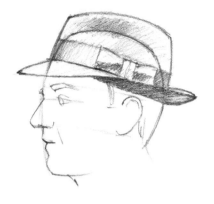
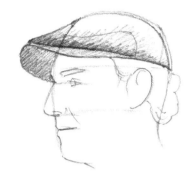

Start With the Head

Hats fit around the wearer's head, so it works well to sketch the head, then the form of the hat around the head.

Baseball Cap
MINI-DEMONSTRATION

A baseball cap follows closely the top of the head with the visor coming out from the front.

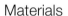

Materials

8" × 10" (20cm × 25cm) sketch paper

2B pencil

kneaded eraser

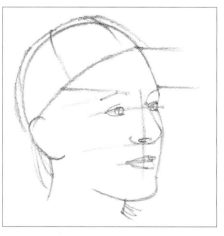
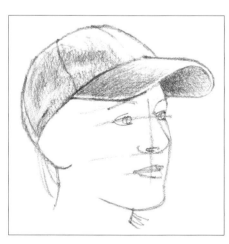

1 Sketch the Shape of the Head and the Basic Hat Shape
Sketch the shape of the head in three-quarter view. Form the cap part of the hat around the shape of the head.

2 Develop the Cap and Visor
Add horizontal lines to the front of the cap for the visor. Add the seams to the cap.

3 Complete the Visor and Add Values
Complete the form of the visor. Add values.

Eyeglasses

Glasses also give a portrait personality. People who wear glasses may want to take them off for a portrait; however, if they usually wear their glasses, the glasses might be part of their identity.

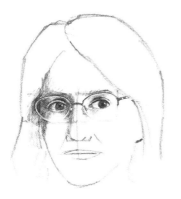

Front View
The lenses can change the image of the eyes behind them by casting light and shadow and sometimes distorting the elements.

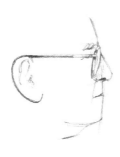

Side View
From the side, glasses may display their convex shape.

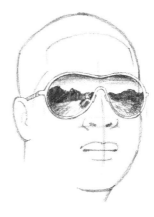

Mirrored Lenses
Some lenses of sunglasses act as mirrors and reflect their surroundings.

Glasses
MINI-DEMONSTRATION

When drawing glasses, draw a top line and a bottom line connecting both lenses. This ensures that the lenses will line up and be proportioned similarly.

Materials
8" × 10" (20cm × 25cm) sketch paper
2B pencil
kneaded eraser

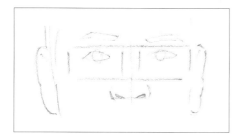

1 Sketch the Shape of the Face and the Proportions of the Lenses
Sketch the front view of the face around the eyes. Sketch two horizontal lines and four vertical lines as the proportions of the lenses.

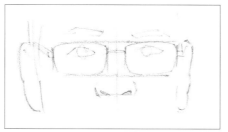

2 Form the Shape of the Lenses and Frames
Form the lenses and frames, rounding the sides and connecting the frames to the tops of the ears and across the nose bridge.

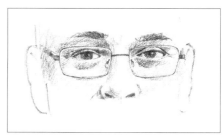

3 Erase Unwanted Lines, Add Details and Values
Erase unwanted lines, add details to the frames and add values to the face and glasses.

Woman

Use graphite pencils on white drawing paper for this demonstration. The light source of the subject is from top right. The contrast of values in the hair, especially the rich darks created with the 8B pencil, gives it a silky appearance.

Reference Photo

1 Proportion and Sketch the Shape of the Face
With a 2B pencil, proportion the top and bottom to the sides of the face. Sketch an egg shape as the overall form of the face.

Don't Aim Too High

Accurately sketched placement of features and proportions are necessary for a likeness of the subject. A common misproportion is to place the eyes up too high instead of toward the center of the head. Hair that covers the forehead may give the false sense that the middle of the head is much higher than it actually is.

2 **Sketch the Shape of the Hair, Neck and Shoulders**
Continue using the 2B pencil to sketch the outer shape of the hair. Add the neck and shoulders. The top of the shoulders can be sketched as a single line.

3 **Sketch the Eyes, Nose and Mouth Lines and Center Line**
Sketch the horizontal lines for the placement of the eyes, bottom of the nose and the mouth. Add a vertical line to indicate the center of the face.

4 **Sketch Lines for the Brows and Lips, and Indicate the Width of the Eyes, Nose and Mouth**
Sketch horizontal lines for the brows and lips. Short vertical lines indicate the width of the eyes, base of the nose and corners of the mouth.

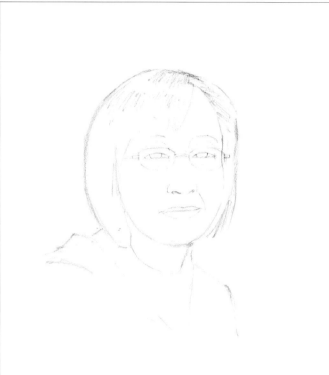

5 Define the Features
Define the features including the brows, eyes, nose and lips. Develop the hair, face and clothes. Add the eyeglasses.

6 Erase Unwanted Lines and Sketch Lines for the Hair
With a kneaded eraser, erase any unwanted lines. Sketch some lines for the hair, indicating highlighted regions. With the 2B pencil, transfer the image onto drawing paper if you are not already working on the drawing paper.

Get to the Point
To create thin, detailed lines, sharpen the lead on your pencil to a point and hold your pencil upright.

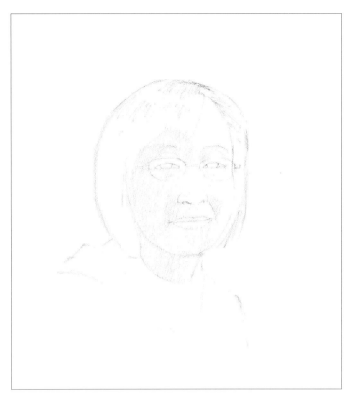

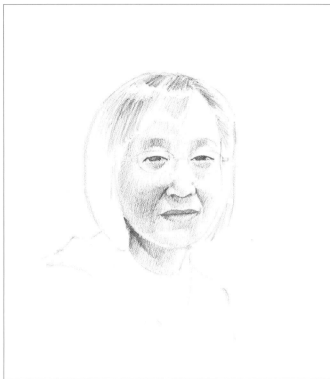

7 Start Shading the Face and Neck
Continue using the 2B pencil to start shading regions of the face and neck. The light source is from the top right, so the right side of the face will be lighter than the left side.

8 Add More Shading to the Face, Neck and Hair
Continue shading with the 2B pencil to develop the forms of the face, neck and hair.

9 Add Shading to the Clothes and Background
With the same pencil, add the initial shading to the clothes so they are darker on the left than on the right. Shade the left portion of the background at this stage so that the left is darker than the right, which fades to the white of the paper.

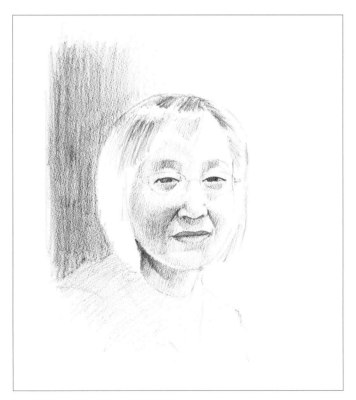

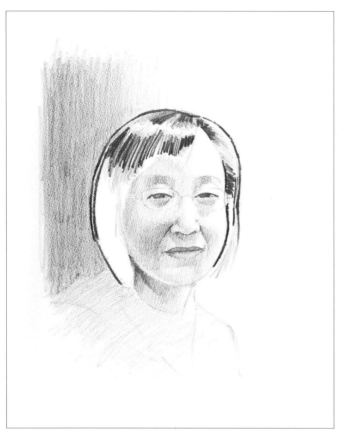

10 Start Darkening the Hair

With an 8B pencil, add dark pencil strokes to the hair closest to the highlighted regions. Leave a thin light stripe around the perimeter of the hair to give the impression of reflected light on the hair.

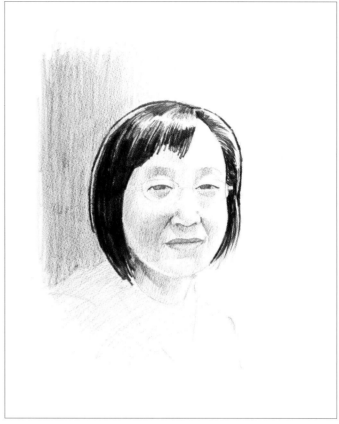

11 Finish Darkening the Hair

With pencil strokes following the direction of the hair, complete the dark regions of the hair using the 8B pencil.

Sign and Date

Take pride in your artwork. It is unique and so are you. Sign and date your sketches and drawings when finished so that you'll be able to see a progression of your skills. Also, by setting aside your artwork and viewing it at a later date, you are likely to see it with a renewed appreciation.

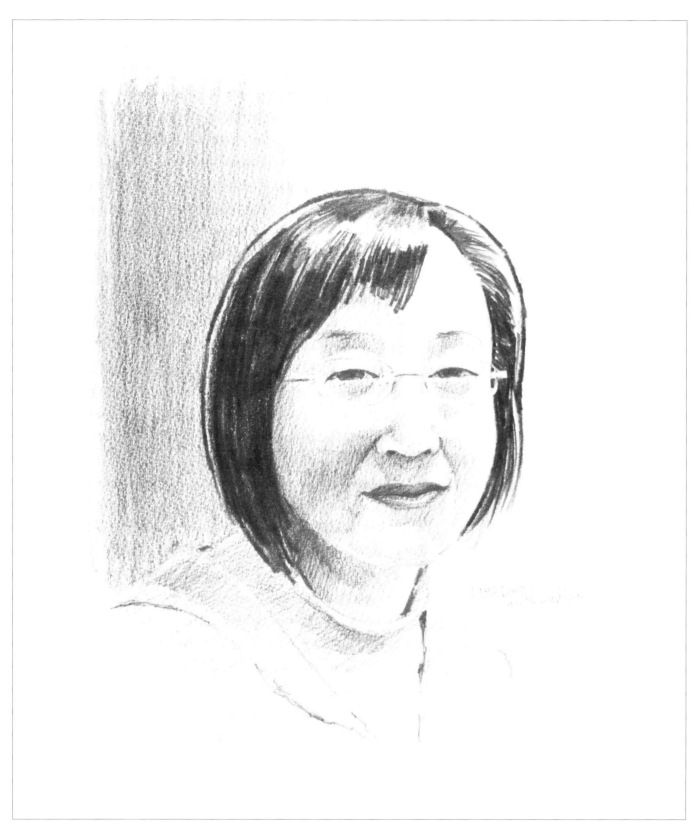

12 Make Adjustments and Add Details

After you have added the dark of the hair, you may find that other regions of the drawing need some darkening. With the 2B and 8B pencils, darken as needed. Finish the clothes, though these don't require much detail. Indicate the eye-glass frames by erasing along the top of the frame lines. Sign and date your portrait.

Soleda
graphite pencil on drawing paper
12" × 9" (30cm × 23cm)

Man With Beard

Interesting faces are fun to draw. The goal is to capture the depth of their personalities. The beard in this demonstration is especially interesting to draw because the drawing paper is gray and can be used as a base value for the drawing. You'll draw light areas such as the beard with white pastel pencil and dark areas with black pastel pencil.

It may be difficult to see through the gray drawing paper if you use a lightbox to trace the image. Other options are to use transfer paper or to draw from beginning to end directly onto the gray drawing paper.

Materials

Paper
12" × 9" (30cm × 23cm) light gray medium-tooth drawing paper

Pencils
black pastel pencil
white pastel pencil

Other Supplies
kneaded eraser
white vinyl eraser

Optional Supplies
12" × 9" (30cm × 23cm) sketch paper
lightbox or transfer paper

Reference Photo

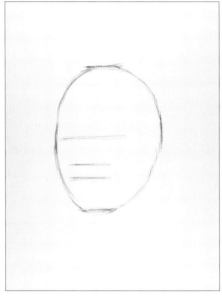

1 Sketch the Head Shape and Lines for Basic Features
Using a black pastel pencil, proportion the head without the beard and sketch the form. You will have to guess where the bottom of the chin is underneath the whiskers.

Facial Hair
Facial hair commonly follows the contours of the face. For instance, a beard may follow the jawline; a mustache may follow the creases of the cheeks. Whiskers have a coarse appearance and can be drawn with irregular pencil strokes to show their texture.

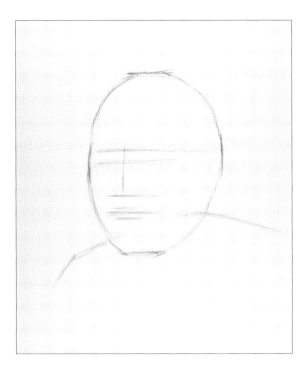

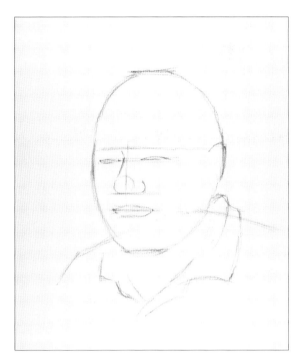

2 Sketch a Line for the Center of the Face and Lines for the Brows, Lips and Shoulders
To help place the features, sketch a vertical line indicating the center of the face. Add horizontal lines for the brows and lips. Add lines for the shoulders, paying attention to where the shoulder lines are in relation to the face.

3 Add More Structural Lines to Distinguish the Features
Start to form the eyes, nose, ear, lips and shirt collar with more linework.

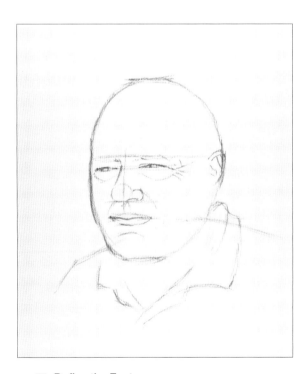

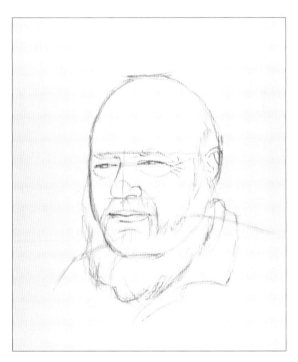

4 Define the Features
Add more detail lines to the eyes, nose, ear and lips as well as adding facial lines.

5 Sketch the Placement of the Hair and Beard
Add the brows, hair, mustache and beard. Avoid drawing in too many whiskers with the black pastel pencil (you'll draw most of the whiskers with a white pastel pencil later).

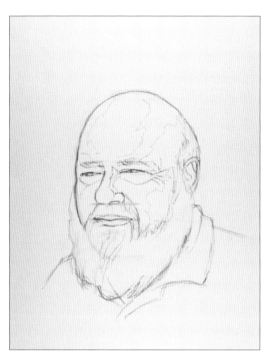

6 Erase Lines and Plan Shading Regions
If you started on sketch paper, transfer the image onto drawing paper. Add lines indicating regions for shading.

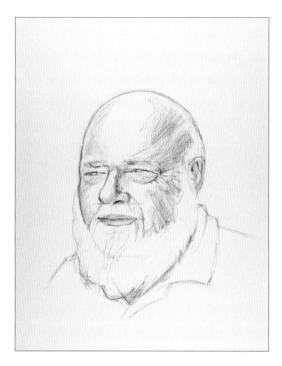

7 Start Shading
Lightly start shading regions of the face and neck including the lips and ear. Keep in mind the light is coming from the upper left and note how this affects the form and contours of the subject. To create smooth shading, place the line strokes evenly and close to each other.

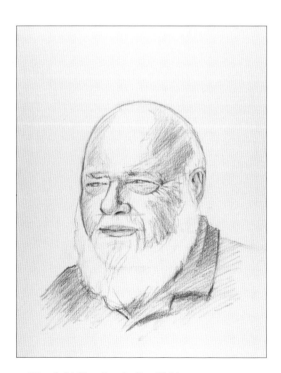

8 Add Shading to the Shirt
Now add shading to the shirt. For this portrait, the shirt is simple and can be drawn with little detail.

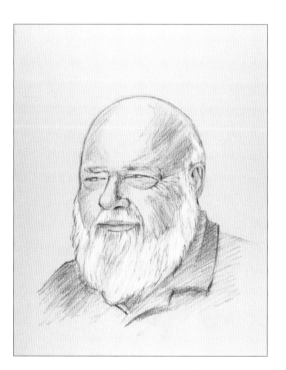

9 Add the Hair, Mustache and Beard
With a white pastel pencil, add the hair and whiskers. Add some dark pencil strokes with a black pastel pencil. Apply the white strokes before the black strokes because the white won't cover over the black effectively.

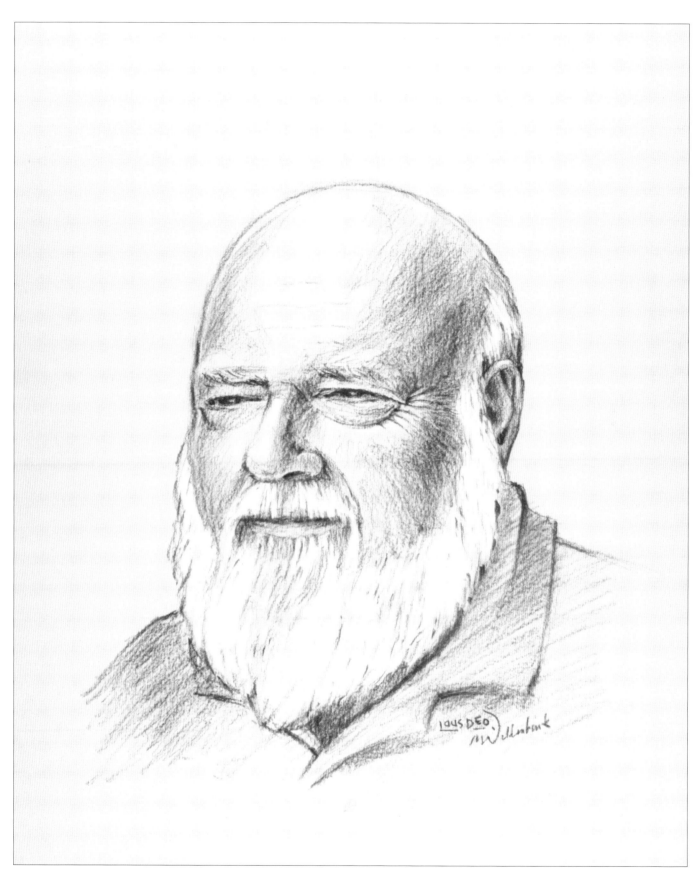

10 Add Darks and Details

Make adjustments, adding more details and darkening or lightening in some places. Sign and date your portrait.

Donald
pastel pencil on gray drawing paper
12" × 9" (30cm × 23cm)

Male Contour Drawing

This demonstration is produced as a contour drawing over a preliminary structural sketch. The linework is to be as continuous as possible. However, the pencil may be stopped, lifted and started at different places during the drawing process. The goal of this demo is not to achieve a photo-realistic representation of the subject, but to allow for a more creative interpretation.

You'll need a lightbox to see the structural sketch through the drawing paper for the contour drawing process. Use sketch paper for the structural sketch.

Materials

Paper
12" × 9" (30cm × 23cm) sketch paper
12" × 9" (30cm × 23cm) medium-tooth drawing paper

Pencils
2B graphite pencil
4B graphite pencil

Other Supplies
kneaded eraser
lightbox

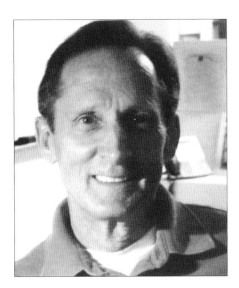

Reference Photo

1 Sketch the Basic Proportions
With a 2B pencil, sketch horizontal lines for the top of the head (without hair) and for the chin. Sketch a horizontal line for the eyes slightly above the halfway point between the head and chin lines. Add vertical lines for the width of the head.

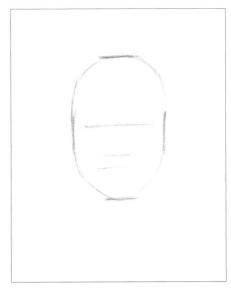

2 Sketch the Head Shape and Lines for Basic Features
Sketch the egg shape of the head and horizontal lines for the nose and mouth with the 2B pencil.

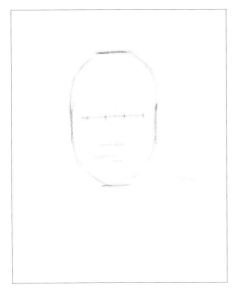

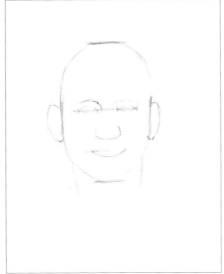

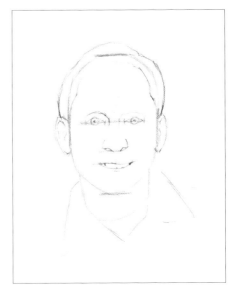

3 Sketch the Centerline and Other Lines for the Features
Sketch a vertical line for the center of the face. Add other lines for the placement of the brows, lower mouth and width of the eyes. Draw a long curved line for the shoulders.

4 Add Form to the Features
Form the eyes, ears, brows, nose, mouth and neck.

5 Add and Develop the Features
Add features such as hair and the shirt. Develop the eyes, ears and mouth by adding details.

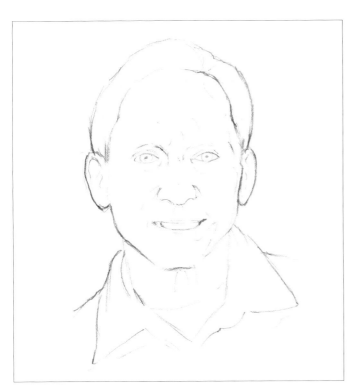

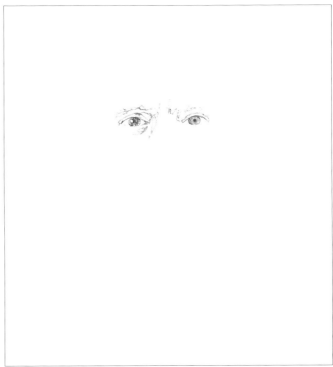

6 Erase Unwanted Lines, Refine the Features and Add Shadow Lines
Erase lines that are no longer useful. Refine and add detail to the features, and add lines to distinguish shadows.

7 Start the Contour Drawing
Tape the structural sketch to the back of a sheet of drawing paper. Illuminate the structural sketch through the drawing paper with a lightbox and start the contour drawing using the 4B pencil. Draw the left eye and begin working on the right eye.

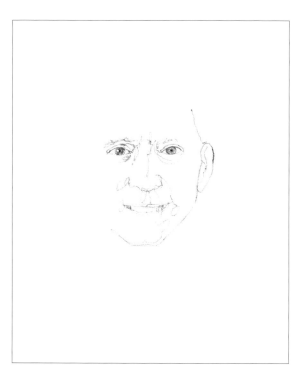

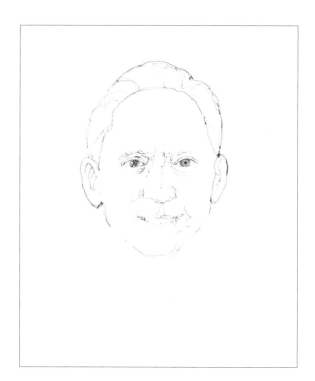

8 Draw the Central Features and the Form of the Right Side of the Face
From the right eye, draw the form of the nose, mouth, jaw and ear, continuing with the 4B pencil.

9 Draw the Form of the Hair and the Left Side of the Face
From the left side of the face, draw the hairline, left ear and jawline, then back up and around the top, drawing in some of the hair during the process.

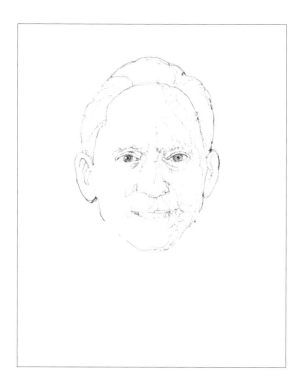

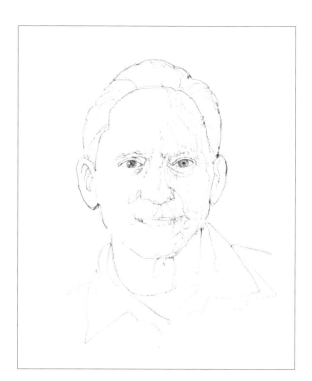

10 Add Form and Shading to the Right Side of the Face
Continue the line, following the shapes of the face, adding form to the right side. Add vertical linework for shading. Draw around the top of the head and left side of the face and ear.

11 Add Form to the Neck and Shirt
Continue the linework, drawing the form of the neck and shirt.

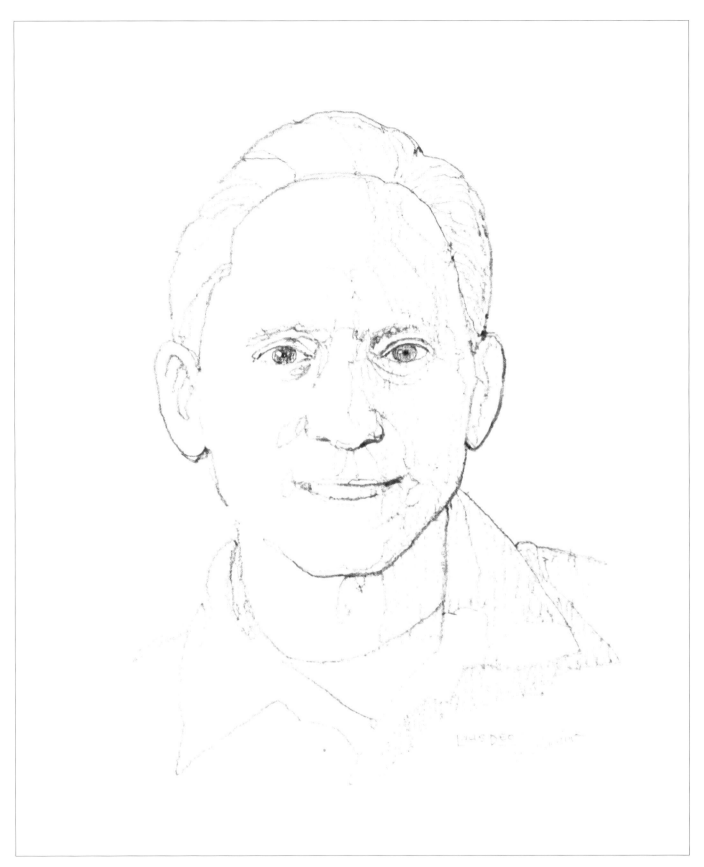

12 Add Shading and Darken Some Linework

Add shading to the neck, shirt, hair and right ear. Darken some linework to make it more shadowed, using the 4B pencil. Sign and date your portrait.

J.V.
graphite pencil on drawing paper
12" × 9" (30cm × 23cm)

Woman on Toned Paper

The paper for this portrait is gray, giving you the ability to darken with a black pastel pencil and lighten with a white pastel pencil. The light is mostly from the right, lightening the right side of the face and providing a wide range of values.

The reference photo for this portrait has a cluttered background that detracts from the subject. To remedy this, the background of the drawing will be left blank.

Materials

Paper
12" × 9" (30cm × 23cm) light gray medium-tooth drawing paper

Pencils
black pastel pencil

white pastel pencil

Other Supplies
kneaded eraser

Optional Supplies
12" × 9" (30cm × 23cm) sketch paper

lightbox or transfer paper

Reference Photo

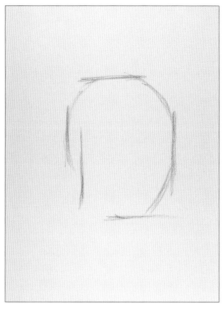

1 Proportion and Sketch the Basic Head Shape
With a black pastel pencil, proportion the height and width of the head without the hair. Sketch the basic form of the head. Add a line for the neck.

Just a Pinch

For small spots needing to be erased, pinch the end of a kneaded eraser to form a point, then press down and pull up to lift unwanted graphite.

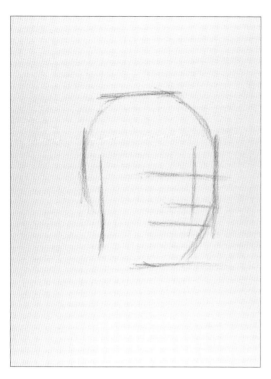

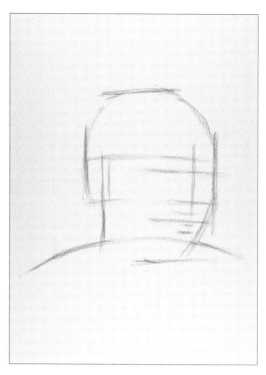

2 Sketch Lines for the Center of the Face and the Basic Features

Sketch a vertical line for the center of the face. Add horizontal lines for the eyes, base of the nose and mouth.

3 Add Lines for the Shoulders, Brows, Lips and Ear

Add a curved line for the shoulders and lines for the placement of the eyebrows, lips and ear.

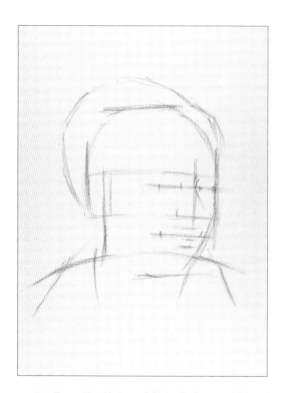

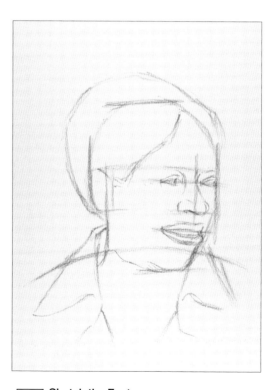

4 Form the Hair and Shirt Collar, and Size the Facial Features

Sketch the form of the hair and the shirt collar. With short lines, plot the size of the eyes, mouth and nose, and sketch the nose bridge.

5 Sketch the Features

Sketch the eyes, nose, mouth and ear. Add the form of the hair over the forehead and develop the chin and collar.

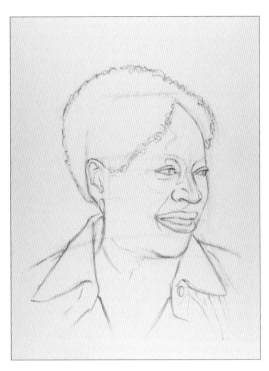

6 Clean up and Add Details

Erase unwanted structural lines, and add detail lines to the features. If you decided to begin the drawing on a different sheet of paper, transfer the image onto the drawing paper at this stage. Add light lines indicating some of the contours of the face, neck and shirt.

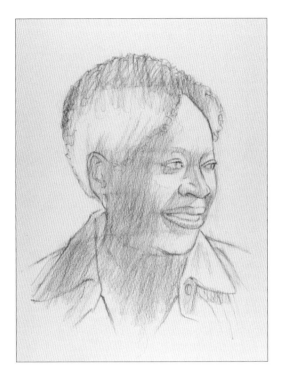

7 Start Shading

Start shading in the lightest values on the gray paper. With the primary light source coming from the upper right, the top right side of the face and many features will remain light.

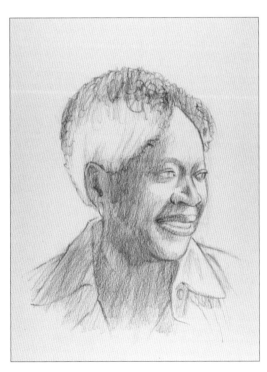

8 Add Middle Values

Add the middle values. In many places, transition from lighter to middle values. Start adding the hair with random pencil strokes to imply the small, tight curls.

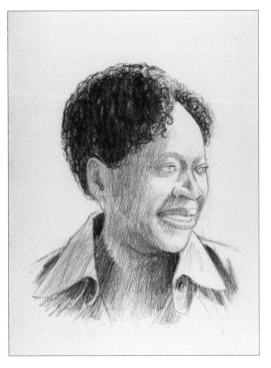

9 Add Dark Regions

Add dark values to the hair, neck and shirt.

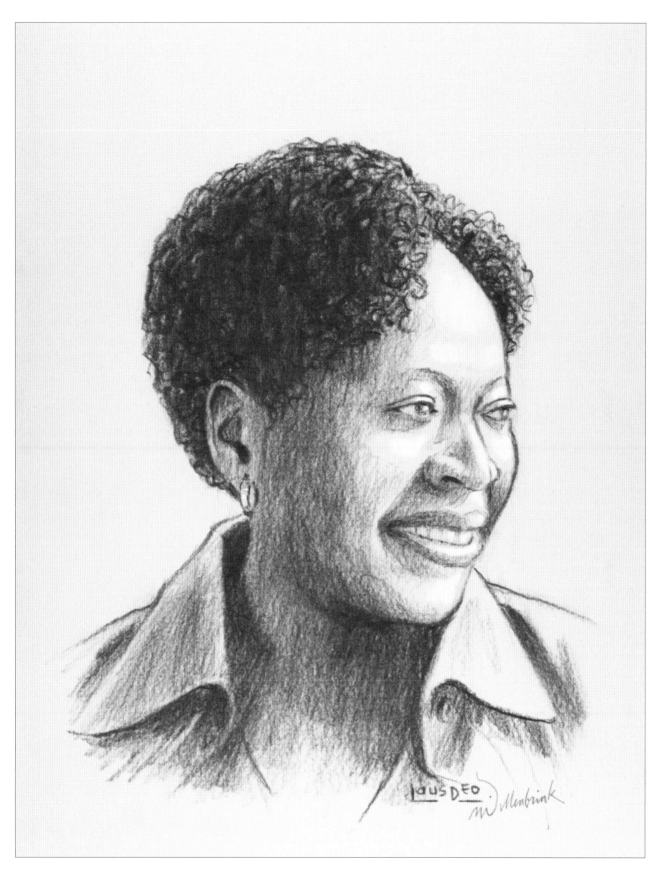

Add Details and Adjustments

Add details to the eyes, nose, lips, ear and earring. Lift some dark pastel from the hair with the kneaded eraser to suggest the curls. Use a white pastel pencil for the highlights on the face and earring. Sign and date your portrait.

C.W.
pastel pencil on gray drawing paper
12" × 9" (30cm × 23cm)

Baby

Not only is the placement of the facial features different for babies than for adults, but the overall form and proportions of the head are also different. Babies' heads are short and wide. Notice that the widest part of the head is only about one third of the way down from the top of the head. As the head develops with age, it becomes longer, lengthening the features such as the nose and ears.

The lighting is coming just left of center, creating subtle value transitions.

Materials

Paper
12" × 9" (30cm × 23cm) medium-tooth drawing paper

Pencils
2B graphite pencil
4B graphite pencil

Other Supplies
kneaded eraser

Optional Supplies
12" × 9" (30cm × 23cm) sketch paper
lightbox or transfer paper

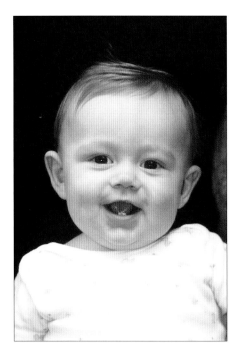

Reference Photo

1 Proportion and Sketch the Shape of the Head

With the 2B pencil, proportion the top, bottom and sides of the head. Form the basic shape of the head, following the proportion lines.

2 Sketch the Placement Lines for the Features and the Center of the Face

Continuing to use the 2B pencil, sketch horizontal lines, slightly angled, for the placement of the eyes, nose and mouth. Sketch a vertical line, slightly angled, for the center of the face.

3 Sketch Lines for the Brows, Lips and Ears

Sketch placement lines following the same angles as the previous lines for the brows, lips and ears. Notice that the tops of the ears line up below the brows and the bottoms of the ears line up with the mouth.

4 Sketch Lines for the Width of the Features and a Line for the Shoulders

Sketch short lines to indicate the width of the eyes, nose, mouth and ears. Sketch a line for the position of the shoulder.

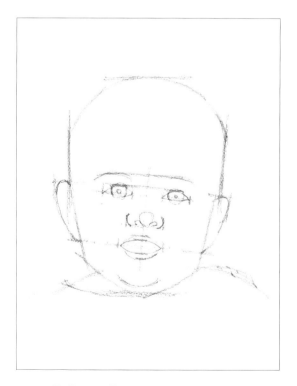

5 Define the Features

Define the brows, eyes, nose, mouth, chin and ears. Add the shirt and collar.

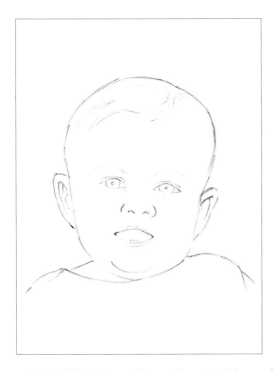

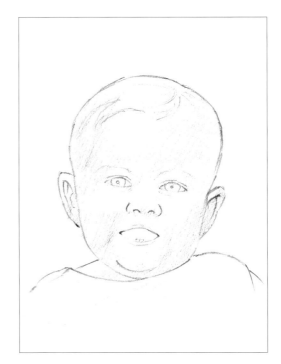

6 Add Details and Erase Unwanted Lines or Transfer the Image

Add details including hair, eyelid creases, folds of the ears and two cute little bottom teeth. Erase unwanted lines if working directly on the drawing paper, or trace or transfer the image onto drawing paper using the 2B pencil.

7 Start Shading With the Lighter Values

Continuing with the 2B pencil, start shading the lighter regions. Notice that the light source is from above, left of center, making the tops of the forehead, cheeks and nose some of the lightest places on the face.

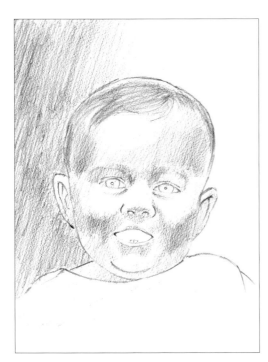

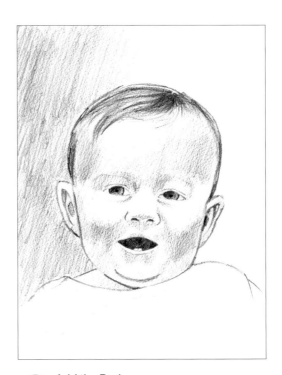

8 Add Middle and Background Values

Add the middle values to the subject, using the same pencil. Add values to the background, shading the area so there are middle values on the left, gradually lightening to the white of the paper on the right.

9 Add the Darks

With the 4B pencil, add the most noticeable darks, including hair, irises, pupils and the inside of the mouth.

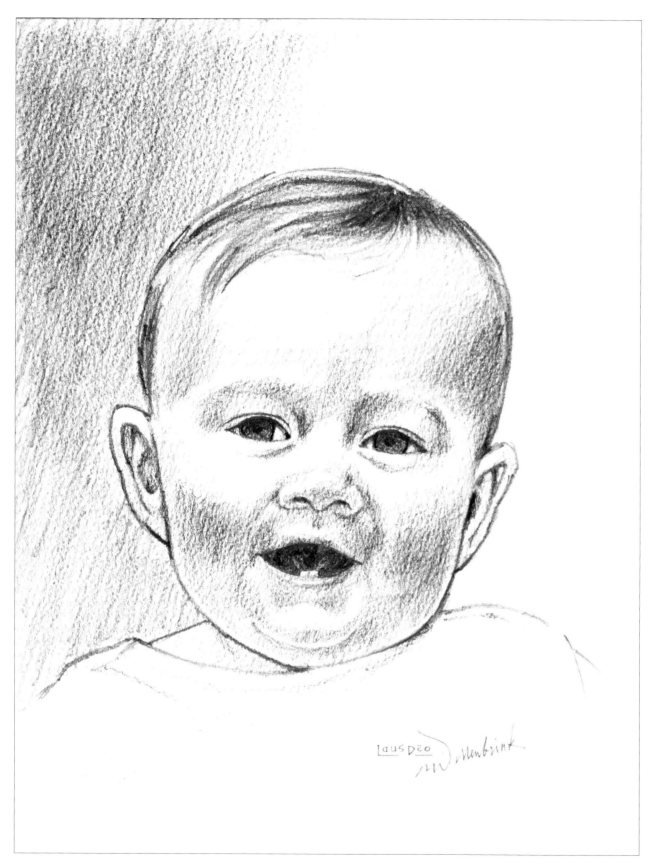

10 Make Adjustments and Add Details

Make adjustments, including darkening some areas with both 2B and 4B pencils. Lighten some areas if needed with the kneaded eraser, and add details. Sign and date your portrait.

Eli
graphite pencil on drawing paper
12" × 9" (30cm × 23cm)

Costumed Woman

Practice makes perfect! The more you practice drawing portraits, the better you will become. After practicing on your friends and family, you may feel you have run out of models for your portraits. Consider taking photos of people when you are out and about. This portrait is of an actress at a historical festival.

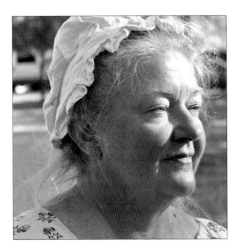

Reference Photo

1 Proportion and Sketch the Shape of the Head

With the 2B pencil, proportion the top, bottom and sides of the head with horizontal and vertical lines. Start to form the shape of the head using the proportion lines for guidance.

Prop It Up

Jewelry, props and costumes included in a portrait can add another chapter to the story about the subject. If the person has an interest or hobby, consider having a prop in the drawing that suggests the interest.

2 Sketch Placement Lines for the Basic Features and the Center of the Face

Continuing with the 2B pencil, sketch horizontal lines for the placement of the eyes, nose and mouth. Add a vertical line for the center of the face.

3 Sketch Placement Lines for the Remaining Features

Sketch horizontal placement lines for the brows and lips, and a vertical line for the ear. Sketch lines for the basic form of the hat and lines for the neck.

4 Develop the Features and Shoulders

Sketch short vertical lines for the width of the eyes and mouth. Form the nose and side of the mouth. Sketch a curved line for the shoulders.

5 Define the Features

Define the eyes, brows, lips, ear and hair.

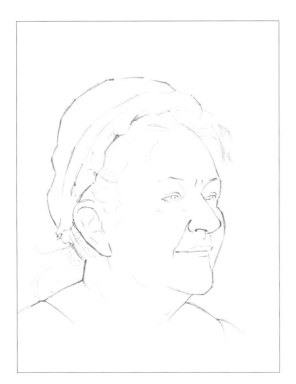

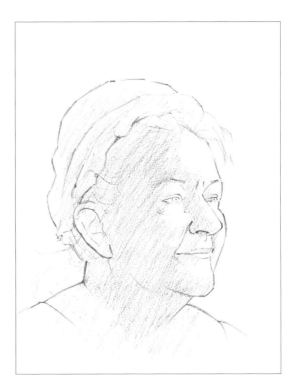

6 Add Details and Erase Unwanted Lines or Transfer the Image

With the 2B pencil, add details to the features including the hair and hat. Erase unwanted lines if you are working directly on the drawing paper, or trace or transfer the structural sketch onto drawing paper.

7 Start Shading With Lighter Values

Start shading the lighter regions with a 2B pencil. The light source is coming from the top right, making the right side of the face lighter than the left side.

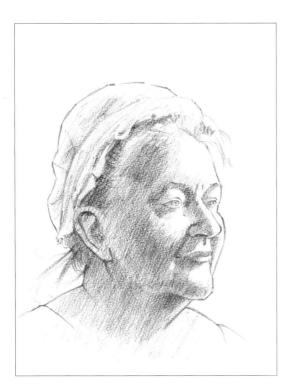

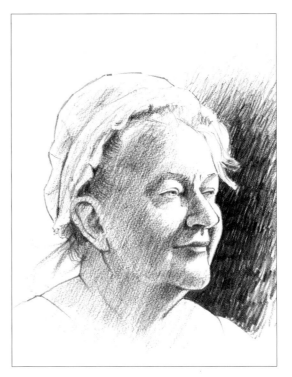

8 Add Middle Values

Add middle values to the subject with a 4B pencil.

9 Add Darks and Values to the Background

With a 6B pencil, add dark values to the subject and to the right side of the background.

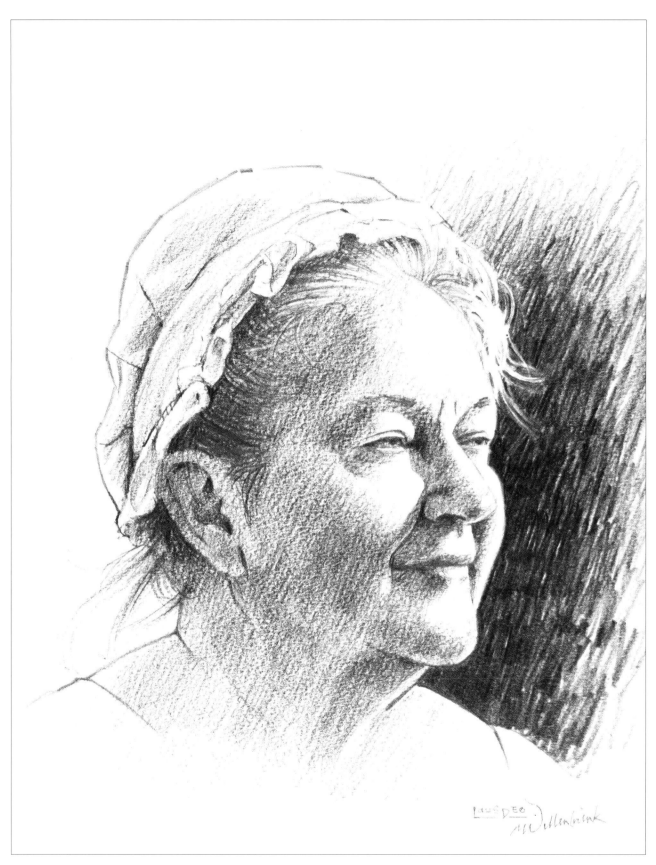

10 Make Adjustments and Add Details

With the 2B, 4B and 6B pencils, make adjustments and add details to features such as the hair and the hat. Use the kneaded eraser to lighten if needed. Sign and date your portrait.

Rebecca
graphite pencil on drawing paper
12" × 9" (30cm × 23cm)

Man in Profile

The light source for this subject is primarily coming from the upper left, causing the face to be lighter than the back of the head.

 Use charcoal pencil to obtain the values in this demo. Charcoal lines can be blended using facial tissue and a blending stump to create smooth shading and transitions, but the medium can also cause unintentional smearing. Place a slip sheet under your hand to avoid unwanted smears and fingerprints.

<div style="float:right;">

Materials

Paper
12" × 9" (30cm × 23cm) medium-tooth drawing paper

Pencils
2B charcoal pencil
2B graphite pencil

Other Supplies
blending stump
facial tissue
kneaded eraser
slip sheet

Optional Supplies
12" × 9" (30cm × 23cm) sketch paper
lightbox or transfer paper

</div>

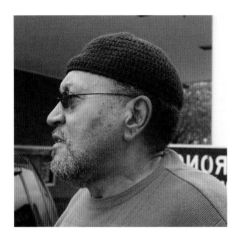

Reference Photo

1 Sketch the Basic Head Proportions
With a 2B graphite pencil, sketch the height and width proportions of the head on a sheet of sketch paper. The curved line for the left side will be the basis for the profile. You can make this line with a 2B charcoal pencil directly onto the drawing paper if you choose not to trace the structural sketch onto the drawing paper at a later stage.

2 Sketch the Head Form and Lines for the Features
Sketch the overall form of the head, following the proportions previously determined. Add lines for the placement of the eye, nose and mouth.

3 Sketch Lines for the Brow, Upper Lip, Neck and Shoulders
Sketch lines for the placement of the brow and upper lip. Sketch lines for the neck and shoulders.

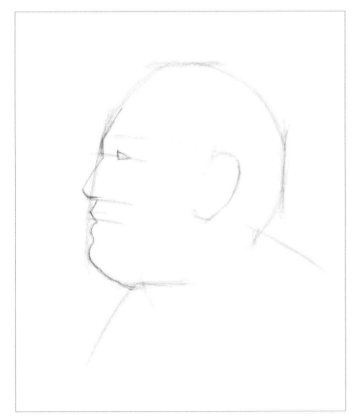

4 Define the Profile Features and Add the Eye and Ear
Define the profile of the face by shaping the forehead, brow, nose, lips and chin. Sketch the eye as a triangle shape and form the ear.

Eyes From the Side

When viewed from the side, the eye shape is triangular, formed by the top and bottom eyelids and the cornea. Placement of the eye from the nose bridge is important for the correct appearance. The cornea appears as a narrow elliptical shape.

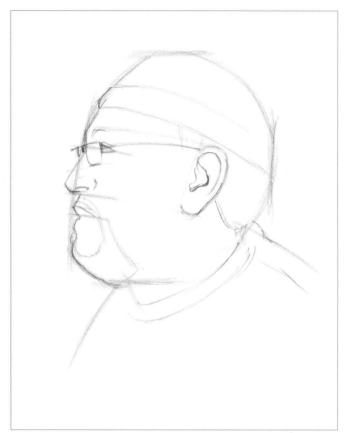 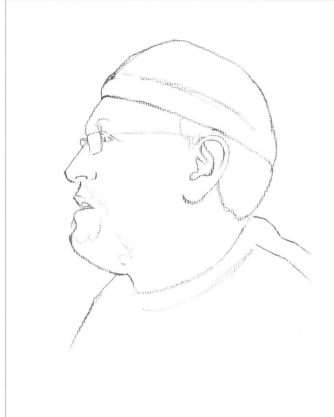

5 Add and Define the Structural Features
Add and define the features that make up the structural sketch including the eye, nose, top lip, ear, eyeglass frames, goatee, hat and shirt.

6 Trace the Image Onto Drawing Paper
Using a lightbox, trace the necessary lines of the image onto drawing paper with a 2B charcoal pencil, or erase any unwanted lines if you chose to work directly on the drawing paper with the 2B charcoal pencil.

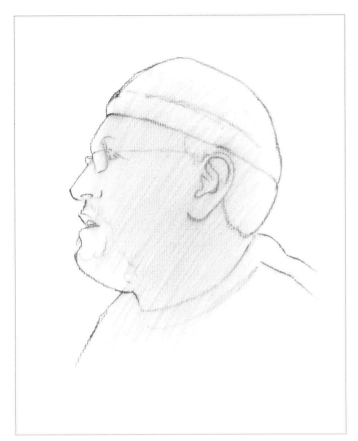

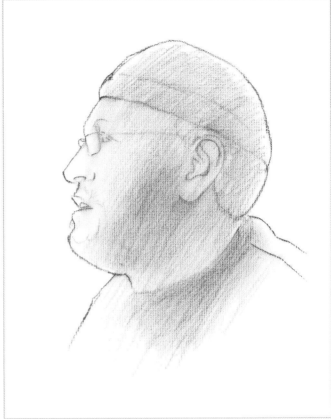

7 **Add Light Values Over the Image**
With light side-by-side strokes of the 2B charcoal pencil, add values to the image. The pencil strokes can be smeared with a facial tissue to soften the values. You'll make the highlights by lifting off the charcoal with a kneaded eraser at a later stage.

8 **Add Middle Values**
Add the middle values with more charcoal pencil strokes, with the left side of the face being somewhat lighter because of the light source. Lightly smear the charcoal with a tissue. Remember to rest your hand on a slip sheet to avoid unwanted smears and fingerprints.

Slip a Sheet Under It

Remember to use a slip sheet under the hand you're drawing with to avoid unintentionally smearing your drawing as you are working.

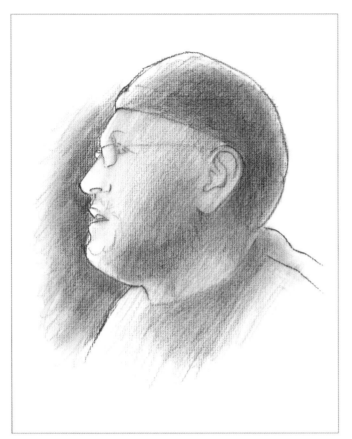

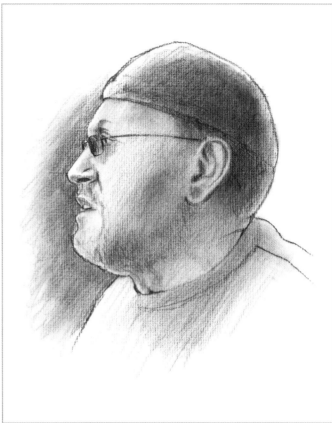

9 **Add Darker Values**
Add darker values to the face, hat and left side background. Smear with a tissue.

10 **Add Detailed Darks**
Add detailed darks to areas including sunglasses, eye, ear and mouth. For more detailed blending of values, use the blending stump.

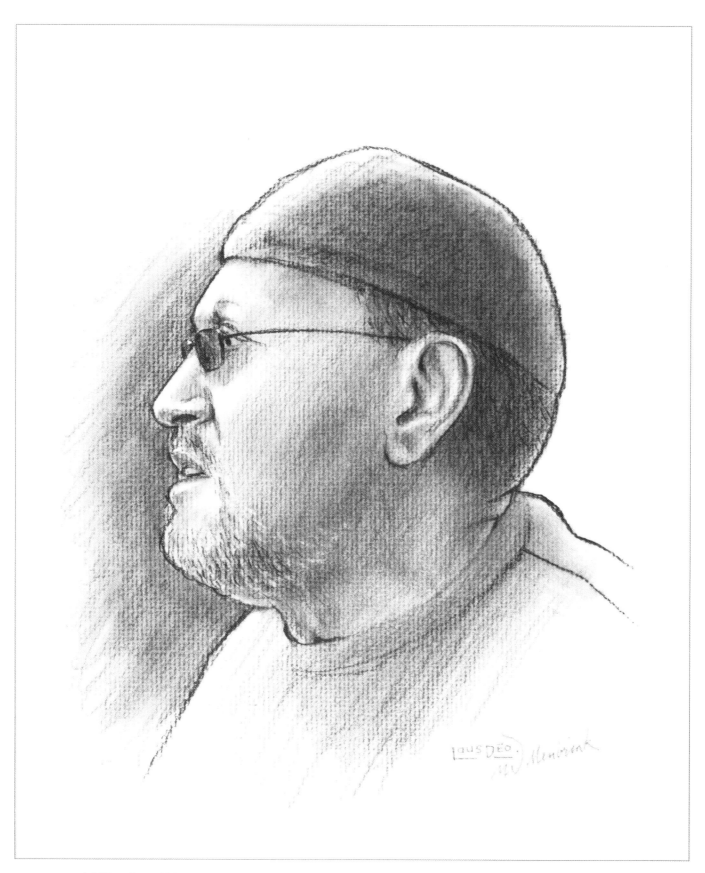

11 Add Details and Make Adjustments

Add final details and make adjustments, including removing graphite with a kneaded eraser to make highlights and lighter whiskers. Darken some areas and make some dark whiskers. Sign and date your portrait.

Earl
charcoal pencil on drawing paper
12" × 9" (30cm × 23cm)

Mother and Baby

Children's heads are generally smaller than those of adults. However, in this photo the baby's and mother's heads appear to be about the same size. The features and their placement will help to express their ages.

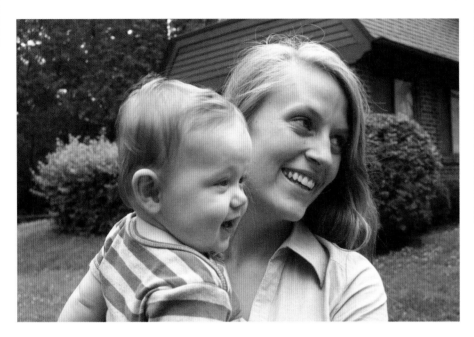

Reference Photo

Materials

Paper
9" × 12" (23cm × 30cm) fine-tooth drawing paper

Pencils
2B graphite pencil
4B graphite pencil

Other Supplies
kneaded eraser

Optional Supplies
9" × 12" (23cm × 30cm) sketch paper
lightbox or transfer paper

1 Sketch the Basic Proportions and the Shape of the Baby's Head

Using a 2B pencil, sketch the proportions for the width of the baby's head with vertical lines and the height of the head with horizontal lines. Form the basic head shape with proportion lines. Place the baby's head left of center on the paper to allow room for the mother's head.

2 Sketch the Basic Proportions and the Shape of the Mother's Head

Continuing with the 2B pencil, sketch a vertical line for the placement of the forehead and horizontal lines for the height of the head without the hair. Form the basic head shape following the proportion lines. Pay attention to the placement of the mother's head in relation to the baby's head.

3 Sketch Placement Lines for the Basic Features

Sketch lines for the center of the faces and for the placement of the eyes, base of the noses and mouths. Remember, babies are proportioned much differently than adults.

4 Sketch More Placement Lines

Sketch lines for the brows, lips and the baby's ear. Add lines for the shoulders.

5 Sketch Lines for the Width of the Facial Features

Place short lines to indicate the width of the eyes, noses and mouths.

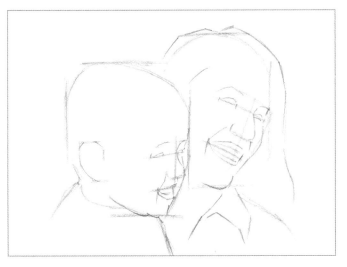

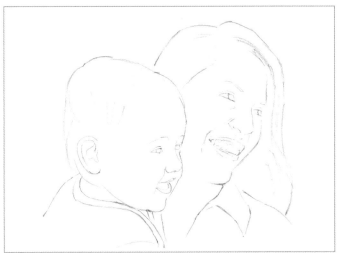

6 **Form the Features**
Form the facial features following the placement lines. Form the hair, shirt collars and facial shapes.

7 **Add Detail Lines and Trace or Transfer the Images or Erase the Unwanted Lines**
With the 2B pencil, add detail lines to the features. Trace or transfer the image onto drawing paper, or erase the unwanted lines if you chose to work directly on the drawing paper.

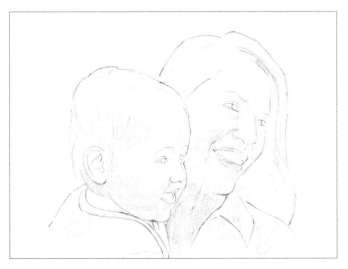

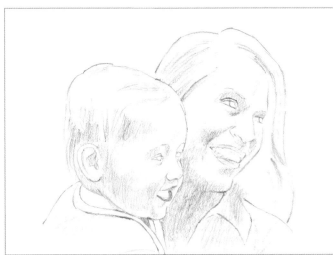

8 **Start Adding Values**
Start adding values over the baby and mother with the 2B pencil. Leave some of the areas white for the highlights.

9 **Continue With Middle Values**
Add middle values to the baby and mother, using the same pencil.

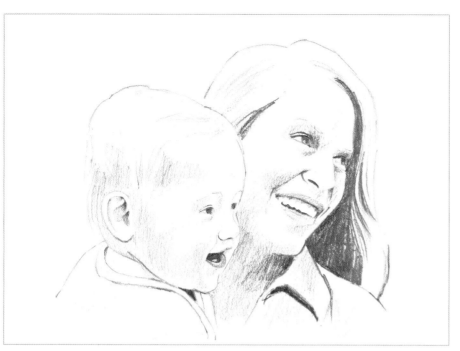

10 **Start Adding Darks**
With the 4B pencil, add darks to the eyes and shadowed regions.

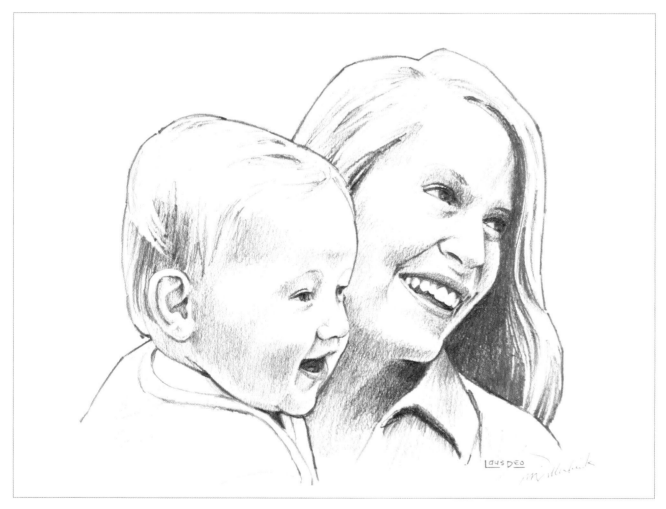

11 **Finish With Details and Adjustments**
Add details with both 2B and 4B pencils. Lighten some areas with a kneaded eraser. Sign and date your portrait.

Mother and Baby
graphite pencil on drawing paper
9" × 12" (23cm × 30cm)

Close-up Portrait

I find this view of the subject more challenging to draw than a direct profile but less challenging than drawing the full head because part of the head is cropped out of the picture. This draws more attention to the features than to the overall form. Though the subject is interesting, the lighting of the photograph makes the face look flat and could be improved upon. For this reason, I will broaden the range of values in the face to add more depth to the drawing.

The man who modeled for this demonstration was a personality at an outdoor historical reenactment. Such events are great places to photograph people in period costumes.

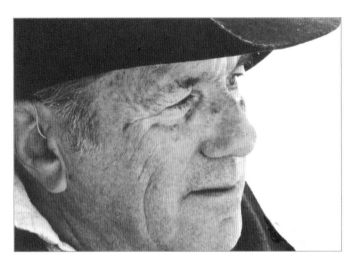

Reference Photo

Materials

Paper
9" × 12" (23cm × 30cm) fine-tooth drawing paper

Pencils
2B graphite pencil
4B graphite pencil
8B graphite pencil

Other Supplies
kneaded eraser

Optional Supplies
9" × 12" (23cm × 30cm) sketch paper
lightbox or transfer paper

1 Sketch Placement Lines
With a 2B pencil, sketch a slightly curved vertical line for the right side of the face. Sketch curved diagonal lines for the brows and the base of the chin, then a line halfway between for the base of the nose. Add lines for the eyes and mouth.

2 Place and Form the Basic Features

Place the eyes, and form the nose and mouth. Sketch basic shapes for the placement of the eyes on the previously drawn line. Start to form the nose and mouth.

3 Place the Ear

Continue the lines from the brows and base of the nose around the side of the face. Add a vertical line across the line coming from the base of the nose. The distance between this short line and the right vertical face line is equal to the distance between the brow line and the chin line.

4 Form the Ear, Hat, Shirt and Vest

Sketch the form of the ear, using the previous lines for its placement. Add lines for the hat, shirt and vest.

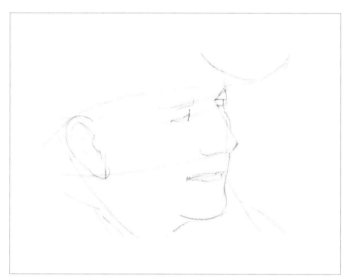
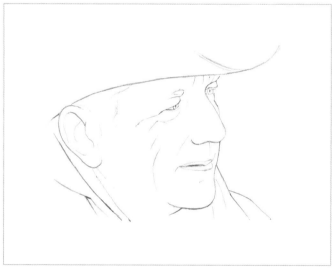

5 Add Lines to the Features

Add lines to the ear, brows, eyes and lips. Form the right side of the face, nose and chin. Sketch the curved line of the hat.

6 Add Detail Lines and Transfer the Image or Erase Unwanted Lines

With the 2B pencil, add detail lines to the eyes and brows. Sketch the wrinkles and sideburn. Trace or transfer the image onto drawing paper, or erase unwanted lines if working directly on the drawing paper.

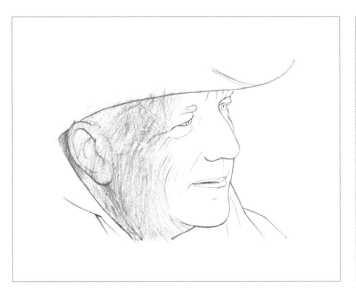

Start Adding Values

7 With the 4B pencil, start adding the middle values. The direction of the pencil strokes may follow the creases and lines of the face.

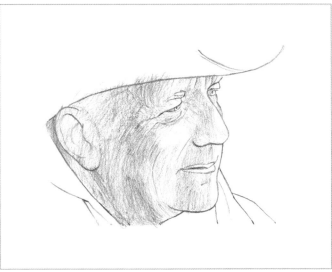

Continue Adding Middle Values

8 Continue covering the face with middle values, going lighter or darker in some areas. There is more light on the right side of the face than on the left. This will affect the values of the individual features.

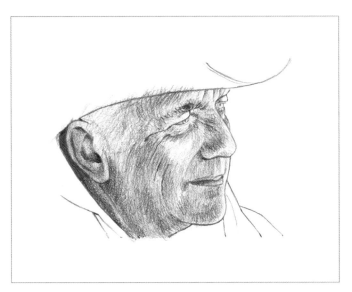

Start Adding Darks to the Face

9 Add darks to the face with the 4B and 8B pencils. Some places such as the neck area and behind the ear need to be very dark.

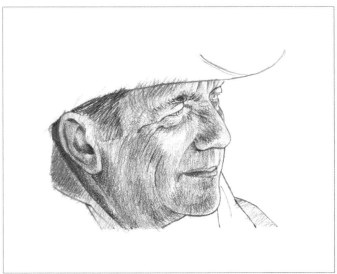

Add the Shirt and Sideburn

10 Add values of the shirt and sideburn with a 4B pencil. To draw the individual hairs, sharpen the pencil to a fine point.

Changes With Age

Skin becomes less hydrated and thinner as we age, causing wrinkles, sags and thinner lips. Continued bone growth is noticeable in the nose, jaw and forehead. Ears can become a bit more outstanding. Hair grays and thins, except for the eyebrows, which may actually become bushy for males.

11 Add the Hat and Vest

Add the rich darks of the hat and vest with the 8B pencil.

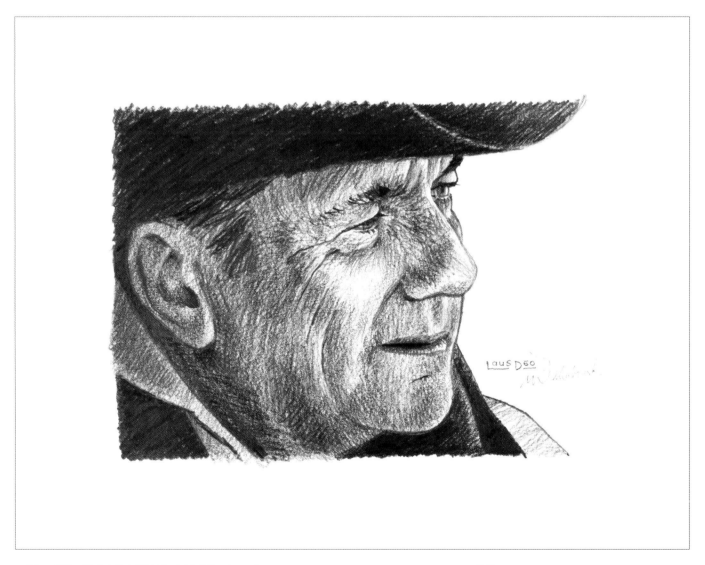

12 Finish the Details and Adjustments

Add details to the eyes. Make adjustments by lightening some areas with a kneaded eraser and darkening other areas with the 2B, 4B and 8B pencils. Sign and date your portrait.

E.B.
graphite pencil on drawing paper
9" × 12" (23cm × 30cm)

Male Teen With Hat

The lighting for this subject is coming almost evenly from both the right and the left. Notice how dark the lower left portion of the face is compared to the rest of the face. Including the hand gives more personality to the subject.

Reference Photo

Materials

Paper
12" × 9" (30cm × 23cm) fine-tooth drawing paper

Pencils
2B graphite pencil
4B graphite pencil
8B graphite pencil

Other Supplies
kneaded eraser

Optional Supplies
12" × 9" (30cm × 23cm) sketch paper
lightbox or transfer paper

1 Sketch the Basic Proportions and the Shape of the Head

With a 2B pencil, sketch the proportions for the width of the head with vertical lines and the height of the head with horizontal lines. The head should be placed to the upper left on the paper to allow room for the hand and shoulder. The line for the top of the head is placed just below the top of the hat. Form the basic head shape using the proportion lines.

Get Nosey

It may be visibly noticeable where the bony part of the nose bridge ends and where the cartilage begins. Try observing your own nose with a mirror and feeling its structure to recognize this transition.

2 Sketch Placement Lines for the Basic Features
Continuing with the 2B pencil, sketch a vertical line, slightly angled, for the center of the face. Sketch horizontal lines that are slightly angled for the eyes, base of the nose and mouth.

3 Sketch More Placement Lines
Sketch horizontal lines for the placement of the brows, lips and ear. Add vertical lines for the width of the ear. Add lines for the neck and shoulders.

4 Sketch Lines for the Hat, Features, Hand and Wrist
Sketch a curved line for the lower portion of the cap and a short vertical line for the placement of the brim. Use short vertical lines to indicate the width of the eyes, nose and mouth. Sketch lines for the basic shapes of the hand and forearm, paying attention to the relationship of the hand to the brim of the hat.

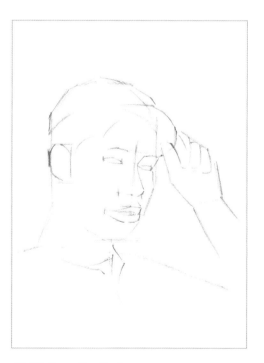

5 Form the Features
Form the facial features including the brows, eyelids, nose, lips, hairline and the side of the face. Form the top of the hat and brim. Add the fingers and then collars to the undershirt and outer shirt.

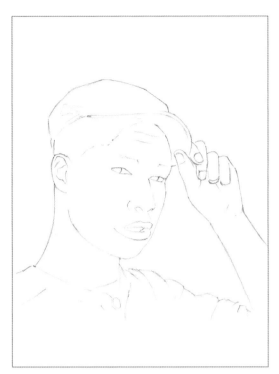

6 Add Detail Lines and Transfer the Image or Erase Unwanted Lines

With the 2B pencil, add detail lines to all of the features. Trace or transfer the image onto drawing paper, or erase unwanted lines if working directly on drawing paper.

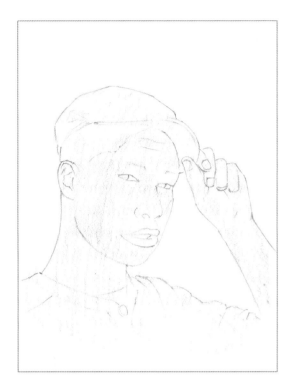

7 Start Adding Values

With a 4B pencil, start adding lighter values to the subject. Keep the background white. The hat will be drawn darker than it is in the photo and without the plaid pattern.

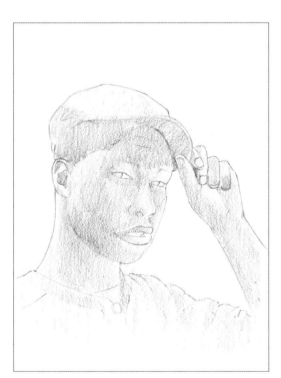

8 Add Middle Values

With the same pencil, add the middle values to give depth to the subject. At a later stage you can lighten some areas with a kneaded eraser.

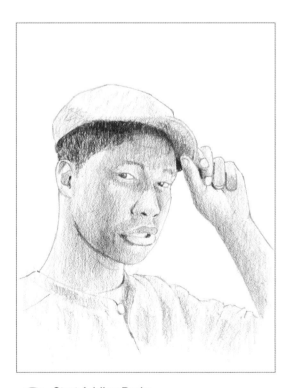

9 Start Adding Darks

With the 8B pencil, start adding darks to the face, hand, arm and shirt.

10 Finish Details and Make Adjustments

Add details to the features using both 4B and 8B pencils. Lighten some of the areas with a kneaded eraser. Sign and date your portrait.

M.C.
graphite pencil on drawing paper
12" × 9" (30cm × 23cm)

Little Girl in Pastel

For this drawing, I selected a gray paper with three pastel pencils, one pencil lighter and two darker than the paper. When working with pastel pencils, build up values slowly. It can be difficult to place one pastel over another, especially a white pastel over a darker pastel, so be thoughtful in their use.

I sketched the structural drawing on sketch paper and transferred it to the drawing paper. However, you may choose to work out the structural sketch directly on the drawing paper.

The light source is from above, slightly to the right.

Materials

Paper
12" × 9" (30cm × 23cm) medium gray, medium-tooth drawing paper

Pencils
black pastel pencil

light gray pastel pencil

medium gray pastel pencil

Other Supplies
kneaded eraser

Optional Supplies
2B graphite pencil

12" × 9" (30cm × 23cm) sketch paper

lightbox or transfer paper

Reference Photo

1 Proportion and Sketch the Shape of the Head

Using a 2B pencil (or medium gray pastel pencil if working directly on the drawing paper), sketch an angled line for the center of the face. Proportion the top, bottom and sides of the head, then follow the proportion lines for the shape of the face.

Making Faces

Facial expressions involve more than just the mouth and eyebrows. They involve the muscles that change the contour and shape of the face. A smile pulls the cheeks up along with the corners of the mouth and affects the shape of the eyes and brows. A frown pulls down the cheeks, turning down the corners of the mouth and affecting the other features.

2 Place the Features
Sketch angled lines to place the eyes, nose and mouth.

3 Place the Brows, Lips and Hair
Sketch lines to place the brows, lips and the shape of the hair.

4 Establish the Width of the Facial Features and Place the Collar
Sketch lines for the width of the eyes, nose and mouth. Sketch a curved line for the shirt collar.

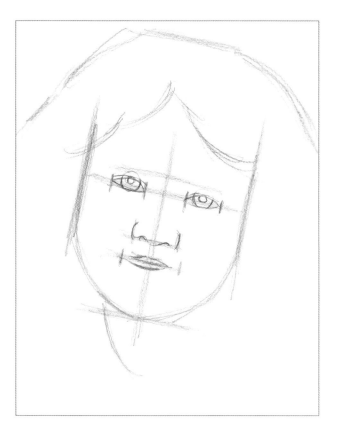

5 Define the Facial Features
Define the eyes, nose and mouth.

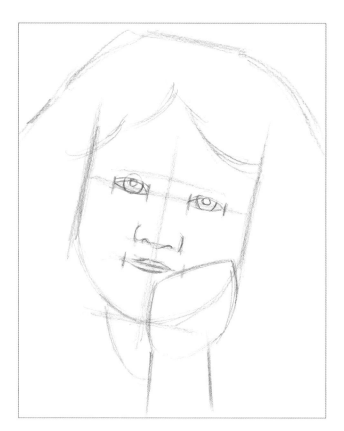

6 Sketch the Hand and Arm
Sketch the basic shape of the hand, paying attention to its size and placement in relation to the face. Add two lines for the arm.

7 Define the Hand
Sketch the fingers and thumb to define the hand.

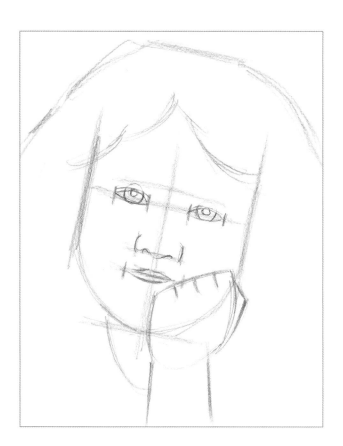

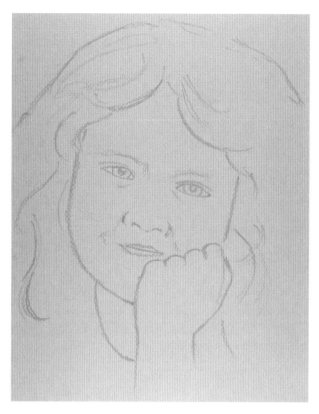

8 Add Details and Erase Unwanted Lines or Trace or Transfer the Image

Add details, including hair. Erase unwanted lines if working directly on the drawing paper, or trace or transfer the image onto drawing paper using a medium gray pastel pencil.

9 Start Shading the Face

Start adding values to the face with a medium gray pastel pencil that is darker than the paper.

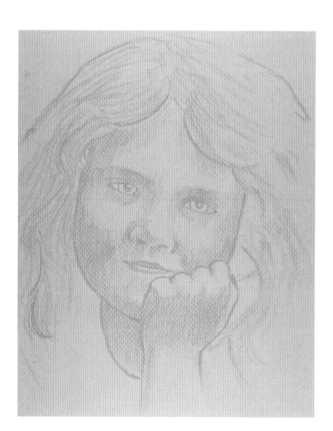

10 Add Shading to the Hair, Hand, Arm and Neck

Continue adding values to the hair, hand, arm and neck. The paper provides the value for many areas throughout the portrait, so it isn't necessary to go heavy with the pastel pencil.

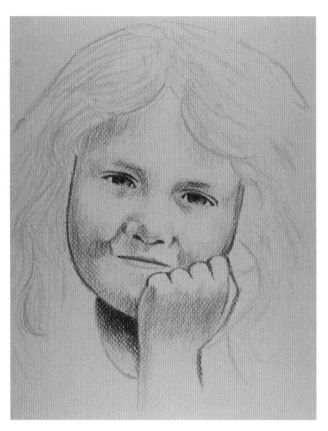

11 Add Dark Values to the Face, Hand and Arm
With the black pastel pencil, add darks to the face, hand, arm and neck.

12 Add Dark Values to the Hair and Shirt
Darken the hair and shirt with the black pastel pencil.

13 Add Lighter Values
With the light gray pastel pencil, add lighter values to the face, hand, arm and hair.

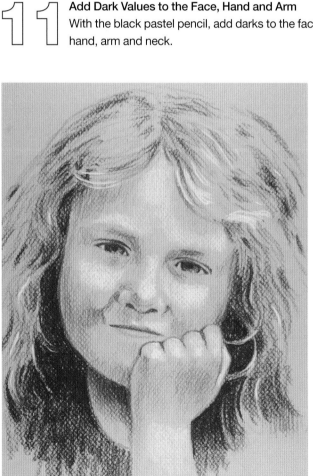

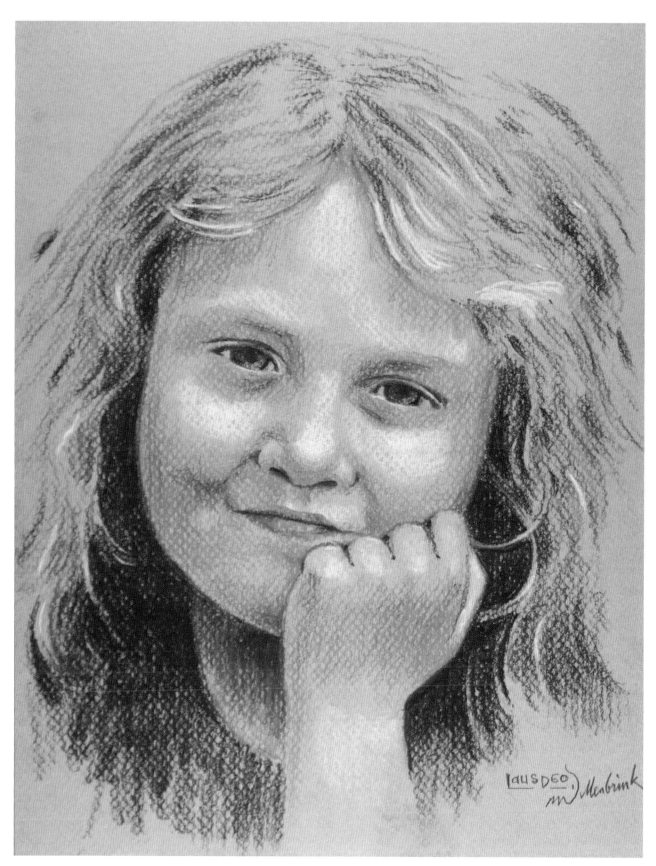

14 Make Adjustments and Add Details
With the light gray, medium gray and black pastel pencils, lighten or darken, adding details as needed to complete the portrait. Sign and date your portrait.

Little Princess
pastel pencil on gray drawing paper
12" × 9" (30cm × 23cm)

Self-Portrait in Profile

This demonstration is a self-portrait of me, Mark Willenbrink. You can draw this portrait of me, or you can work from a photo of yourself, following the same steps. To take a photo of yourself, it is best to use a camera supported with a tripod, then use a remote shutter release. Many digital cameras can be set to take black-and-white photos, which are easier to work from than color photos when doing monochromatic (one color) art because there is less guesswork when translating the values. A plain sheet can be used as a backdrop for the background.

The primary light source of my photo is from the right, causing the right side of the face and hand to receive more light than other areas.

Materials

Paper
12" × 9" (30cm × 23cm) medium-tooth drawing paper

Pencils
2B graphite pencil
4B graphite pencil
8B graphite pencil

Other Supplies
kneaded eraser

Optional Supplies
12" × 9" (30cm × 23cm) sketch paper
lightbox or transfer paper

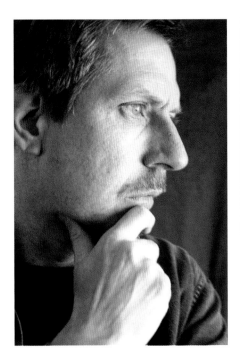

Reference Photo

1 Sketch Placement Lines
With a 2B pencil, sketch a curved line for the basic form of the right side of the face. Sketch lines for the eyes, nose, brows and mouth. Add a line for the chin, placing it the same distance from the nose as the nose is from the brows. Though the hand covers the chin, sketching the chin will help place the hand and shadows.

2 Place the Eye, Nose and Ear
Sketch two short vertical lines along the previously drawn line to place the eye. Sketch a diagonal line and a short vertical line to place the nose. Add two vertical lines between the previously drawn brow and nose lines to place the ear.

3 Form the Facial Features
Form the eye, brow, nose, lips, ear, hair, chin and jawline.

4 Sketch the Index Finger and Knuckles
Start sketching the hand, beginning with lines for the index finger, which rests below the lower lip. Draw a line to place the knuckles.

5 Sketch the Overall Hand Shape
Sketch a rectangle for the back of the hand. Notice its size in relation to the face. Add two curved lines for the thumb, paying attention to their placement in relation to the jawline.

6 Add the Shoulder, Shirt and Details, and Transfer the Image or Erase Unwanted Lines
Sketch the shoulder and shirt. Add details to the face and hand, and refine the creases and shadow lines. Erase unwanted lines if you are working directly on drawing paper. Otherwise, trace or transfer the structural sketch onto drawing paper with the 2B pencil.

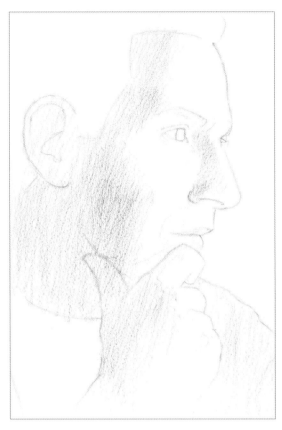

7 Start Adding Values

With a 4B pencil, start adding values, keeping the areas white that receive the most light.

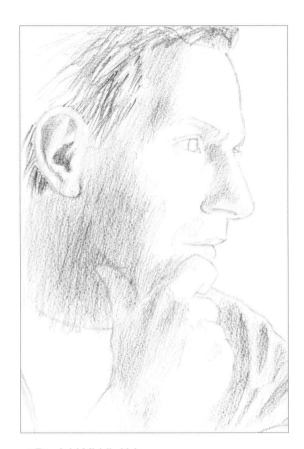

8 Add Middle Values

Continue adding middle values in many places, building upon the lighter values previously laid down.

9 Add Darks

With the 8B pencil, add the dark values including the hair, shirt, background and shadows on the jaw.

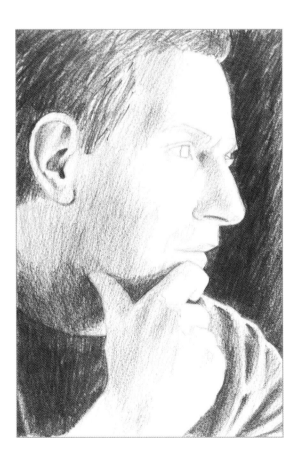

Test Your Portrait

Once you have completed a demonstration, you may look at your portrait and think that something just isn't right. Many times a good portrait is one step away from a great portrait. You can improve your work just by making simple adjustments and pushing contrasts. Place a sheet of tracing paper over a portrait drawing to test darkening areas of a subject.

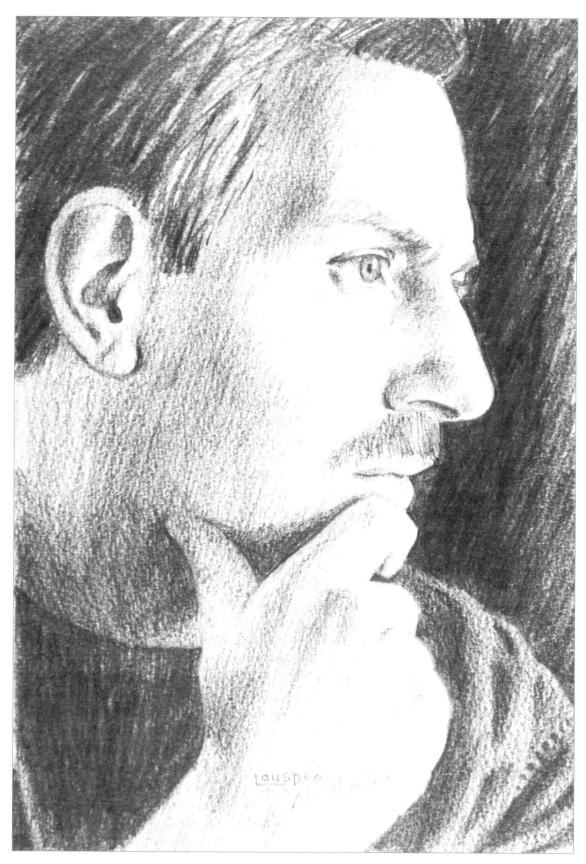

10 Finish With Details and Adjustments

Add details to the eyes and adjust some of the lights and darks. To make an area lighter, just pinch the kneaded eraser and dab to lift out some of the graphite in that area. Sign and date your portrait.

Self-Portrait
graphite pencil on drawing paper
12" × 9" (30cm × 23cm)

Toddler With Toy Phone

To help simplify the process of drawing this portrait, think of the structural sketch as three elements placed together: the head and torso, the telephone, and the hands and arms. To make the portrait look believable, it's important to get these elements proportioned and positioned accurately.

The light is coming from the left, causing the right side of the subject to be darker.

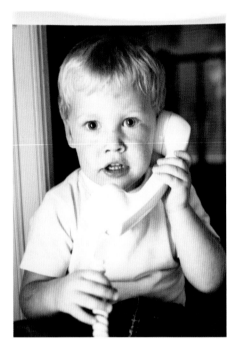

Reference Photo

Materials

Paper
12" × 9" (30cm × 23cm) medium-tooth drawing paper

Pencils
2B graphite pencil
4B graphite pencil
6B graphite pencil

Other Supplies
kneaded eraser

Optional Supplies
12" × 9" (30cm × 23cm) sketch paper
lightbox or transfer paper

1 Proportion and Sketch the Shape of the Head

Use a 2B pencil to proportion the top, bottom and sides of the head. Follow the proportion lines to form the shape of the head. Notice how the top of the head is wider than the lower portion of the head.

Gender and Youth

Facial proportions and features of boys and girls are very similar. It isn't until young adulthood that the face displays features more specific to being male or female.

2 Place the Eyes, Nose, Mouth and Center of the Face
Continuing with the 2B pencil, sketch slightly angled horizontal lines to place the eyes, nose and mouth. Sketch a slightly angled vertical line for the center of the face.

3 Sketch Placement Lines for the Brows, Lips and Ear
Sketch more lines for the placement of the brows, lips and ear.

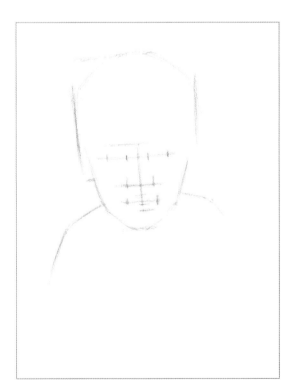

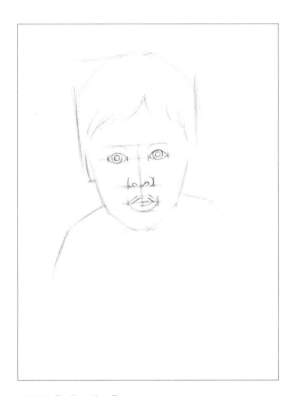

4 Sketch Lines for the Width of the Facial Features and for the Shoulders
Indicate the width of the eyes, nose and mouth with short vertical lines. Sketch lines for the shoulders.

5 Define the Features
Add definition to the features, including the hair, brows, nose, mouth and ear.

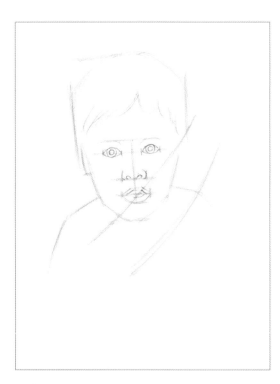

6 Sketch the Telephone

Start sketching the shape of the phone, making the long curved lines of the handle and a similar line connecting the receiver and mouthpiece. Make sure these lines are in the correct position to the face.

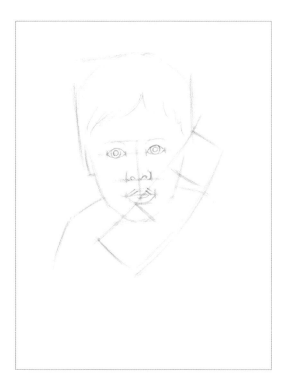

7 Sketch the Ends of the Telephone

Sketch lines for the receiver and mouthpiece of the phone.

8 Define the Form of the Telephone

Define the curved forms of the phone including the cord.

9 Sketch the Hands

Sketch the hands with basic mitten shapes for the fingers in contact with the telephone handle and cord.

10 Sketch the Arms
Sketch the basic shapes of the arms in relationship to the hands.

11 Develop the Hands and Arms
Sketch the individual fingers to develop the hands, and complete the right arm.

12 Add Details and Erase Unwanted Lines or Trace or Transfer the Image
Add details including the hair, teeth and shirt. If working directly on the drawing paper, erase unwanted lines. Otherwise, trace or transfer the image onto drawing paper using the 2B pencil.

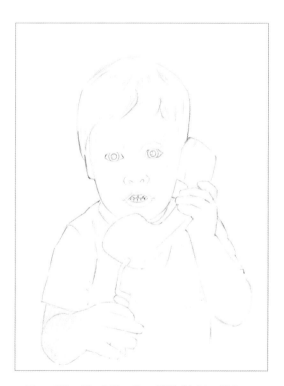

13 Start Shading With Lighter Values
With a 2B pencil, start shading the lighter areas of the subject. Most of the phone handle can be kept white. The darker form of the shirt will distinguish it from the shape of the phone.

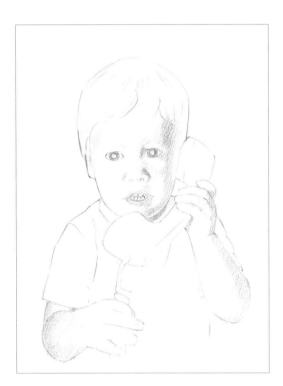

14 Add Middle Values to the Face, Hands and Arms

With a 4B pencil, add middle values to the face. Most of the light is coming from the upper left with some reflected light on the right side of the face. Add middle values to the hands and arms.

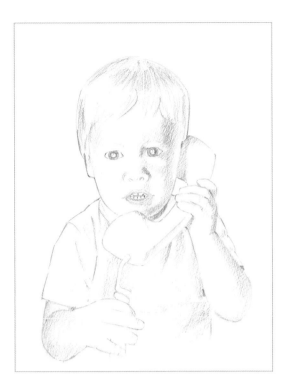

15 Add More Middle Values

Continue adding middle values to the hair, phone and shirt.

16 Add Darks to the Background

With the 6B pencil, add dark values to the background. Notice that the darkest areas are toward the top around the head.

17 Add Darks to the Subject

With 4B and 6B pencils, add darks to the hair, eyes, nose, mouth and fingers of the subject.

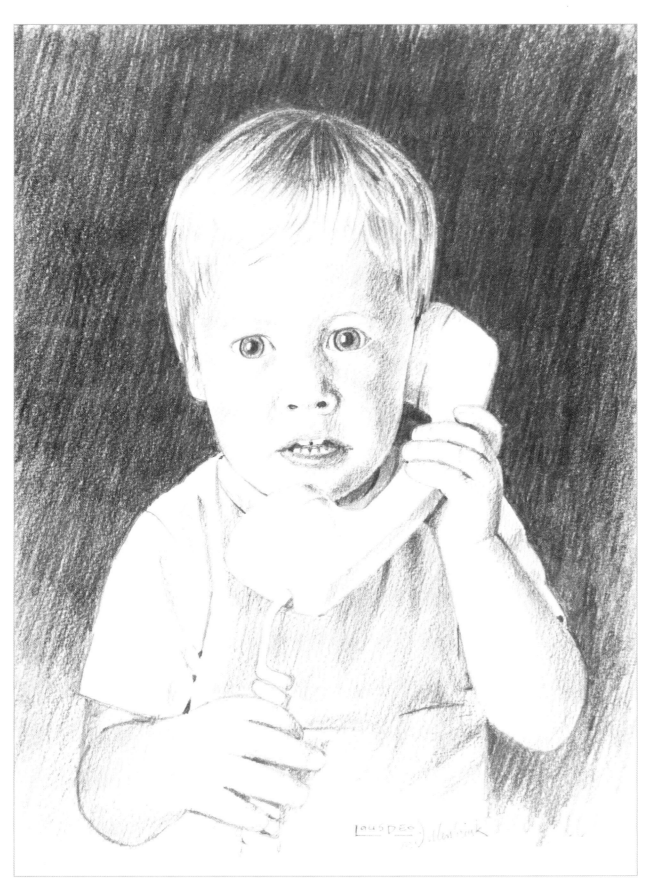

18 Make Adjustments and Add Details

Adjust by erasing and darkening different places, and add details. Sign and date your portrait.

J.T.
graphite pencil on drawing paper
12" × 9" (30cm × 23cm)

4 Let's Draw
Nature

Observing and studying individual subjects is an important part of the drawing process. Let's build on what we learned in the previous chapters and apply it to the study of each of these subjects in nature. Look for the structure, values and texture of your subject. As you begin, establish the proper proportions and the accurate placement of your lines and shapes. Then add your lights and darks, along with the texture of your subject.

Many inanimate subjects, such as rocks and trees, can be implied in the art rather than drawn as a literal image. However, to be successful in doing this, the light and shadows must be placed so the end result appears authentic.

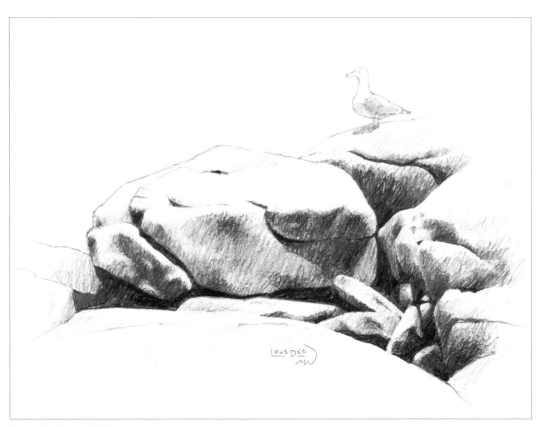

Shore Rocks and Gull
graphite pencil on drawing paper
8½" × 11" (22cm × 28cm)

Choosing a Format

The overall format for artwork can be horizontal, vertical or square, each offering a different feeling that can be used to enhance the specific subject matter.

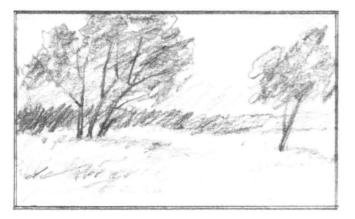

Horizontal Format
Using a horizontal format in a composition can express a comforting, pastoral feel.

Using a Square Format
The sameness of a square format may detract from the image; however, with the right subject, it can work.

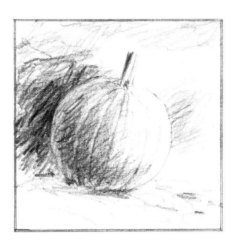

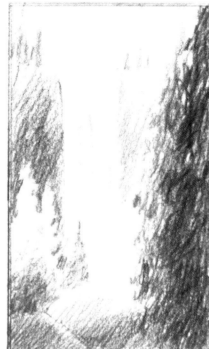

Vertical Format
A vertical format chosen for a composition can express a bold, forceful feel or emphasize the towering qualities of a subject.

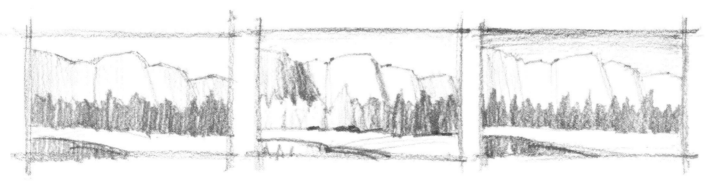

Using Thumbnail Sketches
These small, quick sketches, used for planning a composition, are good for working out problems and comparing ideas before starting a drawing.

Rock Formations

MINI-DEMONSTRATION

Rocks may be jagged, layered, smooth or round. When there is nothing to compare them to in a scene, the size or scale of rocks and their formations may be difficult to determine. Backyard rocks can be studied as smaller versions of larger boulders or rock formations.

This cluster of rock forms is first drawn as a structural sketch, then the values are added with the consideration that the light source is coming from the upper left.

Materials

8" × 10" (20cm × 25cm) medium-tooth drawing paper

2B graphite pencil

kneaded eraser

1 Sketch the Basic Shape
Sketch the overall shape of the rock forms with basic lines. With this example, the shape of the rocks forms a triangle.

2 Develop the Forms
Develop the rock forms, sketching the largest shapes first, then adding the smaller shapes.

3 Add Detailed Lines
Add detailed lines to the structural sketch to define the shapes of the rock forms. Erase any unwanted lines.

4 Add the Values
Add the lighter, middle and dark values. Add any detailed linework and, if necessary, lighten any areas with a kneaded eraser.

Mountains With Snow

MINI-DEMONSTRATION

Mountains may be thought of as rock formations on a grand scale. The surface of mountains may be exposed rock or covered with trees or snow, but when seen from a distance, they may appear as a single form when in actuality, they are made up of numerous contours.

These Colorado mountains are partially covered with snow that is supported by the layered rock forms. The light source is from the upper right, causing the left sides of the mountains to be in shadow.

Materials

8" × 10" (20cm × 25cm) medium-tooth drawing paper

2B graphite pencil

kneaded eraser

1 Sketch the Basic Shapes
Sketch the overall forms of the mountains as basic shapes.

2 Develop the Forms
Develop the forms of the mountains, working in the order of the largest and most noticeable shapes, then sketching the smaller shapes.

3 Add Detailed Lines
Add detail lines to define the shapes of the structural sketch, including lines for the rock layers and the snow. Erase any unwanted lines.

4 Add Values
Add the lighter, middle and dark values. Adjust by lightening, if necessary, with a kneaded eraser.

Small Waterfall

MINI-DEMONSTRATION

The appearance of water is different than solid or opaque elements. It can appear clear or reflective, active or still, and can change depending on how it is viewed and its relationship to other elements.

The water in this scene displays a range of values from white to middle to dark values. The darkest values are of the shadowed rocks that are on the sides of the falling water. The water at the top and bottom appears calm, while the waterfall and foam are more active.

Materials

8½" × 5½" (22cm × 14cm) medium-tooth drawing paper

2B graphite pencil

kneaded eraser

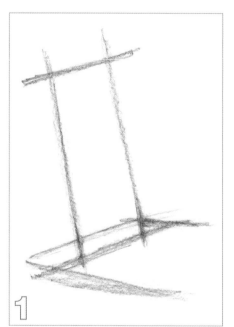

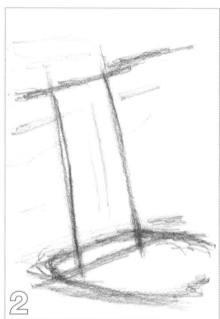

1 Sketch the Basic Shapes
Sketch a rectangle as a basic shape for the waterfall. Sketch the foam area at the base with simple lines.

2 Develop the Forms
Develop the forms of the waterfall and foam, adding curved lines where needed.

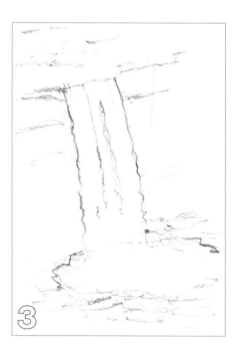

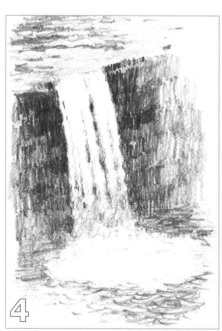

3 Add Details
Add details and refine the linework of the structural sketch, erasing any unwanted lines in the process.

4 Add Values
Add the lighter, middle and dark values. Adjust any areas by lightening with a kneaded eraser, if necessary.

Coneflower

MINI-DEMONSTRATION

Attention to details is a key to capturing the simple elegance of a flower. The long, curved petals of a coneflower make the overall shape convex. A drawing may include more than one flower, all of which can be drawn with the same process.

Materials

8½" × 5½" (22cm × 14cm) medium-tooth drawing paper

2B graphite pencil

kneaded eraser

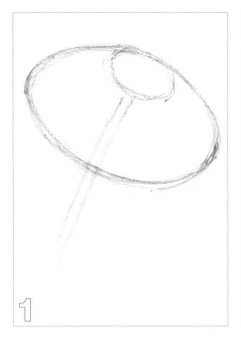

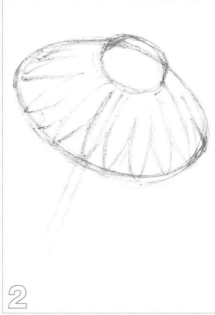

1 Sketch the Basic Shape
Sketch the basic outer shape of the flower and its center with ellipses. Sketch two lines for the stem. Connect the stem lines to the center for drawing accuracy.

2 Develop the Form
Sketch the petals, then add curved lines for the center of the flower to create a convex appearance.

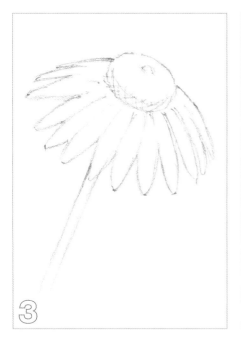

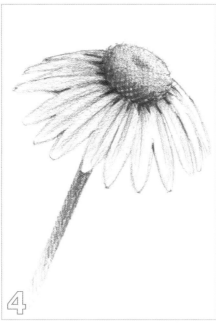

3 Add Detailed Lines and Erase Unwanted Lines
Add detailed lines to the center and to the petals. Erase unwanted lines such as the stem lines underneath the petals.

4 Add the Values
Add the lighter, middle and dark values. Add details to the petals and center. Lighten with a kneaded eraser, if necessary.

To capture the specific personality of a tree, begin by drawing its trunk and overall shape, then the branches, limbs and twigs. The leaves are sketched last, creating the lights and darks according to the placement of the light source.

Paying attention to the details of the trunk and shape of this tree's full foliage will help capture the personality of this tree.

Materials

8½" × 5½" (22cm × 14cm) medium-tooth drawing paper

2B graphite pencil

kneaded eraser

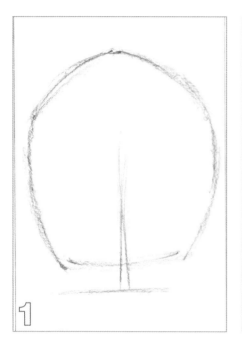

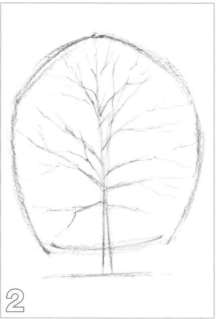

1 Sketch the Basic Shape
Sketch the trunk, baseline and outer form to create the basic shape of the tree.

2 Add Limbs and Branches
Add the limbs and branches to the main trunk, sketching them to be more vertical as the branches approach the top of the tree.

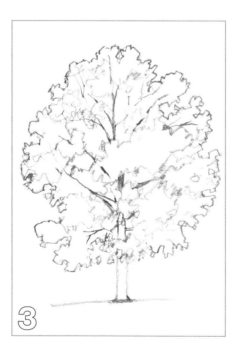

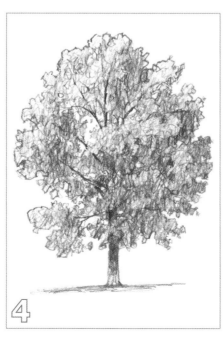

3 Develop Leaf Forms
Develop the forms of the leaves and erase the outer form as well as the unwanted limbs and branches that are obscured by the leaves.

4 Add Values
Add the lighter, middle and darker values and, if necessary, lighten with a kneaded eraser.

Butterfly

MINI-DEMONSTRATION

The close-up world of insects provides another dimension of interest to your drawings. Study a subject through detailed reference photos to increase your observational skills and add credibility to a drawing.

The complex form of the butterfly is easier to draw when first sketched with simple geometric shapes. Butterflies vary in appearance; however, the process for drawing them can be the same.

Materials

5½" × 8½" (14cm × 22cm) medium-tooth drawing paper

2B graphite pencil

kneaded eraser

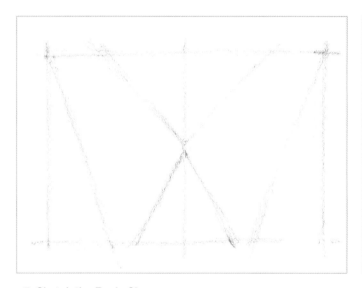

1 Sketch the Basic Shape
Sketch a rectangle with a centerline and then add more lines for a basic symmetrical shape.

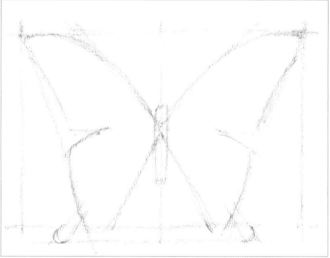

2 Develop the Form
Develop the form of the butterfly, including the wings, thorax and abdomen.

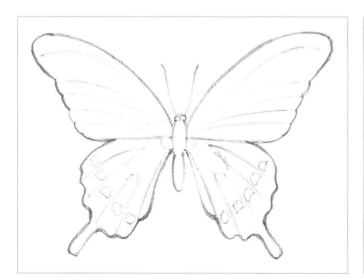

3 Add Detailed Lines and Erase Unwanted Lines
Add lines detailing the inner and outer forms, erasing unwanted lines throughout the process.

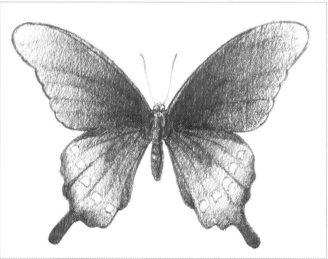

4 Add Values
Add the lighter, middle and dark values, lightening with a kneaded eraser, if necessary.

Deer

MINI-DEMONSTRATION

To be walking quietly in a forest and happen upon a deer is an amazing experience. Both the deer and observer are startled, looking at one another for an instant before deciding to move on.

The head and antlers, viewed straight on, can be drawn symmetrically. The basic shape can be sketched as a straight vertical with horizontal lines. More fluid lines are developed throughout the drawing process.

Materials

10" × 8" (25cm × 20cm) medium-tooth drawing paper

2B graphite pencil

kneaded eraser

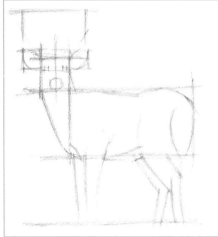

1 Sketch the Basic Shape
Proportion and sketch a rectangle for the body and a baseline on which to rest the hooves. Sketch lines for the top and sides of the head.

2 Define the Animal Form
Add lines for the neck and torso area and the closer front and rear legs. Sketch squares on the side of the head for the placement of the ears.

3 Develop the Deer
Sketch lines for the other two legs and the tail. To keep elements symmetrical, sketch a centerline for the face, lines for the eyes and a circle for the snout. Add lines to place the antlers and develop the form of the body.

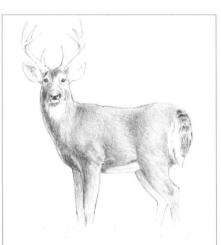

4 Add Detailed Lines
Add details and refine the overall form, erasing unwanted lines throughout the process.

5 Add Values
Add the different values, use a kneaded eraser to lighten some areas, if needed.

Opossum

MINI-DEMONSTRATION

If you live in eastern North America, you are no doubt familiar with the opossum, a nocturnal marsupial with a ratlike tail. The basic shapes of the body and head can be sketched as circles. The legs and feet are concealed in this picture so they don't have to be drawn.

Materials

5½" × 8½" (14cm × 22cm) medium-tooth drawing paper

2B graphite pencil

kneaded eraser

1 Sketch the Basic Shapes
Sketch the horizontal baseline, then sketch a large circle as the basic shape of the body, then a smaller circle as the shape of the head.

2 Add to the Basic Shapes
Add to the circles a center face line, lines for the eyes and ears, a smaller circle for the snout and two lines for the back of the opossum.

3 Add Features
Add features to the basic shapes including eyes, ears, nose and tail.

4 Add Lines and Erase Unwanted Lines
Add details including lines for the direction and shading of the fur. Erase any unwanted lines with the kneaded eraser.

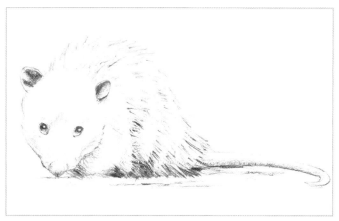

5 Add Values
Add values, mostly straight lines to indicate fur. Lighten with a kneaded eraser, if necessary.

Goose

MINI-DEMONSTRATION

The Canada goose is a pleasant subject to draw with its recognizable form and distinctive markings. The shape of a bird is different depending on whether it is sitting or active. Pay attention to its overall shape to find the foundation for a successful drawing. Attention to detail is important when you are drawing features such as the eyes and feathers.

Materials

5½" × 8½" (14cm × 22cm) medium-tooth drawing paper

2B graphite pencil

kneaded eraser

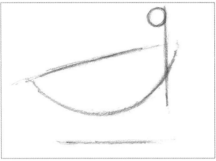

1 Sketch the Basic Shapes

Sketch the basic shapes of the form of the bird starting with an arc with a line at the top for the body. Add a vertical line on the right to determine the placement of the circle for the head along with a horizontal baseline for the feet.

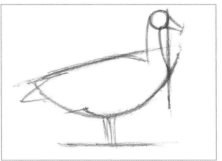

2 Develop the Form

Add the neck, bill and legs, and shape the body to develop the form of the bird.

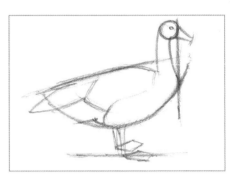

3 Start to Add Details

Start adding the details including the eye and feet and the forms of the feathers.

4 Create Details and Erase Unwanted Lines

Add more details including feathers. Refine the outer form and erase unwanted lines.

5 Add Values

Add the wide range of values. Use a kneaded eraser to lighten any areas.

Eagle in Flight

MINI-DEMONSTRATION

Large predatory birds have a regal beauty that is inspiring. The tapering of the wings and the off-center placement of the body contribute to the impression that one wing is farther away than the other.

Materials

5½"× 8½" (14cm × 22cm) medium-tooth drawing paper

2B graphite pencil

kneaded eraser

1 Sketch the Basic Shape of the Wings
With curved and straight lines, sketch the basic shape of the outstretched wings.

2 Sketch the Shape
Sketch a rectangle for the basic shape of the body, including the head and tail feathers. Because the subject is shown in perspective, the placement of the body appears farther to the left than it does to the center of the wings.

3 Develop the Form
Develop the overall form of the wings, head, body and tail.

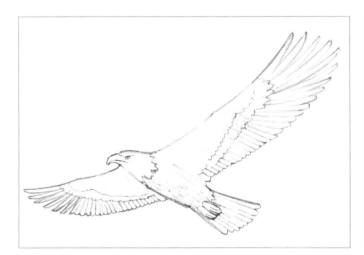

4 Create Details and Erase Unwanted Lines
Refine the lines and add details including the feathers, which fan out at the ends of the wings. Erase any unwanted lines.

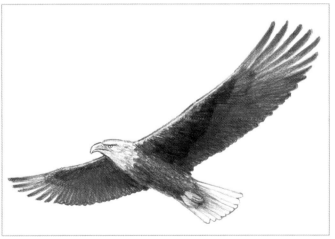

5 Add Values
Add the values throughout the form of the eagle. Lighten any areas with a kneaded eraser, if necessary.

Rocks

Nature provides many simple subjects that are interesting to draw. For this demonstration, the structural sketch can be made directly onto the drawing paper or done on a separate sheet of paper, then traced or transferred onto the drawing paper to avoid unwanted lines and erasing. Sketch the whole rock, not just the part that is seen, so that you can be more accurate with the shape of the rocks. Duplicating the size and shapes of the rocks is as important as keeping the light and shadows consistent.

The light source is coming from the upper right, causing the rocks to be lighter at their upper right and darker at their lower left. The dark regions are well defined and can be established at the beginning of the values stage.

The values of your drawing can be compared to the finished demonstration in the book using your value scale.

Materials

Paper
6" × 9" (15cm × 23cm) rough-tooth drawing paper

Pencils
2B graphite

4B graphite

8B graphite

Other Supplies
kneaded eraser

value scale

Optional Supplies
6" × 9" (15cm × 23cm) fine- or medium-tooth sketch paper

lightbox or transfer paper

slip sheet

1 Start the Structural Sketch
With a 2B pencil, start the structural sketch with the biggest rock, paying attention to its shape and its placement on the paper.

2 Add More Rock Shapes
Sketch the rocks that are on top of other rocks. Though the full shape of some of the rocks may be obscured by other rocks, sketching their complete shape will ensure accuracy.

Continue to Add Rock Shapes

3 Add more rock shapes until all are sketched in. Add lines for showing the cracks and crevices.

Erase, Trace or Transfer

To avoid erasing on the drawing paper, work up the structural sketch on a sheet of sketch paper, then trace or transfer the structural sketch onto the drawing paper, leaving out any unwanted lines.

Erase or Transfer and Add Details

4 Erase any unwanted lines or transfer the sketch onto drawing paper by tracing it if you are working from a separate sketch. Add lines indicating shadowed regions on the individual rocks.

Add Darkest Regions

5 With an 8B pencil, place the darkest regions using the handwriting grip for controlled linework. Avoid drawing a heavy line around the rocks. Look for the darkest, most recessed places and add darks according to what you see.

Start Adding Light and Middle Values

6 With a 4B pencil, start adding middle values with a pencil grip that places the lead flat against the paper's surface for wide, smooth linework. You may want to rest your hand on a slip sheet to avoid smearing the paper surface.

7 Continue Adding Light and Middle Values
Continue adding the light and middle values. The rocks that rest below other rocks may appear darker.

8 Finish Adding Light and Middle Values
Finish adding the light and middle values to the rock surfaces.

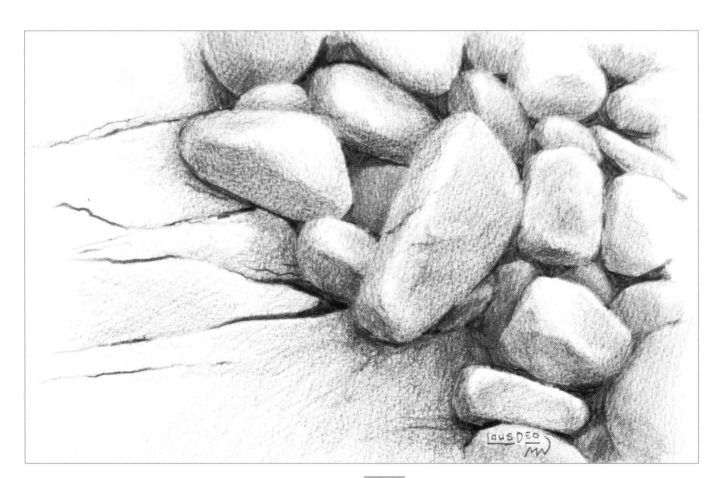

9 Darken and Lighten to Finish the Drawing
Make adjustments, darkening some areas with 4B and 8B pencils and lightening other areas with a touch of a kneaded eraser. Use your value scale to compare the lights and darks. Add your signature to the front and the date on the back.

Don't Smear It
Rest your hand on a separate piece of paper when adding the values to keep from smearing the graphite of your drawing.

Rocks
graphite pencil on drawing paper
6" × 9" (15cm × 23cm)

Sunflower

The contrast of the dark background against the light petals causes the flower to look bright. The background itself can be drawn to express values rather than distinct forms.

Materials

Paper
9" x 6" (23cm × 15cm) medium-tooth drawing paper

Pencils
2B graphite

4B graphite

8B graphite

Other Supplies
kneaded eraser

value scale

Optional Supplies
9" × 6" (15cm × 23cm) fine- or medium-tooth sketch paper

lightbox or transfer paper

1 Sketch the Flower's Outer Shape
With a 2B pencil, start the structural sketch of the flower with an ellipse for its outer shape. This will be a guide for the outermost tips of the petals.

2 Sketch the Two Central Ellipses
Sketch the larger of the two central ellipses, then the smaller one.

3 Sketch the Petals
Sketch the shapes of the individual petals, going from the center to the outer shape. Some of the petals will overlap others. Though all of the petals remain within the outer ellipse, they vary in shape and size.

4 Sketch Leaves and Stalk
Sketch the surrounding leaves and the stalk of the flower.

5 Erase or Transfer to Drawing Paper
Erase unwanted lines or transfer the image onto drawing paper, leaving out any unwanted lines.

6 Add Values to the Petals
With the 2B pencil, start adding values by lightly shading some regions of the petals. The pencil lines can follow the direction of the petals.

7 Add Values to the Center
Add light and middle values to the center of the flower with scribbly pencil lines.

8 Add Values to the Leaves and Stalk
Continuing with the 2B pencil, add light, middle and dark values to the leaves and stalk.

9 Darken the Background
With a 4B pencil, darken the area of the background against the flower at the lower right.

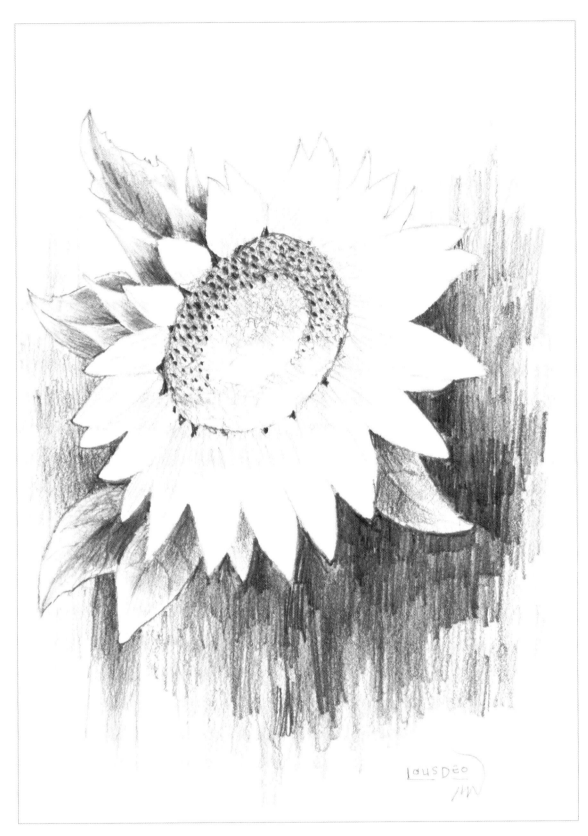

10 Add Darks and Details

With the 8B, 4B and 2B pencils, add darks and details. Compare the lights and darks with a value scale and darken with pencil or lighten with a kneaded eraser, if necessary. Add your signature to the front and the date on the back.

Sunflower
graphite pencil on drawing paper
9" × 6" (23cm × 15cm)

Shells Along the Beach

Seashells can bring to mind vacationing by the beach with a warm, gentle breeze and the sound of the waves pounding on the shore. However, if you aren't near the ocean but you like the subject matter, consider buying items such as shells, a starfish and sand from a craft store to make up your own composition.

The structural sketch starts with the basic shapes of the larger elements. The starfish is a big circle to indicate its outer perimeter, a smaller circle for its center, then the lines connecting the circles to form the legs. The light source for this scene is coming from the upper left, casting shadows of the objects to the lower right.

Materials

Paper
9" × 12" (23cm × 30cm) medium-tooth drawing paper

Pencils
2B graphite
4B graphite

Other Supplies
kneaded eraser
value scale

Optional Supplies
9" × 12" (23cm × 30cm) fine- or medium-tooth sketch paper
lightbox or transfer paper

 Begin the Structural Sketch
With a 2B pencil, begin the structural sketch with the outer form of the starfish, first proportioning its width and height, then sketching an overall circle.

Create the Starfish Form
To create the starfish, sketch a circle for its center, then connect the inner circle with the outer circle with lines that will make the legs. Start sketching the most prominent shells using basic shapes.

3 Add the Other Shells
Sketch the other shells with basic shapes.

4 Erase or Transfer and Add Details
Erase unwanted lines or transfer the sketch onto the drawing paper, leaving out the unwanted lines. Add details including lines to place the shadows.

5 Start Shading the Objects
Continuing with the 2B pencil, shade the seashells. If you are right-handed, start at the upper left to avoid unwanted smearing, or if you are left-handed, start with the upper right. The 4B pencil may be used for the darker areas.

6 Continue Shading
Continue shading the seashells and starfish. Scribbling can be used to imply the texture of the starfish.

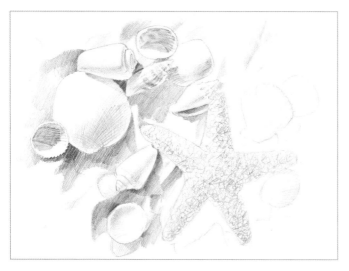

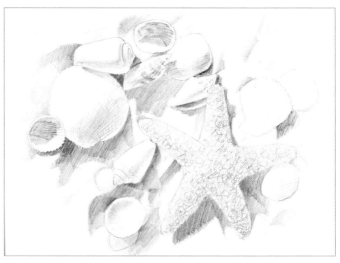

7 Begin Shading the Sand
With the 2B and 4B pencils, begin shading the sand. The values used for the sand can be drawn to contrast with the shells and starfish.

8 Complete Shading of the Sand
Complete the shading of the sand around the seashells and starfish.

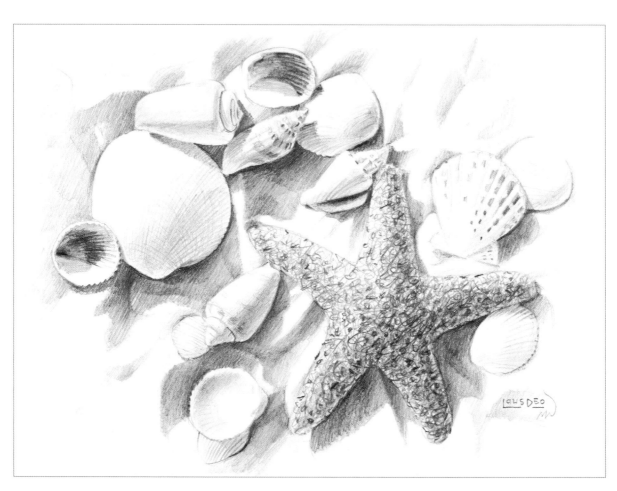

9 Finish the Drawing
Make adjustments and add details, darkening some areas with pencil and lightening others with a kneaded eraser. Compare the lights and darks with a value scale. Add your signature to the front and the date on the back.

Shells Along the Beach
graphite pencil on drawing paper
9" × 12" (23cm × 30cm)

Tree Trunk and Roots

You will find subject matter for drawing right at your feet, such as a tree trunk with a tangle of exposed roots. The exact placement is not as important as the implied form of the gnarly roots that taper the farther they extend from the trunk.

The light source is from the upper left, causing the tree trunk and roots to be shadowed to their lower right areas. Add some whimsy by drawing a little arched gnome door at the crook of the tree trunk.

Materials

Paper
9" × 12" (23cm × 30cm) medium-tooth drawing paper

Pencils
2B graphite
4B graphite
6B graphite

Other Supplies
kneaded eraser
value scale

Optional Supplies
9" × 12" (23cm × 30cm) fine- or medium-tooth sketch paper
lightbox or transfer paper

1 Start the Structural Sketch and Add Roots
With a 2B pencil, start the structural sketch of the tree trunk, which is the biggest, most prominent element. Add the center tree root, then add the wide roots that are directly connected to the tree trunk.

2 Lengthen the Tree Roots
Lengthen the previously sketched roots, tapering the shapes throughout the process.

3 Add Smaller Roots and Branches
Add the smaller offshoot tree roots and branches.

4 Erase or Transfer and Add Details
Erase any unwanted lines or transfer the structural sketch onto drawing paper. Add detailed elements such as leaves and rocks.

5 Begin the Darkest Values
With a 6B pencil, draw the darkest values, which appear in the recessed areas.

6 Add Values to the Trunk and Roots
With a 4B pencil, start adding the light and middle values to the tree trunk and roots.

7 Continue Adding Values
Continue adding the light and middle values to the trunk and roots.

8 Develop the Surrounding Elements
Add values to the elements surrounding the tree trunk and roots with the 4B pencil. Much of it can be done with horizontal scribble linework.

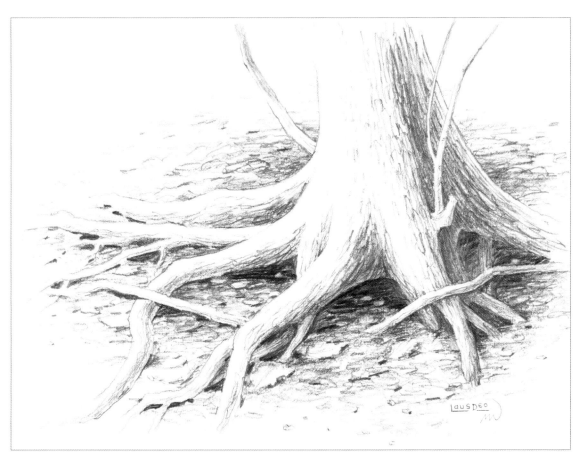

9 Darken and Lighten to Finish
With 2B, 4B and 6B pencils, add details such as rocks, leaves and tree bark lines. Darken some areas and lighten some with a kneaded eraser as needed. Compare the lights and darks with a value scale. Add your signature to the front and date the back.

Tree Trunk and Roots
graphite pencil on drawing paper
9" × 12" (23cm × 30cm)

Flowers and Butterfly

It may be easier to sketch the butterfly and flowers separately, then combine their images on the drawing paper after their forms have been worked out. The background may be shown as values, lighter at the top left and darker at the lower right. The light source for this scene is from the upper right.

Materials

Paper
8" × 10" (20cm × 25cm) medium-tooth drawing paper

Pencils
2B graphite
4B graphite
6B graphite

Other Supplies
kneaded eraser

Optional Supplies
8" × 10" (20cm × 25cm) fine- or medium-tooth sketch paper
lightbox or transfer paper

1 Sketch the Basic Shape of the Middle Flower
With a 2B pencil, sketch the basic shape of the middle flower, then add a circle for its center.

2 Add the Other Flower Shapes
Sketch the other two flower shapes, then add circles starting at the center of the flowers for the form of the petals. These circles are farther apart at the center of each flower and become closer toward the outside.

3 **Develop the Petals**
Following the form of the circles, sketch the individual petals, keeping the width uniform.

4 **Sketch the Butterfly's Basic Form**
On a separate sheet of sketch paper, sketch the basic form of the butterfly, keeping the shape symmetrical, with wings outstretched.

5 **Develop the Form**
Develop the form of the butterfly. Add curves to the wings and shape to the body.

6 **Add Some Details**
Include lines for the markings and the antennae.

7 Erase or Transfer and Add Details

Erase unwanted lines if working directly on the drawing paper. If you are using sketch paper for the structural sketch, trace or transfer the image onto the drawing paper, omitting unwanted lines and adding details to the wings and flower petals.

8 Add Values to the Middle Flower

With a 2B pencil, add values to the middle flower. Keep in mind that the light source is from the upper right. Make the overall form of the flower lighter at the upper right and darker at the lower left. The curl of the petals is also evident in the shading and is most noticeable at the center of the flower.

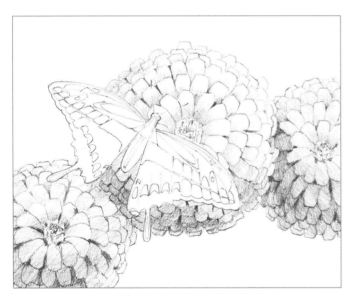

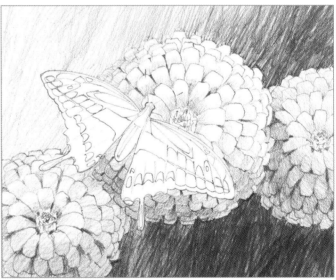

9 Add Values to the Other Flowers

Add values to the other two flowers, shading in a similar manner to the middle flower, only slightly darker.

10 Add Background Values

With a 4B pencil, add the values to the background, keeping it lightest at the upper left.

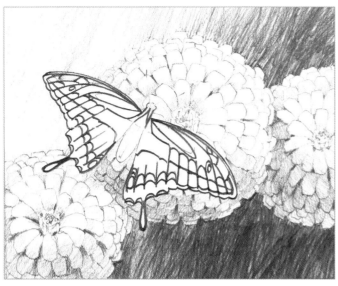

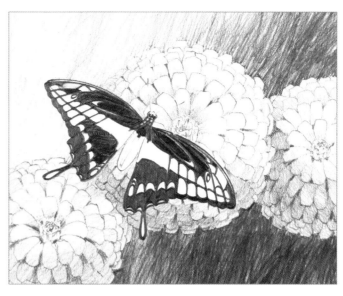

11 **Outline the Butterfly**
With a 6B pencil, outline the forms and regions of the butterfly. This will make it easier to add the shading.

12 **Develop the Butterfly**
Add the darkest of the dark values to the butterfly.

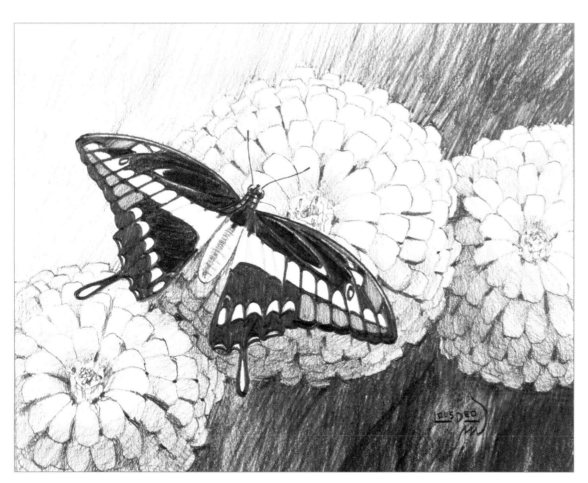

13 **Add Values and Make Adjustments**
Add any necessary values with the 4B pencil. Adjust by lightening any areas with a kneaded eraser. Add your signature to the front and date the back.

Zinnias and Swallowtail
graphite pencil on drawing paper
8" × 10" (20cm × 25cm)

Rock Formation

The light is coming from the upper left, casting on the sharp edges of the rocks to create striking and clearly defined shadows. The values of the rock formation groups diminish in contrast as they recede into the background.

1 Proportion the Dominant Rock Formation

With a 2B pencil, sketch the proportions of the most dominant rock formation. Sketch the slope of the foreground hillside.

2 Add More Formations

Sketch the basic shapes of additional rock formations.

3 Develop the Outer Shapes

Beginning with the most prominent features, develop the outer shapes of the rock formations and the largest of the foreground rocks.

4 Begin Details and Add Rocks

Begin sketching the details of the formations and add some of the foreground rocks.

5 Add More Details

Add more details to the formations, defining the shapes. Add more foreground rocks and sketch cloud forms.

6 Erase or Transfer and Add Details

Erase any unwanted lines or transfer the sketch onto drawing paper, omitting any unwanted lines. Add more details as needed.

7 Add Lighter Values
With the 2B pencil, add the lighter values, keeping the clouds and much of the foreground white.

8 Add Middle Values
With a 4B pencil, add middle values throughout the drawing.

9 Add Dark Values
With a 6B pencil, add dark values to the shadowed areas.

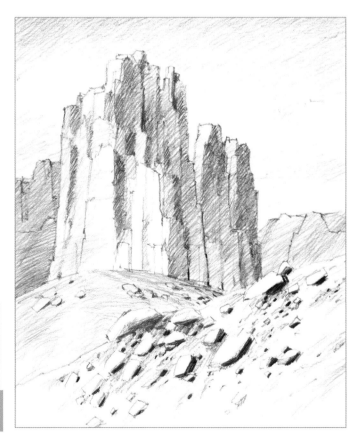

Rock Forms

Rock formations may be big in size but share the same characteristics of smaller rocks. The study of form, light effects and shadows of small rocks can aid in the drawing of larger, more complicated rock formations.

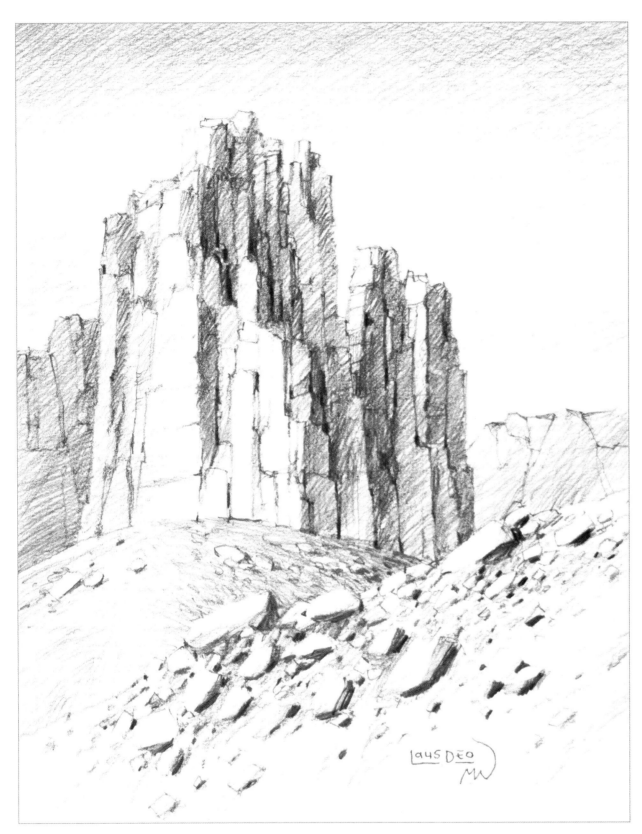

10 Darken and Lighten to Finish

Using the 2B, 4B and 6B pencils, add any necessary details such as lines to the rock formations and small foreground rocks. Darken with the pencils or lighten with a kneaded eraser as needed. Add your signature to the front and date on the back.

Rock Formation
graphite pencil on drawing paper
10" × 8" (25cm × 20cm)

Waterfall

Though the waterfall is the focal point of this drawing, it is the use of graduated and contrasting values that defines the elements and makes the scene interesting. Much of the water and mist is done as negative drawing and kept as the white of the paper.

Materials

Paper
9" × 6" (23cm × 15cm) medium-tooth drawing paper

Pencils
2B graphite
4B graphite
8B graphite

Other Supplies
kneaded eraser
value scale

Optional Supplies
9" × 6" (23cm × 15cm) fine- or medium-tooth sketch paper
lightbox or transfer paper

1 Sketch the Basic Shape of the Waterfall
With a 2B pencil, sketch the top, bottom and sides of the waterfall with straight lines.

2 Sketch the Boulders and Cliff
Sketch the boulders in the foreground and the cliff tops on the sides of the waterfall.

3 Sketch Basic Tree Shapes
Sketch the basic shapes of the evergreens as triangles with a centerline for the trunk.

4 Add Details
Add details including tree branches, rock forms and waterfall lines. Add a curved line for mist at the bottom of the falls.

Erase or Transfer and Add Details
Erase unwanted lines or transfer the image onto drawing paper, leaving out any unwanted lines.

Add Values to the Waterfall
With a 2B pencil, add values to the waterfall, keeping the top and bottom regions white.

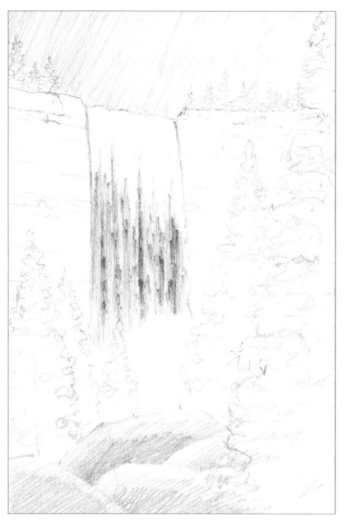

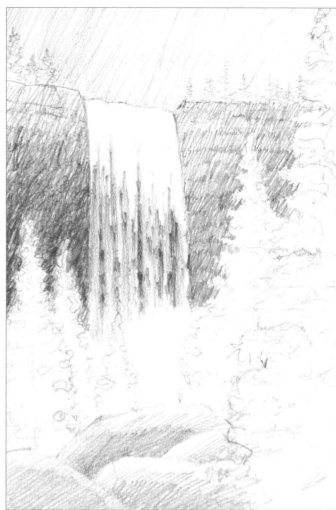

7 **Develop the Cliff and Foreground Boulders**
Add values to the cliff face in the distance, above the falls, and to the boulders in the foreground, giving them dimension. Additional darks can be added later.

8 **Develop the Cliff**
With a 4B pencil, add middle values to the cliff face and the sides of the waterfall.

Cropping the Composition

It can be hard to decide how much of a scene should be included in a composition, especially when drawing outdoors. A viewfinder can help to crop an image before starting on a piece of artwork. Just because you see something doesn't mean that it has to be included in your work.

When held up to the subject, a viewfinder can help you to limit how much of your scenery will be used for your composition. Viewfinders are available at art stores, or you can make your own with cardstock. Another method for cropping a composition is to form a rectangle with your fingers.

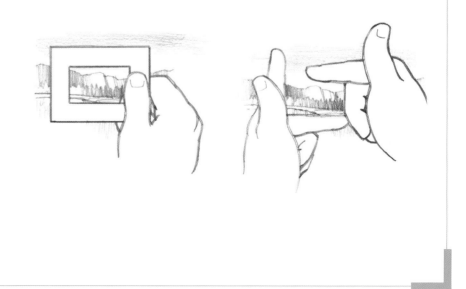

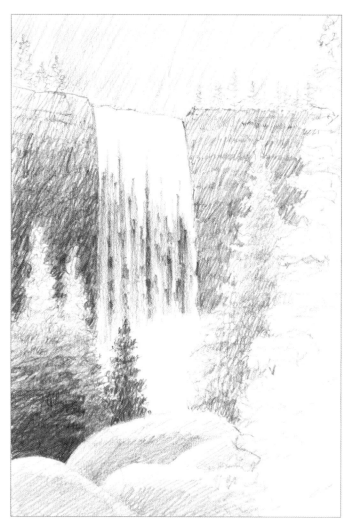

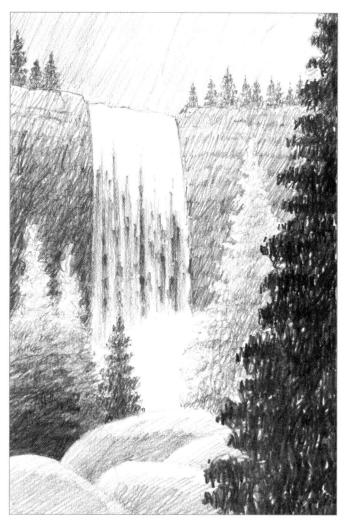

9 Add Values to the Middle Trees
Add values to the four trees in the middle to contrast with their surrounds.

10 Add Values to the Background Trees
With the 4B pencil, add middle values to the trees at the top. Add dark values to the tree at the right with an 8B pencil.

11 Darken and Lighten

With the 2B, 4B and 8B pencils, darken areas such as the boulders and lighten areas, if needed, with a kneaded eraser. Add your signature to the front and the date on the back.

Canyon Waterfall
graphite pencil on drawing paper
9" × 6" (23cm × 15cm)

Deer in Forest

In this scene, the light source is coming from the upper left. This fact isn't very noticeable except for the shadows cast on the snow and the form shadow of the large tree. The structural sketch of the deer can be done separately from the background and the image enlarged or reduced with a copier, if needed. The structural sketch of the deer can then be combined with the structural sketch of the background for the final drawing process.

Toward the end of the drawing stage, the snow on the background tree limbs can be created by lifting out the graphite with a kneaded eraser.

Materials

Paper
8" × 10" (20cm × 25cm) medium-tooth drawing paper

Pencils
2B graphite

4B graphite

6B graphite

Other Supplies
kneaded eraser

Optional Supplies
8" × 10" (20cm × 25cm) fine- or medium-tooth sketch paper

lightbox or transfer paper

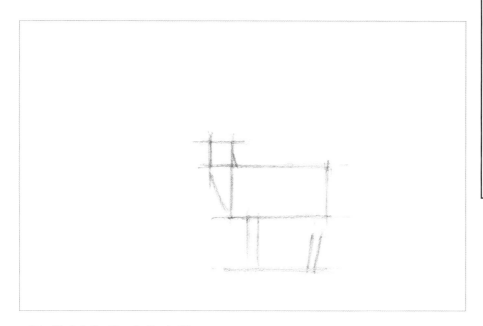

 Sketch the Deer's Basic Shape
With a 2B pencil, sketch a rectangle for the body and a horizontal line as a baseline for the hooves. Add a square for the head and lines for the neck and legs.

Add to the Deer's Basic Shape
Add ears, nose and legs to the basic shape. Start to sketch the antlers and develop the outer form including the tail.

3 Sketch the Large Tree and Snow

Sketch two vertical lines as the basic shape of a large tree on the right. For snow forms, make horizontal lines at the lower portion of the picture.

4 Develop Tree Forms

Add basic tree forms in the background and develop the form of the large tree.

5 Erase or Transfer and Add Details

Erase unwanted lines or transfer the image onto drawing paper, leaving out any unwanted lines. Add detail lines to the trees and deer including snow on the tree limbs.

6 Add Values to the Background

With the 2B pencil, add the values to the background trees. Avoid shading the snow on the larger tree limbs.

Hidden Hooves

If you find hooves troublesome to draw, the deer can always be placed in tall grass (or in this case snow), which hides the hooves.

7 **Continue Developing the Background**
Continue adding values to fill in the background trees.

8 **Add Values to the Deer**
Add values to the head and body of the deer. The antlers are to be kept white to contrast with the background.

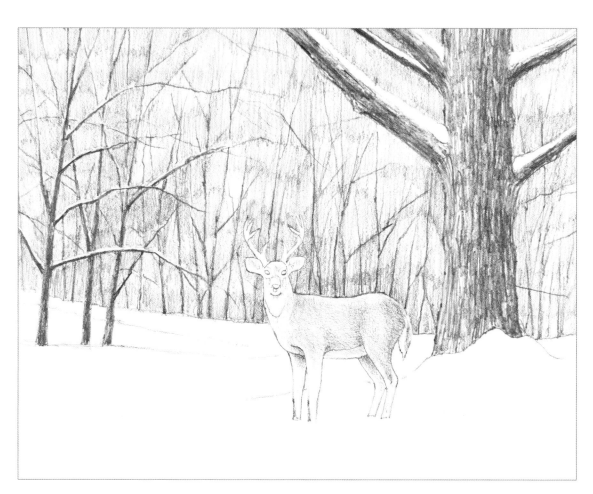

9 **Add Values to the Tree Trunks and Limbs**
With a 4B pencil, add the values to the trunks and limbs of the trees, making sure they are slightly darker than the background.

10 Darken the Background Trees

With a 6B pencil, shade the background trees to the middle and right. This will give contrast to the deer and better define its form.

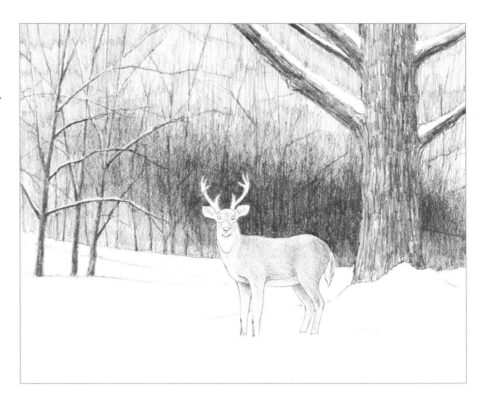

11 Darken the Shadows on the Snow

With the 4B pencil, darken the cast and form shadows on the snow.

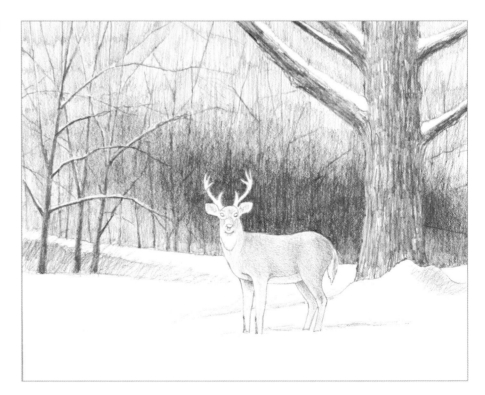

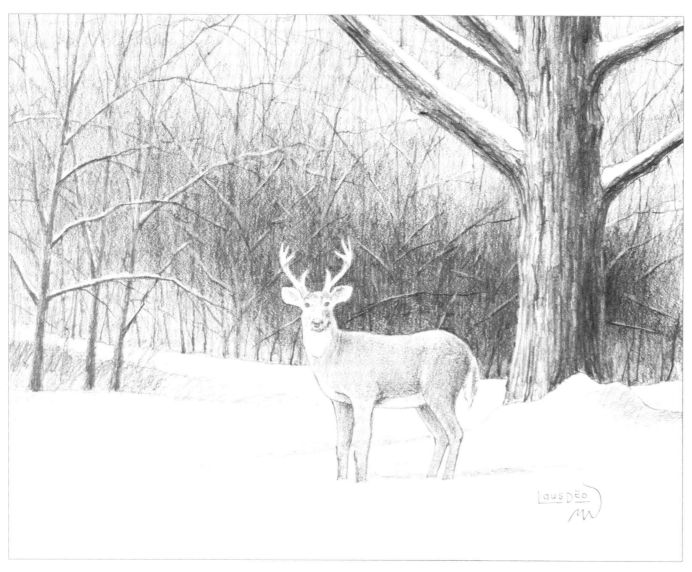

12

Add Details and Make Adjustments

Add details and shading to the deer, tree trunk and limbs. Make adjustments, including darkening the background tree branches and lifting graphite with a kneaded eraser to show snow on those branches. Add your signature to the front and the date on the back.

Deer in Forest
graphite pencil on drawing paper
8" × 10" (20cm × 25cm)

Beach Scene

Several vacation photos were combined to create this scene, which includes sky, clouds, water, waves and palm trees. The light source is from the upper right, causing the clouds to be lighter at the upper right portions of their round forms. The sky behind the clouds is dark at the top, graduating to light at the bottom.

1 Sketch the Horizon and the Basic Cloud Shapes
Sketch a line for the horizon. Sketch the large, basic shapes of the clouds as simple lines.

2 Sketch the Basic Shapes of the Trees and Waves
Sketch a line slightly below the horizon as the land that the trees are on. Sketch the basic shapes of the land, rocks and trees. Sketch lines for the waves, making sure that the angles increase as you work farther down the scene to demonstrate perspective.

Cumulus Clouds
Cumulus clouds are typically round at the top with an underside that is flat. They are affected by light and shadow much like forms that are solid, like fluffy cotton balls.

3 **Develop the Cloud Forms**
Following the previously drawn shapes, develop the forms of the clouds, which may be round and fluffy toward the top and flatter at the bottom.

4 **Develop the Trees and Waves**
Develop the tree trunks and the forms of the leaves and branches. Sketch the areas of the whitecaps and foam of the waves.

5 **Erase or Transfer and Add Details**
Erase unwanted lines or transfer the image onto drawing paper, absent of unwanted lines.

6 **Add Values to the Clouds**
With a 2B pencil, start adding values to the clouds. Keep the lighter areas as the white of the paper.

7 **Add Values to the Sky**
Darken the sky around the clouds, which is very dark at the top and lightens as it goes toward the horizon.

8 **Add Values to the Water and Beach**
Keep the whitecaps and foam pure, using the white of the paper. Add values to the water and beach. Near the horizon the water should be darker than the sky.

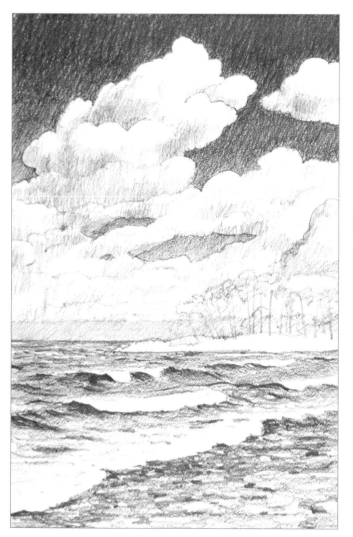

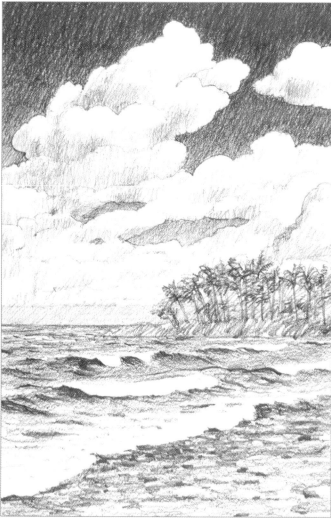

Add Darks

9 With a 6B pencil, add darks to the tops of the waves. This is most noticeable underneath the curl of some of the whitecaps. Add darks to show off scattered rocks and wet beach.

Add Values to the Land and Trees

10 With the 2B pencil, add the light and middle values to the land and palm trees.

11 **Finish the Drawing**
Make adjustments by darkening with a 6B pencil and lightening with a kneaded eraser. Add your signature to the front and the date on the back.

Holiday Beach
graphite pencil on paper
9" × 6" (23cm × 15cm)

Great Blue Heron

The contrasts of this scene are strategically placed to bring emphasis to the head of the bird and form to the body as well as to create a pleasing composition. Though the main subject of this drawing is the bird, the environment that it is in is also important. Just as details are added to the heron, such attention can be paid to the grass, ground and water.

Materials

Paper
9" × 6" (23cm × 15cm) medium-tooth drawing paper

Pencils
2B graphite
6B graphite

Other Supplies
kneaded eraser

Optional Supplies
9" × 6" (23cm × 15cm) fine- or medium-tooth sketch paper
lightbox or transfer paper

1 Sketch the Basic Shape of the Bird
With a 2B pencil, sketch a diagonal line for the top of the body of the heron, then a curved line for its underside. Sketch a vertical line to help with the placement of the head, which is shown as a small circle. Add a horizontal line below the body for the placement of the feet.

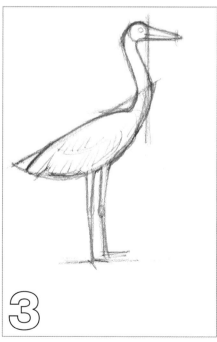

2 Develop the Heron's Basic Shape
Add the beak, neck and legs to the bird's basic shape.

3 Develop the Form
Round the lines, add the feet and some of the feathers to develop the bird.

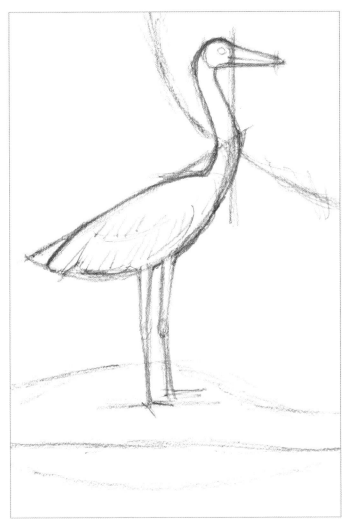

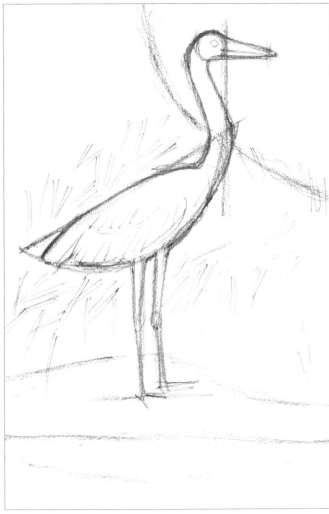

4 Sketch the Basic Shapes Around the Heron
Sketch the basic lines and shapes of the area surrounding the heron to place the grass, bank, water and reflection.

5 Sketch the Grass
Start sketching the blades of grass in the background. Each blade is two parallel lines.

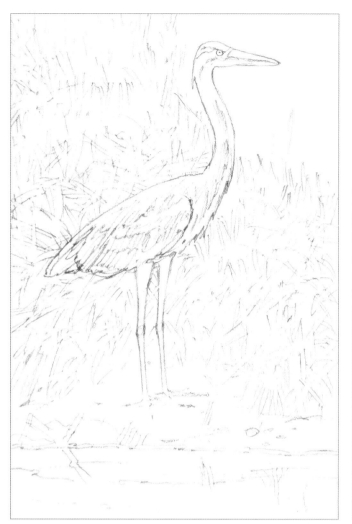

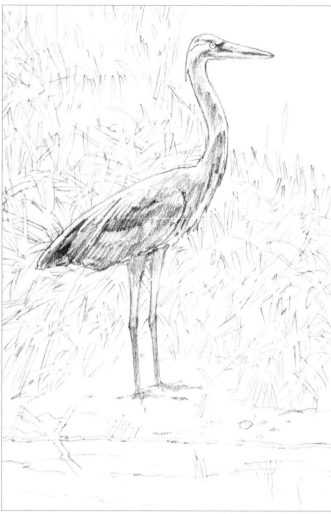

6 **Erase or Transfer and Add Details**
Erase unwanted lines or transfer the image onto the drawing paper, absent of unwanted lines. Add details to the feathers and erase any unwanted lines where the grass blades overlap each other.

7 **Add Value to the Bird**
With the 2B pencil, start adding values to the heron. The head and neck should remain mostly light so they will contrast against the background, which will be drawn dark.

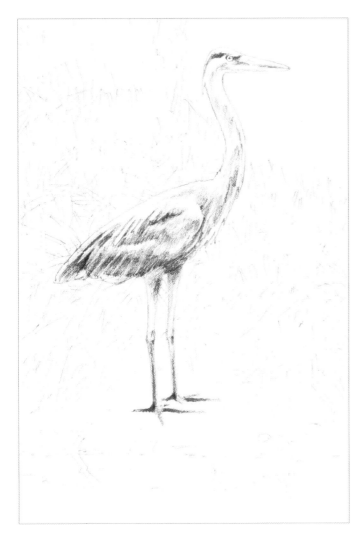

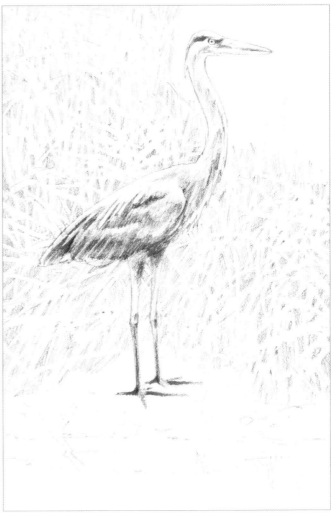

Continue Developing the Bird
Add more values, lights and darks, to the heron, giving depth and definition.

Add Values to the Background
Start filling in the values around the grass, leaving the blades white. More grass blades may be added by erasing some of the graphite with a kneaded eraser.

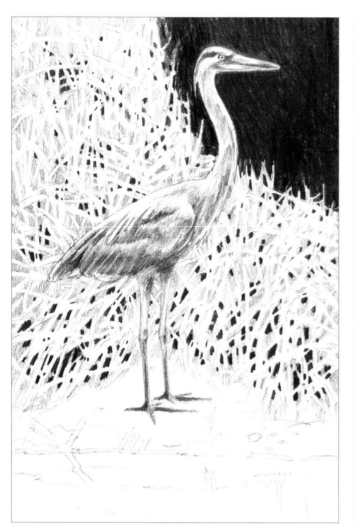

10 Add Darks to the Background
With a 6B pencil, add darks to the background including some of the areas between the blades of the grass.

11 Add Values to the Foreground and Water
With the 2B pencil, add values to the foreground and water, keeping a strip of white at the waterline.

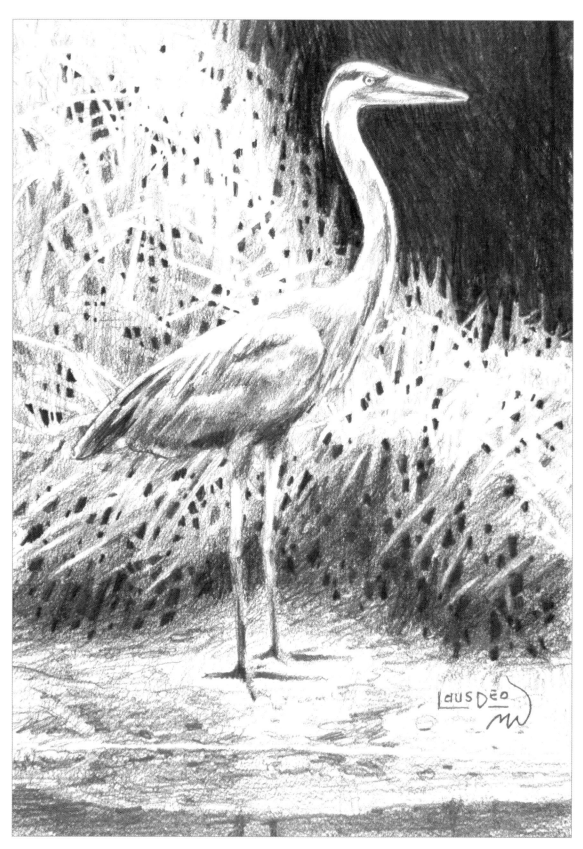

12 Finish the Drawing

Add details throughout and make adjustments, including additional values to the grass and water, and lightening some of the blades of grass. Add your signature to the front and the date on the back.

Great Blue Heron
graphite pencil on drawing paper
9" × 6" (23cm × 15cm)

Chipmunk on a Tree Stump

For this drawing, the structure of the chipmunk is worked out before the tree stump because it is easier to adjust the tree stump to the chipmunk than the chipmunk to the tree stump. The light source is coming from the upper left and affects the lights and shadows of the chipmunk and tree stump. The background varies in values to contrast with the elements in front.

Materials

Paper
6" × 9" (15cm × 23cm) medium-tooth drawing paper

Pencils
2B graphite
4B graphite

Other Supplies
kneaded eraser
value scale

Optional Supplies
6" × 9" (15cm × 23cm) fine- or medium-tooth sketch paper
lightbox or transfer paper

 Sketch the Chipmunk's Basic Proportions
With a 2B pencil, sketch a diagonal line for the underside of the chipmunk. Add lines to place proportions for the length and width of the body.

Develop the Body Shapes
Following the proportions, sketch the basic shapes of the body, head and tail. Add a baseline for the feet, then the basic shapes of the legs.

Develop the Form
Develop the form, following the basic shapes including adding the eye and ears.

4 Add Details
Start to add details, including stripes in the fur and defining features such as its paws.

5 Sketch the Basic Form of the Tree Stump
With simple linework, sketch the form of the tree stump.

6 Erase or Transfer and Add Details
Erase any unwanted lines or transfer the structural sketch onto the drawing paper, leaving out unwanted lines. Add structural details to the chipmunk, tree stump and background.

7 Add Light and Middle Values to the Chipmunk

With the 2B pencil, add light and middle values to the chipmunk. The short pencil strokes can follow the direction of the fur.

8 Add Darker Values

Continue working on the chipmunk, adding darker values that will add depth to the form and distinction to the features.

9 Add Values to the Tree Stump

Start adding the range of values of the tree stump with vertical pencil strokes that display its texture.

10 Continue Developing the Background

Add a range of values behind the chipmunk and tree stump.

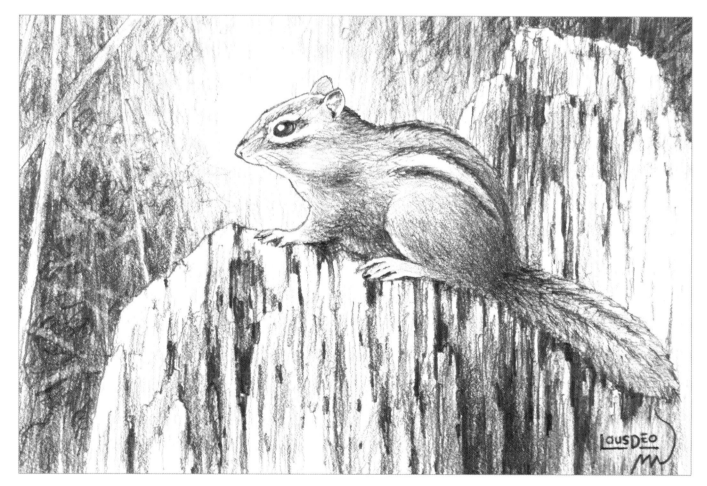

11 Finish the Drawing

Add details throughout, making some areas darker with a 4B pencil. Make adjustments such as lifting graphite from the background with a kneaded eraser. Add your signature to the front of the drawing and the date on the back.

Chipmunk on a Tree Stump
graphite pencil on drawing paper
6" × 9" (15cm × 23cm)

Mountain Majesty

The individual subjects in this demonstration rely mostly on their outer forms for recognition. The closest trees are large and dark, and those farther away will be more neutral, making use of linear and atmospheric perspective. Refer back to earlier mini-demonstrations for step-by-step instructions on individual subjects.

Materials

Paper
12" × 9" (30cm × 23cm) medium-tooth drawing paper

Pencils
2B graphite
4B graphite
6B graphite

Other Supplies
kneaded eraser
value scale

Optional Supplies
12" × 9" (30cm × 23cm) fine- or medium-tooth sketch paper
lightbox or transfer paper

1 Sketch the Basic Shape of the Mountains
Use a 2B pencil to sketch the basic form of the mountains, with the peak on the left slightly taller than the one on the right.

2 Sketch the Larger Tree Shapes
Make triangles for the basic shapes of the larger trees with a centerline for the trunk.

3 Draw the Small Tree Shapes
Sketch the shapes of the smaller and more distant trees. These trees don't need center trunk lines.

4 Add the Basic Shape of the Eagle's Wings
Sketch four lines as the basic shape of the eagle's wings, paying attention to the curve and direction of the lines. Add more lines for the body and tail feathers.

5 Define the Basic Shapes
Add linework to the trees, mountains and eagle to define their forms. Lines are added for the clouds.

6 Erase or Transfer and Add Details
Erase any unwanted lines or transfer the sketch onto the drawing paper, omitting any unwanted lines. Add detail linework to the trees, mountains and eagle.

7 Add Lighter Values to the Background
With the 2B pencil, add lighter values to the sky and mountains. The mountains remain white on their left sides.

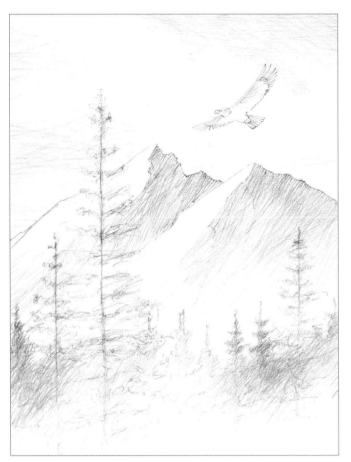

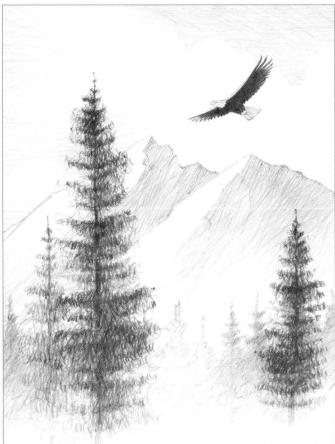

8 Add Values to the Distant Trees and Eagle
Add values to the eagle with the 2B pencil. With a 4B pencil, add middle values to the distant trees, making them darker at the top.

9 Darken the Eagle and Foreground Trees
With a 6B pencil, add dark values to the eagle and the foreground trees.

Paper Mountains

Drawing mountains is a study of light and shadow. One exercise to examine the subtle variations of values is to sketch a crumpled piece of paper or cloth that is formed like a miniature mountain.

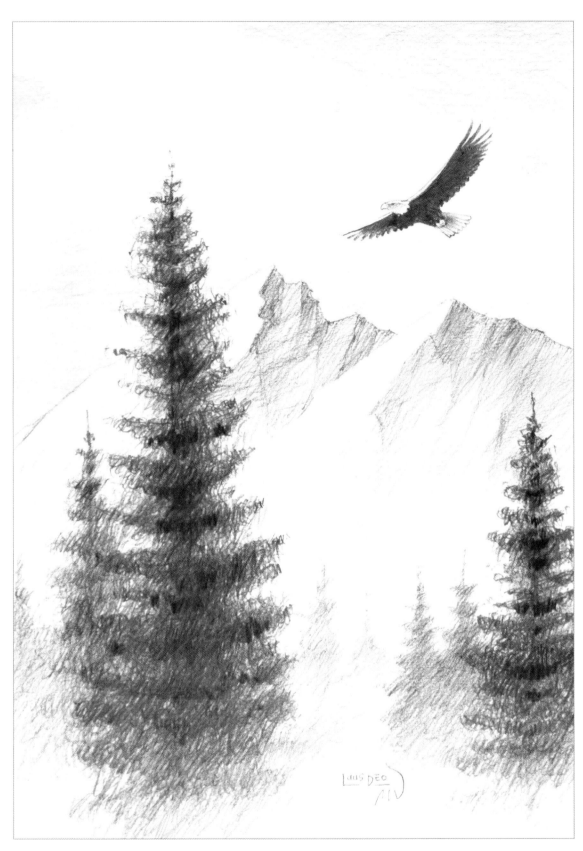

10 Finish the Drawing

Darken areas as needed with the 4B and 6B pencils, and lighten other areas with a kneaded eraser to complete the drawing. Add your signature to the front and date the back.

Mountain Majesty
graphite pencil on drawing paper
12" × 9" (30cm × 23cm)

Canada Geese in Winter Snow

With their bold contrasts of lights and darks, Canada geese make a good subject matter for drawing. In this picture, their webbed feet are lost in the snow, making the drawing process a little easier. The winter sky is darker at the top and gradually gets lighter as it goes downward. The tall grasses are drawn over the sky. The structural sketches of the geese can be done separately and then combined for the final drawing.

Materials

Paper
10" × 8" (25cm × 20cm) medium-tooth drawing paper

Pencils
2B graphite

4B graphite

6B graphite

Other Supplies
kneaded eraser

Optional Supplies
10" × 8" (25cm × 20cm) fine- or medium-tooth sketch paper

lightbox or transfer paper

1 Sketch the Basic Shape of the First Goose

With a 2B pencil, sketch two horizontal lines, a vertical line on the right and a diagonal line on the left for the proportions of the body. Add a circle for the head and a horizontal line below the body for the feet, which will be hidden by the snow.

2 Develop the Form

Develop the overall form of the goose by sketching an oval for the body and adding straight lines for the neck, beak and legs.

3 Add Details

Start to add details with the 2B pencil, adding form to the neck and placing the feathers and the eye.

4 Sketch the Background Goose

Following the steps used to sketch the foreground goose, sketch the goose in the background.

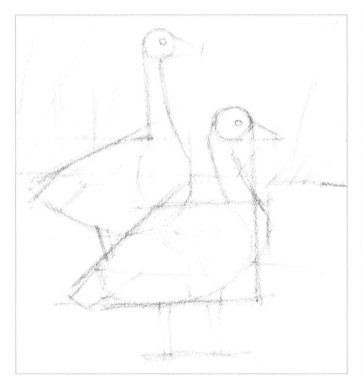

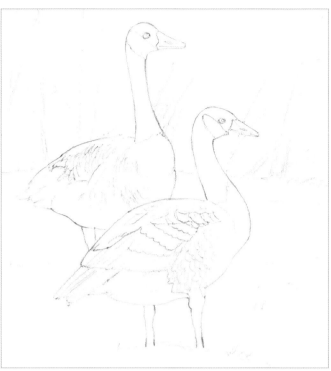

5 Add Background and Foreground Lines
Add lines for the background including the grass. Some lines can be added to the foreground for the contours of the snow.

6 Erase or Transfer and Add Detail Lines
Erase any unwanted lines or transfer the sketch onto drawing paper, leaving out unwanted lines. Add detail lines such as the feathers.

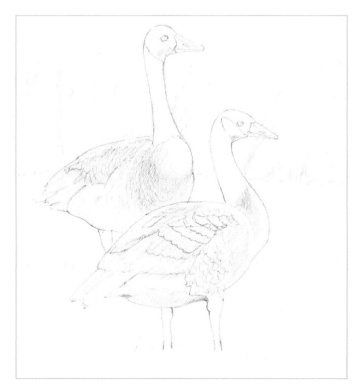

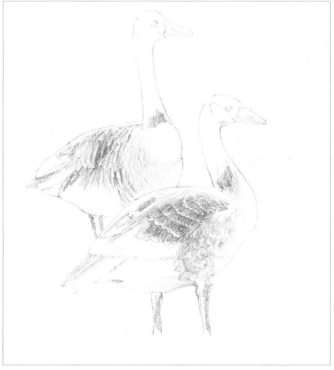

7 Add Light Values to the Geese
With the 2B pencil, add the lighter values to the geese.

8 Add Middle Values to the Geese
With a 4B pencil, add the middle values to the geese. Many of the feathers are lighter at the ends.

9 Add Dark Values to the Geese
With a 6B pencil, add the darker values to the geese.

10 Add Values to the Sky
With the 4B pencil, add values to the sky so that it appears darker at the top.

11 Add the Grass
Add the grass in the background, first by erasing some of the grass that has been darkened by shading in the sky, then by drawing in some of the grass.

12 Finish the Drawing
Add details to the geese and values to the foreground grass and snow.
Make any necessary adjustments. Sign the front and date the back.

Winter Geese
graphite pencil on drawing paper
10" × 8" (25cm × 20cm)

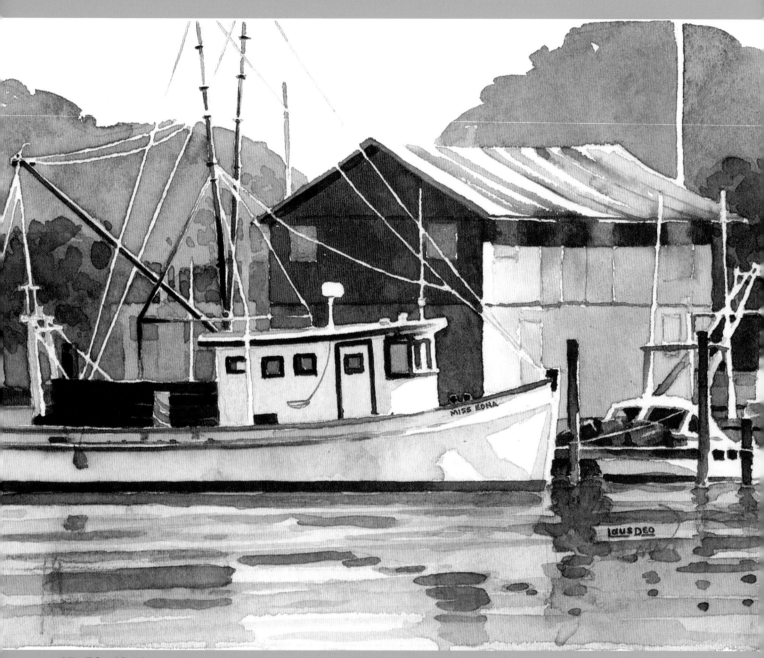

Miss Edna, Mooring
watercolor on 140-lb. (300gsm) cold-pressed
watercolor paper
5½" × 8" (14cm × 20cm)

Part 2 **Watercolor**

5 Gather the **Materials**

When you're prepared, sitting down to paint a watercolor is exciting. When you're not prepared, the stop-start feeling of getting up and down to find supplies or go to the store can impede your creative mood, inspiration and focus. This chapter will help you collect the right materials to prepare you for a positive experience whenever you feel inspired to paint.

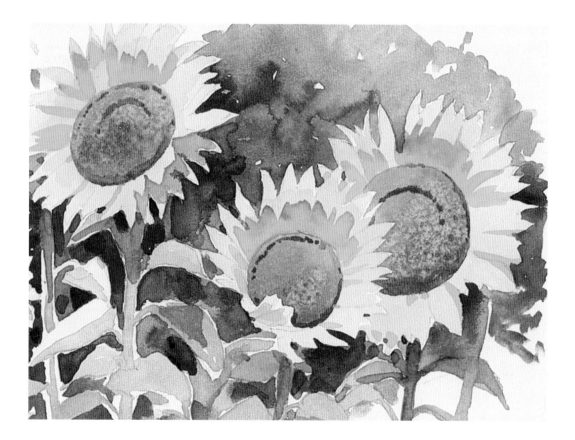

Paints

I use a variety of paint brands and choose paints mostly for their color, solubility and price. Pigments of the same name can vary from one manufacturer to another. Understanding the following variables will help you determine which paints are best for you.

Grade

The biggest variable of paint is its *grade*. Watercolor paints are available in two grades, student and professional. Student-grade paints are less expensive, but professional-grade paints may provide more intense color and better solubility.

You may not be able to distinguish between the two at first, but after becoming more familiar with watercolors and how the paint behaves, try different colors and brands to see what appeals to you and suits your style.

Intensity

Intensity, the brightness of a color, describes the difference between brilliant and less vibrant colors.

Solubility

Solubility describes the ability of the paints to blend with water and mix with each other. The better the quality of the paint, the easier it will dissolve and the more evenly it will mix.

Lightfastness

Manufacturers often rate the degree of *lightfastness*, a paint's resistance to fading over time, on the package.

Packaging

I use tubes of paint instead of dry cakes or half pans. You must add water to cakes to make them workable, and the already soluble paint from a tube is easier to work with. If you'll be painting only occasionally, use 8ml or 10ml tubes. Larger volumes may be more economical, but the paints might dry out before you finish using them.

How Paints Differ

grade
intensity
solubility
lightfastness
packaging

student-grade　　　professional-grade

Different Grades
Examine the difference between these two grades of Cadmium Yellow. I prefer the more vibrant color of the professional-grade paint, even though it costs more than the student-grade paint. Experiment to find the paints that work best for you. You might like different colors in different grades.

Common Paints
Winsor & Newton Cotman, Grumbacher Academy and Van Gogh student-grade paints are pictured at top. Winsor & Newton, Grumbacher, Rembrandt, Daler Rowney and Sennelier professional-grade paints are pictured below. Other brands include Da Vinci, Holbein, Schmincke, Lukas, MaimeriBlu, BlockX, Old Holland, Daniel Smith and American Journey.

Palettes

Use a palette to hold and mix your paint. Your palette should have a flat, white surface with low sides. Small palettes are easier to carry, but big ones are better for mixing lots of paint. You'll also need a cover to keep dust and dirt off the palette and paints, especially when traveling. If you have an airtight cover, let your paints dry out before covering them to avoid mildew. If your cover isn't airtight, remember to carry your palette flat so wet paint won't spill. When you finish a painting, don't clean the palette and throw away good paint. Because watercolors are water soluble, you can add water and reuse them.

Plastic Plate Palette

You can transform plastic plates into inexpensive palettes. Use one plate to hold paint and the other to mix it. When you're not painting, flip one plate over the other and hold them together with binder clips. This palette is lightweight and inexpensive, so you won't have to worry about carrying heavy supplies or losing expensive ones.

Manufactured Palettes

You can buy plastic palettes that come with paint wells and covers. Get a palette with enough wells to hold all of the colors you want and a surface large enough to mix lots of paint.

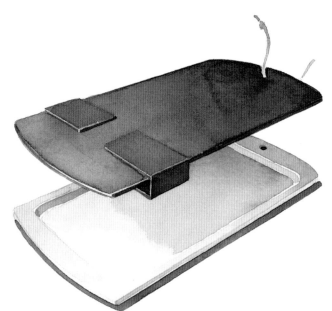

Butcher's Tray Palette

A porcelain butcher's tray is another option. It's sturdy, and you can place the paint anywhere you choose because there aren't any preformed paint wells. Make sure the surface of the tray is flat before you buy one; many of these trays have convex surfaces that cause paint to run together into the corners. Porcelain butcher's trays don't come with covers, so I fashioned my own with two pieces of heavy cardboard and a piece of string.

To make your own cover, cut one piece of cardboard to the same dimensions as the surface of the palette. Then wrap a strip of cardboard around the lid and palette. Attach the strip to the cardboard lid so it acts as a sleeve to slide the palette into. On the other end of the lid, make a hole and thread a shoestring through to tie the cover and palette together, or secure the lid with a rubber band.

How Palettes Differ

cover

shape

size

Palette Setups

Each setup shown here progresses in complexity. Most of the colors are available in both student and professional grades. I prefer not to use white or black paint. Instead, I use the white of my paper as the white in my paintings, and I mix my rich darks from other colors. I'll talk more about color practice and theory later.

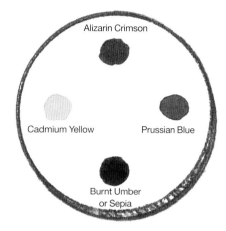

Four-Color Setup

A basic setup uses the three primary colors, red, yellow and blue, and one brown. These colors are available in student and professional grades.

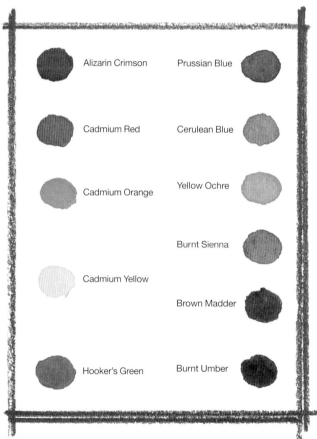

Eleven-Color Setup

This setup for the beginner provides a variety of possible combinations without using too many colors. You'll use this palette for most of the demonstrations in Chapter 8. All of these colors are available in both grades except for Brown Madder, which usually is available only in professional grade. I also recommend using professional-grade Cadmium Yellow.

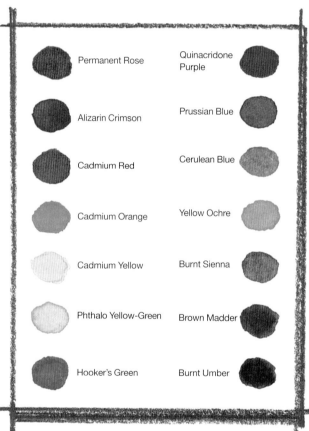

Fourteen-Color Setup

I usually work with this setup. The additional colors are mostly available only in professional grade. Try this palette after you've gained some experience. It's fairly crowded, so sometimes I use an additional palette or the palette lid for mixing.

Paper

Your painting experience and the end result will differ based on the kind of paper you use. Some papers are harder to work with than others. Many artists use their best paper just for final paintings and other paper for sketches and practice. Consider the following variables when deciding which paper works for your style.

Quality

Student-grade paper generally absorbs paint faster and dries quicker, which makes it harder to work with than higher-grade paper. Professional-grade paper, for the most part, is better for layering and lifting paint and exhibiting the true color and brightness of paints. It's user-friendly, which makes it worth the cost.

Surface Texture

Watercolor paper's texture can be hot-pressed, cold-pressed or rough. Hot-pressed paper is smooth and produces hard edges and interesting watermarks when you apply paint. This kind of paper doesn't work well for gradations of color—a smooth transition from one color to another.

Cold-pressed paper has a moderate texture and allows smooth color gradations. Some manufacturers refer to cold-pressed paper as "not hot-pressed."

Rough paper is an even coarser, more textured paper. Like cold-pressed paper, it allows smooth color gradations, but if offers more extreme textural effects. The rough, pitted surface allows lots of the white of the paper to show through when you paint on dry paper with little water. The texture also adds interest to certain subjects such as ocean waves.

Content

The content of the paper affects how paint responds to the paper. Most papers are made of natural substances, but some are completely synthetic or made from a combination of natural and synthetic ingredients.

As paper ages, acid can cause it to yellow. To be safe, use 100-percent cotton, acid-free, pH neutral paper. Don't assume that pH neutral paper is acid-free; the manufacturer may simply have neutralized the acid. Look for "acid-free." I use this paper even for practice paintings because I'm never sure when I'll want to keep one.

Tooth Translates to Texture
These color swatches show how paint looks when applied to the different kinds of paper: hot-pressed (1), cold-pressed (2) and rough (3).

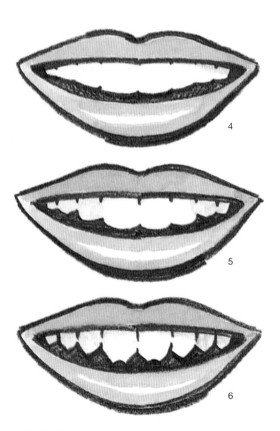

A Paper's Tooth
A paper's coarseness sometimes is referred to as tooth. Hot-pressed paper (4) is smooth and has very little tooth. Cold-pressed paper (5) has a moderate tooth. Rough paper (6) has lots of tooth.

Packaging

Watercolor paper comes in individual sheets, watercolor blocks and watercolor pads. Watercolor paper in pad form usually comes in weights of 90-lb. (190gsm) or 140-lb. (300gsm). The paper wrinkles when wet because the sheets are bound on one side only. Watercolor blocks are bound on all four sides. The individual sheets stay in place and wrinkle less. Separate each sheet after painting by running a knife around each side between the top two sheets.

Weight

The heavier the weight, the thicker the paper. Thicker paper wrinkles less after getting wet. Larger pieces of paper wrinkle more than smaller ones.

Common paper weights are 90-lb. (190gsm), 140-lb. (300gsm) and 300-lb. (640gsm). 90-lb. (190gsm) is so thin and wrinkles so easily I find it impractical. Don't use 90-lb. (190gsm) or lighter paper unless it is made from synthetic ingredients.

140-lb. (300gsm) paper can wrinkle, but it's thin enough to see through for tracing drawings and is affordable. Use this paper for any painting 12" × 16" (30cm × 41cm) or smaller.

For larger paintings, use 300-lb. (640gsm) paper. Because of the thickness of this heavy paper, even larger sheets will stay relatively flat when wet. Seeing through it to trace an image is difficult though. It's also twice the price of 140-lb. (300gsm) paper.

For big wet-into-wet paintings, which you'll learn more about in Chapter 7, you can wet both sides of a sheet of 300-lb. (640gsm) paper and then mount the paper to a board with bulldog clips. The thick paper takes longer to dry than lower weights, so you'll have more time to work on the painting before the paper starts to dry.

How Papers Differ

quality
surface texture
content
packaging
weight

Pads
Pads are bound on one side.

Blocks
Blocks are bound on all four sides.

Mounting the Paper
It's economical to buy paper in large sheets, then trim them to the size you want. To prevent individual sheets of paper from wrinkling when you apply water, mount the dry paper to a thin, sturdy board such as waterproof Masonite, plywood or watercolor board. Attach the dry paper on all four sides with 2-inch (51mm) wide sealing tape.

Preventing Wrinkling
You can also mount paper with binder or bulldog clips. Though easy to use, the clips can get in the way and the paper is more apt to wrinkle than when secured with tape.

Another option is to stretch wet paper by fastening it to a sturdy board with staples or 2-inch (51mm) wide wet application tape. As the paper dries, it pulls or stretches itself into a smooth, flat sheet, so the paper is less likely to wrinkle when you apply more water. Stretching may be effective, but I don't find it worth the extra effort.

Brushes

Brushes have either synthetic bristles, natural hairs or a combination of both. I can't tell much difference between them except the price; natural hair brushes cost more.

An artist's supply of brushes should include a range of shapes and sizes. Larger brushes hold more moisture and cover big areas, and smaller brushes work well for detailed work. I recommend the following collection of brushes for beginners.

Round

A good round brush has fine, stiff hairs that come to a nice, straight point and spring back to their original shape.

Bamboo

Big bamboo brushes are inexpensive and hold lots of fluid. They work well for loose, spontaneous painting in big areas, but don't expect to do detail work with them. Besides the large size, the coarse hairs don't always make a point and may seem clumsy to handle.

Flat

Flat brushes look like regular housepainting brushes with wide, flat edges. A flat brush makes wide strokes and leaves clean edges. If you find a flat brush with a round handle, you can twirl the brush as you drag it across the paper to vary the thickness of the stroke.

Hake

Hake (pronounced "hockey") brushes are flat, hold lots of fluid and are relatively inexpensive. Use a hake brush for really big washes.

Care and Use

To clean a brush, just swish it back and forth in water until the paint is released from the hairs or bristles. Gently dry it on a clean rag and lay it flat. Once you're done painting, follow the instructions below. When considering quality and cost, don't underestimate the importance of owning good brushes. Cheap brushes can save money but make for a frustrating painting experience.

How Brushes Differ

bristles

shape

size

Storing Brushes
When you're done painting, clean your brushes and place them with the bristles or hairs up in a cup or can.

Storing Large Brushes
Drill a hole in the handles of large flat brushes, and hang them from nails, hooks or wires so the hairs or bristles hang down. If you use a nail, make sure the hole in the handle is wide enough to fit over the head of the nail. If you use a hook, make sure it's deep enough to hold the handle.

Protecting Brushes
Never stand a brush on its hairs, even in a jar of water. The hairs will bend permanently and ruin the brush's point. Also, don't squeeze the hairs to wring them dry or push down hard and scrub while painting. Brush hairs are delicate and the original shape can be bent easily. A good-quality brush can last for years if you care for it properly.

Standard Brushes

These are all the brushes you need to paint just about anything. In addition to the types of brushes mentioned on the previous page, I also like quill mop brushes. They combine the precise qualities of round brushes with the capacity of bamboo brushes. The hairs are not springy, but they can make a nice point. These brushes require an investment, but they're a lot of fun to paint with.

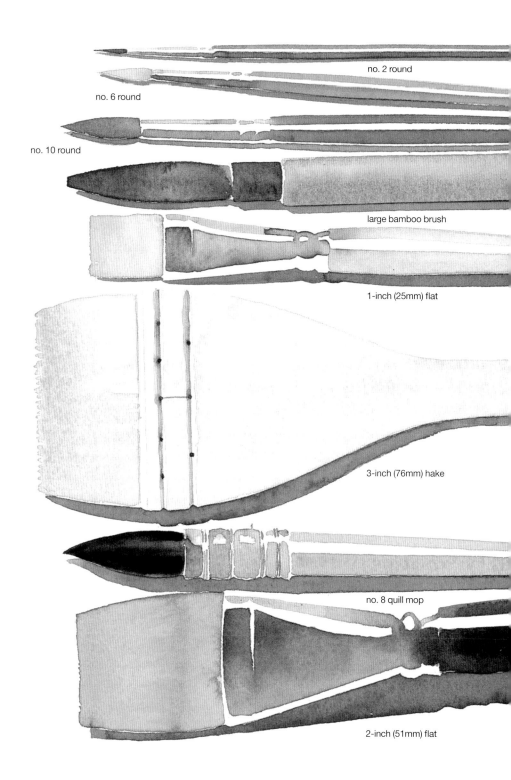

no. 2 round

no. 6 round

no. 10 round

large bamboo brush

1-inch (25mm) flat

3-inch (76mm) hake

no. 8 quill mop

2-inch (51mm) flat

Painting in Your Studio

This is how I set up to paint in my studio. With all of these materials within reach, I'll have a productive painting session.

I cut down a gallon jug to use as a water container. It holds lots of water and has a handle and clear sides, which make it easy to see the water inside. Dry your brushes with a soft, absorbent, 100-percent cotton rag free of lint and dirt. Flannel works well. Make sure you use a light-colored cloth so you can tell if it's dirty. Fill a spray bottle with water for cleaning the palette and moistening your paints.

Use a 2B pencil to draw the basic forms of your composition before painting. A softer lead may smear when wetted down, and a harder lead pencil is difficult to erase. Keep a pencil sharpener and a soft, gray kneaded eraser nearby. Other erasers are abrasive and crumble too easily.

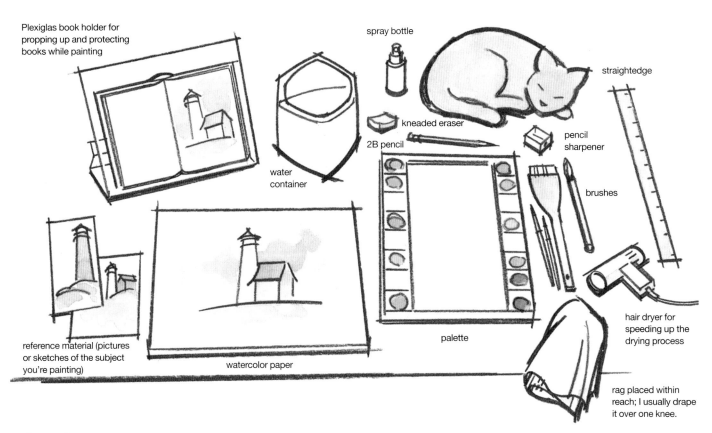

Plexiglas book holder for propping up and protecting books while painting

spray bottle

straightedge

kneaded eraser

2B pencil

pencil sharpener

brushes

water container

reference material (pictures or sketches of the subject you're painting)

watercolor paper

palette

hair dryer for speeding up the drying process

rag placed within reach; I usually drape it over one knee.

Studio Setup

It works best for me to have my tools and palette on the same side as my dominant hand and my water container just above these. I usually sit down while painting, but standing gives you freedom to move, which is especially valuable when painting big. It's important to have adequate lighting, so I make sure I have an overhead light or a desk lamp with a 100-watt bulb. Oh, and if you have a cat, it probably will claim a portion of your work surface. While you may enjoy the company, be careful because pet hair can wind up in your paints.

Painting Outdoors

You don't need an elaborate setup to paint plein air, or outdoors, so I usually pack light. You'll need paints, brushes, a palette, paper, a water container, a 2B pencil, a rag and an eraser, plus the items discussed on this page.

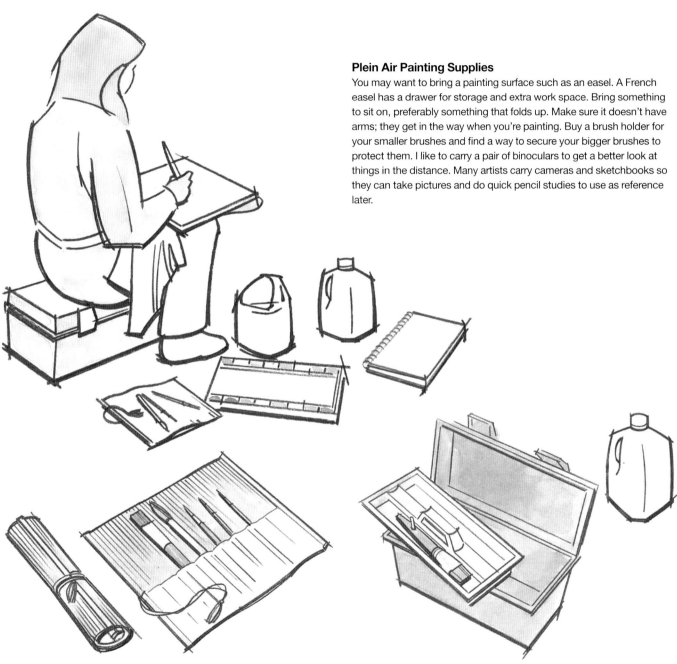

Plein Air Painting Supplies

You may want to bring a painting surface such as an easel. A French easel has a drawer for storage and extra work space. Bring something to sit on, preferably something that folds up. Make sure it doesn't have arms; they get in the way when you're painting. Buy a brush holder for your smaller brushes and find a way to secure your bigger brushes to protect them. I like to carry a pair of binoculars to get a better look at things in the distance. Many artists carry cameras and sketchbooks so they can take pictures and do quick pencil studies to use as reference later.

Bamboo Brush Holder

Travel can damage the bristles of smaller brushes easily. A bamboo brush holder protects brushes by keeping their hairs straight and allowing wet brushes to dry on the go.

My Toy Box

I use a tackle box as both a seat and a carrying case for my materials. Besides your regular water container, use a separate container with a lid to transport water. I protect my larger brushes by attaching them securely to the tray in my tackle box. First drill a hole in the bottom of the tray. Then run a bolt up through the hole and attach the brush with a nut. You also could attach the brush with a wire or make a cardboard sleeve.

Hot-Pressed Paper

What makes hot-pressed watercolor paper so much fun for me are the unique watermarks that result when the paint interacts with the smooth surface. This quality may make the paper a bit harder to work with, but as you gain experience, you'll be able to predict these effects and feel more in control. Then they can add so much to your artwork. To keep the feel of this painting loose, I used a large round brush as much as possible. I especially like the effect of the watermarks on the front of the car, blending the fenders and tires together.

Cobra
watercolor on 140-lb. (300gsm) hot-pressed watercolor paper
6¼" × 9" (16cm × 23cm)

Yupo

Unlike other kinds of watercolor paper, Yupo synthetic paper is basically a really smooth sheet of plastic. The nonabsorbent paper does not wrinkle at all and makes for a very loose painting style with hard paint edges. Because Yupo doesn't absorb paint, you can lift and manipulate color much more easily than on regular watercolor paper. You'll also need to use a large round brush that holds a lot of paint because the paint will want to come back up with the brush rather than lie on the paper. You may need to scrub the surface before you begin to get rid of grease or fingerprints, which can repel paint. Unless the surface is perfectly clean, paint won't adhere to it. Notice how the oil from one of my fingerprints seems to repel paint from the top of the post on the left.

Flower Cart
watercolor on 74-lb. (160gsm) Yupo synthetic water-color paper
5" × 7" (13cm × 18cm)

Cold-Pressed Paper

I use Strathmore Aquarius watercolor paper at times when I want a smoother, cold-pressed paper. It's less prone to wrinkling than other cold-pressed papers because it's made from a blend of cotton and synthetic fibers. At 80-lb. (170gsm), it's thinner than most watercolor papers I use and easier to see through for tracing. Because the surface is not as soft as others, paint often doesn't seem as lively and removing pencil lines can be difficult.

Sunbathers
watercolor on 80-lb. (170gsm) cold-pressed water-color paper
6" × 8" (15cm × 20cm)

6
Learn the
Basics

Get back to the basics! Structure. Value. Color. An understanding of all of these components will help you create better compositions and successful watercolor paintings.

Structural Drawing

To create a successful painting, you need a solid foundation. Create an accurate drawing of the shapes and elements in a scene before you begin to paint. Structural drawing may seem too scientific or monotonous, but it's essential to the beauty of art. Structural drawings include basic shapes without shading and provide the right starting point for every painting. The basic principles of drawing follow.

Look for Basic Shapes
Look for basic shapes such as circles, squares, triangles, ovals and rectangles.

Draw Basic Shapes
Put the big basic shapes together.

Draw Smaller Shapes
Then draw the smaller shapes, arranging them around the bigger ones. Really observe what you see. Do objects overlap? Your brain tells you an object is round, but does it really look oval? You don't have to draw tons of detail now. Leave the details for the painting process.

Measuring

Making art is a creative process, but that doesn't mean you should ignore the facts. To draw an accurate, believable object or scene, measure to get the proportions right. You can use something as simple as a pencil to measure, compare and align elements.

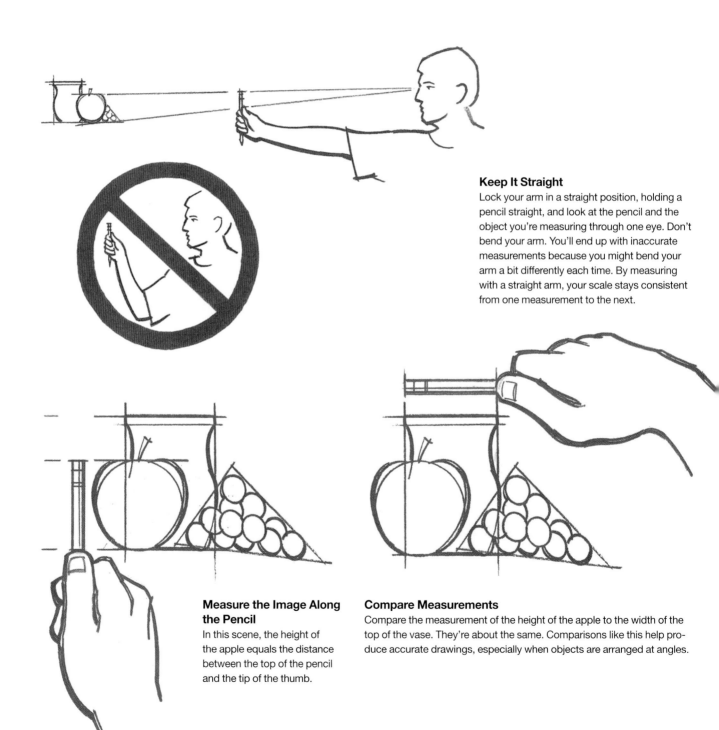

Keep It Straight

Lock your arm in a straight position, holding a pencil straight, and look at the pencil and the object you're measuring through one eye. Don't bend your arm. You'll end up with inaccurate measurements because you might bend your arm a bit differently each time. By measuring with a straight arm, your scale stays consistent from one measurement to the next.

Measure the Image Along the Pencil

In this scene, the height of the apple equals the distance between the top of the pencil and the tip of the thumb.

Compare Measurements

Compare the measurement of the height of the apple to the width of the top of the vase. They're about the same. Comparisons like this help produce accurate drawings, especially when objects are arranged at angles.

Getting the Proportions Right

Capturing the correct proportions in a painting
is the first step in achieving a realistic drawing.
The building's width is about twice its height.

Sewing Gauge

A *sewing gauge* is an inexpensive measuring
device that gives more accurate results than a
pencil.

Drawing Linear Perspective

Perspective gives an impression of depth. When viewing an image on a two-dimensional surface, perspective makes the image look three-dimensional. Linear perspective uses lines and varies the relative sizes of objects to create this illusion.

The secret to perspective is finding the horizon. Land and sky meet on a horizon line. Somewhere on this line is at least one vanishing point where parallel lines, such as the rails of a railroad track, seem to converge.

One-Point Perspective

One-point perspective is the simplest form of linear perspective, with only one vanishing point. Use one-point perspective when you're looking at an object head-on.

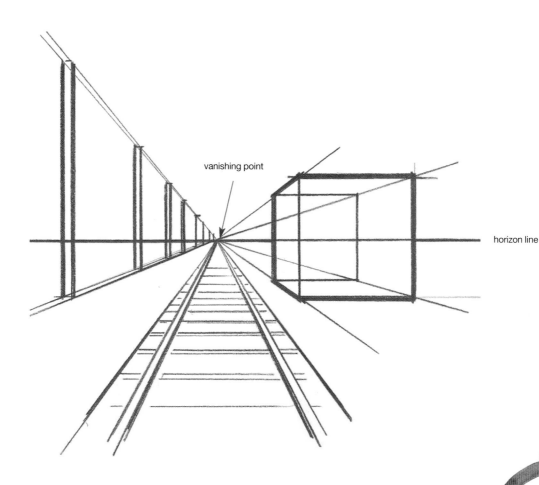

vanishing point

horizon line

Translating From a Three-Dimensional Scene to Two-Dimensional Paper

Observe one-point perspective while looking straight down a set of railroad tracks. Just make sure there's not a train in the way! The parallel tracks converge in the distance at the vanishing point. If a building or other structure is parallel to the tracks in reality, it will share a vanishing point with the tracks. If you extend the structure's line to the horizon, it will meet the others at the vanishing point rather than actually running parallel on the paper. Notice that objects of equal size in reality appear larger the closer they are to the viewer. Drawing things in perspective means drawing them not as they are in reality, but as they look from a certain viewpoint.

Two-Point Perspective

Let's look at the same railroad tracks from the side to get a glimpse of two-point perspective.

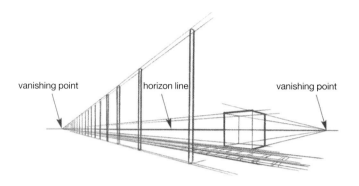

Common Perspective

The most common form of linear perspective is two-point perspective, in which two vanishing points land on the horizon.

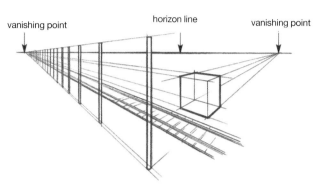

Changing Perspective

By raising the horizon on this two-point perspective scene, the viewer now seems to be looking down on the same scene.

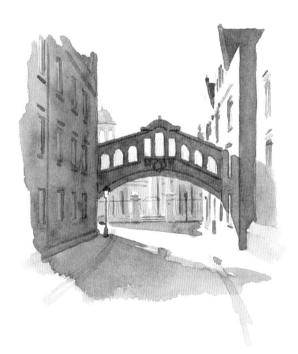

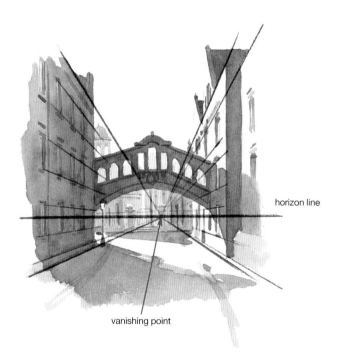

Hidden Vanishing Point

This scene may look simple, but planning ahead and getting factors like perspective right make the scene look accurate and believable. Even though you can't actually see the horizon in this cityscape, you should determine its location and figure out where your vanishing point will be. Notice that all of the lines—the road, the windows and even the roofs—disappear at the vanishing point.

Understanding Value

Values are the light and dark areas of a scene. Use shading, shadows and contrasting values to provide form and definition for objects and the entire painting.

Shading and Shadows

Observe values on basic shapes to get a better understanding of shading and shadows. Use white foam shapes from your local craft store as models to examine the characteristics of light. You may need to paint the foam a light color to get an opaque surface that reflects light smoothly and accurately.

Pay attention to the direction of the light source—whether it shines from the left or right, above or below, in front of or behind the object. Once you've determined the light source, observe the lightest and darkest areas and the effect of the light source on the object's shadow.

Light

Especially when painting with watercolors, keep the light areas as well as the shadows in mind. You can always make areas darker with watercolors, but you have to plan the light areas from the very beginning.

Contrast

Contrast is the range of dark and light between values. Value enhances the depth and clarity of a picture. Objects with values that contrast very little appear to be close together. Objects with highly contrasting values appear far apart and more defined. Look at the example below.

The darker the darks in your painting, the lighter the lights will appear. So if you want a light area to look really bright, make the objects around it dark.

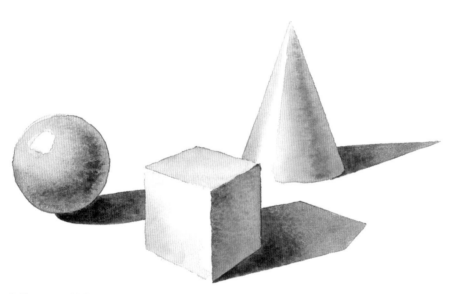

A Range of Values
Values don't always just come in white, black and gray. Value also defines the light and dark aspects of color. For instance, the color green may appear as a light value or dark value, each portraying very different moods. In this example, the light source is located to the left and in front of the three objects.

Don't Be Afraid of Contrast
A picture with a low contrast of values (top) may look flat and undefined, as on an overcast day. Beginners tend to be timid with their paints, so they often end up with low-contrast paintings. A picture with a high contrast of values (bottom) shows depth and definition, as on a sunny day.

Making a Value Scale

When you've completed this value scale, you'll be able to look through the punched holes to identify the values in a scene and determine the values you'll need for a drawing or painting. You'll need 140-lb. (300gsm) cold-pressed paper, Burnt Umber or another dark, neutral color, a no. 10 round brush and water.

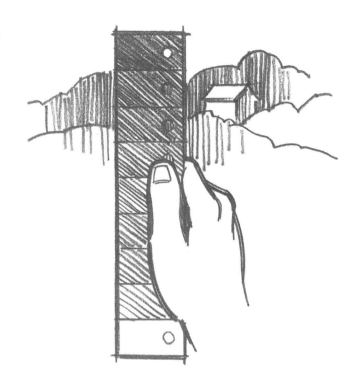

Measuring Value

A *value scale* is a tool that helps identify light and dark areas. Use it while drawing or painting to compare the values within a scene and within a painting. Look through the holes in each value block to compare your painting or drawing to the scale. This scale also will help you plan the range of values you want to use.

Establish Darkest and Middle Values

Divide a 10-inch (25cm) rectangular piece of 140-lb. (300gsm) cold-pressed paper into nine equal rectangles, leaving about a ¼-inch (6mm) border around the edges of the paper. Number the rectangles one through nine from left to right on the top border. Paint the ninth rectangle as dark as possible. Then paint in the fifth rectangle with a value about midway between the ninth value and white.

Paint Intermediate Values

Paint the third rectangle with a value between the fifth value and white. Then paint the seventh rectangle with a value between the fifth and ninth values.

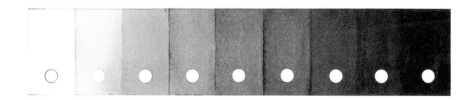

Fill in Values

Paint the even-numbered rectangles to make a continuous line of values that gradate from light to dark. Leave the first rectangle white. Trim all four sides and punch holes in each of the rectangles.

Understanding Color Intensity

Think of intensity as the richness or potency of a color—how yellow is a yellow, how blue is a blue—and value as the lightness or darkness of a particular color.

Some colors, such as yellow, can vary in intensity but not much in value. Other colors, such as blue, can vary in both intensity and value.

You can't control intensity like you can control value. Certain colors and paints simply have certain intensities. As you paint more often and experiment with different paints, you'll find the brands and grades of paint that suit your style.

Varying Intensities

The yellow (1) is very intense. The yellow (2) is not intense. Both are light in value. The blue (3) is very intense and has a dark value. The blue (4) is not intense with a light value.

Using Intense Colors

Both paintings use light values of yellow around the sun, but the less intense colors in the scene on the left lose the penetrating effects of the intense colors in the scene on the right.

Painting Atmospheric Perspective

Atmospheric perspective, also referred to as *aerial perspective*, is the use of color and value to express depth. Objects close to the viewer—in the foreground—have well-defined shapes, contrasting values and intense colors. Objects in the distance aren't as clearly defined and have more neutral values and dull blue-gray colors.

Atmospheric Perspective
The trees show depth with atmospheric perspective but without linear perspective. Only value and color indicate depth. The darkest, most intense tree appears closest to the foreground.

Linear Perspective
The trees show depth with linear perspective but without atmospheric perspective. Size and overlapping objects indicate depth.

Combining Both Forms of Perspective
These trees show depth through both principles, creating the most realistic and appealing scene.

Understanding Color

Color, also referred to as hue, is based on the three primary colors. From these all other colors are derived.

Primary Colors
Red, yellow and blue can't be made from other colors.

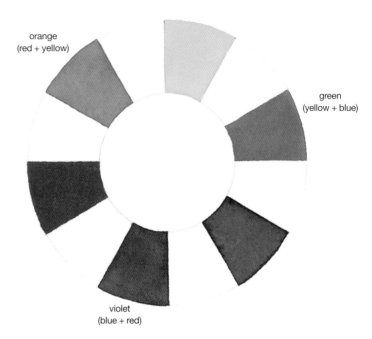

Secondary Colors
Orange, green and violet result from mixing two of the three primary colors.

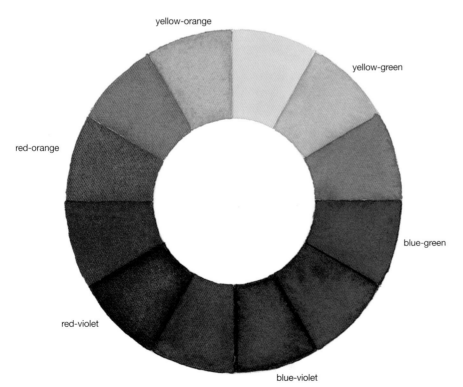

Tertiary Colors
These colors result from mixing a primary color with its adjacent secondary color.

Using Complementary and Analogous Colors

Complementary colors are any two colors that appear opposite each other on the color wheel. *Analogous colors* are a range of neighboring colors that make up a portion of the color wheel—red-orange, orange, yellow-orange and yellow, for example.

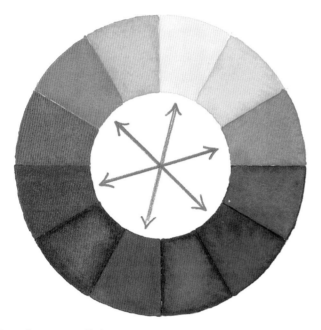

Complementary Colors

Colors that are directly opposite each other are considered a pair of complementary colors—red and green, for example.

Analogous Colors

A group of analogous colors always includes just one primary color.

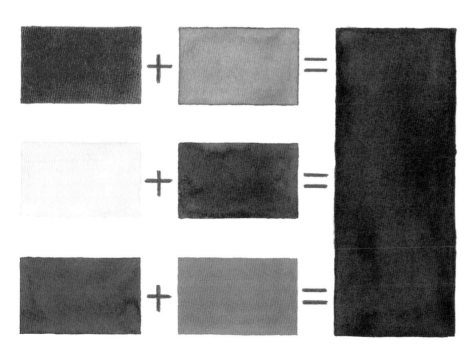

Mixing Complementary Colors

A pair of complementary colors is made up of one primary and one secondary color. If you mix a pair of complementary colors together, you've combined all three primary colors, which will result in a neutral gray or brown. If you mix the primary color red with its complement green (yellow plus blue), you'll get a brown mixture. The same result occurs if you mix yellow with its complement, violet (blue plus red), or if you mix blue and the color orange (yellow plus red).

Understanding Color Temperature

Warm colors are the reds, oranges and yellows and are also referred to as *aggressive colors* because they give the impression of coming forward. Cool colors, greens, blues and violets, are referred to as *recessive colors* because they give the impression of dropping back.

warm colors

cool colors

Assigning Temperature on the Color Wheel
Yellow-green and red-violet fall between warm and cool and can be used as warm or cool. You can use color temperature along with linear and atmospheric perspectives to emphasize depth.

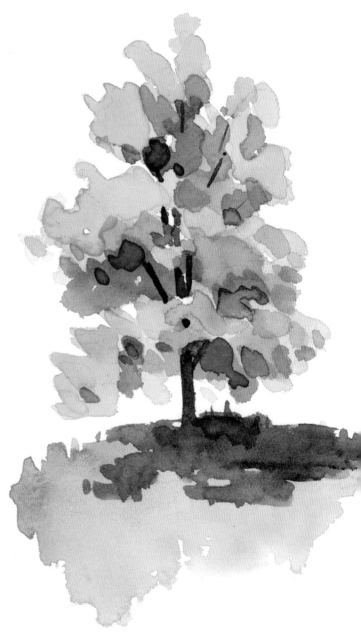

Assigning Temperature to a Scene
When I'm working on a painting, I often think of the areas bathed in sunlight as predominantly warm colors and the areas in shadow as predominantly cool colors.

Making a Color Wheel

You'll need one sheet of 140-lb. (300gsm) cold-pressed paper; tracing paper; a 2B tracing pencil; Alizarin Crimson, Cadmium Yellow and Prussian Blue paints; a no. 10 round brush and water.

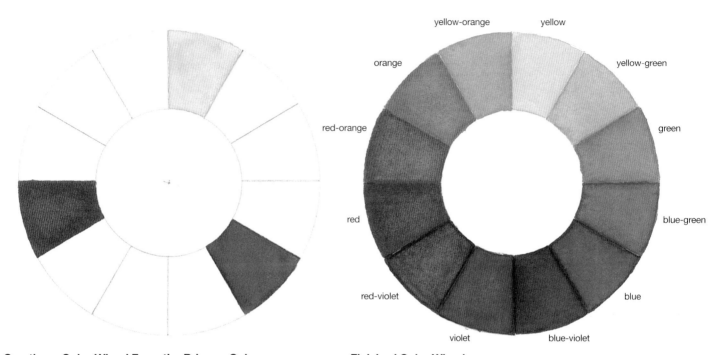

Creating a Color Wheel From the Primary Colors

Trace this wheel onto tracing paper and then onto 140-lb. (300gsm) cold-pressed paper. Your color wheel doesn't have to be this neat; you may prefer just to lay down swatches of color in a circular arrangement. Paint the primary colors in every fourth block as done above. Then mix each primary color with each of the other primary colors to make the secondary colors. Paint these between the primary colors so every other block has color. Make sure you leave enough of each secondary color on your palette to mix the tertiary colors. Mix each of the primary colors with the adjacent secondary color to create the six tertiary colors: yellow and orange for yellow-orange, yellow and green for yellow-green and so on. Paint the tertiary colors in the remaining blocks.

Finished Color Wheel

Your color wheel should look something like this.

Planning Composition

Composition refers to the arrangement of elements in a picture. Whether simple or complex, composition always plays a part in a piece of artwork. Good composition rarely happens by chance. It involves planning before and during the painting process. Practice the following basic principles while planning and painting your artwork.

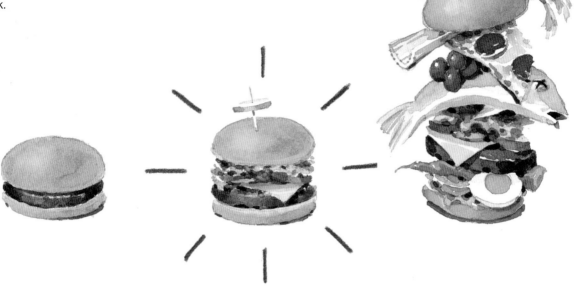

Less Is More, More or Less

Too much of a good thing can be overwhelming. Too little results in a bland painting. Think of a composition as a hamburger. There's more to a good burger than meat and a bun, but if you add everything you have in the refrigerator, it may be hard to swallow! Instead, enhance the flavor with just a few complementary ingredients.

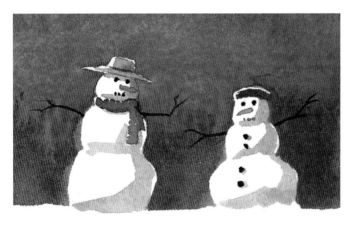

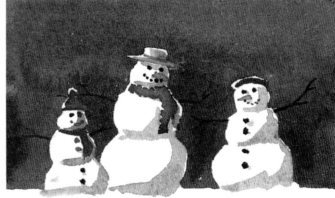

Odds Add Interest

Odd numbers tend to look more interesting. An even number of elements can make the painting look too structured, so it may seem balanced but also looks repetitive. An odd number, on the other hand, is more interesting to the viewer. This concept also applies to the number of elements that overlap the edges of the painting.

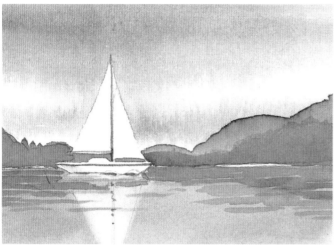

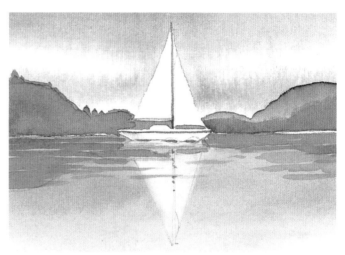

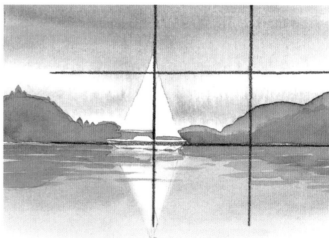

Asymmetrical vs. Symmetrical

A symmetrical composition like the one at the right may look orderly and structured, static and bland. Let's face it: Structure can be boring sometimes, and viewers of your artwork may start to yawn. The asymmetrical composition above gives an interesting, random feel to the painting.

An Odd Way of Looking at Things

The concept of odd numbers works in more ways than one. Don't just use odd numbers of elements; also divide the painting into an odd number of parts. Imagine a grid that splits your painting into thirds horizontally and vertically. Place objects close to the intersection points of these lines to make an appealing composition.

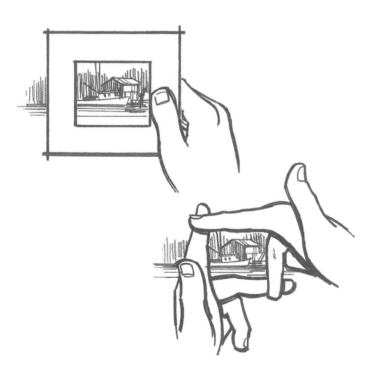

Using a Viewfinder

Some subject matter can be daunting. Landscapes in particular can be overwhelming to a painter trying to capture the great outdoors within the dimensions of a piece of paper. Use a viewfinder to focus in on a manageable composition. You can make your own viewfinder by using a craft knife and straightedge to cut a hole out of a piece of cardboard. You can also form your fingers into the shape of a rectangle.

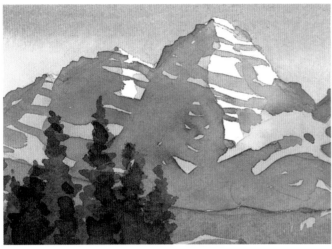

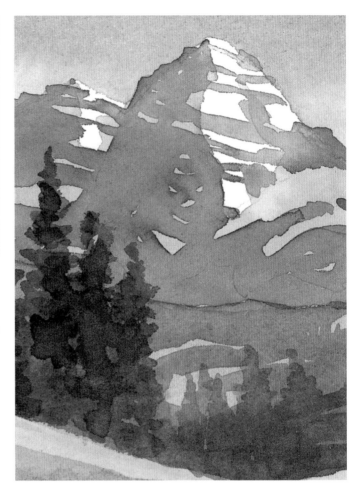

Horizontal or Vertical

Different formats affect viewers differently. Horizontal formats lend themselves to calm, peaceful scenes. In the example above, the width of the horizontal format emphasizes the sturdiness and stability of the mountains. Vertical formats lend themselves to dramatic, intense scenes. In the example at right, the vertical format emphasizes the height and power of the mountains and gives the viewer a feeling of awe.

Don't Fence Me Out!

Walls and fences in the lower portion of a painting give an unfriendly feeling that shuts out the viewer. If you want to place a wall or fence in the foreground, add an open gate to make the scene more inviting.

Angles Add Action

Angled lines and elements give the impression of movement, which adds action and liveliness to a picture.

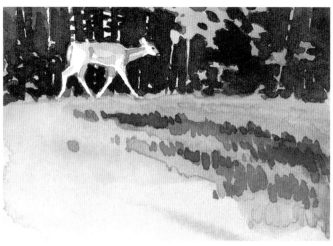

Plan Leading Lines

You can form lines in a composition that direct the viewer's eye to points of interest or guide the eye through the painting. In this case, the shadowy area in the foreground leads the viewer's eye to the point of interest, the deer.

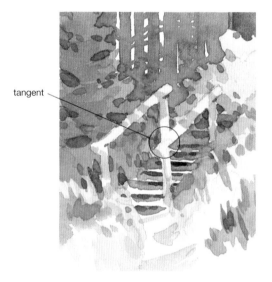

tangent

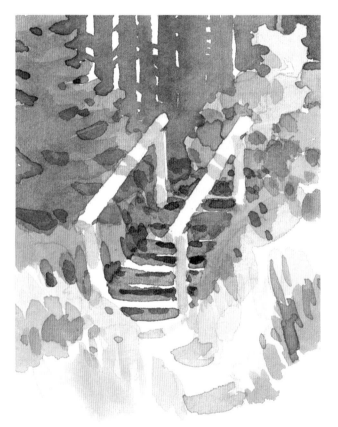

Avoid Tangents

In the painting above, the handrail and two of the posts all meet at one point, called a *tangent*. The composition becomes confusing when the viewer can't see where one object stops and another starts. The painting at right is much easier to comprehend. It uses the same composition viewed from a different perspective.

Following the Painting Process

Watercolors are said to be unforgiving because once you've applied them to paper, they're difficult or even impossible to change. Artists can easily become overly cautious and timid with their paints, which results in a pale, stiff and unexciting painting. Instead, embrace the unpredictability of watercolors and incorporate it into your painting.

Planning

There's more to the painting process than simply applying paint to paper. To maintain control over your painting and to give yourself confidence, plan ahead. If you plan your painting well, you won't need to worry about the fact that there are no "do-overs" in watercolor. Decide on the structure, values and colors you'll use before you start painting.

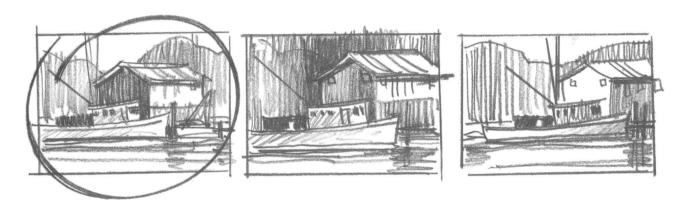

Thumbnail Value Sketches

On sketch paper with a 2B pencil, draw a few thumbnail sketches of the scene you're going to paint. These small, quick sketches show different approaches to value, composition and cropping. I prefer my first sketch because the composition and values lead the eye to the focal point while producing a balanced and interesting scene.

Color Sketches

Now work up some different color schemes using the thumbnail value sketch you chose. On scrap watercolor paper, draw the structural lines without the values. Then try different color schemes, paying attention to the values of the colors you're auditioning. I prefer the direction and balance created by the use of warm and cool colors in my second color sketch. I'll use this as a reference for my final painting.

Drawing

Once you're satisfied with your composition, values and colors, draw the structural drawing that will serve as the basis of your final painting. If you're confident in your drawing skills, go ahead and draw directly onto your watercolor paper. Be careful though. If you redraw or erase too much before painting, you'll damage the paper so paint will streak and spot. If you prefer, take a few extra minutes to draw the structural drawing on a regular sheet of paper and then trace or transfer it to watercolor paper once you're satisfied with it.

Tracing

To trace your structural drawing, you'll need a form of backlighting. Secure a piece of watercolor paper over the structural drawing with masking tape. Then attach both to your light source: a lightbox or a window. Trace the image with a 2B pencil. If you need to erase any lines, use a kneaded eraser, which is less abrasive than other erasers.

Heavy watercolor paper, such as 300-lb. (640gsm) paper, is too thick to use for tracing. Watercolor paper in block form is also impractical for tracing. If you're using thick paper or a watercolor block, you can transfer the structural drawing onto your watercolor paper (see the next page) rather than trace it.

Structural Lines
With a 2B pencil, lightly draw the structure of the subject onto watercolor paper. Don't worry about indicating values here; just draw the structural lines.

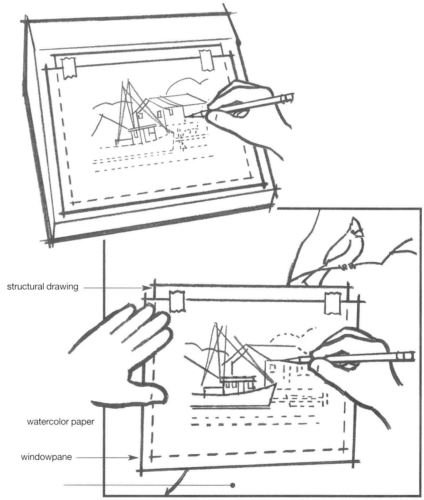

structural drawing

watercolor paper

windowpane

Light Sources for Tracing
You can use a lightbox or a window as backlighting when tracing an image onto watercolor paper. The light outside must be brighter than the light inside so you can see through the watercolor paper. Try to find a window where you can sit to trace.

Transferring

To transfer an image, you'll need a graphite transfer sheet. As you press down on the transfer sheet, graphite transfers onto the watercolor paper. I make my own transfer sheets because commercial versions leave waxy lines that repel paint from the watercolor paper and are hard to erase.

Make Graphite Paper

Cover one side of an 11" × 14" (28cm × 36cm) piece of tracing paper with graphite using a 2B pencil. Zigzag down the paper in columns until the paper is completely and evenly covered. Rotate your paper forty-five degrees and repeat this process so the new lines crisscross the original ones.

Bind Graphite to Paper

Dampen a cotton ball with rubbing alcohol and wipe it across the graphite. The rubbing alcohol evens out the graphite and binds it to the surface of the paper so it's no longer powdery. Keep the surface as dry as possible while smearing the graphite to avoid wrinkling the paper. Some wrinkling is bound to happen, but too much alcohol—and it doesn't take much—will keep the paper from lying flat. Let the sheet dry.

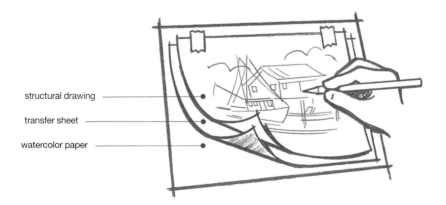

structural drawing

transfer sheet

watercolor paper

Transfer Image

With the graphite side facing down, place the transfer sheet on top of the watercolor paper and then place the structural drawing face up on top of the transfer sheet. Tape the sheets together with masking tape so they won't slip. Then go over the lines of the structural drawing with a hard lead pencil, such as a 2H pencil, and press hard enough to transfer the image, but not so hard as to leave deep grooves in the watercolor paper. Check to make sure the image is transferring to your watercolor paper before you get too far into the process.

Painting

Now you've got a structural drawing on your watercolor paper whether from a direct drawing, tracing or transferring. If the paper you're working on is in block form, you're finally ready to start painting. If you're working on a loose sheet of watercolor paper, mount it to a board or stretch it with sealing tape or clips, then start painting.

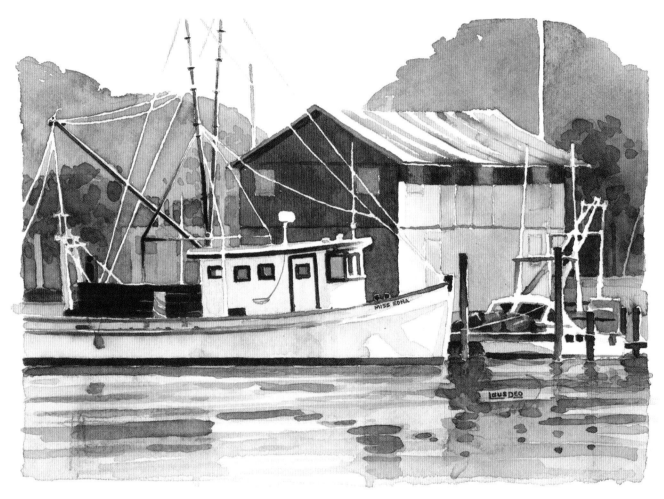

Time to Paint

Once the paint is dry, erase your pencil lines with a kneaded eraser, sign and date your painting and you're done!

Miss Edna, Mooring
watercolor on 140-lb. (300gsm) cold-pressed watercolor paper
5½" × 8" (14cm × 20cm)

7 Practice the **Techniques**

Painting with watercolors is fun, and it's even more exciting when you learn the techniques unique to this particular medium. In this chapter you'll learn some easy techniques that will bring more creativity, interest and enjoyment to your watercolor painting experiences.

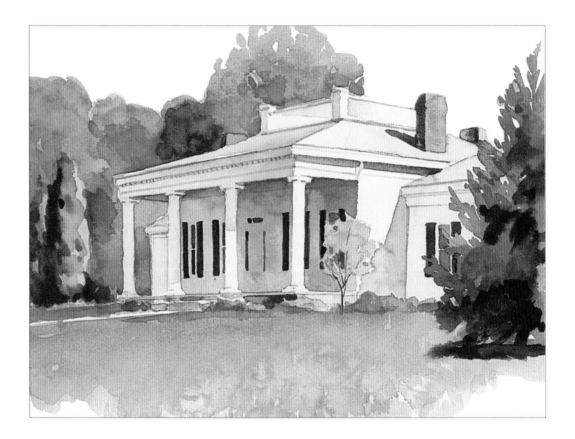

Mixing Paint and Handling Brushes

Unlike other mediums, watercolor paints are supposed to be used transparently to utilize their luminescent qualities, so you have to mix the paint with water before applying it to paper. Whenever I talk about a color in this part of the book, I'm referring to a mixture of water and paint. The ratio of paint to water that you should use depends on how light or dark you want a color to be. Only hands-on experience can teach you how much water and paint to use to get the results you want.

The idea behind mixing colors is to start with a base color, or the lightest color, and then add small amounts of the darker color or colors until you get the color you want. If two colors are equally dark, think back to the color wheel. Green and blue can be equally dark, but green is made up of yellow and blue. Yellow is lighter than blue, and green has yellow in it, so it should be the base color. Start with green and add bits of blue until you get the color you want. Then add water until you get a good working consistency.

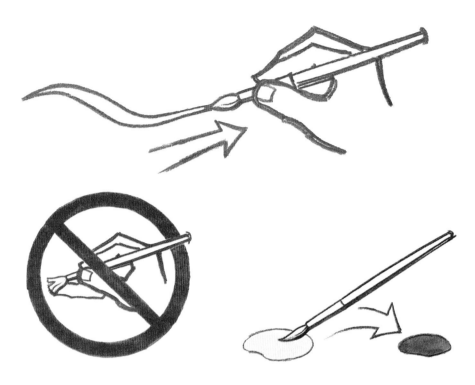

Using Brushes Correctly

Watercolor brushes can be pricey. Handle them carefully to get the most mileage out of them. A good round brush has bristles that come to a fine point. To maintain the point, gently pull or draw the brush away from the hairs toward the handle as you paint. Pushing or scrubbing with a brush can ruin the fine point that your brush once made.

Mixing Colors

Start with the lighter colors. Darker colors are more dominant than lighter colors and can overpower them.

Don't Skimp

Don't worry about using too much paint or water. Beginners often mix too little and then try to stretch what little they have. This means your paint application will be weak and pale or you'll spend lots of time trying to make another mixture of the exact same color and value to finish your painting. The mixture at left is much more realistic than the mixture at right. Fresh-squeezed paints from the tube are more soluble than paints that have dried out on your palette. Use fresh paints to avoid pale colors.

Painting Wet-Into-Wet

To work wet-into-wet, apply a brush loaded with paint to wet paper. This technique offers less control than wet-on-dry or dry-brush techniques, but it also offers plenty of unique and unexpected results. Applying paint wet-into-wet allows the painter to use loose strokes and bold colors.

Time is of the essence when you're working wet-into-wet because you need to finish painting the area before the paper dries. Choose your colors and mix lots of paint and water on the palette before you wet the paper. Use a big, wide brush to cover the area with water just before you begin to paint so the whole area is covered with a smooth, even sheen. If the paper is too wet or too dry, the color won't bleed out smoothly.

The paint should transfer easily from the brush to the paper and spread to areas where the paper is wet.

Apply Water
Wet the surface of the paper with a wide, flat brush filled with water. Use long, straight, back-and-forth strokes. The entire area you want to paint should have an even sheen just before you start painting.

Apply Color
Load a brush with paint and gently touch or sweep the brush along the paper surface so the color transfers from the brush to the damp paper. Remember that these are watercolors—trying to brush the paint into submission once it's been applied can cause smearing. After the color leaves your brush, let the spontaneity of watercolors take over.

What Paper to Use

The smooth surface of hot pressed paper doesn't allow paint to spread out as much as cold-pressed or rough paper does, though I do like the interesting watermarks and hard edges. If you want to create soft edges with the wet-into-wet technique, use cold-pressed or rough paper.

1

2

3

4

5

Wet-Into-Wet on Different Papers
Examples of this painting technique on different papers appear above: hot-pressed (1), cold-pressed (2) and rough (3).

How Much Water Do I Use?
The trick when painting wet-into-wet is to apply just the right amount of water to the paper before painting. If the surface is too wet (4), it won't want to accept the color, and you'll get pale, uneven results. Before adding color, gently smooth any puddles of water so you have a thin, even sheen of water over the paper's surface. If the surface is too dry (5), the color may bleed out in an inconsistent manner. Don't get frustrated. It may take some practice to learn how much water to use.

Painting Wet-on-Dry and Drybrushing

Wet-into-wet, wet-on-dry and dry-brush techniques are synonymous with watercolor. Often, all three are used in one painting.

Wet-on-Dry

To paint wet-on-dry, apply a wet brush loaded with paint to dry paper. Because there is no water on the paper to help the paint disperse, wet-on-dry produces defined strokes with hard edges. Different papers react similarly to the wet-on-dry technique. However, the smooth surface of hot-pressed paper allows cleaner edges.

Drybrush

The dry-brush technique uses dry paper and a dry brush loaded with a mixture that has very little water. Hot-pressed paper lets very little texture show through after you've painted over it. Rough paper shows plenty of texture. If you want to use wet-on-dry or dry-brush techniques, make sure the area is completely dry before painting.

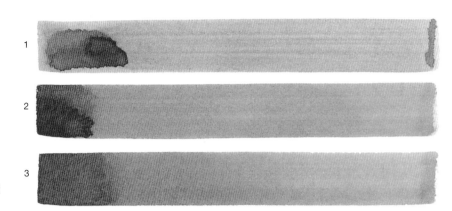

Wet-on-Dry on Different Papers
Examples of this technique used on different papers appear above: hot-pressed (1), cold-pressed (2) and rough (3).

Drybrush on Different Papers
Examples of this technique used on different papers appear above: hot-pressed (4), cold-pressed (5) and rough (6).

Use Very Little Water for Drybrushing
Mix the paint with just enough water to allow the mixture to transfer from the brush to the dry paper. The tree on the far left shows too much water used.

Applying a Flat Wash

A *flat wash* covers a large area with even color. You need to work quickly to cover the surface evenly, finishing the wash before any part dries.

Make a generous mixture on your palette so you'll have enough paint to work quickly. For big washes, use a second palette or the palette cover so you'll have enough room to create a big mixture.

Paper quality makes a big difference when painting washes. In general, professional-grade paper stays wet longer, providing more time to work on the wash. Good paper also accepts multiple washes better than student-grade paper. For paintings larger than 11" × 17" (28cm × 43cm), use nothing thinner than 300-lb. (640gsm) paper to prevent wrinkling.

Painting a Flat Wash

Lay out paper, a palette, a water container, a rag and three brushes—one for mixing, one for painting and one for pulling up puddles of extra paint—within easy reach. Use a separate brush to mix the paint so you won't have undiluted clumps of pigment on the brush you're using for painting.

Load a wide, flat brush with the paint mixture. I use a 3-inch (76mm) hake brush for 8" × 10" (20cm × 25cm) areas—the larger the area, the wider the brush. Cover as much space as possible at once. Stand when you paint washes so you have plenty of freedom of movement. Stroke across the top of the dry paper. Load the brush again and make another stroke, this time in the opposite direction and overlapping the bottom of the previous stroke by about a third. Continue this process—loading the brush and stroking back and forth down the paper until the area is covered.

Flat, Even Color

A flat wash covers the paper evenly and doesn't vary in value or color.

Tilting Your Paper

As long as the painted area is still very wet and hasn't started to dry yet, you can tilt your paper to even out the paint. Tilt it back and forth in whatever direction necessary to smooth out any lines. Then use a dry brush to lift any puddles of water that may have formed at the edges of the wash. This prevents the extra water from running back in. If the finished results aren't as dark as you wanted, wait for the area to dry completely and repeat the wash. A word of caution: Some cheaper papers don't absorb repeated washes well, and the paint will smear instead.

Applying a Gradated Wash

A gradated wash changes value. You must work quickly to complete the wash before any part of it dries.

Work on a wash from light to dark. If you try to apply a gradated wash from dark to light, you'll waste precious time cleaning the dark color out of your brush before moving on to the lighter value. If you want a wash to go from dark to light, turn your paper upside down and paint from light to dark.

To save much needed time, make a big gradated mixture on your palette before you start painting. First, make a big puddle of clear water at the top of the palette. Then, make a big puddle of a dark mixture at the bottom of the palette. Join the two puddles in the middle to make one mixture that gradates from almost clear water to a dark mixture.

Start With Water
Lay out your supplies the same way you did for a flat wash, using two water containers instead of one. Use the water on the left for making the mixture and the water on the right for cleaning your brushes. Load a wide, flat brush with clear water. While standing, stroke the brush across the dry paper.

Add Some Color
Load the brush again, this time from the top portion of the puddle on your palette.

Gradual Transition
Apply the paint and water mixture so the wash begins as mostly water and gradates to more and more color.

Add More Color As You Go
Make another stroke in the opposite direction, overlapping the bottom of the previous stroke by about a third. Continue this process—loading the brush and stroking back and forth from the top to the bottom of the paper. As long as the painted area is still very wet and hasn't begun to dry, smooth the wash by tilting your paper. Lift up any puddles at the edges with a dry brush to prevent backruns. If you want the wash to be darker, repeat it after the first wash has dried.

Applying a Variegated Wash

A variegated wash changes from one color to another, with the two colors blending in the middle.

Just as you mixed a gradated wash on your palette, mix a variegated wash before painting. Make a big puddle of the first paint mixture at the top of the palette. In the example on this page, I used Prussian Blue. Wash out your brush and make another puddle of the second paint mixture at the bottom of the palette. I used Alizarin Crimson in this example. Join the puddles so the two colors bleed together to make one big puddle of paint that gradates from blue to purple to crimson.

Start With One Color

Lay out your supplies as you did for the gradated wash including two water containers. Load a clean, wide flat brush from the top of the paint mixture.

Continue With More Color

While standing, stroke the brush across the dry paper. Then load the brush from a slightly lower part of the puddle.

Multiple Transitions

A variegated wash changes from one color to another, blending the two in the middle.

Smooth out the Wash

Make another stroke in the opposite direction, overlapping the bottom of the previous stroke by about a third. Continue this process—loading the brush from the palette, from the top down, and stroking back and forth to the bottom of the paper. As long as the area hasn't begun to dry, smooth out the wash by tilting your paper. Lift any puddles at the edges to prevent backruns. If the finished results aren't as dark as you'd like, repeat the wash after the first one has dried completely.

Something's Wrong With My Wash

So you've been practicing, and your wash just didn't turn out like you thought it would. Here are some pitfalls artists often fall into. Once you've identified the problem, keep practicing until you get it right.

Unwanted Streaks and Lines Appeared
Unwanted streaks and lines appear if you try to cover a large area with a brush that is too small. Work quickly with as large a brush as possible so the wash won't start to dry before you're finished.

Paint Dried Unevenly
Starting in the middle of the area you want to cover makes your job harder than it has to be. The paint on the outer edge starts to dry before the paint in the middle. If you overlap the edge with a stroke of wet paint, the edge of the first stroke will show. Each area should dry at the same time. Start at a corner and work outward so you won't have to overlap old strokes.

Watermarks From Backruns Occurred
Puddles of excess fluid left at the edges of a wash can run back into the area starting to dry and cause watermarks. Touch the tip of a dry brush—sometimes called a thirsty brush—to the puddle while the paper is still wet to lift the extra fluid from the paper. Dry the brush with a rag and repeat as many times as necessary. Be careful not to smear any paint that has begun to settle.

Paint Smeared
Watercolors are not like oils or acrylics. Brushing the paint once it begins to settle can smear the paint. Once watercolor paint starts to dry, it's out of your hands. Don't overwork it.

Second Wash Repelled Color
Applying another wash before the previous one has dried may smear or repel the color from the first wash. Make sure each wash is completely dry before starting another one.

UFOs Have Invaded
"Unwanted foreign objects," such as dust, lint, cat hair and oil from fingerprints, cause streaks and spots if they end up in your wash before it dries. Make sure anything that comes in contact with the paper, such as paint, a rag or brushes, is clean before you use it, and don't handle the surface of the paper any more than you have to.

Positive and Negative Painting

Negative painting is an easy technique to learn when painting with watercolors. You just need to plan ahead. You might paint the negative space of an object around a white area or over a previous wash of color. It's easy to plan what areas to leave untouched if indicating a white object, such as white water in rapids. Take the challenge of painting an object that normally is brown, such as a fence, by leaving the fence white and painting the shapes around it.

You can make a dull, drab fence into an interesting part of your composition. Use negative painting as a way to present an ordinary image in a unique way. I like to imply the shapes of daisies on a dark background using negative painting.

negative painting

positive painting

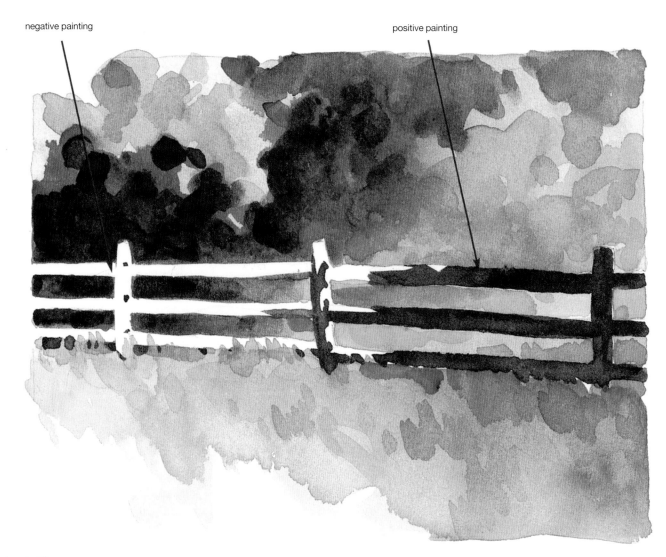

Imply Shapes

Negative painting implies an image by painting the shapes around it. *Positive painting*, in contrast, means simply painting the object. To paint a fence using negative painting, for instance, you'd leave the white of the paper for the fence and define the fence's shape by painting the colors of the foliage behind it. To paint the fence positively, the brushstrokes themselves should indicate the fence posts and rails. Carefully plan your composition before painting. Draw all of the shapes in lightly, then paint around the object, only implying its shape.

Painting Straight Lines

You can use a straightedge, such as a ruler, to make long, straight lines. Following the edge with a round brush, as you would with a pencil, can cause the paint to spill under the ruler with unpredictable results. Instead, follow the technique below.

Steadying Your Hand

Prop up the ruler with the hand you don't paint with, resting your fingers between the surface and the back of the ruler. Place your thumb along the front of the ruler to stabilize it. The top edge of the ruler should be elevated while the bottom edge rests on the paper.

Next, load a no. 2 or no. 6 round brush with paint. Place the ferrule, or metal part, of the brush so it rests on the ruler's edge. Paint the line by dropping the tip of the brush to the surface of the paper. If you're right-handed, start at the left and pull the line to the right. If you're left-handed, start at the right and pull the line to the left. Let the ferrule ride along the edge of the ruler.

Using Straight Lines in a Painting

I painted most of this scene loosely, but the contrast of the straight lines on the blades really brings the focus to the windmill and makes a bold statement. The straight lines make the mill look much more realistic than freehand lines would indicate.

Creating Texture

You can create texture by moving or disbursing paint while it's still wet. The results vary depending on the type of paper you use and how damp you make the paper. Experiment on scrap watercolor paper before trying any of these techniques on a painting. Keep your practice scraps and trim them to be used as bookmarks or notecards. Applying textures can be great fun, but texture shouldn't be the main attraction of a painting. Instead it should enhance the overall theme.

Adding More Water
Apply a wash of color and let it stand until almost dry. Then touch the tip of a round brush loaded with water onto the wet surface. This water will push away the previously applied wet paint. This technique works well for elements like the leaves above. To emphasize contrast in these areas, you can use a tissue to carefully blot the center of a freshly painted area.

Adding More Paint
Rather than applying more water, you can apply a paint mixture. The mixture will push away the previously applied wet paint. This is similar to painting wet-into-wet, except now you'll wait until the paint from the previous wash is almost dry before applying a second color. The colors won't blend smoothly as in a wet-into-wet wash, but instead they'll push against each other to create unique textural effects. Experiment on scraps of watercolor paper to be certain of the results before using this technique in a painting.

Adding Salt

Hold grains of salt between your thumb and forefinger and drop them onto the wet surface of a freshly applied wash. Be patient. The effect doesn't always appear immediately. The salt continues to work its magic until the wash dries completely. Don't use a hair dryer to speed up drying time, though. When the wash is dry, gently wipe away remaining salt crystals. Bigger salt grains, such as coarse kosher salt and rock salt, leave bigger splotches than regular table salt.

Use Different Amounts of Water

The results can vary depending on the dampness of the paper. In the top example, I added table salt once the wash looked like a thin sheen. The bottom wash practically had puddles when I added the table salt. Experiment with adding salt at varying levels of dampness. The wetter the wash, the more the salt spreads and dissolves, which results in a subtle texture.

Lifting Paint

After you've applied a wash, you can lift some of the paint from the surface before it has dried. Professional-grade papers usually respond better to this technique.

Lifting With a Tissue
While the wash is still damp, bunch up a facial tissue, press it firmly against the paper and quickly pull it away to lift some of the paint. This technique works well for clouds, for example.

Lifting With a Paintbrush
Drag an old, dry brush over a wash of color that is nearly dry. The pressure you need to use could damage a good brush. This technique works well to paint weathered wood.

Spattering

Random dots can add a rustic feel to a watering can or imply the texture of sand on a beach. Practice on a scrap piece of paper to get used to the results. Use scrap paper to cover any area where you don't want the dots to land.

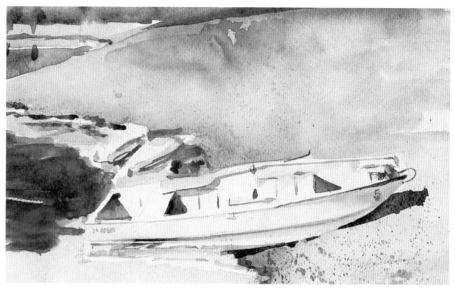

Indicating Sand
Spattering with two paintbrushes produces fewer dots, but they're bigger. Spattering with a comb and a toothbrush produces lots of small dots. I painted the dots above using two brushes.

Return From Fishing
watercolor on 140-lb. (300gsm) cold-pressed watercolor paper
7½" × 13" (19cm × 33cm)

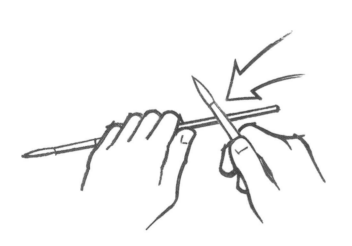

Two Paintbrushes
Gently tap one paintbrush loaded with paint against the handle of another paintbrush.

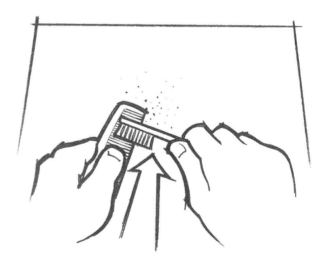

Toothbrush and Comb
Instead of brushes, you can also use a toothbrush and comb. Load the toothbrush with paint and drag it over the teeth of a comb with the tip pointed toward the watercolor paper.

Matting and Framing

A watercolor painting isn't complete without a mat and frame. Correctly matching a mat and frame to the composition of your painting will dramatically enhance it.

Use the table on the next page as a guide for the sizes of mats and frames to use for your paintings. This information is based on standard paper, mat and frame sizes. The image size is the amount of the paper that will show after you've matted the painting. It's OK to paint bigger than this and let the mat crop the scene for you.

If you're painting on 9" × 12" (23cm × 30cm) paper, for instance, an 11" × 14" (28cm × 36cm) mat will work well and allow an 8" × 10" (20cm × 25cm) area to show through. Or if you want a framed picture that is 12" × 16" (30cm × 41cm), go backwards through the chart to see that you should paint on 10" × 14" (25cm × 36cm) or 12" × 16" (30cm × 41cm) paper, and a 9" × 12" (23cm × 30cm) part of the image will show. You also can have mats custom cut to fill a frame or fit the paper you're working on.

Like paper, mat board that isn't acid-free will yellow with age. Make sure you look for the acid-free label. If a picture is worth framing, it's worth the cost of acid-free mat board.

Achieving a Professional Look

Once you've got the right mat and frame for the size of paper you used, just drop in your painting, put the backing board in behind it, and you're done! The frame, the glass and the backing board should match the mat board size in the chart.

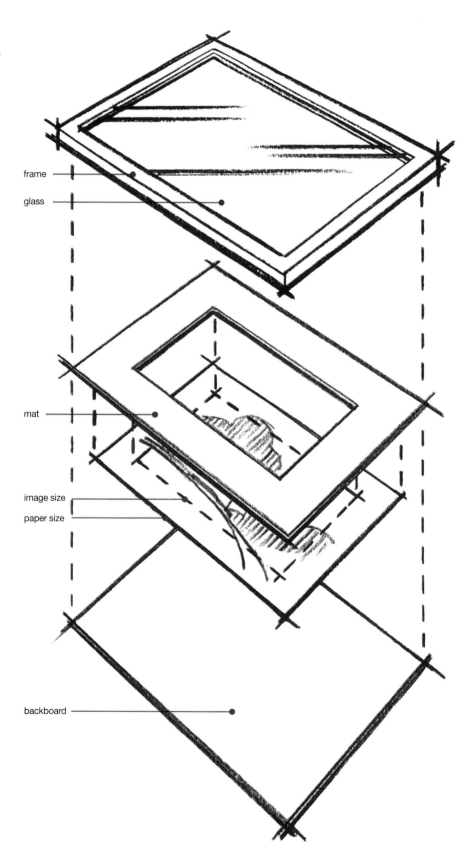

frame
glass
mat
image size
paper size
backboard

A Beginner's Efforts

Mary considers herself an absolute beginner when it comes to watercolor, so we thought it would be helpful for you to see the result of Mary's efforts from the demonstration you'll soon be doing. She's proud enough of what she was able to do with the help of my demonstration to show the painting to some of her friends.

A Beginner's Professional Results

Look at the difference a mat and a frame make in creating a professional-looking product. Mary painted the 8" × 10" (20cm × 25cm) image on 10" × 14" (25cm × 36cm) paper and framed and matted it with an 11" × 14" (28cm × 36cm) mat and frame.

Camargo Gatehouse
Mary Willenbrink
watercolor on 140-lb. (300gsm) cold-pressed watercolor paper
8" × 10" (20cm × 25cm)

What Size Mat and Frame Do I Need?

Paper Size	Image Size	Mat and Frame Size
4" × 6" (10cm × 15cm)	3½" × 5" (9cm × 13cm)	5" × 7" (13cm × 18cm)
7" × 10" (18cm × 25cm)	5" × 7" (13cm × 18cm)	8" × 10" (20cm × 25cm)
9" × 12" (23cm × 30cm)	8" × 10" (20cm × 25cm)	11" × 14" (28cm × 36cm)
10" × 14" (25cm × 36cm)	8" × 10" (20cm × 25cm)	11" × 14" (28cm × 36cm)
10" × 14" (25cm × 36cm)	9" × 12" (23cm × 30cm)	12" × 16" (30cm × 41cm)
12" × 16" (30cm × 41cm)	9" × 12" (23cm × 30cm)	12" × 16" (30cm × 41cm)
14" × 20" (36cm × 51cm)	11" × 14" (28cm × 36cm)	16" × 20" (41cm × 51cm)

8 Let's
Paint

Painting with watercolors is fun, and it's even more exciting when you learn the techniques unique to this particular medium. In this chapter you'll practice some easy techniques that will bring more creativity, interest and enjoyment to your watercolor paintings and experiences.

Before each demonstration, you'll find a list of materials you'll need to complete each painting. You'll also see the image size listed. The image size is the part of the painting that will show if you mat and frame the painting. I've also listed the lessons from the book that you'll use in each demonstration. Glance back to those pages to refresh your memory before starting a painting or when you reach a trouble spot during the painting. Have fun!

Getting Ready

As we were writing this book together, we kept in mind that we were writing for you, the absolute beginner. I am a professional artist and a teacher, but teaming up with Mary, an absolute beginner herself, as a cowriter helped. Often, Mary would ask questions you might have asked if you were in one of my classes: "How did you do that?" "Why did you do this first?" "Can you talk me through this demonstration?" "Why don't my colors look like yours?" Then we tried to include answers in the book for your benefit.

Prepare Your Work Area

Make sure all of your supplies are within reach before you start painting; watercolors sometimes demand you work quickly. You'll find a comprehensive list of painting and drawing supplies in the beginning of the book. You'll also find materials specific to each painting on the first page of each demonstration. Make sure your work area is clean and dry; it's essential to a peaceful, stress-free painting session.

Prepare Your Mind

Remember to have fun with watercolors! Because watercolors are unpredictable, some artists feel tense and out of control at first. You just have to approach watercolor painting with the appropriate mind-set: Let the watercolors behave as the transparent, fluid paints they are. Let them do their thing. You may be surprised and enjoy the results.

Also keep the tips mentioned at the beginning of each demo in your mind as you paint. I'm teaching you how to paint from afar. In an actual class, I would remind you, for instance, "Remember where your light source is coming from as you lay this wash! Look for some of the whites in the painting." I can't be there to do that for you as you paint these demos, so train yourself to remember these things as you paint.

A Bit of Praise

As an instructor, I also like to comment on the positive aspects of your work as you're painting. I wish I could be there to point out the neat and unique things I can see about your painting. Encouragement is a major part of the painting process.

Don't be humble. Appreciate the successes in each painting you do. Remember that inconsistencies aren't mistakes; there will be nuances in your work. Don't forget to encourage and praise yourself. You deserve it.

Date Your Paintings

Dating your paintings will give you a creative diary of your progress. I like to go through my old paintings every once in a while, and I actually enjoy them more after they've been set aside a few months.

You may not always like a painting when you finish it. Maybe the composition didn't turn out as you had planned, or maybe you feel you went too dark with the background colors. A few weeks later, though, you may find you're actually growing in your talents. Perhaps you've finally moved away from colors that are too muted. You may have trouble recognizing and appreciating growth in your own work. Keep your paintings for awhile; you may find that they grow on you.

Great Aunt Harriet

Consider matting and framing each painting. It's amazing what it can do to a simple watercolor. Although you may not always appreciate your end results, art is in the eye of the beholder. Someone else may view your painting altogether differently. Something in the composition may have special meaning to him or her, or someone like your Great Aunt Harriet may simply love it because she loves you.

Keep It Clean
Food crumbs and oils from your fingers can affect the way paint lies on your paper— so it's probably a good idea not to eat fried chicken while you paint!

Structural Drawing

In this demonstration, you'll create a structural drawing by sketching the simple shapes of a gatehouse. Take the time to draw straight, parallel lines with a straightedge.

This drawing will be the foundation for the next two watercolor demonstrations. You can either draw a structural drawing directly onto watercolor paper or draw the image on sketch paper and then trace or transfer it to watercolor paper once you're satisfied with the drawing. I prefer to draw an image on sketch paper at whatever size is comfortable. I use a photocopier to enlarge or reduce the drawing to the size I want to paint and then I transfer my drawing onto watercolor paper.

Each step in this demonstration adds basic shapes that will provide the structure for your paintings. The layered shapes will make up a complete scene.

Materials

Paper
10" × 14" (25cm × 36cm) 140-lb. (300gsm) cold-pressed watercolor paper

Other Supplies
2B pencil

kneaded eraser

LESSONS/TECHNIQUES

- Structural Drawing (Chapter 6)
- Measuring (Chapter 6)

Tips

- Take the time to create a sound drawing. It's the secret to painting a beautiful watercolor you will be proud of for years to come.
- Don't worry about including too many details now. You can leave some, such as the details on the foliage, for the painting stage.

1 Draw the Basic Structure of the House

Draw two rectangles to create the base of the house with a 2B pencil. The bottom line should be a few inches from the bottom of your paper. Sketch a vertical dividing line through the left rectangle to help you keep things balanced.

2 Draw the Roofs

Add slanted lines over the first rectangle to make a triangle that will form the peak of the roof. Divide the right rectangle horizontally to indicate the roof of this part of the house. Add a rectangle on each side of the picture, creating the wall.

3 Draw the Accents
Sketch the windows, chimney and sides of the door.
Draw a line to indicate where the top of the door will be.

4 Draw the Curved Lines
Add the curves on the door and the roof, and start detailing the windows.

5 Add Details
Add trim details to the windows and slate roof, and draw some stones on the walls of the gatehouse.

Draw the Foliage
Indicate the basic shape of the foliage.

Add Finishing Touches
Finish by drawing the outline of the trees and shrubs, throwing in a few stones on the walkway and a bit of grass. You can leave the details of the foliage for your watercolors.

Now erase any unnecessary lines, such as the dividing lines that helped you draw the rooftops. On any painting, erase any unnecessary pencil lines before painting. They will be more difficult to erase once you've painted over them.

Painting With One Color

In this demonstration you'll examine the lights and darks of the scene. Concentrating on this aspect of painting, especially in watercolors, will help you master values and colors for later demonstrations. It's truly rewarding to show people a finished painting and be able to tell them that the white areas are actually the white of the paper. It shows people that you planned this painting and have the skills to follow through.

If you drew the gatehouse from the last demonstration on watercolor paper, you're ready to paint! If you drew the image on sketch paper so as not to ruin the watercolor paper with lots of erasing and redrawing, trace or transfer the image onto your watercolor paper. Unless you're using a watercolor paper block, secure all four sides of your paper to a mounting board with sealing tape.

Tips
- Keep a value scale close by as you paint or even make one using the same color you're painting with.
- Remember that watercolor will look lighter after it dries. Don't be discouraged if a wash doesn't look like it's supposed to. Consider it a learning experience.
- Let each wash dry before applying the next one.
- Start with general shapes and value masses and then move on to painting fine details later.
- Make the background darker than the gatehouse so the building's shape is clear and well defined.
- Keep your light source in mind as you paint.
- As you paint in the details, leave a bit for the imagination. Just imply texture in some places rather than painting each stone on the walls, each leaf on the trees and each blade of grass.

Materials

Paper
10" × 14" (25cm × 36cm) 140-lb. (300gsm) cold-pressed watercolor paper

Image Size for Matting and Framing 8" × 10" (20cm × 25cm)

Watercolors
Burnt Umber or Sepia

Brushes
no. 2 round

no. 6 round

no. 10 round

large bamboo

LESSONS/TECHNIQUES
- Understanding Value (Chapter 6)
- Following the Painting Process (Chapter 6)
- Mixing Paint and Handling Brushes (Chapter 7)
- Painting Wet-on-Dry (Chapter 7)
- Positive and Negative Painting (Chapter 7)

1 Paint the Background

Paint the background leaves with a large bamboo brush. Turn the painting sideways to make it easier for you to paint around the gatehouse.

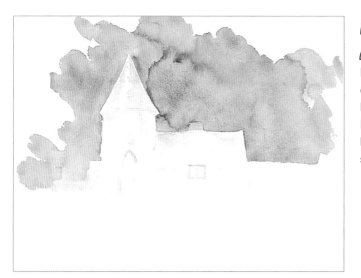

2 Paint the Building

Make a mixture with a liberal amount of water to create a value lighter than the background. Add this color to the building to contrast the dark background with a no. 10 round brush. Leave some areas white to appear as highlights, paying attention to the light source shining from the upper left.

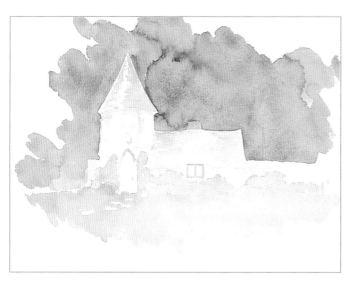

3 Paint the Foreground

Make a paint mixture that is a bit darker than the building. Sweep the paint across the foreground ivy, shrubs and grass with a bamboo brush. At this point, don't worry about defining these elements; just block in the general values of the area.

4 Add Darks to the Background

The darkest value so far should be the background. Layer a darker value over some areas of the leaves with a no. 10 round brush. This will add depth to the foliage.

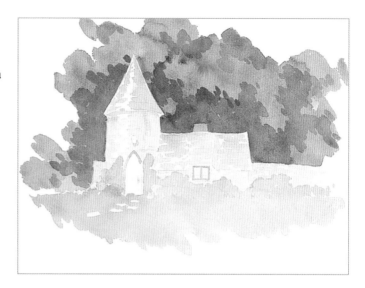

5 Add Midtones to the Building

Add washes of color over several parts of the building with a no. 10 round. Make the value slightly darker than the first washes on the building.

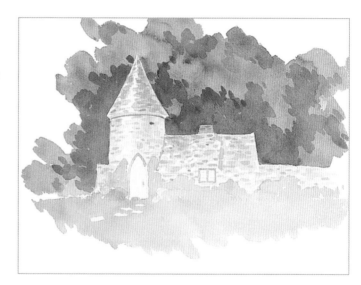

6 Suggest Details in the Foreground

Make some mixtures that are slightly darker than the first foreground wash. Apply washes of these mixtures in the foreground with a no. 10 round to suggest bushes, ivy and grass.

7 Add Another Layer of Washes

Add darker washes to the background to better define the trees and leaves with a no. 10 round. Indicate the tree trunks by painting the negative shapes around the trunks with a darker wash. Add a few dark accents to the building, including the window on the tower, the door, the eaves and some dark areas on the roof, with a no. 6 round. Remember to paint around small detail areas that will remain light, such as the handle on the door. Also add some definition to the vegetation in front of the building with a no. 6 round.

The Gatehouse
watercolor on 140-lb.
(300gsm) cold-pressed
watercolor paper
8" × 10" (20cm × 25cm)

8 Paint the Final Details

Paint details on the shrubbery and roof of the building with a no. 6 round brush. Paint the smaller details on the roof, door and window with a no. 2 round. Erase any unwanted pencil lines after the painting has completely dried and then sign your name with a no. 2 round brush or a 2B pencil. If you've never signed a painting before, practice on a scrap piece of paper. If you plan to mat and frame it, keep in mind the area that will be covered by the mat board. The paper you've been painting on is 10" × 14" (25cm × 36cm). Following the table in the previous chapter, the image area that will show after matting will be 8" × 10" (20cm × 25cm) or 9" × 12" (23cm × 30cm), depending on the size mat and frame you choose. Sign the painting within this image area and then date the painting either next to your signature or on the back of the painting.

Painting With Three Colors

This demonstration will show you just how much you can do with a limited palette. We'll use only the three primary colors to mix all of the colors represented in this scene. You'll use the structural drawing from the first demonstration as you will have worked out the values.

You'll be layering washes of different colors, just as you layered washes of different values in the last demonstration. You'll also be working on the background, building and foreground in a cycle. Allow the paint to dry before adding a new wash so paint doesn't smear or bleed into other colors. You can use a hair dryer to speed up the process, but make sure you haven't left any puddles of water, which will spread around from the force of the air. You can lift puddles with a dry brush.

Materials

Paper

10" × 14" (25cm × 36cm) 140-lb. (300gsm) cold-pressed watercolor paper

Image Size for Matting and Framing 8" × 10" (20cm × 25cm)

Watercolors

Alizarin Crimson

Cadmium Yellow (professional-grade)

Prussian Blue

Brushes

no. 2 round

no. 6 round

no. 10 round

large bamboo

Other Supplies

color wheel

kneaded eraser

LESSONS/TECHNIQUES

- Understanding Value (Chapter 6)
- Understanding Color (Chapter 6)
- Mixing Paint and Handling Brushes (Chapter 7)
- Painting Wet-on-Dry (Chapter 7)
- Positive and Negative Painting (Chapter 7)

Tips

- Spend the extra money to buy professional-grade Cadmium Yellow. You'll be mixing a bright yellow-green, and the student-grade Cadmium Yellow will not do the job.
- The initial background and foreground washes are mixtures of Cadmium Yellow and Prussian Blue. As the washes get darker, add more blue. Add small amounts of Alizarin Crimson to the darkest washes to make the color more neutral and natural.
- To get a dark gray mixture, mix Cadmium Yellow, Alizarin Crimson and Prussian Blue. If it looks like one color is dominant in this mixture, add a bit of that color's complementary color to make it more neutral. For example, if the mixture looks too red, add green (yellow + blue). Then dilute the mixture with water until you get the right value of gray. Keep a color wheel close by to help control and mix your colors.
- If you are at all unsure about the color and value of a mixture you've created, try it out on a scrap piece of watercolor paper before using it in the painting. Watercolors don't allow do-overs like other mediums do.

1 Paint the Background

Make a few different yellow-green mixtures of light value from Cadmium Yellow and Prussian Blue. Apply washes of these mixtures to the background with a bamboo brush.

2 Paint the Building

Make a few different brown and gray mixtures of light value. Before you lay any paint down, plan which parts of the paper will be white so you can preserve the white of the paper for these areas. Refer to the monochromatic painting you just finished to help you plan. Apply washes of these mixtures for the stones, brick chimney and slate roof with a no. 10 round brush.

3 Paint the Foreground

Lay down light, yellow-green washes for the foreground shapes with a bamboo brush. Add more Cadmium Yellow to the mixture for the grass, and add more Prussian Blue for the ivy and shrubs.

4 Add Midtones to the Background
Add more Prussian Blue and a small amount of Alizarin Crimson to your yellow-green mixture. Remembering that your light source is coming from the upper left, lay down some darker washes with a no. 10 round brush.

5 Add Midtones to the Building
Make slightly darker brown and gray mixtures and paint over the lighter washes on the building with a no. 10 round. Leave some areas from the first layer of washes untouched. The building should now have three values: the white of the paper, the first layer of washes and some areas with the second wash layered on top of the first.

6 Add Midtones to the Foreground
Darken the ivy and shrubs with more green and add some slightly darker washes of yellow-green in the grass with a no. 10 round.

7 Add Darks

Add a few washes of a dark blue-green mixture to the background with a no. 10 round. To mix a dark blue-green, start with a regular green mixture—Cadmium Yellow and Prussian Blue. Add small amounts of blue. Mix the color thick and rich on the palette, adding one brush full of water at a time until it is a good consistency to work with. If your paints have dried too much for you to mix them before adding water, use fresh paint.

Layer darker gray and brown washes on the building, and paint dark areas like the window, door and shadow under the eaves with a no. 6 round. Add splashes of green to the foreground with a no. 6 round.

8 Add Details

Paint in the dark and light details with no. 2 and no. 6 round brushes. Erase unwanted pencil lines after the painting is completely dry. Don't forget to sign your name and date your painting!

The Gatehouse in Summer
watercolor on 140-lb. (300gsm) cold-pressed watercolor paper
8" × 10" (20cm × 25cm)

Positive Painting

Trees are beautiful to paint, and each one has its own character. A tree can add to the composition of an outdoor scene or stand alone in its own painting. This demonstration provides an easy, fun way to make graceful, interesting trees.

I chose to paint the trees void of leaves as stark silhouettes against a flaming sunset. I love to paint trees during all four seasons because each season seems to bring out a different aspect of trees. These trees are set in autumn. The analogous warm colors of the background contrast the stark, cold feeling of the tree. I also angled the wet-into-wet background strokes to add interest.

Tips

- The paper will need to be wet for steps 1 through 4. Make sure you have all of your supplies at hand, and be ready to work quickly.
- Use a large brush to apply the wet-into-wet washes to save time.
- After you've finished laying down your wet-into-wet washes and the paint has dried, you'll notice that the colors have become much more muted. After gaining some experience, you'll learn to anticipate and plan for these changes.
- Draw the trunks of the trees first, then all the large limbs, then the medium-size branches, then the smallest ones. This yields a more natural, pleasing composition. Placing the tree trunks to the side of the painting and overlapping the branches also aids the composition, creating interesting negative space and making the trees look more natural.

Materials

Paper
12" × 16" (30cm × 41cm) 300-lb. (640gsm) cold-pressed watercolor paper

Image Size for Matting and Framing
11" × 14" (28cm × 36cm)

Watercolors
Alizarin Crimson
Cadmium Orange
Cadmium Red
Cadmium Yellow (professional-grade)
Cerulean Blue
Prussian Blue

Brushes
no. 2 round
no. 6 round
no. 10 round
3-inch (76mm) hake
large bamboo brush

Other Supplies
2B pencil
kneaded eraser
spray bottle

LESSONS/TECHNIQUES

- Using Analogous Colors (Chapter 6)
- Planning Composition (Chapter 6)
- Painting Wet-Into-Wet (Chapter 7)
- Positive Painting (Chapter 7)

1 Begin the Background
Because you'll be painting the first four steps wet-into-wet, you'll need to work quickly before the paper or paint starts to dry. Make the following mixtures of paint and water before wetting your paper: Cadmium Yellow, Cadmium Orange, Cadmium Red and a purple mixture of Alizarin Crimson and Cerulean Blue.

Now wet down the paper with water from a spray bottle, and even it out with a 3-inch (76mm) hake brush so the paper is covered with an even sheen of water. Try to avoid puddles of water. Apply angled streaks of Cadmium Yellow with a 3-inch (76mm) hake brush.

2 Add Orange
Add Cadmium Orange with a 3-inch (76mm) hake brush using the same angled strokes. Once the colors have dried, notice how similar the orange and yellow appear. Colors are more vivid when the paint is wet. Keep that in mind as you paint.

3 Add Red
Add Cadmium Red.

4 Add Some Interest
Add the purple color that you mixed from Alizarin Crimson and Cerulean Blue with a 3-inch (76mm) hake brush. Then sit back and take a deep breath. You've finished the wet-into-wet part of the painting.

5 Draw the Trees
After the paint has dried, lightly draw the thickest parts of the trees. Sometimes it's hard to erase pencil lines after you lay a wash of paint over them, so it's easier to draw the structure of the tree over the background washes. Notice that each tree is thicker at the bottom and thinner at the top.

6 Add the Limbs
Add limbs, again making sure they taper as they grow away from the trunks.

7 Finish the Structural Drawing
Add the rest of the branches.

8 Paint the Smallest Branches
Paint the thinnest branches with a no. 2 round and a dark mixture of Prussian Blue and a slight amount of Alizarin Crimson.

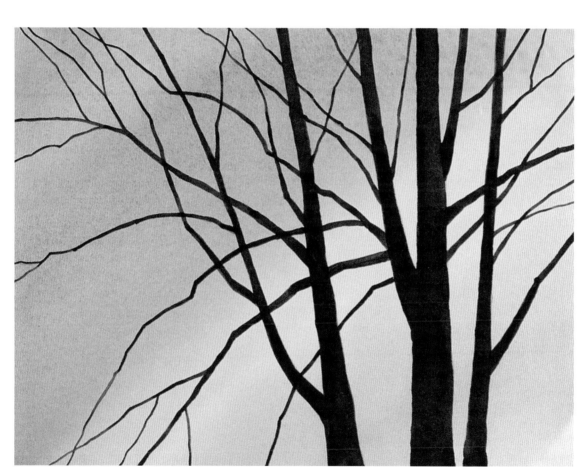

9 Finish the Trees
Paint the medium-size branches with a no. 6 round, the largest branches with a no. 10 round and the trunks with a bamboo brush. When the paint has dried completely, erase any visible pencil lines, and sign and date the painting.

Autumn Sunset
watercolor on 300-lb. (640gsm) cold-pressed watercolor paper
11" × 14" (28cm × 36cm)

Negative Painting

Painting around an object to imply its shape is a pleasant change of pace. If you enjoy doing this painting, try to incorporate negative painting into a composition of your own. Whether you use it in most of your paintings, some of them or just as a creativity exercise, negative painting enhances your composition skills and techniques. I used hot-pressed paper for this painting because the sharp, clean edges that result work well with the subject matter.

Remember: You don't need a bad attitude to produce a negative painting.

Tips

- For a beginner, negative painting can seem intimidating and time-consuming. To make this demonstration easier, I've made the image size half the size of the positive painting demonstration.
- This demonstration requires detail painting. Make sure you're using brushes that form good points.
- Practice dropping salt into wet washes on a scrap piece of paper before trying it on your painting. Dropping salt into paint that is too dry, too wet or too thick will have little effect. Be patient; the results may be most noticeable once the paint and salt are almost dry. But don't use a hair dryer to make this part of the painting dry more quickly. It will block the salt's effect.
- If you're painting over another color, let the paint dry before moving on to the next step. If you're not careful, the colors will bleed and you won't have a tree anymore!

Materials

Paper
7" × 10" (18cm × 25cm) 140-lb. (300gsm) hot-pressed watercolor paper

Image Size for Matting and Framing 5" × 7" (13cm × 18cm)

Watercolors
Burnt Sienna

Prussian Blue

Yellow Ochre

Brushes
no. 2 round

no. 6 round

no. 10 round

Other Supplies
2B pencil

kneaded eraser

table salt

LESSONS/TECHNIQUES

- Structural Drawing (Chapter 6)
- Understanding Color (Chapter 6)
- Understanding Color Temperature (Chapter 6)
- Mixing Paint and Handling Brushes (Chapter 7)
- Negative Painting (Chapter 7)
- Creating Texture (Chapter 7)

Avoid Large, Unbroken Spaces

Don't draw your trees like this. Instead, continue the branches beyond the image area. The branches on the left of this image end within the dimensions of the painting. I would have to paint the entire area on the left at once, which might leave unwanted lines if I paint over an area that already has started to dry. Instead, plan medium-size, easy-to-paint areas in the drawing stage. The drawing in step 1 provides an easier guide to follow as you lay paint down.

1 Draw the Structure

Draw the trees as you did in the previous demonstration, starting with the thickest parts and moving on to the thin, tapered branches.

2 Paint the Trees

Make separate pale mixtures of Prussian Blue, Burnt Sienna and Yellow Ochre. To make a pale mixture, touch the paint with the very tip of your brush and put the paint on the palette. Add enough water to make a good size puddle. With so much water and so little paint, the mixture should be a very light value. Paint the trees with a no. 6 round, starting with blue at the bottom, fading up to a warm, light brown, then to the Yellow Ochre and finally to the white of the paper. The trees should be mostly white with just a bit of color.

3 Begin the Background and Add Salt

Make a variegated mixture of Prussian Blue and Burnt Sienna on your palette so you can pick up a variety of these two colors as you paint. Wipe other puddles of color off your palette. Make a large, dark mixture of Burnt Sienna at the bottom and another large, dark mixture of Prussian Blue at the top of your palette and blend the two colors in the middle. Begin to paint in the background around the trees with no. 6 and no. 10 round brushes. Because the tree trunks will draw the viewer's attention to the right, balance the composition by concentrating the strongest contrasting values, especially the dark blue, on the left. You'll notice that the background uses darker values of the same colors used to accent the trees. After painting a few segments of the background, drop salt into the wet paint to add more texture.

4 Add Yellow Ochre to the Mix

To bring in some of the yellow from the trees, add Yellow Ochre to the middle of the variegated mixture on your palette and continue painting the background. Add salt as you go.

5 **Don't Rush**
Continue painting the background just a little at a time so you have control over the paint. Take your time adding salt to get the right effect. Don't rush yourself.

6 **Continue the Background**
Paint a few more pieces of the background and add salt.

7 Paint the Details
Once you've painted the bigger parts of the background, concentrate on the smaller, more detailed areas with a no. 2 round. Don't forget to keep adding salt.

8 Add Missing Pieces
Finish painting the background with no. 2 and no. 6 rounds as if you were adding the last few pieces of a jigsaw puzzle.

9 **Finish Up**
After I filled in the background and the paint dried, I stepped back to evaluate the painting. I decided to darken some of the background areas. When everything is dry, brush away the remaining salt and erase your pencil lines carefully. Sign and date your painting.

Winter Exposure
watercolor on 140-lb. (300gsm) hot-pressed watercolor paper
5" × 7" (13cm × 18cm)

Painting Flowers

You're going to get an extra drawing lesson here. You learned about linear perspective in Chapter 6. Perspective also applies to objects that don't have straight lines, such as the daisies in this demonstration.

To draw a circle in perspective, simply draw an ellipse. An ellipse is a circle viewed from an angle. Use ellipses for both the general shape of the daisy and for its center. The petals will point outward with a slight curve.

Tips

- Plan your painting well during the drawing stage. Don't draw each daisy as if you were looking at it head on. Vary the perspective and tilt of each flower.
- Add some thickness and bulk to the flower center to keep the flower from looking flat.

Materials

Paper
10" × 14" (25cm × 36cm) 140-lb. (300gsm) cold-pressed watercolor paper

Image Size for Matting and Framing 8" × 10" (20cm × 25cm)

Watercolors
Alizarin Crimson

Cadmium Orange

Cadmium Yellow (professional-grade)

Cerulean Blue

Hooker's Green

Prussian Blue

Yellow Ochre

Brushes
no. 6 round

no. 10 round

Other Supplies
2B pencil

kneaded eraser

LESSONS/TECHNIQUES

- Structural Drawing (Chapter 6)
- Drawing Linear Perspective (Chapter 6)
- Understanding Value (Chapter 6)
- Understanding Color (Chapter 6)
- Planning Composition (Chapter 6)
- Painting Wet-Into-Wet (Chapter 7)
- Painting Wet-on-Dry (Chapter 7)
- Positive and Negative Painting (Chapter 7)

Indicating Perspective

The circles at the bottom form the base shapes of a daisy from a head-on viewpoint. The image just above on the left represents a daisy barely leaning back. The top set of ellipses represents daisies tilted even farther back. The daisy at the top left is almost facing straight up.

Giving the Flower Form

You can make a daisy look convex or concave depending on where you place its center. If you place the center of the flower on its middle axis (1), the flower looks flat, although curving the petals at the ends does give the flower some form. If you place the center above the axis (2), the daisy looks convex. If you place the center below the axis (3), the daisy looks concave.

1 Draw the Structure

Draw the daisies at slightly varying angles. Leave some gaps between petals to add interest and a natural feel to the scene. Just roughly draw the leaves in the background. Then erase any lines that you no longer need. Once you've got the structural drawing down, you won't need the outline of each individual petal. On your watercolor paper, you might want to make your lines a bit darker than these. I realized too late that the lines for the background leaves were difficult to see after laying down my first wash of color.

Paint the Shadows

2 Mix Alizarin Crimson and Cerulean Blue to make purple and then add water to the mixture. Apply it to the shadow areas of the petals with a no. 10 round. While the paint is still wet, add a few touches of a mixture of Yellow Ochre and Cerulean Blue to parts of the shadow areas to add interest. The light source is shining from the upper left and slightly behind the flowers. There are also a few shadows on the bottoms of the flowers where the petals have curved down. Don't worry if the shadows look too dark. Once you paint the background, which will define the shapes of the flowers, the shadows won't appear nearly as dark. Also remember to leave the white of the paper for the white of the flowers.

Paint the Centers

3 Paint the flower centers with a no. 6 round brush and Cadmium Yellow. While the paint is still wet, drop in a small amount of Cadmium Orange and an even smaller amount of a mixture of Cadmium Orange and Hooker's Green in the middle and near the edge of each flower's center.

4 Paint Negative Shapes

Make puddles of the following mixtures or colors on your palette: Hooker's Green and Prussian Blue; Hooker's Green and Cadmium Yellow; Hooker's Green and Yellow Ochre; Cadmium Orange and Alizarin Crimson. Paint small, manageable sections of the background with a no. 10 round, taking paint from various puddles on the palette. Notice how the daisies have taken shape and that the shadows no longer look as dark.

Painting a background this large is easier if you concentrate on small portions at a time. I painted the background in stages. Don't worry about hard edges resulting from applications of wet paint over a drying background. You'll paint over these when you add details to the background. Sometimes I even drop water onto the drying paint to add texture.

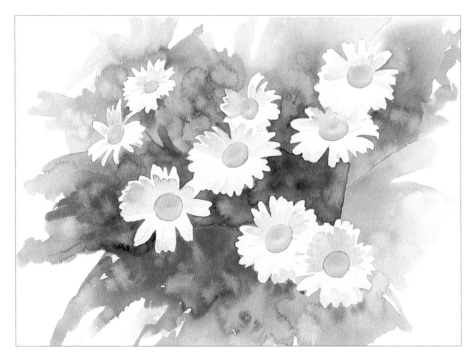

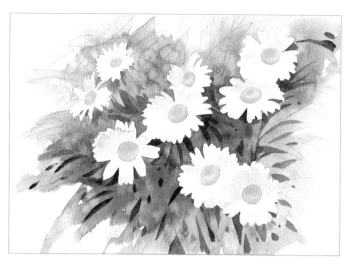

5 Define the Background

Define the leaves with a no. 6 round brush and a mixture of a light amount of Alizarin Crimson and equal amounts of Hooker's Green and Prussian Blue.

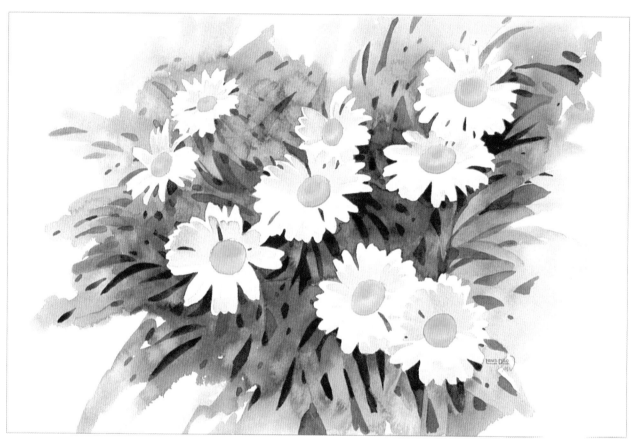

6 Finish Up

Finish the background, erase pencil lines and then sign and date your painting.

Shasta Parade
watercolor on 140-lb. (300gsm) cold-pressed watercolor paper
8" × 10" (20cm × 25cm)

Developing Composition

This painting's composition has three main elements: the sailboat, the house and the dinghy. The composition holds the viewer's interest because it has no elements placed directly in the center. This makes the composition seem random, though the placement of elements is actually well planned.

Tips

- Review the lesson on how to paint straight lines in Chapter 7 so you don't get frustrated; this painting has a lot of detail. If you take your time, this demonstration will reward you with a beautiful and impressive watercolor.
- To paint the sky, you may want to turn the picture upside down so the part you're painting is closest to you.

Materials

Paper

10" × 14" (25cm × 36cm) 140-lb. (300gsm) cold-pressed watercolor paper

Image Size for Matting and Framing 8" × 10" (20cm × 25cm)

Watercolors

Brown Madder

Hooker's Green

Prussian Blue

Yellow Ochre

Brushes

no. 2 round

no. 6 round

no. 10 round

1-inch (25mm) flat

3-inch (76mm) hake

large bamboo

Other Supplies

2B pencil

straightedge

LESSONS/TECHNIQUES

- Structural Drawing (Chapter 6)
- Measuring (Chapter 6)
- Understanding Value (Chapter 6)
- Painting Atmospheric Perspective (Chapter 6)
- Understanding Color (Chapter 6)
- Planning Composition (Chapter 6)
- Painting Wet-on-Dry (Chapter 7)
- Applying a Flat Wash (Chapter 7)
- Positive and Negative Painting (Chapter 7)
- Painting Straight Lines (Chapter 7)

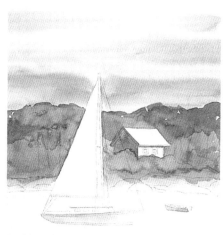

1 Draw the Structure
Draw, trace or transfer the image onto watercolor paper.

2 Paint the Sky
Wet the sky and any other area that you want to be blue with clear water and a 3-inch (76mm) hake brush. Add Prussian Blue to the wet areas with a 1-inch (25mm) flat. Paint the building, boat and dinghy's shadow areas with no. 6 and no. 10 round brushes and Prussian Blue. The paint will spread to any area where the paper is wet, so don't wet any area you don't want to be blue.

3 Paint the Shore
Paint the shoreline with Yellow Ochre and Brown Madder and a no. 10 round. Add the trees with mixtures of Yellow Ochre, Brown Madder, Hooker's Green and Prussian Blue.

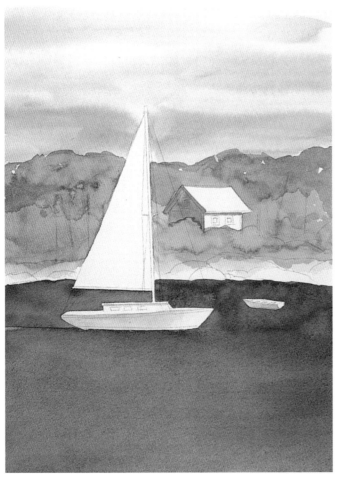

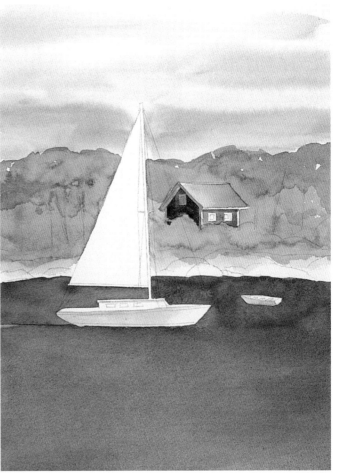

Paint the Water

4 Paint the water with Prussian Blue and a no. 10 round. Use a wet-on-dry technique and work quickly. Keep the edges active. Don't let the edge of a stroke dry before adding more paint and continuing to cover the water area. Start at the upper left, painting around the boat first. Then paint around the dinghy. Switch to a large bamboo brush and work across the picture from top to bottom. The point where you started painting the water probably will have started to dry, leaving a hard edge. In this part of the painting process, that's OK. It will look like wake from the sailboat, a little detail that indicates movement and makes the painting more interesting. If you accept watercolors for the way they behave, you'll come to appreciate the effects they produce and the creativity they allow.

Paint the Building

5 Paint the building and the roof with a no. 6 round and a mixture of Brown Madder and Prussian Blue, leaving the trim white.

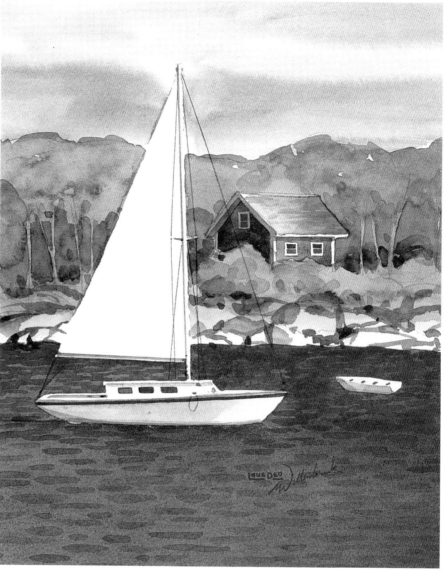

6 Add Details

Paint shadows in the trees and on the shore with a no. 10 round and mixtures of Prussian Blue, Brown Madder, Hooker's Green and Yellow Ochre. Indicate tree trunks with negative painting using a darker mixture than the trees in step 3.

7 Paint the Finishing Touches

Paint the waves with a no. 10 round and a mixture of Prussian Blue and Brown Madder. Start with small horizontal lines at the shore and use progressively longer, more spread out strokes as you get closer to the bottom of the picture.

Paint the windows on the building and boat with a no. 2 round and Prussian Blue. Emphasize the shadow and add some accents to the roof with Brown Madder and the same brush. Add some accents to the dinghy. Add accents to the sailboat and sail with Prussian Blue, Yellow Ochre and Brown Madder, using a straight edge and a no. 2 round to paint the straight lines. Paint the curved lines on the hull with a fluid motion by moving your arm at the elbow rather than at the wrist or fingers. Add some vague shadows on the sail with a light value of Prussian Blue to indicate some wind. Sign and date the painting and you're done!

Easy Going
watercolor on 140-lb. (300gsm) cold-pressed watercolor paper
10" × 8" (25cm × 20cm)

Using a Color Scheme

Pumpkins are good subject matter to paint when learning to use watercolors because they have relatively simple shapes. As my students have learned, pumpkins may not hold the beauty of roses, but they sure are a lot easier to paint! Starting simply is a valuable part of the learning process.

Tips

- Limiting your palette to just four colors and using each of these in almost each element will give your painting a feeling of continuity. Even if pumpkins are orange, that orange can have a little red, yellow and blue in it.
- Use all four colors to paint the two outer pumpkins. Leave Prussian Blue out of the mixture for the three center pumpkins until the shading stage. Because orange and blue are complements, adding blue to the predominantly orange pumpkin will make it dull. The center pumpkins will be brighter and more noticeable to the viewer's eye.
- Remember to plan and preserve white space and highlights. The light source is shining from the upper right.
- When mixing browns, use your color chart to help get the color right. If your mixture has a bit too much of one color, add a slight amount of its complement. For example, if your brown is too green, add red.

Materials

Paper
12" × 16" (30cm × 41cm) 300-lb. (640gsm) cold-pressed watercolor paper

Image Size for Matting and Framing 11" × 14" (28cm × 36cm)

Watercolors
Alizarin Crimson

Cadmium Orange

Cadmium Yellow (professional-grade)

Prussian Blue

Brushes
no. 6 round

no. 10 round

large bamboo

Other Supplies
2B pencil

kneaded eraser

LESSONS/TECHNIQUES

- Structural Drawing (Chapter 6)
- Measuring (Chapter 6)
- Drawing Linear Perspective (Chapter 6)
- Understanding Value (Chapter 6)
- Using Complementary and Analogous Colors (Chapter 6)
- Understanding Color Temperature (Chapter 6)
- Planning Composition (Chapter 6)
- Following the Painting Process (Chapter 6)
- Mixing Paint and Handling Brushes (Chapter 7)
- Painting Wet-into-Wet (Chapter 7)
- Painting Wet-on-Dry (Chapter 7)

1 Draw the Structure

Draw the basic shapes of your composition to work out the placement of your pumpkins. Vary the pumpkins' sizes and tilt some of them to create interest. Overlap them and make the pumpkins closest to the viewer appear lower in the scene. Even pumpkins have perspective! After adding the barrel and pumpkin stems, I decided my painting still needed a little something, so I added a few apples and some simple lines to indicate grass.

2 Begin to Paint Pumpkins

Draw or transfer the image onto watercolor paper. I changed the tilt of the pumpkin on the bottom left because I felt that it led the viewer's eye out of the painting. This small change will keep the viewer's eye within the frame of the picture. I decided to use orange and its analogous colors plus orange's complement, blue, for the color scheme.

Fill in the pumpkin on the left with a large bamboo brush and very wet, somewhat sloppy applications of Cadmium Orange. Painting wet-into-wet, drop in a mixture of Alizarin Crimson and Cadmium Yellow with a no. 6 round. Paint the stems with a brown mixture of Alizarin Crimson, Cadmium Orange, Cadmium Yellow and Prussian Blue.

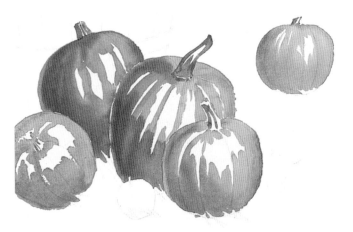

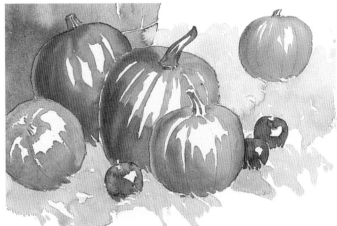

Continue Working on the Pumpkins

Paint the three center pumpkins with Cadmium Orange. Painting wet-into-wet, add some color from a mixture of Alizarin Crimson and Cadmium Yellow. Paint the pumpkin on the right the same way, adding a trace amount of Prussian Blue to the mixture. Remember to preserve the white of the paper for highlights. Paint the pumpkin stems with a brown mixture of Alizarin Crimson, Cadmium Orange, Cadmium Yellow and Prussian Blue.

Add Browns

Paint the barrel with a mixture of all four colors and a large bamboo brush. Paint the grass area a more neutral orange-green color with a mixture of Cadmium Orange, Cadmium Yellow, Prussian Blue and just a touch of Alizarin Crimson. Just suggest the grass, leaving lots of white space. Paint the apples with a no. 10 round and a mixture of all four colors, using mostly Alizarin Crimson.

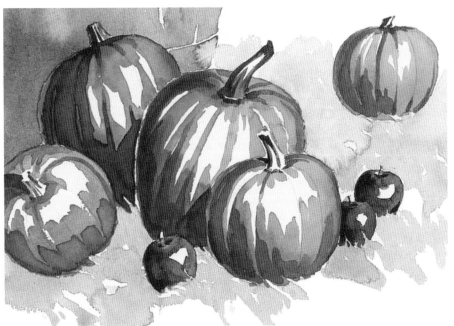

Add Shading

Add shading to the pumpkins to imply depth with a mixture of Alizarin Crimson, Cadmium Orange and Prussian Blue and a no. 6 or no. 10 round. Add shading to the apples with a mixture of all four colors, using predominantly Alizarin Crimson and a little more Prussian Blue than you used to paint them in step 4.

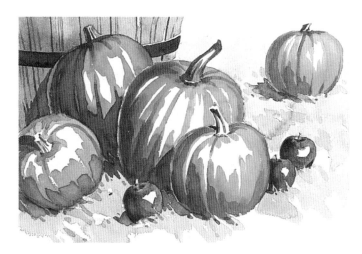

6 Add Details to Barrel

Paint the linework on the barrel with a darker brown mixture of all four colors and no. 6 and no. 10 round brushes. Add details and shading to the grass with a dark green mixture of all four colors, using mostly Prussian Blue. The blue will make the green color of the grass a bit deeper, creating cool shadows.

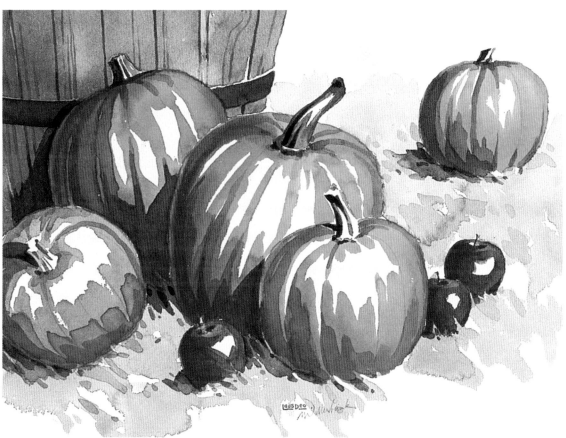

7 Add Finishing Touches

Add a darker wash over the barrel. Make the shadows on the pumpkins and apples darker with mixtures of Alizarin Crimson and Prussian Blue. Define the shadows in the grass with a darker version of the green mixture from step 6. Erase the pencil lines and sign and date your painting.

Fall Pumpkins
watercolor on 300-lb. (640gsm) cold-pressed watercolor paper
11" × 14" (28cm × 36cm)

Painting a Landscape

It's rewarding to transform a sheet of white paper into a chilly winter scene with just a few applications of paint. Perhaps you live in an area that never sees snow. Or maybe you'll end up wanting to try this demonstration in the summertime. If so, you obviously won't be able to observe snow outside your window. When your real-life options are limited, look for reference materials in books, magazines, calendars and greeting cards to help you understand how light reflects off snow and what the shadows look like.

These reference materials will remind you that, for instance, shadows on snow usually have a blue tint, and this information will help make your painting accurate. To add to the mood and feel of the painting, heat up some hot chocolate and put on some warm slippers. Once you've finished this demonstration, try painting your own winter scenes.

Tips

- Planning your white space for this painting will be even more important than for the last demonstration. You're going to use the white of your paper to represent the snow, which is a large part of this scene.
- The only times I use Cerulean Blue and Yellow Ochre in this painting are for the shadows in the evergreen trees and for a few finishing touches. I recommend a limited palette because using every color you have whenever you feel like it will make your color composition noisy. Instead, plan your color scheme before you start painting, occasionally adding a splash or two of interesting colors such as the Cerulean Blue and Yellow Ochre in this painting.

Materials

Paper
9" × 12" (23cm × 30cm) 140-lb. (300gsm) cold-pressed watercolor paper

Image Size for Matting and Framing
8" × 10" (20cm × 25cm)

Watercolors
Brown Madder

Cadmium Yellow (professional-grade)

Cerulean Blue

Prussian Blue

Yellow Ochre

Brushes
no. 2 round

no. 6 round

no. 10 round

Other Supplies
2B pencil

kneaded eraser

LESSONS/TECHNIQUES

- Structural Drawing (Chapter 6)
- Drawing Linear Perspective (Chapter 6)
- Understanding Value (Chapter 6)
- Painting Atmospheric Perspective (Chapter 6)
- Understanding Color Temperature (Chapter 6)
- Painting Wet-on-Dry (Chapter 7)
- Applying a Variegated Wash (Chapter 7)
- Positive and Negative Painting (Chapter 7)

1 Draw the Structures
Draw or transfer the image onto watercolor paper.

2 Paint the Sky
Paint the sky with a no. 10 round and a light wash of Prussian Blue. You'll paint the limbs later, but leave parts of them white now to indicate highlights and snow sitting on the branches.

3 Paint the Background
Paint the background hills with a no. 10 round and a mixture of Prussian Blue and Brown Madder. Remember to leave the trees white.

4. Add Interest

Paint the evergreen trees with a no. 10 round and a mixture of Prussian Blue, Cerulean Blue, Cadmium Yellow and Yellow Ochre. I decided to add two more evergreen trees on the right to balance the painting.

5. Paint the Tree Trunks

Paint some extra tree trunks in the distance with no. 2 and no. 6 round brushes and a mixture of Prussian Blue and Brown Madder. Make a relatively cool mixture that favors blue more than brown. Atmospheric perspective tells you that distant elements should be bluish gray with a neutral value, and the closer elements should have more intense color and contrast.

6 Paint the Bridge
Apply a variegated wash of Yellow Ochre, Brown Madder and a slight amount of Prussian Blue over the bridge with a no. 10 round. The bridge's color is warm, so it will appear closer than the cooler background.

7 Add the Details to Bridge
Add some character to the stones of the bridge with a no. 6 round and a mixture of Prussian Blue and Brown Madder. You can indicate texture without actually painting every stone.

8 Paint Shadows
Paint shadows in the foreground with a no. 6 round and Prussian Blue. Follow the contour lines of the snow as you paint.

9 Paint the Trees

Fill in the trees that you left white earlier. Use no. 2 and no. 6 round brushes and a mixture of Prussian Blue and Brown Madder to paint dark, broken lines, leaving light areas to imply sunlight and snow on the branches.

10 Add Accents

Add details to the bridge and paint the bushes with a no. 2 round and a mixture of Brown Madder and Prussian Blue. Add shadows to the evergreens with a no. 6 round and a mixture of Prussian Blue, Cerulean Blue, Brown Madder and Yellow Ochre.

11 Add Some Finishing Touches

Add whatever little touches you think will bring your painting together. I added light washes of Yellow Ochre on some parts of the background and over the bush in the foreground. When you're happy with the painting, erase extra pencil lines and sign and date your painting.

Snowy Stony Bridge
watercolor on 140-lb. (300gsm) cold-pressed watercolor paper
8" × 10" (20cm × 25cm)

Planning a Painting

What I really like about this painting's composition is the subtlety of the cat watching the bird in the tree. The viewer really has to look at the painting to get it, and then the viewer has the pleasure of an "ah ha!" moment. The viewer feels like she is sharing something with the artist. Adding little surprises to your compositions will keep your viewers on their toes.

Have fun with the challenge of painting a slightly more complicated scene. Do this demonstration more than once and see how much progress you make next time.

Materials

Paper
9" × 12" (23cm × 30cm) 140-lb. (300gsm) cold-pressed watercolor paper

Image Size for Matting and Framing 10" × 8" (25cm × 20cm)

Watercolors
Alizarin Crimson

Brown Madder

Burnt Sienna

Cadmium Orange

Cadmium Yellow (professional-grade)

Prussian Blue

Yellow Ochre

Brushes
no. 2 round

no. 6 round

no. 10 round

large bamboo

Other Supplies
2B pencil, kneaded eraser, references, salt, scraps of watercolor paper, sketch paper, straightedge

Tips

- Do thumbnail value and color sketches before you start on the actual painting to help you decide what will work best. Then use these materials for reference as you paint.
- The cat is the focal point of the composition, so I especially wanted it to look good. Before starting the actual painting, spend some time on a color sketch of the cat. You'll feel much more confident going into the painting.
- Some paint may spill onto the window frames as you paint. To fix this you can press firmly on the area with a rag to pull up the wet paint. If the paint is still noticeable, scrape the paper with a craft knife after it dries. Scraping to correct paint spills works here because the frames will remain white. Be careful when scraping an area over which you'll apply more paint later. The area will be rough and the paint may not lie right.
- Don't base your success on a comparison between your results and my painting. You can look at my example for pointers and tips, but your painting doesn't have to look like mine to be interesting and successful.

LESSONS/TECHNIQUES

- Structural Drawing (Chapter 6)
- Understanding Value (Chapter 6)
- Understanding Color (Chapter 6)
- Understanding Color Temperature (Chapter 6)
- Planning Composition (Chapter 6)
- Following the Painting Process (Chapter 6)
- Painting Wet-Into-Wet (Chapter 7)
- Painting Wet-on-Dry (Chapter 7)
- Applying a Flat Wash (Chapter 7)
- Positive and Negative Painting (Chapter 7)
- Painting Straight Lines (Chapter 7)
- Creating Texture (Chapter 7)

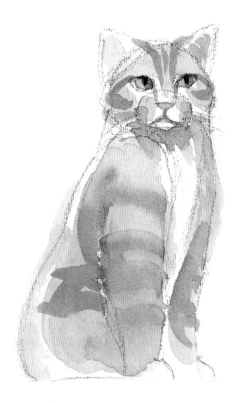

1 **Gather References**
Planning ahead will help answer questions that could arise while you're painting. I gather reference material from books, magazines and photographs. In this case, I looked for references of cats, birds, windows, trees and shrubs. It's extremely helpful to sketch the subject or other elements before putting them into your painting.

2 **Do Preliminary Sketches**
Draw small, quick thumbnail value sketches on sketch paper to work out values and your composition. I decided to use the third sketch. I like the size and arrangement of elements.

3 Draw Color Sketches

On scraps of watercolor paper I redrew the thumbnail sketch as a structural drawing without indicating values. Then I applied a few different color schemes, following the value pattern I had established. I like the second sketch best, though the color composition of the third is also pleasing.

4 Paint the Windowpanes

Paint the windowpanes around the cat and window frames with a no. 10 round and Prussian Blue. Make the value gradate as you move up the window. The easiest way is to lay multiple washes as you move up until each windowpane is the value you want. Remember to let each wash dry completely before laying down the next one.

5 **Paint the Bricks**
Lay a variegated wash of Brown Madder, Burnt Sienna, Prussian Blue and Yellow Ochre over the bricks with a large bamboo brush. While the paint is still wet, add salt for texture. Wipe off the remaining salt after the painting has dried.

6 **Add Accents**
Lay second washes over individual bricks with a no. 6 round brush, taking colors from different parts of the variegated mixture from step 5 for different bricks. You don't have to paint every brick. Let some of the original wash show to provide variety. Remember to paint around the mortar between the bricks.

7 **Paint the Shutter**
Apply a mixture of Brown Madder and Burnt Sienna over the shutter with a no. 10 round. If you want, leave some white space to indicate highlights. Make sure you paint straight lines. Paint the shutter in portions so it will seem less intimidating. A straightedge will help you paint straight lines.

Paint the Cat

8 Add shadows to the shutter with no. 2 and no. 6 rounds and a mixture of Brown Madder and Prussian Blue. Remember that the light source is shining from the upper left. Paint the cat with a wash of Yellow Ochre, Cadmium Orange and Brown Madder and no. 6 and no. 10 rounds. Make sure to leave the window frames white. Apply a darker value of this mixture wet-into-wet to paint the cat's stripes.

Darken the Stripes

9 Let the previous step dry. Make the cat's stripes more noticeable by applying washes of clear water followed by washes of Burnt Sienna, using a no. 10 round. This wet-into-wet technique will soften the edges of the stripes so they look more like fur.

10 Add Details

Paint the cat's eyes with a mixture of Yellow Ochre, Cadmium Yellow and Burnt Sienna and a no. 2 round. Leave a small amount of white space to indicate highlights on the eyes. Paint the nose and mouth with a mixture of Alizarin Crimson and Yellow Ochre and a no. 2 round. Use the same mixture to paint the ears with a no. 6 round. Add shadows and define the facial features with the same colors and no. 2 and no. 6 rounds.

11 Add the Silhouette

Paint the silhouette reflection on the window with a no. 6 round brush and a mixture of Prussian Blue and Brown Madder. Start with the bird to make sure you get the proportion and placement right. Add shadows to the window frames and sill. Don't forget the shadows on the cat from the window frames. Erase extra pencil lines, and sign and date another successful painting.

Window Shopping
watercolor on 140-lb. (300gsm) cold-pressed watercolor paper
10" × 8" (25cm × 20cm)

Painting a Still Life

The shapes of these objects will provide a good challenge to sharpen your drawing skills and to observe how the surfaces interact with each other, with the light source and with the shadows. You might want to find some shiny metal and glass objects to set up your own still life. Study how these objects reflect the light. The metal surface reflects the objects around it while distorting their shapes. Notice how the colors of the objects behind glass come through. In the structural drawing I indicated which areas to leave untouched by paint. This kind of planning will help you paint the shine on the glass so it indicates the outline of the bottle. The matte finish of the books doesn't react with surrounding objects the same way as shiny objects, but this contrast makes the painting more interesting. I chose to paint the background with a dark color to contrast the light urn and the reflections from the glass.

Tips

- Avoid tangents, like placing the candlestick at the side of the urn so their edges share a line. Centering the candlestick on the urn also would have looked unnatural. Instead, I placed the candlestick about a third of the way down from the edge of the urn to make a pleasing composition.
- For your structural drawing, draw the highlights the same as you would draw any other object or element. This will help you preserve the white of the paper for these areas.
- To enhance depth, use warm, aggressive colors in the foreground and cool, recessive colors in the background.

Materials

Paper
10" × 14" (25cm × 36cm) 140-lb. (300gsm) cold-pressed watercolor paper

Image Size for Matting and Framing 8" × 10" (20cm × 25cm)

Watercolors
Brown Madder
Burnt Sienna
Cadmium Orange
Cadmium Yellow (professional-grade)
Prussian Blue
Yellow Ochre

Brushes
no. 6 round
no. 10 round
large bamboo

Other Supplies
2B pencil

LESSONS/TECHNIQUES

- Structural Drawing (Chapter 6)
- Drawing Linear Perspective (Chapter 6)
- Understanding Value (Chapter 6)
- Painting Atmospheric Perspective (Chapter 6)
- Understanding Color Temperature (Chapter 6)
- Planning Composition (Chapter 6)

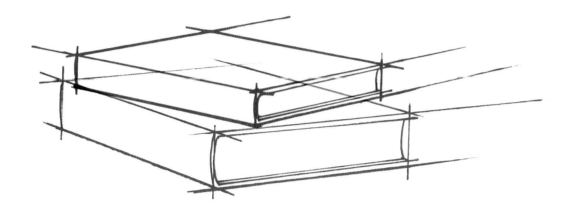

Observe Each Object Separately
Think of the books as two simple boxes, each box with its own perspective.

Two Two-Point Perspectives
Each book is drawn in two-point perspective, and each has its own vanishing points to make a total of four. All four still fall on the horizon.

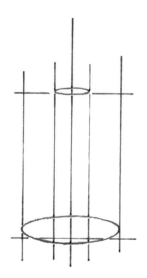

Draw Symmetrical Objects
This method for drawing a symmetrical candlestick works for all symmetrical objects. Draw a vertical line to serve as the center of your subject. Draw two horizontal lines to serve as the top and bottom of your subject.

Draw Widths
Draw two more vertical lines equidistant from the centerline to denote the width of the base of the candlestick. Draw another pair of vertical lines to show the width of the top of the candlestick. Draw ellipses for the base and top of the candlestick.

Add to the Form
Draw circles and ovals around the centerline to add form.

Finish the Contour
Join the circles and ovals and add the candle to finish the drawing.

 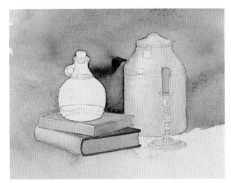

1 Paint the Urn

Draw the still life onto watercolor paper. Paint the urn on the right with a mixture of Yellow Ochre, Burnt Sienna, Brown Madder and Prussian Blue and a no. 10 round. As you draw the highlights and paint around them, remember that the light source is shining from the upper left.

2 Paint the Candlestick and the Background

Paint the candlestick with a mixture of Yellow Ochre, Cadmium Yellow and Cadmium Orange and a no. 6 round. Add a small amount of Burnt Sienna to the mixture to paint the dark areas. Preserve highlight areas on the candlestick. I also left a thin white line between the candlestick and the urn to help define the candlestick's shape. Once the candlestick has dried, paint the candle with a mixture of Prussian Blue and Yellow Ochre and a no. 6 round. I also left a thin line of white around the candle.

Paint in the background using a variegated mixture of Prussian Blue, Brown Madder and Burnt Sienna. Use a large bamboo brush for the big areas and a no. 10 round for the smaller areas.

3 Paint the Books

Paint the sides of the books with a no. 10 round. Paint the bottom book with a mixture of Brown Madder, Burnt Sienna and Prussian Blue. Paint the top book with a mixture of Yellow Ochre, Brown Madder, Burnt Sienna and Prussian Blue. Because the light source is coming from the upper left, the right sides of the books are in shadow, so the mixtures for these sides should be darker and cooler, with more Prussian Blue. When these areas have dried, paint the covers of the books with darker versions of the same mixtures and a no. 6 round.

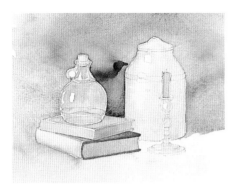 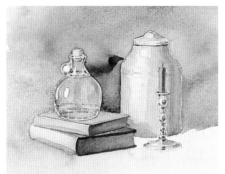 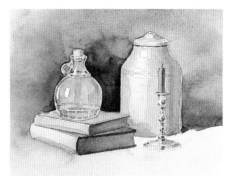

4 Paint the Glass

Paint the background behind the bottle with a no. 10 round. Look for the highlights as you paint. Paint the book underneath the bottle and the cork the same color as the rest of the book with a no. 6 round. Also use this color to add the books' shadow on the urn. Leave a line of white around the edges of the bottle to help define its form.

5 Add Additional Washes

To add more detail and form, add darker washes of the original mixtures to parts of each element. Accent the urn with a no. 10 round, using a no. 6 round for the dark lines. Accent the candle, candlestick and the wick with a no. 6 round. Add accents to the books with no. 6 and no. 10 rounds. Paint details and add more washes to the bottle with a no. 6 round. Darker washes on the bottle will help the highlights stand out and make it look more like glass.

6 Add Washes to the Background

Paint more washes over the background with a large bamboo brush and a no. 10 round. Darken the areas around the subject matter to create contrast.

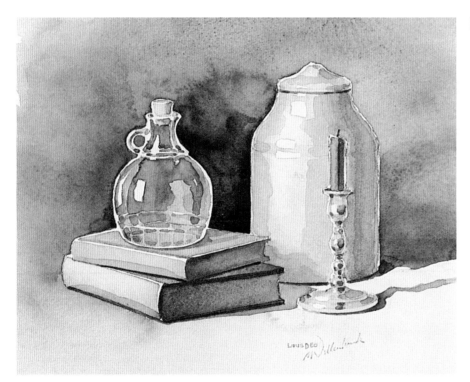

7 Add Finishing Touches

Add the shadows of the books, glass and candlestick, and add details like the dark lines underneath the urn and books to better define their shapes. Add any other washes you think you need. I needed to darken the part of the background that you can see through the bottle. Sign and date your painting and take a step back to admire it!

Relics
watercolor on 140-lb. (300gsm) cold-pressed watercolor paper
8" × 10" (20cm × 25cm)

Painting a Still Life With Vegetables

The makings of a great salad are also the makings of a great still life. These subjects are easily available and fun to draw. Try getting your own vegetables and fruits and setting them up exactly as I have on the next page, putting the light source on the right. Drawing and painting from your own three-dimensional still life will teach you so much more than painting from a two-dimensional picture in a book. This demonstration also will give you insight into the difference between painting dull surfaces and painting glossy surfaces. Bon appétit!

Tips

- Again avoid tangents and make sure you draw the highlight areas in your structural drawing.
- I highly recommend setting up your own still life and painting from it, using the steps in this demonstration as a guide as you paint your own. The point of a still life is to observe what's in front of you, really taking the time to see what's going on with light, color and composition. Painting from your own still life will provide you with this experience much more than painting from this book can.
- You'll paint each vegetable with layers of washes to get the desired impact and value, so don't worry if it looks too washed out at first.

Materials

Paper

10" × 14" (25cm × 36cm) 140-lb. (300gsm) cold-pressed watercolor paper

Image Size for Matting and Framing 8" × 10" (20cm × 25cm)

Watercolors

Alizarin Crimson

Burnt Sienna

Cadmium Orange

Cadmium Red

Cadmium Yellow (professional-grade)

Hooker's Green

Prussian Blue

Brushes

no. 6 round

no. 10 round

Other Supplies

2B pencil, cabbage, carrots, cauliflower, eggplant, orange pepper, red pepper, yellow pepper

LESSONS/TECHNIQUES

- Structural Drawing (Chapter 6)
- Understanding Color (Chapter 6)
- Planning Composition (Chapter 6)

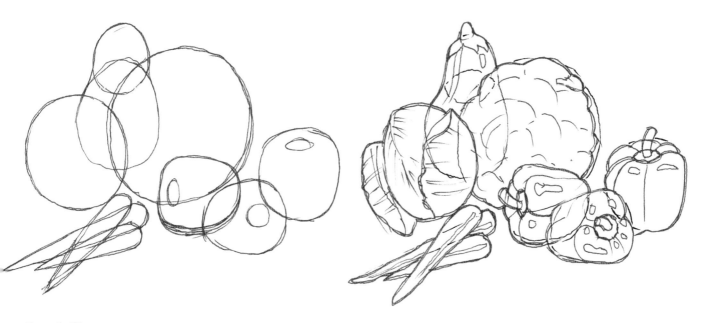

Draw in Stages

Sketch all of the basic shapes first (left) and then sketch in the details (right). Drawing in the details will include reworking a lot of the lines of the basic shapes, but starting with the basic shapes ensures a sound overall composition and accurate proportions and shapes for the vegetables.

1 Draw the Structure
Draw or transfer the image onto watercolor paper.

2 Paint the Yellow Pepper
Paint the yellow pepper with a predominantly yellow mixture of Cadmium Yellow, Cadmium Red and Cadmium Orange and a no. 10 round. Paint around the highlight areas, which are essential to communicate the glossy surface of the pepper.

Paint Reds and Oranges

3 Paint the red pepper with a mixture of Alizarin Crimson, Cadmium Red and Cadmium Orange. Leave just a hairline of white between the yellow and red peppers. If the paint of both is still wet, the colors will bleed into each other a bit. This effect only occurs in watercolors, and it's one of the qualities that makes the medium so popular and fun to work with. When the painting is finished, the bleed will look like a red reflection on the yellow pepper.

Paint the orange pepper and carrots with a mixture of Cadmium Red and Cadmium Orange and a no. 10 round. Paint both with the same mixture, simply watering down the mixture to make a lighter value for the carrots.

Paint the Remaining Vegetables

4 Paint the cauliflower with a mixture of Cadmium Yellow and slight amounts of Hooker's Green and Burnt Sienna and a no. 10 round. Follow its contours with your brushstrokes, leaving highlight areas untouched. Paint the cabbage with a mixture of Hooker's Green, Cadmium Yellow and a slight amount of Alizarin Crimson. The surface of cabbage isn't glossy, so I didn't leave any highlights. The cauliflower was still wet when I painted the cabbage, so I let the green bleed into the cauliflower. The color will make a good shadow on the cauliflower. When the cabbage and cauliflower dry, paint the eggplant with a deep purple mixture of Alizarin Crimson, Prussian Blue and a slight amount of Hooker's Green.

Add Greens

5 When the paint from step 4 dries, use no. 6 and no. 10 round brushes to paint washes of green over the stems and greenery with a mixture of Hooker's Green, Cadmium Yellow and a slight amount of Alizarin Crimson. While you're working with this green mixture, add some washes to the cabbage.

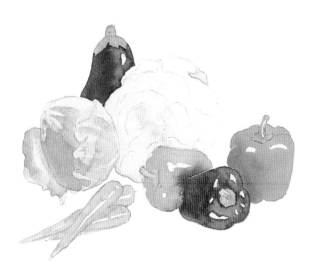

6 Add More Color

Paint additional washes on the carrots and orange and yellow peppers with a mixture of Alizarin Crimson, Cadmium Red, Cadmium Orange, Cadmium Yellow and some Prussian Blue to darken it. Paint the darkest parts of the red pepper with a mixture of Alizarin Crimson and Prussian Blue. When the cabbage and yellow pepper dry, paint the shadow on the cauliflower with a no. 10 round and a mixture of Hooker's Green, Prussian Blue and Alizarin Crimson.

7 Shade the Greens

Add more washes of green over the cabbage and the greenery on the other vegetables with a no. 10 round and a mixture of Hooker's Green, Prussian Blue, Alizarin Crimson and Cadmium Yellow.

8 Add Shading

Add shadows on and under each vegetable, especially on the green areas with a mixture of Prussian Blue, Alizarin Crimson and Hooker's Green. Add some shading on the eggplant with the same mixture. Use a lighter value of this mixture to define the cabbage's shadow on the cauliflower. At this point I considered adding color to the background to define the shape of the cauliflower. Instead, I added a small leaf on its lower right to frame it. This detail and the similar color of the shadows and the eggplant really help bring the composition together. Sign and date your painting.

Fresh Produce
watercolor on 140-lb. (300gsm) cold-pressed water-color paper
8" × 10" (20cm × 25cm)

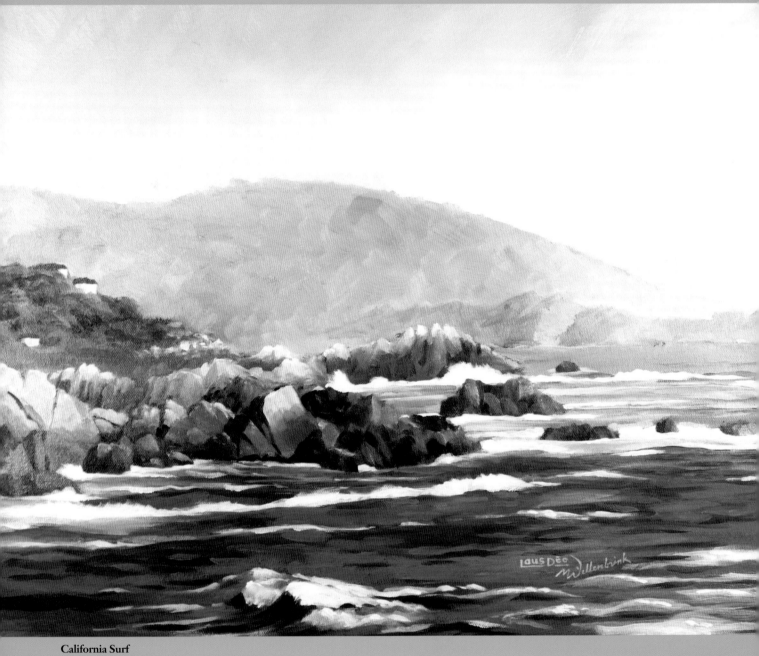

California Surf
oil on stretched canvas
16" × 20" (41cm × 51cm)

Part 3 **Oil Painting**

9 Gather the **Materials**

Oil paintings have a timeless quality. They are durable and fun to work with. There's nothing like mixing the smooth, buttery consistency of the paints on your palette until you have just the right colors for your painting. Whatever the project, you need the right tools to accomplish your task. This chapter will explore the many painting supplies available and will help you find the right supplies for an enjoyable and successful painting experience.

North Point Light
oil on stretched canvas
14" × 11" (36cm × 28cm)

Paints

A variety of oil paints is available on the market. The differences among them can affect performance, price and even your health.

Oil Paint 101

Oil paint is made from a combination of pigment (the color) and oil (the binder). Some paints have wax or filler additives. Years ago, pigments consisted mostly of natural substances. Now, most contemporary paints use synthetic pigments, which are cheaper to produce and have better lightfastness (resistance to fading). Linseed oil is commonly used as the binder, though other oils, such as safflower, sunflower, poppy or walnut oil, may be used. Some pigments, such as cadmium, may be toxic. Follow the manufacturer's guidelines and warnings.

Traditional vs. Water-Soluble Paints

Most traditional oil paints require turpentine or mineral spirits to thin the paints and clean the brushes. The smell of these solvents can be overpowering, and contact or inhalation is a health hazard, even with the "odorless" types. There is also the issue of how to dispose of used solvents. What happens if you dump that stuff down a drain?

Water-soluble (water-mixable) oil paints are made of pigment and oil like traditional oil paints, but the oil has been chemically modified to allow the paints to dissolve in water instead of in smelly, toxic solvents. With the performance of water-soluble oils matching that of traditional oils, more people will be free to work with oils who were previously unable to because of health concerns.

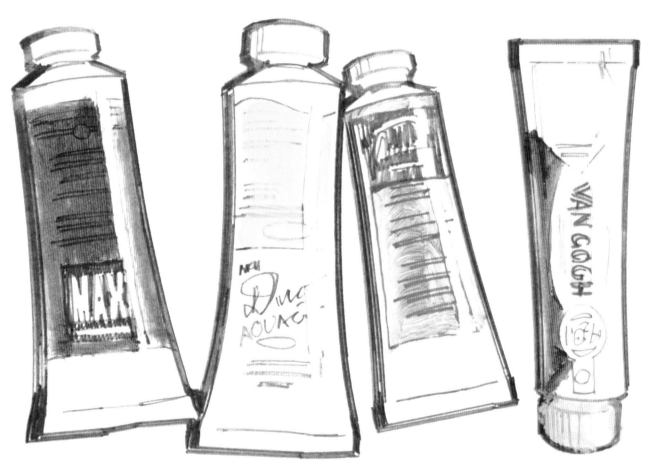

Go Green!
Water-soluble paint brands include Max Grumbacher, Holbein Duo Aqua Oil, Winsor & Newton Artisan and Van Gogh H2Oil.

Grade

Oil paints are available in student grade or professional (also known as artist) grade. Student-grade paints are less expensive, but professional paints contain more pigment and have more intense colors.

Lightfastness

You've probably seen an old poster that has faded so that only the blue and black colors remain. Reds and yellows are more prone to fading, especially if left in direct sunlight. Manufacturers often rate the degree of lightfastness, the resistance to fading, on the paint tube.

Tip

If you want a good palette but are price conscious, you might consider purchasing professional-grade paints for the brighter colors and student-grade paints for the neutral colors.

Professional or Student Grade
The professional-grade Winsor & Newton Permanent Rose on the left is slightly brighter and more pure in color than the student-grade Van Gogh H2Oil Quinacridone Rose on the right.

Weird But True!

All sorts of materials have been ground for use as pigments for paints, many of which have been replaced by synthetic pigments. Some of the more unusual substances include semiprecious stones, mummies and dried urine from cows fed on mango leaves.

Solvents and Thinners

Solvents and thinners are liquids used to thin and dissolve paint. Artists add them to the paints during the painting process to thin the paints and also to release the paint from the brushes and clean the palette.

Mediums

Mediums are liquids or gels that can be added to the paint to change its characteristics. Depending on the medium used, they can speed up or slow down the drying time, improve the flow, affect the consistency and increase the gloss and transparency of the paint.

For a quick study, a painting completed in a few hours, it may not be necessary to add medium to your paint as you work. For longer studies, during which the paint might begin to dry, add a slight amount of medium to the paint so that each layer has more oil (medium) than the previous layer. This technique is called "fat over lean." The first layers of applied paint should dry sooner than the later layers of paint. This decreases the risk of cracking and flaking over time.

Some artists prefer to make their own mediums by combining oils, solvents and varnishes. However, creating the perfect balance can be tricky. If you add too much oil, the paint may discolor. If you add too much solvent, the paint may become too lean. Adding varnish may make the paint tacky and hard to rework. Mixing varnish with the paint may also cause some of the paint to be removed if the painting is cleaned at a later date. I prefer using premade mediums and recommend them for more consistent results.

Hazardous to Your Health

The most common solvents or thinners for traditional oils are turpentine (distilled tree resin) and mineral spirits (distilled petroleum). Even the odorless types of these solvents pose health hazards with contact and inhalation. They are also flammable.

Water-soluble oil paints dissolve in water and don't require hazardous solvents, so toxic fumes are no longer an issue. Water can be used to thin water-soluble paints, but paint manufacturers also sell thinners for these paints. These thinners have a consistency that is slightly thicker than water and can improve the flow of the paint. Brushes used with water-soluble paint can be cleaned with soap and water. Commercially made brush cleaner can also be used to thoroughly clean the brushes.

Solvents/Thinners and Mediums
Solvents/thinners and mediums are available for both traditional oil paints and water-soluble paints. Water-soluble paints do not require any solvent/thinner except water.

Palettes

Palettes are used for holding and mixing paints and are usually made of a thin piece of wood or plastic. They come in a variety of shapes and sizes. Ideally, a palette should be large enough for mixing and holding lots of paint but not so big that it feels awkward and cumbersome. (I usually hold the palette in my hand as I paint.) Many travel easels, such as French easels, include a rectangular wooden palette that fits neatly within the closed box unit.

Oil paints aren't reusable once they have dried on the palette. To clean the palette, scrape off the old paint with a palette knife and wipe it off with a rag before each painting session.

Palette pads are a disposable alternative to regular palettes. The pad is made of thick, coated white paper. After your painting session, you can tear off the top sheet and discard it along with the old paint. Palette pads are available in rectangular- and oval-shaped pads and have a thumb hole so they can be held like traditional palettes.

Palette Cups

Palette cups are small reservoirs that attach to a palette to hold solvents, thinners and mediums. You may not need palette cups since you can use the solvent (or water) contained in the brush wash as thinner, and most of our demonstrations can be completed in one session and thus won't require medium (medium is used when layering new paint on top of dried paint).

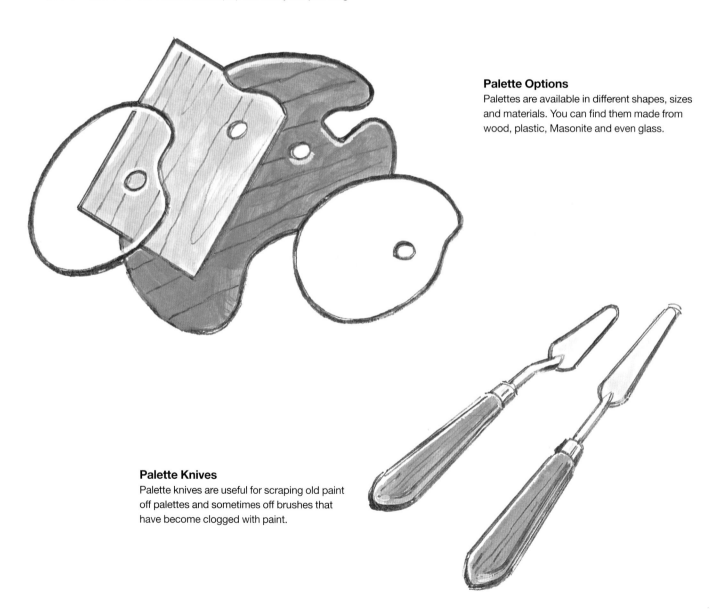

Palette Options
Palettes are available in different shapes, sizes and materials. You can find them made from wood, plastic, Masonite and even glass.

Palette Knives
Palette knives are useful for scraping old paint off palettes and sometimes off brushes that have become clogged with paint.

Palette Pads

Palette pads offer easy cleanup. Just tear off and throw away the top sheet when you're finished with your painting session.

Holding the Palette

It's typical to stand while oil painting, holding the palette in one hand. Because I paint with my right hand, I hold the palette with my left hand, thumb through the hole and cradled on my left arm. Avoid getting paint on your arm or sleeve by keeping the paint away from the lower edge of the palette.

Palette Cups

Palette cups are available in metal or plastic, with or without lids. The lids protect the fluid from dust until your next painting session. You can buy single or twin cups. If using twin cups, labeling the cups will help you avoid confusing the solvent/thinner and the medium. The palette cups can also be clipped on the side of your easel.

Surfaces

There are many options when it comes to painting surfaces, also called supports. The surface you choose depends on your preference and desired results.

Stretched canvas is the most common oil painting surface. This type of canvas is stretched across a frame of stretcher bars (the wooden pieces that the canvas is attached to). For large canvases, it's good to have strong, sturdy stretcher bars. Canvas is available in cotton or linen. While cotton is less expensive, it may not remain as taut as linen over time. There is also a range of different textures. The smoothness of a fine-weave canvas works best for delicate paintings such as a detailed portrait, while the coarseness of a rough-weave canvas is best for paintings that require thick layers of paint.

Manufactured stretch canvases usually come primed and are ready for the artist to begin oil painting. Stretched canvases are recommended for large paintings because they are relatively lightweight for their size.

Masonite and plywood panels are available primed and ready to use, or you can make your own. Relatively inexpensive, these panels are good for smaller paintings.

Masonite and plywood panels can also be bought with canvas glued to one side. These panels provide the genuine canvas texture along with the rigidness of Masonite or plywood board.

Cradled Masonite and plywood panels have a wood frame on the back. The wood frame "cradles" the panel, making it sturdier and less prone to warping.

Canvas-wrapped panels are made of Masonite, plywood or cardboard, and are wrapped with a primed canvas. They are similar to panels with canvas glued to one side. However, if the core is made of cardboard, the panel may swell and warp over time.

Canvas pads are sheets of primed canvas in pad form. These sheets are especially good for practice sessions. Just cut the sheet to the size you want and use bulldog clamps to attach the canvas to a Masonite board.

Make Your Own

You can make your own painting surfaces from 1/8-inch (3mm) Masonite or 1/4-inch (6mm) birch plywood panels. First, sand the surface with sandpaper. This will roughen the surface so that the gesso will adhere. Then apply three coats of gesso, painting the first coat side to side, the second coat up and down, then the third coat side to side. This will mimic the texture of canvas. You can also apply gesso in an irregular pattern to create an uneven surface texture. Covering the back of the panel with gesso will help prevent warping.

Applying Gesso to Unprimed Canvas

Using an ordinary house paint brush, apply two or three coats of gesso, alternating your strokes with each coat for your desired effect. Follow the manufacturer's instructions on the gesso container.

Adding Wedges to Tighten a Canvas

If a canvas appears loose, insert wooden corner wedges into the inside corner slots of the stretcher bars. This may be done long after a painting is completed to tighten a stretched canvas that is loose and saggy.

Gesso
No matter the type, all unprimed surfaces need to be coated with gesso. Otherwise, the paint may not hold up over time. Gesso is a liquid or gel that can be painted onto the surface with a house paint brush. Acrylic gesso primer works with oil paints and is easy to clean off brushes. Gesso is usually white, but it's also available clear or colored.

Stretching Canvas

MINI-DEMONSTRATION

Though it can be costly, some artists prefer to stretch their own canvases. By stretching the canvas themselves, they have control over the type of canvas, the stretcher bars and the application of the gesso.

Materials

Supplies
4 stretcher bars, canvas, canvas pliers, staple gun with staples

Optional Supplies
gesso, house paint brush, wedges

1 Assemble the Stretcher Bars and Cut the Canvas
Fit together the four stretcher bars. Make sure the distance between diagonal corners is equal to ensure that it's perfectly aligned.

Lay the canvas facedown on a clean surface. Place the stretcher bars front side down onto the canvas, lining up the weave of the canvas with the stretcher bars. Cut the canvas 3–4 inches (8–10cm) beyond the sides of the stretcher bars.

2 Attach the Top and Bottom of the Canvas to the Stretcher Bars
Fold the top of the canvas over the top stretcher bar and staple it into the center of the stretcher bar.

Fold the bottom end of the canvas over the bottom stretcher bar. Pull it taut with the canvas pliers and staple into the center of the stretcher bar. Don't overstretch. Unprimed canvas will shrink after you apply the gesso.

3 Attach the Left and Right Sides and Continue Stapling
Using a single staple for each side, repeat this process to attach the left and right sides of the canvas to the stretcher bars.

While pulling the canvas with the pliers, staple 2 inches (5cm) to the left and to the right of the top center staple. Repeat with the bottom and sides. Continue stapling in this fashion, two at a time at each side, stopping 3 inches (8cm) from the corners.

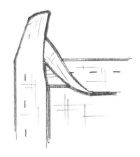

4 Fold and Staple the Canvas Corners
Fold and staple the canvas at the top left corner. Smooth out the canvas on the side bar. Pull the canvas taut and staple once near the corner.

5 Make a Double Fold
Make a double fold with the canvas at the top left corner.

6 Flatten the Canvas and Staple
Press the canvas flat and staple to finish the top left corner.

7 Repeat to Finish the Corners
Repeat steps 4–6 for the three remaining corners so that the folds at the opposite corners mirror each other for a nice, symmetrical appearance.

Brushes

Oil painting brushes are available in a variety of shapes, sizes and hair types. It's good to have a range of brushes. During the painting process, you'll usually use the largest brushes first, then the smaller brushes, working your way to the smallest brush for your final details.

Brush Shapes

Flats have a wide, flat set of hairs that are squared at the end. These range from large house painting brushes for putting down lots of paint to much smaller brushes for chiseling in details. Flat brushes with short, stubby hairs are also referred to as brights. These brushes are stiffer and hold less paint.

Filberts are similar to flats, but their ends are rounded and may come to a point. The brushstrokes made by filberts tend to be less harsh than those of flat brushes. I paint primarily with filberts.

Rounds have a round body of hairs that come to a point. I use these brushes mostly for details.

Riggers (also called scripts or liners) are like round brushes, but they have long, slender hairs for making long brushstrokes. They're useful for signing your paintings.

Hair Types

Brush hairs affect the way paint applies to the painting surface. Two common types of hair are coarse bristle and fine hair.

Coarse bristle brushes are made of hog hair and are durable and easy to clean. Their firmness and ability to hold lots of thick paint allow for vigorous, textural brushstrokes. For this book, you will mainly want to use coarse bristle brushes.

Fine hair brushes are made of natural sable hairs, synthetic hairs or a combination of the two. Their soft hairs provide smooth painting results and are good for thin paint applications, detail work and signing your paintings.

Hair Length

Short-haired brushes are stiffer than their long-haired counterparts. Long-haired brushes are good for holding more paint.

Handle Length

Long-handled brushes are good for standing back from the painting to make loose, quick strokes. Short-handled brushes are useful for closer, more detailed painting.

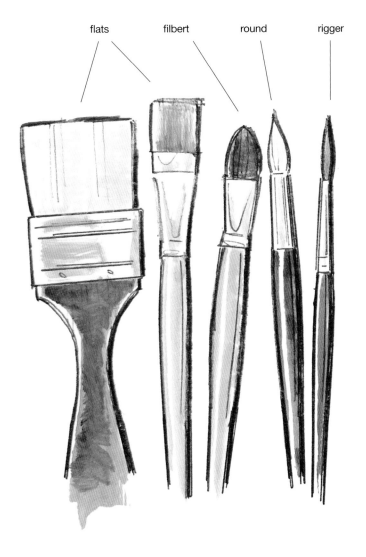

flats filbert round rigger

Choosing a Good Brush

Good brushes are firm, yet have spring so that they return to their original shape. Expensive brushes are nice but aren't always necessary. You can compile an assortment of less-expensive brushes that are just as well suited for your painting experience. However, avoid inferior brushes with hairs that fall out, fray or lose their shape. Aside from following personal recommendations, the only way to find inexpensive, good-quality brushes is through trial and error.

Brush Care and Use

Even the best brushes can fall apart and lose their shape if not maintained properly. Clean brushes thoroughly after each painting session so that they keep their shape and springiness. If the paint dries on them, it will make the bristles too stiff and unmanageable. Furthermore, you may never be able to revive the brush to its earlier condition and it could be ruined. While you want to clean the brushes thoroughly, be as gentle as possible, especially with sable and synthetic brushes. Bristle brushes are more durable and can accept rougher treatment. As you paint, you'll need to clean your brushes when you switch colors. Wipe the brush on a rag or paper towel to remove most of the paint, then use a brush wash to release any remaining paint.

Tip

Never leave a brush standing on its hairs in a jar of solvent. This will eventually bend the tip into an unusable shape.

Using a Brush Wash

You can clean your paint brush by swishing it back and forth in solvent contained in a brush wash. Of course, if you are using the preferred water-soluble oils, water is used as the solvent. Brush washes have a metal screen or coil above the bottom of the jar so that the released paint settles to the bottom below the screen or coil. Dragging the brush along the screen/coil releases more paint from the brush.

When you are finished painting with your brushes for the day, clean them by hand with brush cleaner and reshape the hairs to their intended form. Brushes can be stored standing tip up or flat on their sides.

Brush Washes

Metal brush washes come in different sizes and are good for travel. Glass brush washes are small and can be used in the studio. Both come with lids and a metal screen or coil.

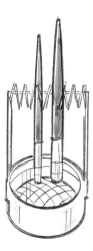

Brush Wash With Spiral Brush Holder

This type of brush wash allows brushes to hang upside down in the solvent without resting the hairs on the bottom of the jar. However, don't leave brushes in that position for too long because the fluid could work up to the wood handle, causing damage.

Storing Brushes

A bamboo brush holder allows brushes to dry from underneath even while lying on their sides. You can also roll your brushes up in this holder to protect them in storage or in transit.

Additional Supplies

Here are a few additional supplies I recommend for your oil painting sessions. You may not need all of these supplies for every demonstration. Before you start, check the materials list to make sure you have everything you need for a successful painting experience.

Palette Knives

Palette knives usually consist of a metal blade attached to a wooden handle. Though the handles are all about the same size and shape, the blades vary in shape, length and flexibility. Palette knives are useful for mixing paint and scraping paint off the palette. Sometimes artists even paint with them. I like to have a few different shapes on hand. Short, firm blades are good for cleaning the palette. Long, flexible blades are good for applying paint.

Rags and Paper Towels

Rags and paper towels can be used to clean brushes and for general cleanup.

Graphite and Charcoal Pencils

Some artists draw the image on the painting surface with graphite or charcoal pencils before applying paint.

Kneaded Eraser

This eraser doesn't crumble or streak like other erasers and can be used to erase unwanted pencil or charcoal lines.

Spray Fixative

If you draw with graphite or charcoal on the painting surface, fixative will keep the graphite or charcoal from smearing when you begin to paint.

Varnish

Varnish is a transparent liquid used to protect the painting and give it an even finish. Allow paintings to dry completely (six months to one year) before applying varnish. As always, follow the manufacturer's recommendations for proper use.

Mahlstick

A mahlstick, a metal or wood stick with a leather-covered cork at one end, is used as a hand rest to steady the painting hand. To use this tool, place the cork end on the edge of the painting surface, then rest your brush hand on the stick to keep it steady as you paint. This tool can be helpful for painting straight lines.

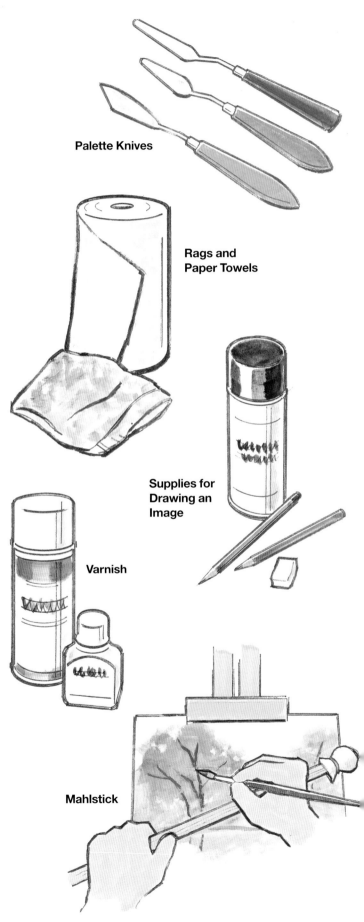

Palette Knives

Rags and Paper Towels

Supplies for Drawing an Image

Varnish

Mahlstick

Easels

Traditionally, artists stand while oil painting so they have freedom in their movements and a better view of their work. Easels securely hold paintings at the proper height and angle for this painting position. Easels vary in size and are generally constructed of wood or metal. Some easels are intended specifically for field use. Read on for descriptions of specific easel types.

Wooden Student Easel

Although this economical easel looks adequate, you may be disappointed if you use it. Flimsy and lacking a top brace to hold the painting, this easel is not very practical.

Studio Easel

Intended for indoor use, these wood or metal easels range in sturdiness and simplicity of design. The most expensive can tilt and move the position of the painting surface, even accommodating more than one painting.

Field Easel

Field easels are lightweight and portable for outdoor use. The metal telescopic legs are similar in design to those of a camera tripod.

French Easel

The versatile French easel doubles as a carrying case for painting supplies, including a palette. Intended for outdoor painting, it can also be used indoors.

Table Easels

For use on a table, the box type is similar to a French easel but without legs. The table easel is sturdy and has a top brace to hold the painting in place.

Indoor Setup

Start simple and add the furnishings for a comfortable work environment that suits your personal painting preferences.

During the painting process, I continually pick up, put down and clean my brushes. I find it most practical to place the brushes I'm working with flat on the work surface so I can identify and keep track of them. The brush holder keeps them from rolling and allows them to dry.

Because I am right-handed, I keep most of my equipment on my right side. The painting surface works best when it is placed at eye level, with the reference photos attached to the easel or nearby for easy viewing. Though a taboret (a portable cabinet) is nice to have, a table at a comfortable height and storage shelves are sufficient. During a painting session, I may stand for hours at a time. The floor mat makes the experience more comfortable on the feet.

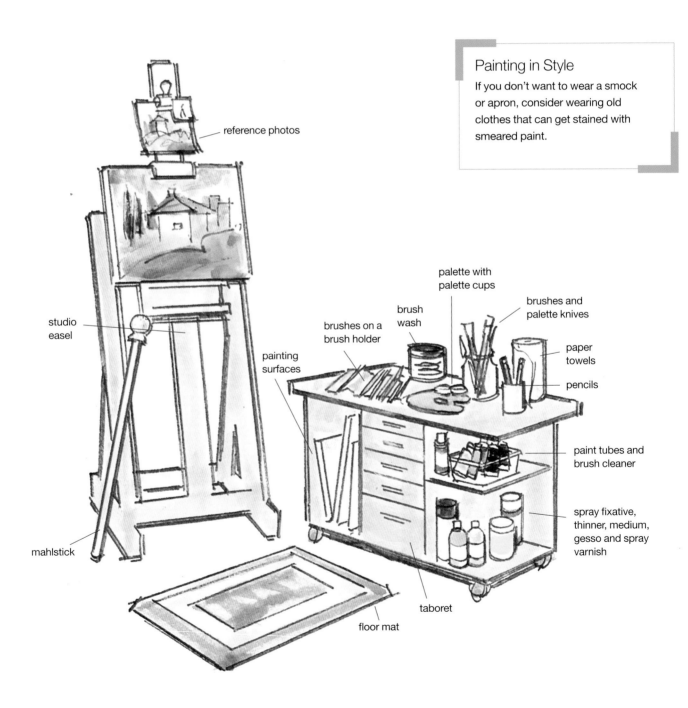

reference photos

Painting in Style
If you don't want to wear a smock or apron, consider wearing old clothes that can get stained with smeared paint.

studio easel

painting surfaces

brushes on a brush holder

brush wash

palette with palette cups

brushes and palette knives

paper towels

pencils

paint tubes and brush cleaner

spray fixative, thinner, medium, gesso and spray varnish

mahlstick

taboret

floor mat

Outdoor Setup

Painting outdoors (*en plein air*) is a great experience because it sharpens observational skills. When packing your supplies to carry to your site, a French easel can carry almost everything needed, including the painting surface and palette. French easels come in different sizes with optional accessories including paper towel holder, shelves and even an umbrella. Use a convenient tote bag or carrying case if you do not have a French easel.

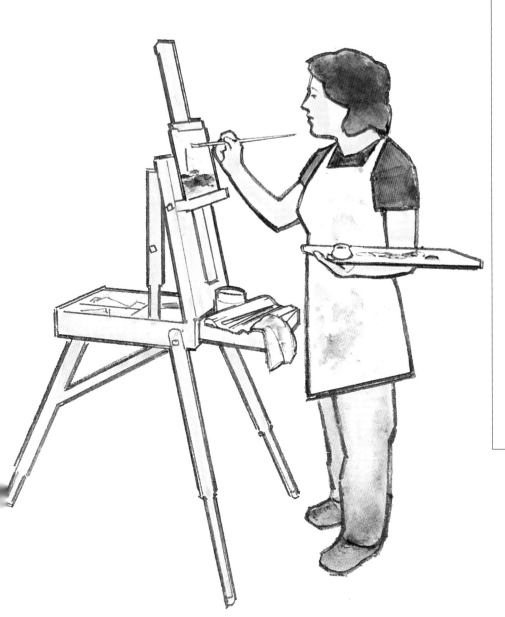

Outdoor Painting Supplies for Water-Soluble Oils

Many of these supplies can fit within a French easel.

Basic Supplies

paints

palette (usually included with French easel)

palette cup with thinner

painting surface

brushes

bamboo brush holder

brush wash with water

palette knife

rag or paper towels

Optional Supplies

extra water for brush wash

water to drink

mahlstick

sketchbook

pencils

camera

folding stool

smock or apron

Optional Easel Accessories

paper towel holder

umbrella

shelves

Discussing Materials

As you paint, you will likely develop a preference for a specific painting surface. Here are examples of oil paint on three different painting surfaces.

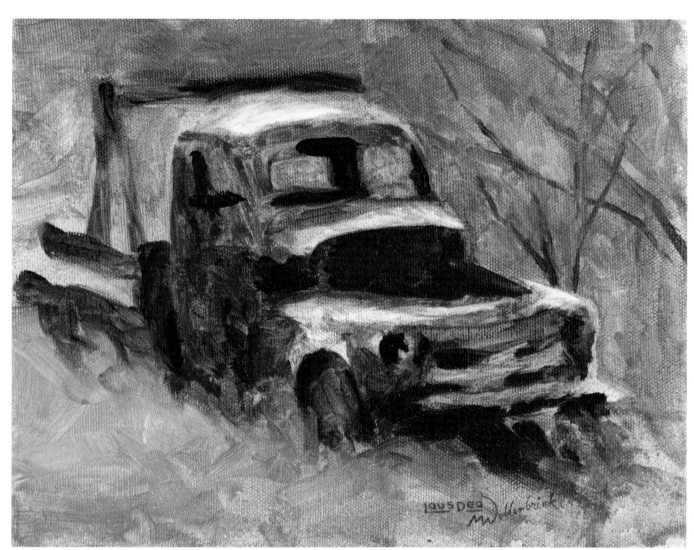

Retirement
oil on stretched canvas
8" × 10" (20cm × 25cm)

Stretched Canvas
Stretched canvas is lightweight and flexible. The drumlike surface makes for a springy feel. It may seem more difficult to control the brush on this giving surface than on a solid support surface. Stretched canvas paintings take up more storage space than paintings done on board.

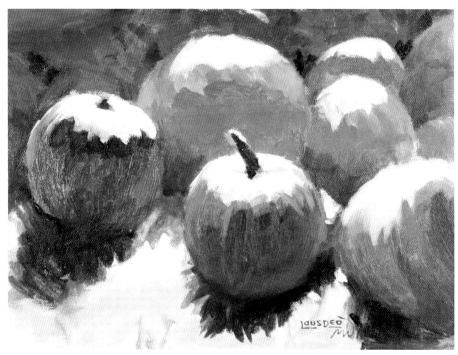

Sunrise Pumpkins
oil on canvas mounted on board
8" × 10" (20cm × 25cm)

Canvas Mounted on Board

This surface offers the texture of canvas with the solid support of plywood or Masonite. The coarse surface is good for gripping the paint for textural effects. This takes less room for storage than stretched canvas.

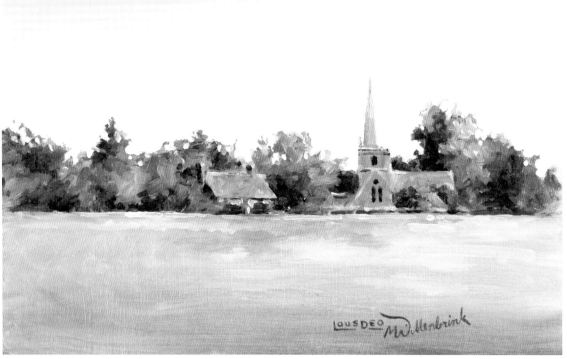

Brockham Green
oil on board
9" × 12" (23cm × 30cm)

Board Coated With Gesso

Plywood or Masonite can be coated with two or three coats of gesso and used as a painting surface. Depending on the application of gesso, the surface can be very smooth or have an assortment of textures. A smooth surface can work well for more detailed painting.

10 Learn the
Basics

Developing great compositions is as simple as understanding structure, value and color. With the information in this chapter, you will be on your way to composing successful oil paintings. Structural drawing will help you to understand drawing, form and linear perspective. You will learn about lights, darks and shadows and atmospheric perspective in the values section, and color relationships and temperature in the color section. Work through the mini-demonstrations in this chapter so that the concepts become a natural part of your painting experience. If you are working on a painting and it seems like something is just a bit off, you will probably find the solution in these pages.

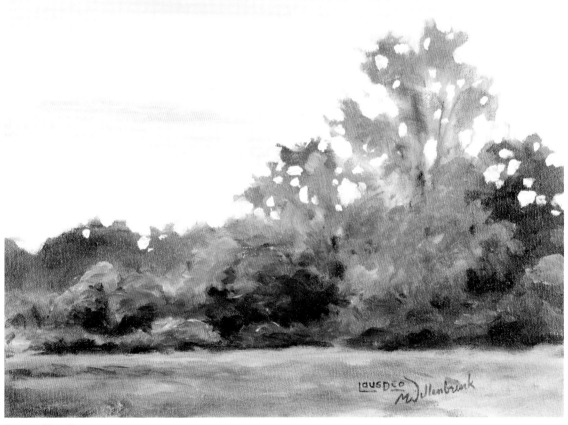

Approaching Sunset
oil on canvas mounted on board
9" × 12" (23cm × 30cm)

Structural Drawing

MINI-DEMONSTRATION

Drawing involves observing a subject and visually interpreting it. *Structural drawing* is reducing the subject to its basic shapes without shading. Drawing is the foundation for most art, so the principles you learn through drawing can be carried over into other forms of art. The more confident you are with drawing, the more confident you will be when you paint.

Materials

Surface
drawing pad or sketchbook

Other Supplies
2B pencil, kneaded eraser

Look for the Basic Shapes
Observe the big basic shapes, such as circles, squares and triangles, that are evident in the structure of the subject.

1 Start Big
Start by drawing the biggest, most obvious basic shapes.

2 Add the Smaller Shapes
Progressively add smaller shapes to fill in the subject.

Draw! Draw! Draw!

The simplest way to improve your drawing skills is to do it. Sketching on a regular basis, just 5–10 minutes at a time, will help you develop your drawing skills through active observation.

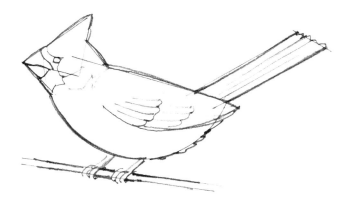

3 Add Details
Add the details to the basic structural shapes and develop the overall form of your subject.

Measuring and Proportioning

Using correct proportions makes your art believable. Use a pencil, brush handle or sewing gauge to observe and compare the proportions of the elements in your drawing. For more precise measurements, use a ruler or dividers when working from photo reference.

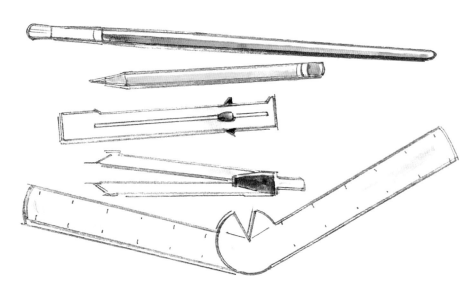

Observational Tools

Tools used for observing proportions of a subject can be as simple as a brush or a pencil. Other tools include a sewing gauge, dividers and an angle ruler, which can be used bent or straight.

Proportioning a Subject

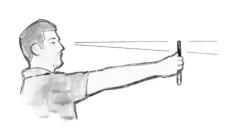

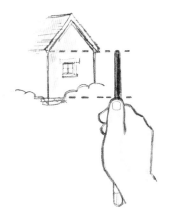

Proportioning From a Distance

When proportioning a subject from a distance, hold your arm straight out to measure the subject with a brush handle, pencil or sewing gauge, using the top of your thumb as your stopping point. Don't bend your arm at the elbow because this may affect your measurements.

1 Measure the Subject

To proportion the front of a building, observe the height with a pencil in hand, placing the top of the pencil at the top corner of the building. Move your thumb so that it lines up with the bottom of the building.

2 Compare Similar Measurements

Without moving the placement of your thumb on the pencil, reposition the pencil horizontally across the building front.

With this example, the front of the building has the same height as width. This information can be used when working out the proportions of the artwork.

Observing Aligned Elements

When drawing or painting, it is necessary to determine where the elements are in relation to each other. The placement of the elements of a subject may align them with other elements. These observations can be carried over into the execution of the artwork.

Aligned Building Features
In this sketch, the dome is aligned with part of the tower.

Aligned Steps
Notice how the corners of the steps are aligned.

Transferring Angles

Angles in artwork can be reproduced through observation and careful plotting.

1 **Dot to Plot**
With a rigid wrist, align the tool with the angle of the subject; then, keeping it at that angle, hold it over the painting surface. Place two dots, one at the beginning and one at the end of the angle line, to plot its placement.

2 **Check and Connect**
To check accuracy, compare the angle of the subject to the dots on your paper. Adjust as necessary. Connect the dots to complete the angle.

Linear Perspective

Depth and distance can be implied in art through the use of perspective. *Linear perspective* uses lines and size variation of objects to make a two-dimensional image appear three-dimensional.

Inherent to linear perspective are parallel lines that converge at one or more vanishing points on the horizon line. The vantage point (where the scene appears to be viewed from) is affected by these elements and their placement in the scene.

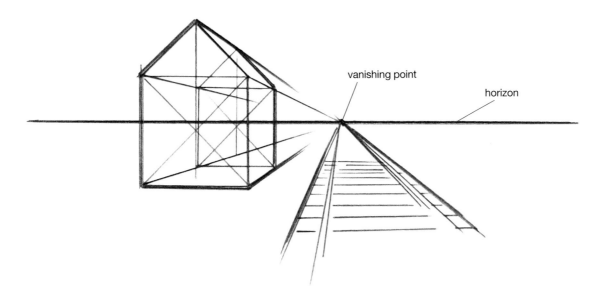

vanishing point

horizon

One-Point Perspective

As the name suggests, *one-point perspective* is linear perspective that uses only one vanishing point. Looking down a long, straight stretch of railroad tracks is a great way to examine one-point perspective (just stay clear of any oncoming trains!). Notice how the tracks and any lines parallel to the tracks visually converge at a vanishing point resting on the horizon. Objects of similar size appear smaller in the distance.

Gaining Perspective

Linear perspective wasn't fully understood until the Renaissance, when artists intentionally sought to comprehend it better.

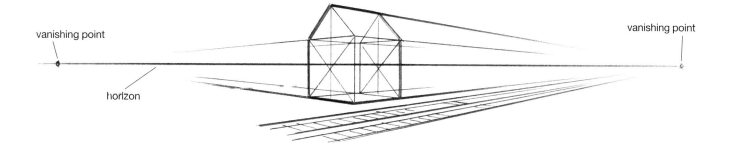

vanishing point

horizon

vanishing point

Two-Point Perspective

Perhaps more common than one-point perspective, *two-point perspective* uses two vanishing points and works with the same principles as one-point perspective. This scene of the corner of a building is a clear example of two-point perspective.

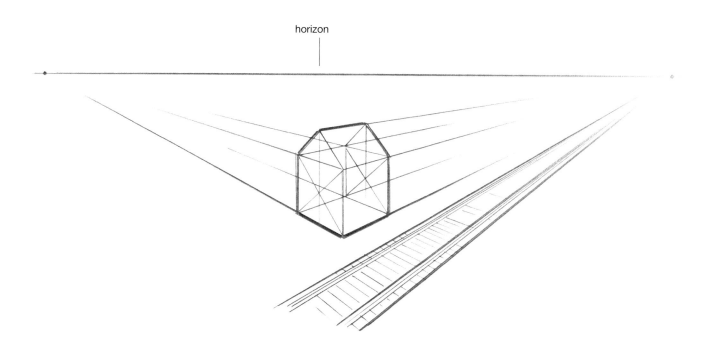

horizon

Horizon Placement

The placement of the horizon will affect the vantage point. If the horizon is placed high in the scene, the vantage point will look as if it is from above.

Vanishing Point Placement

The distance separating vanishing points can affect how close a subject appears to be in your artwork.

Value

Value is the relative lightness or darkness of a color. The lights and darks of a scene are referred to as values. Shadows, shading and the play of contrasting values make an image identifiable and give depth by expressing form.

Contrast

Value differences make *contrast*. The greater the difference in the color values, the greater the contrast.

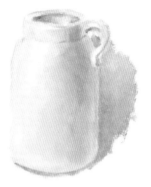

Using Low Contrast
Using similar values creates a muted, low-contrast painting.

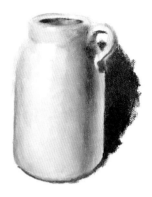

Using High Contrast
Using values of higher contrast adds more depth and drama to the subject.

Light Source

The placement of the light source affects the values of a scene. By changing the direction of the light source, you will change a subject's lights, darks and shadows in ways that may be subtle or dramatic.

Light Source From the Upper Left
With the light shining on the front of the building from the left, the building's shadow falls to the back right.

Light Source From Above
With the light shining from above at a slight angle, the building creates a small shadow.

Light Source From Behind, on the Right
Shining from the sky above the building on the right, the light source creates a shadow coming forward and darkening the walls of the building.

Atmospheric Perspective

Atmospheric perspective (also referred to as *aerial perspective*) implies depth by means of differing values. As elements are more distant, they become muted in value and less defined. The color of the distant objects may become more bluish gray.

Fading Into the Distance
Depth can be enhanced by use of atmospheric perspective. The use of values causes the mountains to seem to fade into the distance.

Rods and Cones

Our eyes have over 100 million light-sensitive cells, designated as rods and cones. Rods are more abundant and they register lights and darks to distinguish form and shape. Cones comprehend color (red, blue and green) and sharp details.

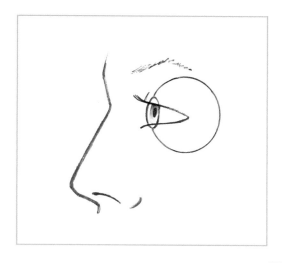

Using a Value Scale

A *value scale* is a tool that shows a range of values, from light to dark. It is used during painting to compare the values of a scene to those of the painting. You can buy a value scale or make your own by painting different values of a dark color on a piece of primed cardboard or canvas and trimming it to size. The holes punched through the scale allow you to isolate, identify and match the value of the subject with the value of the painting.

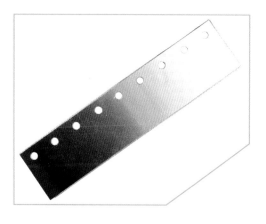

Color Basics

Choosing and mixing the right colors for your paintings is easy once you have simple tools to work with such as a color wheel.

red red-violet

red-orange

violet

orange

blue-violet

yellow-orange

blue

yellow

blue-green

yellow-green green

Using a Color Wheel
A color wheel is helpful for choosing and mixing the right colors for your compositions. Make your own or buy a printed color wheel, which includes helpful tips and color options.

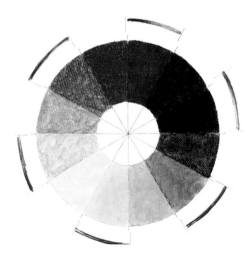

Primary Colors
Of the colors we perceive, the basic colors are red, yellow and blue. All other colors are made from these three primary colors. The colors I used in making this color wheel are Lemon Yellow, Permanent Rose and Phthalo Blue (Red Shade).

Secondary Colors
Combining two primary colors creates a secondary color. Orange, purple and green are the three secondary colors.

Tertiary Colors
Combining a primary color with an adjacent secondary color creates a tertiary color.

Complementary and Analogous Colors

Complementary colors are colors that are directly opposite each other on the color wheel. Mixing any combination of complementary colors will create a neutral gray-brown color.

Analogous colors are a group of colors that are near each other on the color wheel. Because they are all similar in origin, they will keep their bright, pure appearance when used together.

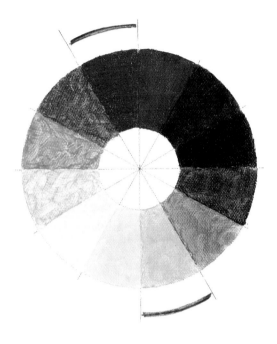

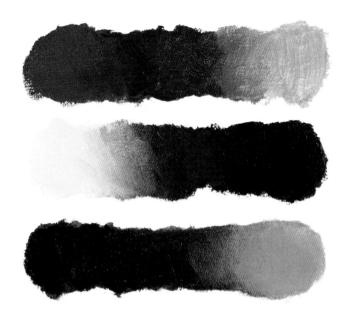

Complementary Colors
Any two colors that are directly opposite each other on the color wheel are complementary. Notice that any two complementary colors are derived from all three primary colors.

Combining Complementary Colors
Combining complementary colors results in neutral colors. If you are in a painting session and you want to make one of your colors muted, just add a little of its complement.

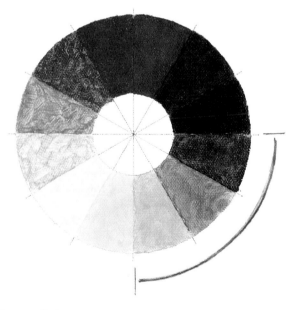

Analogous Colors
A group of analogous colors makes up about a quarter of a color wheel.

Red, Blue and Green
While red, blue and yellow are the three primary colors of reflected surfaces, such as paintings and print material, red, blue and green are the primary colors in light, such as found when light is refracted by a prism.

Color Temperature

Colors can be thought of as warm or cool. Yellows, oranges and reds are warm colors, while greens, blues and purples are cool colors.

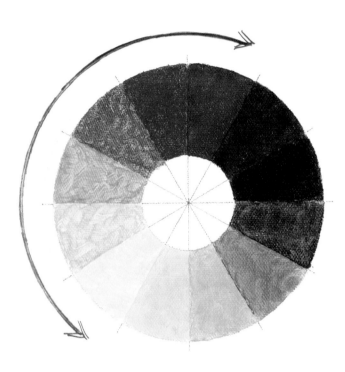

Warm Colors Advance
Yellow, orange and red objects tend to appear as if they are coming forward.

Cool Colors Recede
Green, blue and purple objects tend to appear as if they are receding.

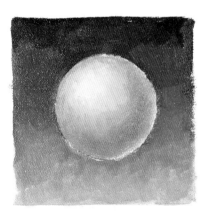
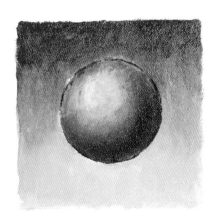

Creating Depth by Using Color Temperature
Warm and cool colors can be used to enhance depth in a scene. The orange ball in the painting on the far left appears to come forward from the background, while the painting on the near left makes the placement of the ball harder to comprehend. The blue ball appears smaller in a background that is bright and advancing.

Color Intensity

Intensity, also referred to as *saturation*, is the potency of a color. Color in its purest form, without white, black or any other color added to it, has the greatest intensity. Color intensity is different from value, which considers how light or dark a color is.

Different Intensities, Similar Values
Some colors, such as yellow, can vary in intensity but remain similar in value.

Different Intensities, Different Values
Other colors, such as purple, can change in both intensity and value.

Glowing Results

With the strategic use of color intensity, value and temperature, you can create a warm, glowing feeling in your paintings. Notice how the warm colors surrounded by cool colors make the window appear to glow.

Combined Perspective

Linear and atmospheric perspective along with color temperature can be combined to convey depth. Before reading further, see if you can pick out and identify elements that contribute to linear perspective, atmospheric perspective and color temperature in this painting.

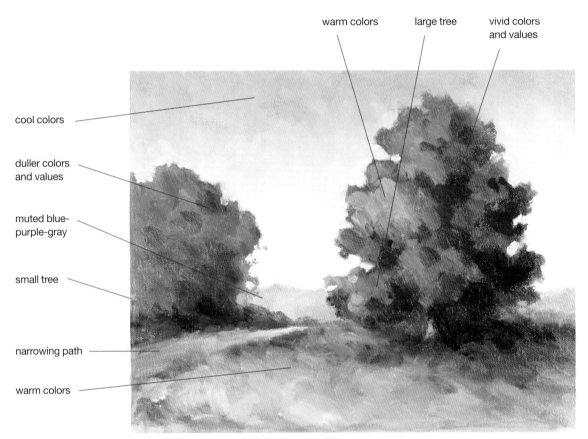

cool colors

duller colors
and values

muted blue-
purple-gray

small tree

narrowing path

warm colors

warm colors large tree vivid colors
and values

Recognizing Different Aspects of Perspective
Paintings generally combine multiple techniques to indicate depth. The following is a breakdown of the separate elements that create depth in this painting.

- **Linear perspective:** A key aspect of linear perspective is that closer elements in a scene appear larger than elements that are farther away. The tree on the right is closer and appears larger than the more distant trees on the left. The path also narrows as it goes farther into the picture plane.

- **Atmospheric perspective:** The use of atmospheric perspective is evident in the brighter, more vivid colors and values in the foreground. As the elements recede into the background, they become duller. Notice how the tree on the right is brighter than the trees on the left and that the distant hills are a muted blue-purple-gray.

- **Color temperature:** Warm colors in the foreground and cool colors in the background help express depth. The tree on the right, predominantly warm in color, rests in front of an expanse of cool blue sky.

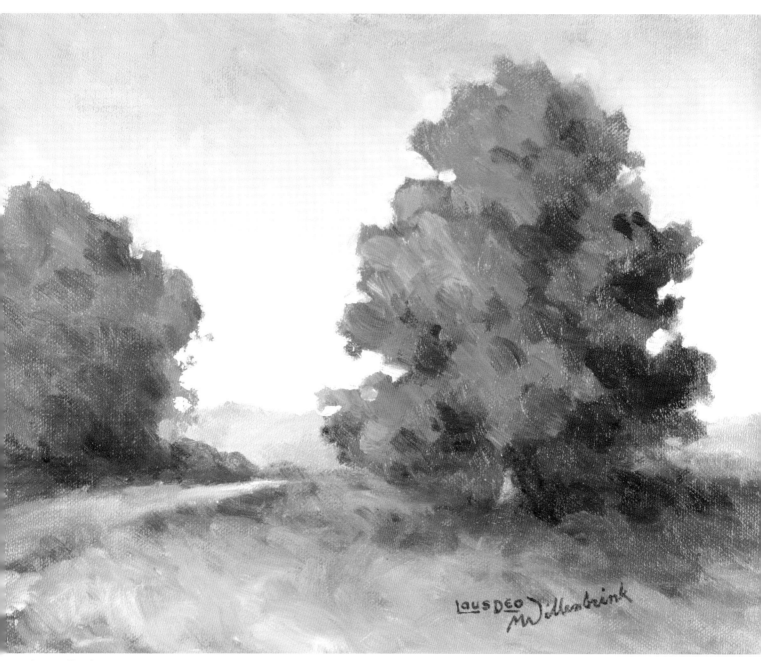

Autumn Landscape
oil on canvas mounted on board
8" × 10" (20cm × 25cm)

Composition

Composition is the arrangement of elements in a work of art. It involves using design elements such as lines, shapes, values and colors. A painting with a good composition is one that communicates its intended message to the viewer. Here are some tips for successful compositions.

Evens and Odds

The number of elements can affect the balance and movement of a scene. An even number of elements usually isn't as interesting as an odd number.

Evens Are Repetitive
An even number of elements can seem dull and predictable.

Odds Add Interest
An odd number of elements can make the scene more interesting.

Even to the Edges
This principle also applies to the number of elements reaching the edge of your paper. Similar elements reaching two edges may not look bad, but the overall composition could be better.

Odd to the Edges
Here, the trees reach three edges, giving the composition a more interesting appearance.

Symmetrical and Asymmetrical

Though a symmetrical composition can be orderly, it may also look mechanical and bland. An asymmetrical composition can give a more random, yet balanced feel.

Symmetrical and Static
Though evenly balanced, a symmetrical composition can be boring.

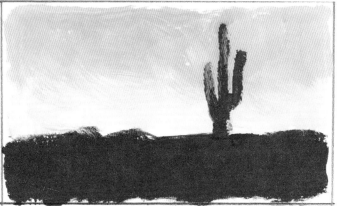

Asymmetrical and Natural
The dominant and subordinate elements balance each other for a more natural feel.

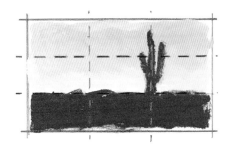

Thinking in Thirds
Use a grid to divide the picture into thirds, then place the elements along the grid lines. This is called the *rule of thirds* and results in compositions that are pleasing to the eye.

Leading the Eye

Movement is an important part of composition and keeps the viewer engaged.

Leading With Line
One way to lead the viewer is with lines and other elements, pointing out where the eye should look next in the painting. Notice how the path, tree, house and shadows direct the eye through the scene.

Leading With Pattern
A more subtle way to direct the eye is to alternate elements, creating movement through pattern. In this example, the red flowers act as stepping stones to lead the viewer.

Moody Formats

The shape of the picture area can influence the overall feel of a composition.

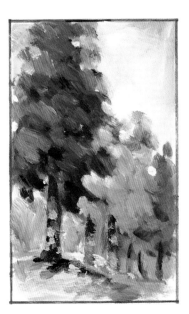

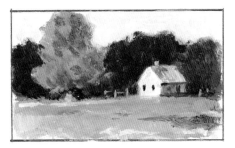

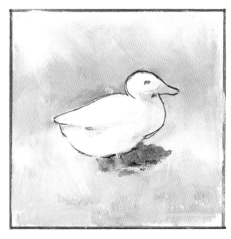

Horizontal Calm
Stable and serene, horizontal formats lend themselves to pastoral scenes.

Vertical Tension
An intense, powerful subject may be best stated through a vertical format.

Don't Be Square
A composition with a square format can be predictably boring.

Cropping a Subject

It is necessary to determine the picture area by cropping the subject. This is especially true when painting outdoors (en plein air).

Using a Viewfinder
Viewfinders can be bought, ready for use, or make your own by cutting a window out of a scrap of cardboard. The window size should be proportional to your painting surface.

Viewing Through Your Fingers
If you don't have a viewfinder, use your fingers to form the shape of a rectangle (or the shape of your painting surface).

Tip
A composition doesn't have to be complex to be complete. A simple composition can often state a message better than one cluttered with irrelevant elements.

The Trouble With Tangents

Tangents occur where two or more elements come together. Try to avoid making them as they can confuse the viewer and create an unwanted distraction.

Too Many Lines Lining Up
The roof edge of the building lining up with the distant hills creates unnecessary tangents.

Life on the Edge
Distraction is created by placing the end of the building at the right edge of the picture.

Remedy for the Tangents
By repositioning the building, the scene is free of the tangents and the subject has more clarity.

Being Led Astray

The placement and direction of the elements may unintentionally guide the viewer right out of the scene.

Out in Left Field
In this example, the direction of the path along with the light of the sky points the viewer outside the picture, to the left.

Pointing in the Right Direction
Simple adjustments to the path and sky keep the viewer within the scene.

11 Practice the **Techniques**

Now that you know about materials and basic principles, it's time to have some fun learning about and practicing oil painting techniques. It's important to understand these techniques and the results they produce. Once you become comfortable with these different painting techniques, it will be easy to choose techniques that will create the desired effects. For example, the fast-paced nature of *alla prima* painting is well suited to painting en plein air, while glazes are more appropriate for painting a detailed portrait. Keep your supplies handy so that you can actively participate in this chapter.

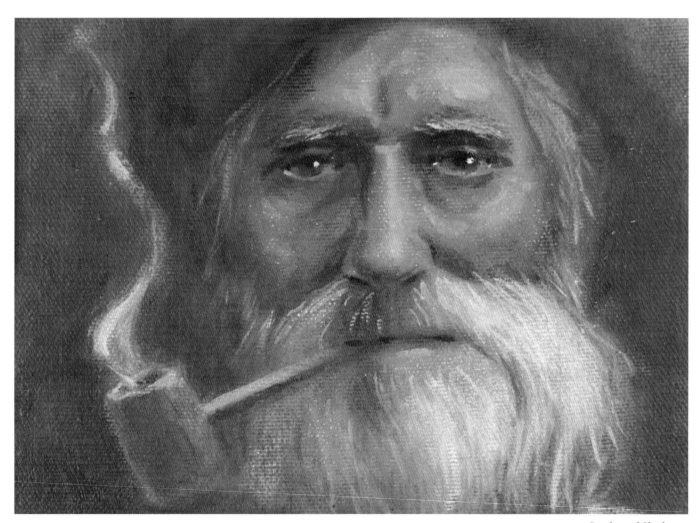

Smoke and Shadows
oil on stretched canvas
5" × 7" (13cm × 18cm)

Mixing Paint

Mixing the paint is one of the joys of oil painting. For the best results, use the correct colors and mix enough paint for the size of your painting. In general, make sure the paint is blended thoroughly on the palette. However, sometimes you may want to blend the paints on the painting surface rather than on the palette. Mixing is fun and easy once you learn some of these simple suggestions.

Add Dark to Light

Dark colors are more dominant than light colors. When mixing paint, start with the lighter color, then add small amounts of the darker color. If you try to do the reverse, you may have to mix more paint than you need to get the color you want. Similarly, when placing paints on your palette, add pea-size amounts of the dark colors and be a bit more generous with the light colors. You can always add more paint as you go, but it's hard to keep oil paints fresh once they have been placed on the palette.

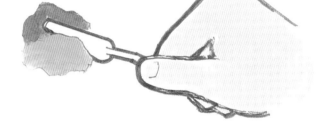

Mixing With a Palette Knife

Though it is common to use the brush that you are painting with to mix paint, a palette knife is also useful for mixing paint. Try mixing some paint with a brush, then switch to a palette knife. With the knife, you can scoop freely without clogging or damaging your brush.

Keep It Clean

When using thinner or medium, avoid dragging the brush against the lip of the palette cup so the paint doesn't release from the brush into the cup and dirty the thinner or medium.

Loading a Brush

How much paint do you want on your brush? The amount of paint you load on a brush depends on how you plan to apply the paint. *Push loading* and *pull loading* are two ways to load a brush. Use the push loading method if you want to grab a lot of paint onto your brush for applying a thick layer of paint. Use the pull loading method to load a smaller amount of paint onto your brush.

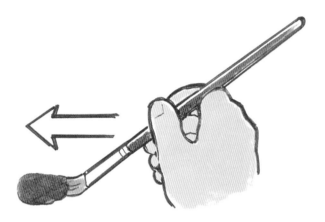

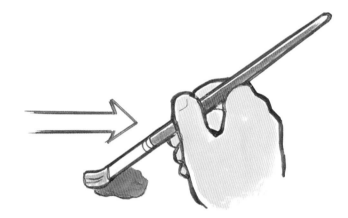

Push Loading
This method involves pushing the brush into the paint. Pushing the brush is hard on the hairs. For this reason, flat and filbert bristle brushes work best for the push loading method. If you push a round brush into your paint, it will splay the bristles, ruining its nice tip.

Pull Loading
This method requires pulling the brush into a quantity of paint on the palette. The angle of the brush determines how much paint is put onto the brush.

Avoid Overloading the Brush
Paint brushes work best when they are not overloaded with paint. Overloading makes the paint harder to control, and paint worked into the ferrule can damage the brush. If the brush becomes choked with paint, wipe it clean.

A Little Dab Will Do!
If you want just a bit of paint on the tip of your brush, use the push loading method to jab the tip of your brush into your paint.

Cleaning Brushes

Thorough cleaning is essential for maintaining brushes. Proper care of brushes ensures that you get the most use out of them. Be gentle with fine hair and round brushes while using or cleaning them.

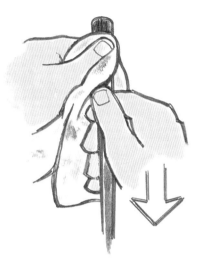

1 Wipe It Off

To remove paint from a brush, wrap it with a paper towel or rag, then squeeze the bristles with one hand and pull the brush through the towel with the other hand.

2 Clean in a Brush Wash

Swish the brush back and forth in a brush wash. If necessary, drag the brush along the screen or coil to remove paint from the brush.

3 Clean With Soap and Water

One of the best benefits of using water-soluble paints is that brushes can be cleaned with just soap and water. Brush soap or cleaner comes in liquid, gel or bar form. After your brush is clean, many of these special soaps can be left lathered on your brush to shape and condition the bristles. Just follow the manufacturer's instructions. After cleaning, reshape the brush hairs and let dry.

4 Soak If Needed

Soak brushes gummed up with old paint in a brush cleaner. Just follow the manufacturer's instructions, then clean the brushes with soap and water, reshape their bristles and let dry.

Get a Grip!

The way you hold a brush affects the types of brushstrokes it makes, from big and bold to small and detailed. Here are some common ways to hold a brush for oil painting.

Baton Grip
Like a music conductor, hold the brush with the end under the palm. This grip is good for creating loose strokes while standing at a distance from the painting.

Overhand Grip
This grip places the middle of the handle over the hand for more controlled stokes.

Handwriting Grip
Holding the brush at the ferrule is good for making smaller, detailed strokes. Use a mahlstick to ensure steady paint application.

Brush Angles

The angle of the brush in relation to the painting surface can affect the texture and application of the paint. To move and spread paint, I may work with the brush perpendicular to the painting surface. To blend the paint, I may angle the brush more. To dab heavy paint onto wet paint, I may position the brush more parallel to the painting surface. This will probably become natural to you as you practice your painting techniques.

Creating Brushstrokes

A single brush can make many different strokes, and these strokes can be altered by your grip and the angle of the brush. Here are some practical tips for common brushstrokes used in oil painting.

Wide Stroke With a Flat or Filbert
Make this stroke with the brush edge perpendicular to the direction of the stroke to use the width of the bristles.

Thin Stroke With a Flat or Filbert
Make thin strokes with a flat or filbert by holding it perpendicular to the painting surface so that only the edge touches the painting surface, then pull the brush sideways to draw a line.

Dabbing With a Flat or Filbert
To deposit paint on a wet surface, place the loaded brush almost flat to the surface and dab with the flat part of the brush.

Wide Stroke With a Round
To make this stroke, lay the round brush somewhat flat to the painting surface, making contact with the body rather than the tip of the brush.

Thin Stroke With a Round or Rigger
Small rounds and riggers can make thin strokes easily. If using a large round, keep the brush upright so that only the tip touches the paint surface.

Don't Put Your Brush in Your Mouth!

Even though water-soluble paints don't require toxic solvents, some pigments such as cadmium are health hazards. Don't put any part of the brush in your mouth because it may have paint on it.

Painting Techniques

During the painting process, any combination of techniques can be used to apply the paint. Though there are many different ways to paint the same subject, through experience you will discover the techniques that you enjoy most for achieving the look that you like. The more you paint, the more comfortable you will be when you do it. Here are some basic techniques to explore.

Fat Over Lean

To allow proper adhesion and to prevent cracking and flaking, apply paint with more oil or "fat" over leaner, less oily paint. This is especially important if the paint is drying between layers. If you are going to work on the same painting for more than one session, add a little medium or oil to the paint.

Thick Over Thin

Start with thinner layers of paint and work gradually toward thicker layers. Working this way allows the initial layers to dry before the subsequent layers. This is especially important when working in multiple painting sessions or if the paint has dried between layers because it helps prevent the paint from cracking over time. If you add a layer of thin paint over a thick layer of previously applied and dried paint, your painting is liable to crack.

Wash
A *wash* is a transparent application of paint that has been diluted with water or thinner. Commonly used to lay a ground, this technique can be used singularly or with other techniques.

Glazing
Glazing involves applying thin, fluid paint over dry layers. This technique can achieve finely detailed results, but the drying time necessary for multiple layers can be a problem.

Drying Times

Drying time can vary with each paint color, so research the manufacturer's information and take this into consideration when painting with methods that involve drying time between layers of paint.

Scumbling

This technique involves brushing undiluted paint over dry paint. Some of the dry paint's color and texture will show through the newly applied paint. The difference between glazing and scumbling is that with scumbling the paint is undiluted.

Impasto

Italian for "paste" or "dough," *impasto* refers to thick applications of paint. This method of painting can use much more paint than other methods, such as glazing.

Alla Prima

This technique derives its name from the Italian, meaning "at first." To use this method, quickly paint the painting, in general, as it will appear when it is completed. After laying down the structure and colors, add details to complete it. Quick, single-session plein air paintings are often completed in this manner.

Direct or Indirect?

Quick, single application painting techniques, such as alla prima, are considered *direct painting*, whereas techniques that require multiple layers, such as glazing, are termed *indirect painting*.

Trees and Reflections
oil on canvas on board
12" × 9" (30cm × 23cm)

Wet-Into-Wet Painting

MINI-DEMONSTRATION

With this exercise you will learn how to paint wet-into-wet. It starts with the paint surface covered with wet paint, and then wet paint is added and blended. For an inexpensive practice surface, try painting on a small sheet of canvas pad taped on all four sides to a board mounted on your easel. Experiment with different colors and different sizes of flat or filbert brushes as you try these exercises.

Materials

Surface
5" × 8" (13cm × 20cm) canvas

Oil Paints
Magenta, Yellow Ochre

Brushes
no. 8 or ½-inch (12mm) flat
no. 12 or 1-inch (25mm) flat

Other Supplies
palette, palette knife, rags or paper towels, easel, smock or apron, water, brush wash

1 Lay Down the Base Color
Paint a base color of Yellow Ochre over the painting surface with a no. 12 flat.

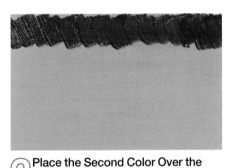

2 Place the Second Color Over the Base Color
With a no. 8 flat, paint Magenta at the top over the wet base color. Do not begin blending yet.

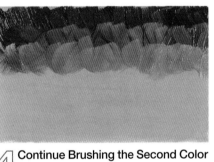

3 Start Brushing the Second Color Into the First Color
Brush the previously applied Magenta over the Yellow Ochre with crisscross strokes, starting at the top corner and working one row across.

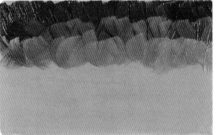

4 Continue Brushing the Second Color Into the First Color
Repeat the previous step, moving down and working the next row across. Repeat with as many rows as necessary to accomplish the desired blend. Don't be tempted to go back or jump ahead in the process, as this will interrupt the smooth transitional look.

5 Brush Over for a Smoother Blend
Brush with crisscross strokes, starting at the beginning and continuing over the sections already worked to blend the colors more evenly.

6 Additional Blending
For a smoother finish, start at a top corner with a clean brush and pull it all the way across the canvas. Move down and work the next row across from the opposite direction. Continue back and forth in this manner, working down row by row. Repeat this process so that the colors blend seamlessly into each other.

Wet-On-Dry Painting

MINI-DEMONSTRATION

This method is similar to painting wet-into-wet, except that the base color is dry, so the paint mixing characteristics are different. You can apply a thin base color or even use a wash if you want it to dry more quickly.

Materials

Surface
5" × 8" (13cm × 20cm) canvas

Oil Paints
Dioxazine Purple, Magenta

Brushes
no. 8 or ½-inch (12mm) flat
no. 12 or 1-inch (25mm) flat

Other Supplies
palette, brush wash, palette knife, rags or paper towels, easel, smock or apron

1 Lay Down a Base Color
Paint a base color of Magenta over the painting surface with a no. 12 flat and allow the paint to dry.

2 Place the Second Color Over the Dry Base Color
Paint Dioxazine Purple over the Magenta with a no. 8 flat. Do not start blending yet.

3 Start Brushing the Second Color Over the First Color
With crisscross strokes, start at a top corner and work one row across, brushing the Dioxazine Purple over the Magenta. The Dioxazine Purple will gradually become thinner, allowing the Magenta to show through.

4 Continue Brushing the Second Color Over the First Color
Repeat the previous step by moving down and working one row across, then the next row and so on. Repeat as necessary. Do not go back or jump ahead in the process, as this will interrupt the smooth transitional look.

5 Additional Blending If Needed
For a smoother appearance, start at the top corner with a clean brush and pull the brush across the surface. Move down and pull the brush in the opposite direction. Continue working down row by row until completed. You can repeat this process if you want the colors to blend seamlessly into each other.

Painting With a Palette Knife

Some artists enjoy the unique results and thick textural effects they can create by painting with palette knives. Use palette knives to complete an entire painting, or use them to accent or aid in the process of painting, such as to smooth out or remove a heavy buildup of paint.

Spreading Paint
Scoop paint onto the underside of the knife, then squish the paint onto the painting surface and spread.

Scraping Paint
Use the knife to move or thin paint from one region of the surface to a different region. Place the back of the knife edge perpendicular to the painting surface and pull it through the paint.

Lifting Paint
To lift paint, place the front edge of the palette knife on the painting surface and pull it under the paint, scooping it onto the knife.

Laying or Removing Lines of Paint
Deposit or remove paint by placing the edge perpendicular against the paint surface and pulling sideways. Scraping the knife tip up and down is a common technique for indicating grass.

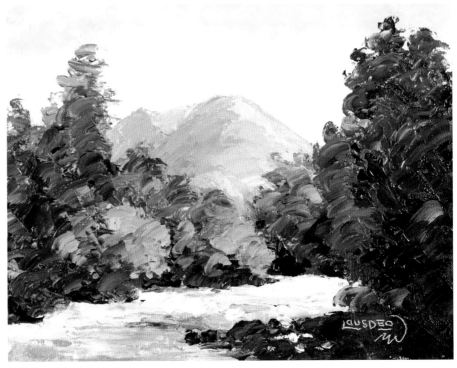

Palette-able Art
Palette knife painting can bring out your creativity. Try experimenting with different palette knives for different results.

Lifting and Wiping off Paint

Oil painting is changeable. During the painting process, you may want to remove or change a small spot or an entire region of wet paint. Knowing how to lift and wipe off paint is especially useful for washes, glazes and underpainting.

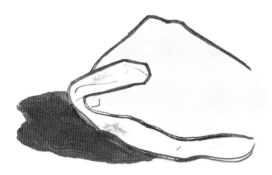

Using a Rag or Paper Towel
Simply wipe up the excess paint with a flattened rag or paper towel. Use a lint-free rag or paper towel to avoid leaving unwanted fibers. Twist the rag or paper towel to make a smaller end to lift paint from a small space.

Using a Flat Brush
Especially good when working with washes, flat brushes can be used to chisel away or lift unwanted paint.

Putting Your Credit Card to Good Use
You can also use an old credit card, rag or paper towel to spread or remove paint.

When You Need a Lift
Lifting paint is part of the painting process, and lifted areas can become part of the finished painting.

Positive and Negative Painting

MINI-DEMONSTRATION

Positive and negative painting refers to the direct or indirect way the forms are made on the painting surface. Positive painting is the more common form of painting. While negative painting is not as common, many artists use this approach to work around a subject already painted or to create a painting with a unique twist in its presentation.

Painting Positive Forms

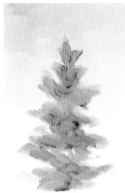

1 Start With the Background
Paint the background with a no. 8 flat and a mix of Titanium White and Ultramarine Blue.

2 Paint the Subject
Paint the positive image of the subject on the background using Sap Green and a no. 4 filbert.

Painting Negative Forms

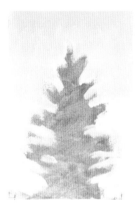

1 Start With the Color of the Subject
Paint Sap Green over all of the painting surface using a no. 8 flat.

2 Paint the Background
Add the background color with a mix of Titanium White and Ultramarine Blue, painting around and forming the shape of the subject with a no. 8 flat. Use a no. 4 filbert for more detailed areas around the tree.

Combining Positive and Negative

1 Start With the Background
Paint the background with a mix of Titanium White and Ultramarine Blue and a no. 8 flat.

2 Paint the Subject
Paint the positive image of the subject with Sap Green on the background, using limited details and a no. 4 filbert.

3 Add Details
Define the form by adding the background mix of Titanium White and Ultramarine Blue over the form using a no. 2 filbert.

Hard and Soft Edges

Forms can be painted with hard or soft edges that influence how defined they are. *Hard edges* define a form distinctly and can give an impressive or clear viewpoint. *Soft edges* may give a more romantic feel to a floral arrangement or a misty feel to a landscape. Using both hard and soft edges strategically can create the impression of depth.

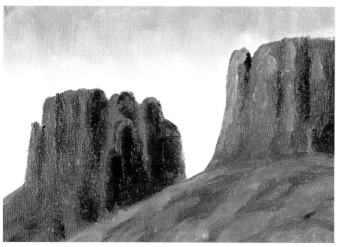

Using Hard Edges
Forms with hard edges are sharply defined. As you paint, keep the colors separate to create hard edges.

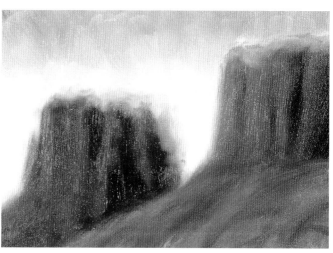

Using Soft Edges
Forms with soft edges are less defined and blend with their surroundings. Make soft edges by very lightly brushing the paint while it is still wet.

Using Hard and Soft Edges Together
Use hard and soft edges in the same painting to emphasize depth and to direct the focal point. The hard edges of the mountain on the right catch your eye, and the close-up details tell your brain it's closer than the mountain on the left. The soft edges and lack of detail on the mountain on the left imply that it's farther away.

12 Let's **Paint**

It's time to put what you have gleaned from the previous chapters of this section into practice. Enjoy the creative process and expect to be pleasantly surprised by the success you have with each finished painting. Each demonstration has its own materials list. Your studio should be set up by now, but make sure you have the suggested materials before you begin. In each demonstration we've also listed the art lessons and painting techniques taught earlier in the section. You may want to refer to these before and during your painting session.

If your family and friends are like ours, they are excited about the artwork you are completing and would love to see photos of your paintings. Consider sending digital images or making note cards to send to your favorite people.

It's All Good
Every painting you complete may not be a masterpiece, but every time you paint can be a learning experience.

Proud Enough to Show It
Mary painted *Summer's End* while taking my Oil Painting for the Absolute Beginner class. As an absolute beginner, Mary likes demonstrations that promise the most encouraging and rewarding results.

Summer's End
Mary Willenbrink
oil on Masonite
12" × 9" (30cm × 23cm)

Getting Ready

Painting is a special experience because each person is unique, and your own personality and style will show through your paintings. I am always amazed that a class of students painting the same subject, using the same techniques, will yield wildly different results, with every painting expressing the unique style of the artist. Cultivate your talent and experience so that you can express your unique creativity through your art.

We want you to be as successful as possible while using this book. Here are a few more tips before you get started.

Start Simple

If painting big feels overwhelming, start with smaller paintings. Also start with a simple subject and composition. We have laid out this chapter so that the easier demonstrations are at the beginning and the more challenging ones are at the end.

Pace Yourself

Some of the complex, detailed paintings that we admire in museums took years to complete. Others were done quickly, in one painting session. Go at a pace that is comfortable for you with the understanding that the pace you choose will also influence your end results. For paintings that require more than one session, list the colors in each mixture along with a swatch of the mixture. This will be a useful reference for the completion of that painting.

Date Your Paintings

Gauge your progress by writing the completion date on the back of each painting. As time goes by, take out your paintings and examine your growth. After setting aside a painting for a while, you may be able to view it more objectively and with new appreciation.

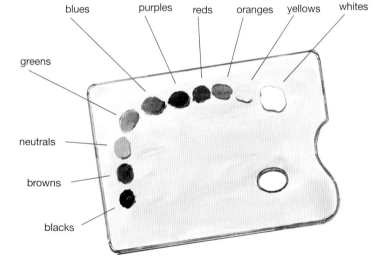

greens · blues · purples · reds · oranges · yellows · whites

neutrals

browns

blacks

Mirror, Mirror

Staring at a painting from the same distance and viewpoint can cloud your perception of your painting. Step back from your easel now and then to help you discern the progress of your painting. Another way to detach yourself and observe the colors and composition of your painting more objectively is to look at your art through the reflection in a mirror.

Orderly Paint Placement

When placing the paints on the palette, consider putting them in an order similar to the arrangement of the color wheel, with white at the end, next to yellow. With this setup, the colors graduate in an orderly and familiar manner, leaving room for mixing the paint in the center. The space at the top can be used for mixture swatches so that you can compare these mixtures to the colors you are trying to match.

Using a Ground

A *ground* is a thinned wash of paint put down as a base color for a painting. Grounds provide tone and color so that you don't have to start with a stark white painting surface. Grounds can be painted on with a brush or smeared on with a rag.

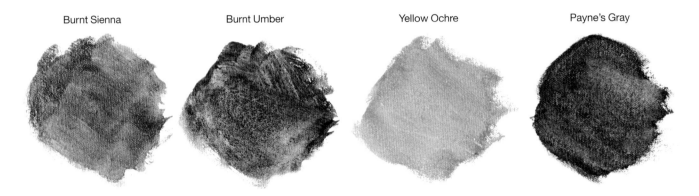

Burnt Sienna Burnt Umber Yellow Ochre Payne's Gray

Common Grounds
Browns and neutral colors are commonly used as grounds, but any color can be used.

Wet and Dry Grounds
You can let a ground dry before painting over it, or try painting into it while it's still wet. Water-soluble oils work well for dry grounds because they dry quickly. Water-soluble oils dry faster than traditional oils but slower than acrylics.

Using Complementary Colors

Colors that are complementary to the dominant color of your painting subject can be used as ground colors. For example, a painting of green trees may start with a ground color of red. This technique will make the dominant color seem less overwhelming and easier to vary.

Underdrawing and Underpainting

Underdrawings and underpaintings are like road maps that help you plan a painting before adding the finished painting layers. To create an underdrawing, draw the basic structure of the subject on a dry painting surface with pencil, charcoal or paint. An underpainting goes beyond the basic structure, developing the lights and darks. Erase or wipe away to make adjustments. For pencil or charcoal, spray your drawing with a fixative before painting to keep the graphite or charcoal from smearing into and dirtying your paint.

Using an Underdrawing
Underdrawing can be used with or without a ground. The great thing about an underdrawing is that it can be wiped off or erased away until you have a satisfactory structure for the foundation of the painting.

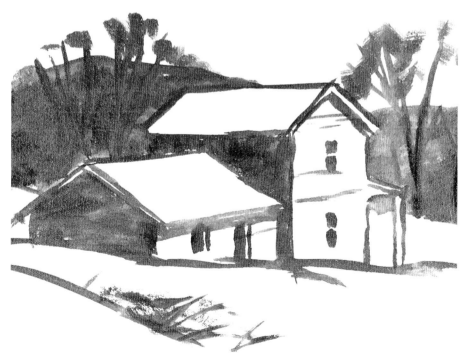

Using an Underpainting
Similar to an underdrawing, an underpainting involves painting the basic structure and dark areas of the subject with a dark color. Apply the paint thinly so it can be wiped away easily for corrections and so that it dries quickly. Underpainting can be used with or without a ground. If underpainting is used over a wet ground, light areas can be made by lifting or wiping away the ground color to expose the lighter painting surface.

You can let an underpainting dry before painting over it, or try painting over it while it is still wet. If you apply paint to a wet underpainting, expect the underpainting to mingle with and darken the newly applied colors.

Monochromatic Rocks

MINI-DEMONSTRATION

Monochromatic painting offers an exceptional opportunity to focus on values and painting techniques. By developing a range of lights and darks, you will see that a painting can be complete without relying on color.

Keep in Mind

The light source for this scene is coming from the upper left. This makes the rocks generally appear lightest at their upper left and darkest toward the lower right.

1 Apply a Ground
Use a rag to apply diluted Payne's Gray over the painting surface to create a light, transparent ground. Don't worry about making the ground completely even since you will paint over it.

2 Paint the Underdrawing
Using a no. 2 filbert, draw the shape of the rocks with Payne's Gray. Start with the big central rocks and work out.

LESSONS/TECHNIQUES

- Value (Chapter 10)
- Light Source (Chapter 10)
- Underdrawing and Underpainting (Chapter 11)

3 Begin Painting the Rocks
With mixtures of Titanium White and Payne's Gray, begin filling in each rock with its general value using a no. 8 filbert. Adjust the values by lightening some rocks and darkening others to enhance the composition.

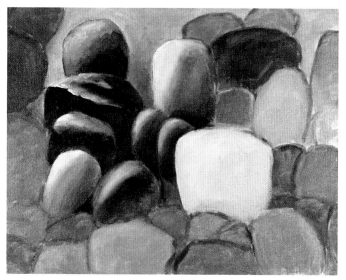

4 Start Adding Blended Values

Start adding and blending lights and darks, using both nos. 2 and 8 filberts. Work rock by rock and start filling the background with values.

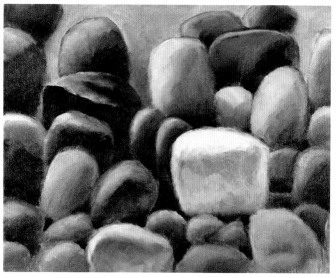

5 Blend the Rocks and Add Darks Between

Finish blending the values of the rocks with nos. 2 and 8 filberts.

With a no. 2 filbert, make adjustments and add more darks between the rocks to give them better definition.

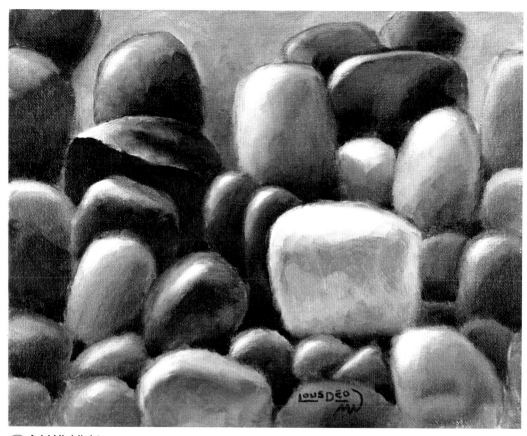

Rocks Along the Shore
oil on canvas mounted on board
8" × 10" (20cm × 25cm)

6 Add Highlights

To finish, add Titanium White for highlights with a no. 2 filbert. Sign and date your painting with a no. 4 rigger.

Sunset Beach

There is nothing quite like being on a tropical beach as the sun is setting. Use analogous colors (colors that lie next to each other on the color wheel) in this demonstration. You'll need to blend the sky and water while the paint is still wet, so be prepared to complete Steps 1–9 in one painting session.

1 **Place the Sun and Add Light Yellow Around the Sun and Water** Use a no. 8 filbert to paint a Titanium White circle for the sun. Continue using the no. 8 filbert in Steps 2–7.

Paint a light yellow mix of Titanium White and Cadmium Yellow Light around the sun and the water under the sun. Add water or thinner to allow the paint to flow better when painting.

2 **Add Yellow and Yellow-Orange** Paint Cadmium Yellow Light around the sun and in the water. At this stage, place the paints, but don't blend them on the painting surface.

Paint Cadmium Yellow Medium around the glowing sun and water.

LESSONS/TECHNIQUES

- Analogous Colors (Chapter 10)
- Wet-Into-Wet (Chapter 11)
- Wet-Into-Dry (Chapter 11)

What a Bright Idea!

To paint this tropical sunset with bright, brilliant colors, use the paint colors recommended for this demonstration. If you use different colors or student-grade paints, you may not achieve the same results.

3 Add Orange-Yellow
Paint a mixture of Cadmium Yellow Medium and Cadmium Orange Hue around the sun and water.

4 Add Orange, Then Red
Paint Cadmium Orange Hue around the sun and water. Add Cadmium Red Hue to the sky.

5 Blend the Sky
Clean the brush thoroughly, then blend the sky colors, starting at the white center and working out.

6 Blend the Water
Clean the brush thoroughly. Using up-and-down strokes to blend the paint, work right to left starting at the lightest part under the sun. Clean the brush and repeat, working left to right from the lightest part under the sun.

7 Create Wave Lines

With narrow, horizontal brushstrokes, create wave lines using only the paint that is on the painting surface; brush through the paint previously laid down with thin, horizontal brushstrokes.

8 Add Lights and Darks to the Waves

With a no. 2 flat, dab or streak Titanium White in the water under the sun. Next add Magenta streaks to the waves, making them larger the closer they get to the bottom.

9 Soften the Dark Waves

Using a no. 8 filbert, gently brush over the dark waves with horizontal strokes to soften their appearance. Let the paint dry before proceeding to the next step.

10 **Paint the Basic Structure of the Tree**
Painting wet-on-dry and starting with the trunk, use a no. 2 flat and Magenta to create the basic structure of the tree and ground.

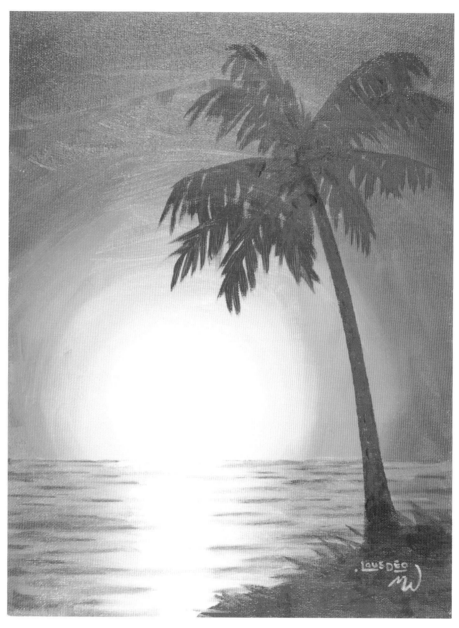

11 **Add Leaves and Grass**
Paint tree leaves and grass with Magenta using a no. 2 flat. Let the painting dry, then sign and date it with a no. 4 rigger.

Tropical Sunset
oil on canvas on board
12" × 9" (30cm × 23cm)

Mountains With Primary Colors

This demonstration will show just how much you can do with a limited palette. You'll use only the three primary colors plus white to mix all of the colors represented in this beautiful mountain scene. You'll learn how to use warm colors to suggest sunlit areas and cool colors for the shadowed regions.

You can build your scene in a horizontal or vertical format, depending on the feeling you want to achieve. The horizontal format will give the scene a calm, peaceful feeling, emphasizing the sturdiness and stability of the mountains. The vertical format emphasizes the height and power of the mountains and creates a feeling of awe.

Materials

Surface
9" × 12" (23cm × 30cm) primed canvas

Oil Paints
Lemon Yellow, Permanent Rose, Phthalo Blue (Red Shade), Titanium White

Brushes
no. 10 or ¾-inch (19mm) flat
no. 2 or ¼-inch (6mm) filbert
no. 8 or ½-inch (12mm) filbert
no. 4 rigger

Other Supplies
brush wash with water, easel, palette, palette knife, rag or paper towels, thinner or water

Optional Supplies
gesso, mahlstick, medium, palette cups, smock or apron

LESSONS/TECHNIQUES
- Primary Colors (Chapter 10)
- Color Temperature (Chapter 10)
- Creating Brushstrokes (Chapter 11)

1 Paint the Sky

Unless it is already primed, prime the canvas surface with gesso, but leave it white, without a ground. Mix Phthalo Blue (Red Shade) and Titanium White, then thin the mixture with thinner or water. Apply this to the top part of the canvas with a no. 10 flat using vertical strokes. For this stage, the paint consistency should be thin enough that you can see the canvas underneath.

Let It Dry!
When adding bright whites to a painting, let previous paint applications dry, or the white might mix with the undercolor.

2 **Paint the Mountains**
Mix Titanium White and Permanent Rose with a little Phthalo Blue (Red Shade). Paint in the shape of the mountains with a no. 8 filbert. Use a somewhat thicker paint consistency than in the previous step.

3 **Paint the Foreground and Mountains**
Mix Titanium White and Lemon Yellow with Permanent Rose to make a yellow-orange. Add this mixture to the foreground with a no. 8 filbert. The light source is coming from the upper left, so add some of this warm color to the sunlit side of the mountains.

4 **Add Green to the Hills**
Mix Titanium White, Lemon Yellow and Phthalo Blue (Red Shade) to make green. With a no. 8 filbert, add this green to the foreground, following the contour of the hills.

5 **Add Cool Colors to the Mountains**
Add shadows to the right sides of the mountains with a mixture of Phthalo Blue (Red Shade), Permanent Rose and Titanium White applied with a no. 2 filbert.

6 **Add Bright Foreground Colors**
With a no. 2 filbert, add a yellow-orange mixture of Lemon Yellow and Permanent Rose to the foreground. The bright, vibrant colors will enhance the depth of your painting.

7 Add Darker Green to the Foreground
Mix Lemon Yellow and Phthalo Blue (Red Shade) to make a dark green. Add this green to the foreground areas with a no. 2 filbert.

8 Paint the Clouds
With a no. 2 filbert, add Titanium White to the sky to suggest clouds. Use soft, white shapes for the clouds. Sharply defined edges would change the composition of the painting, drawing unnecessary attention to the sky.

9 Add Snow to the Mountains
Add white to the mountains, using the edge of a no. 2 filbert to apply the paint.

10 Paint the Trees
Use a mixture of Phthalo Blue (Red Shade), Lemon Yellow and Permanent Rose for the green of the trees. To paint the small trees, hold the no. 2 filbert so that the narrow surface of the bristles is vertical. Start at the base and pull the brush upward, tapering from thick to thin.

11 Add the Accents

With a no. 2 filbert, add a yellow-orange mixture of Lemon Yellow, Permanent Rose and Phthalo Blue (Red Shade) as accents to the distant hills. Add pink to the mountains with a mixture of Permanent Rose and Titanium White. Add shadows to the foreground and background trees with purple mixtures of Permanent Rose, Phthalo Blue (Red Shade) and Titanium White.

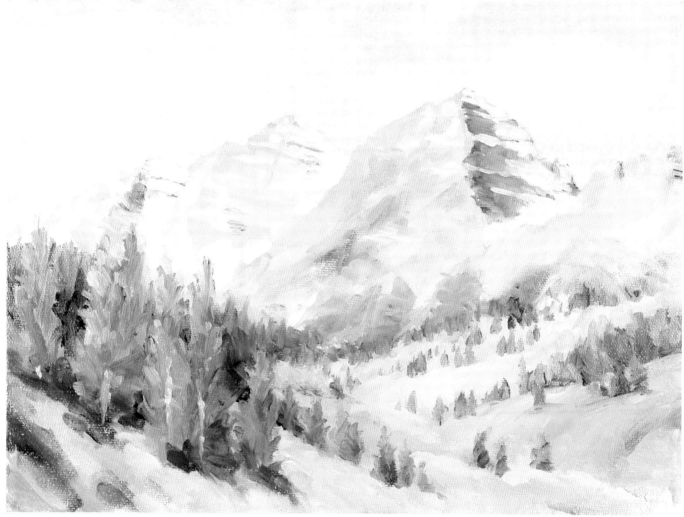

12 Add the Finishing Touches

Take a step back to observe your painting, then add finishing touches and adjustments. At this point, I lightened the dark of the mountains but kept the snow and also added more trees. The painting should feel complete with a depth expressed through contrasts and colors. Let the painting dry, then sign it with a no. 4 rigger.

Majestic
oil on stretched canvas
9" × 12" (23cm × 30cm)

Pear Still Life

Painting a simple still-life arrangement is a good way to examine the effects of light and shadows. A cardboard box or wood panels can be used to form the walls for your still life. An adjustable desk lamp is useful for creating a clear light source. In this demonstration, the light source is from the extreme left, casting long shadows to the right.

Once you have painted pears, consider setting up other still-life studies. Here are some ideas to try: floral arrangements, an assortment of antiques, candles, glass vases or other knick-knacks. The ideas are endless. Each new arrangement offers a play of light and shadows with textures.

Materials

Surface
9" × 12" (23cm × 30cm) canvas on board

Oil Paints
Burnt Sienna, Cadmium Yellow Light, Cerulean Blue, Magenta, Sap Green, Titanium White, Yellow Ochre

Brushes
no. 8 or ½-inch (12mm) flat

no. 2 or ¼-inch (6mm) filbert

no. 4 or ⁵/₁₆-inch (8mm) filbert

no. 4 rigger

Other Supplies
3 pears, 3 wood panels or a cardboard box, adjustable desk lamp, brush wash with water, easel, palette, palette knife, rag, thinner or water

Optional Supplies
mahlstick, medium, palette cups, smock or apron

1 Apply a Ground
Use a rag to apply diluted Burnt Sienna over the painting surface to create a light, transparent ground.

LESSONS/TECHNIQUES

- Values (Chapter 10)
- Light Source (Chapter 10)
- Composition (Chapter 10)
- Alla Prima (Chapter 11)

Sketch the Pears

2 Use a no. 4 filbert and Burnt Sienna to sketch the shape of the pears including the stems.

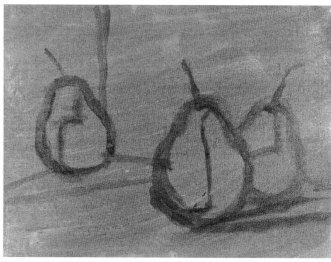

Add Structure and Shadow Lines

3 Add lines indicating the box structure and lines for the shadows including those on the pears.

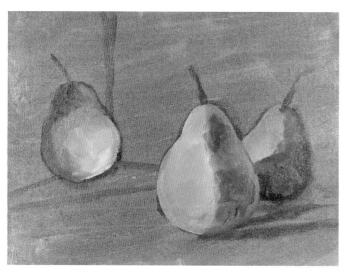

Paint the Pears

4 Mix Cadmium Yellow Light, Sap Green, Cerulean Blue, Titanium White, Magenta and Burnt Sienna to create a range of warm green colors. Use a no. 4 filbert to paint the pears.

Paint the Shadow Areas of the Sides and Bottom

5 Mix Yellow Ochre, Burnt Sienna, Titanium White, Cerulean Blue and Magenta to create a range of warm brown colors. Use a no. 8 flat to paint this color in the individual regions of the shadows.

6 Add the Lighter Areas of the Sides and Bottom

Mix a range of tan colors with Titanium White, Yellow Ochre, Magenta and Burnt Sienna, then paint the bottom and sides with a no. 8 flat and no. 4 filbert.

7 Add Subtle Darks

With a no. 4 filbert, add Burnt Sienna in the shadows. Use a no. 2 filbert for the pear stems.

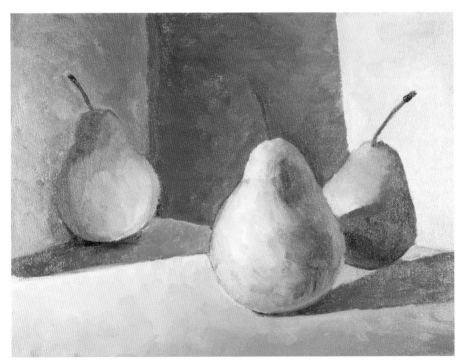

8 Add Lighter Areas to the Pears

Add warm greens to the pears with mixtures of Titanium White, Cadmium Yellow Light and Sap Green and a no. 4 filbert. Smooth the form of the pears during the process.

Add Highlights and Adjustments

9 Add highlights to the pears with Titanium White and make minor adjustments such as adding highlights and lights to the nearest stem. Let the paint dry, then add your signature with a no. 4 rigger.

Still Life With Pears
oil on canvas mounted on board
9" × 12" (23cm × 30cm)

Sunflowers

You can approach this demonstration in one of several ways: Paint the flowers over the background (positive painting); or try painting the surface yellow, then fill in the rest of the background around the flowers (negative painting); or try a combination of the two techniques.

For this composition, the stalks and leaves are more implied and less detailed than the flowers. Keep in mind while you are painting that the light source is coming from the upper left.

Materials

Surface
20" × 16" (51cm × 41cm) stretched canvas

Oil Paints
Burnt Sienna, Cadmium Orange Hue, Cadmium Yellow Hue, Cadmium Yellow Light, Cerulean Blue, Sap Green, Titanium White

Brushes
no. 4 or 5/16-inch (8mm) flat

no. 8 or ½-inch (12mm) filbert

no. 4 rigger

Other Supplies
2B pencil or charcoal pencil, brush wash with water, easel, kneaded eraser, palette, palette knife, rag or paper towels, spray fixative

Optional Supplies
mahlstick, medium, palette cups, smock or apron, thinner

1 Sketch the Basic Flower Shapes
Using a 2B or charcoal pencil, sketch the placement of the flower shapes with circles.

2 Add Details to the Sketch
Sketch the center portion and petals of the flowers.

LESSONS/TECHNIQUES

- Color Temperature (Chapter 10)
- Mixing Paint (Chapter 11)
- Positive and Negative Painting (Chapter 11)

Let Your Creativity Out

After you've completed this demonstration, try another painting using your own silk or live sunflowers as visual reference. You will notice subtle differences that are not as easily seen when looking at a photo. Try setting up other floral arrangements if you like painting flowers.

3 Finish the Underdrawing

Add more details to the scene and erase unwanted lines with a kneaded eraser. When finished, spray with fixative to prevent the paint from smearing the graphite.

4 Add the Ground Color

With a rag, smear Burnt Sienna diluted with water to create a ground. To keep the pencil lines visible, the paint needs to be transparent.

5 Paint the Green Areas

With a no. 8 filbert paint the green areas with a mix of Sap Green, Cadmium Yellow Hue, Titanium White and Cerulean Blue. Thin the paint with water or thinner so the pencil lines remain visible.

6 Add the Sky

Using a no. 8 filbert, paint the sky with Cerulean Blue and Titanium White. The lower portion of the sky is mostly white, the top mostly blue.

7 Paint in the Petals

With a mixture of Cadmium Yellow Hue and Titanium White, paint in the petals using a no. 8 filbert. Roughly paint the distant sunflowers using the same colors.

8 Start Painting the Flower Centers
With mixtures of Cadmium Orange Hue, Burnt Sienna, Titanium White and Sap Green, begin painting the flower centers. The light source for this subject is coming from the upper left. This will noticeably affect the shading of the convex centers of the top two flowers.

9 Add Darks to the Centers
Using the no. 4 flat, apply a mix of Burnt Sienna and Sap Green.

10 Add Light Green
Using both a no. 8 filbert and a no. 4 flat, apply mixtures of Sap Green, Cadmium Yellow Light and Titanium White to the leaves and stalks. Also add these light green colors to the flower centers and between the petals.

11 Add Darker Greens

Using a no. 8 filbert, apply a mix of Sap Green, Cerulean Blue and Burnt Sienna to the leaves and stalks.

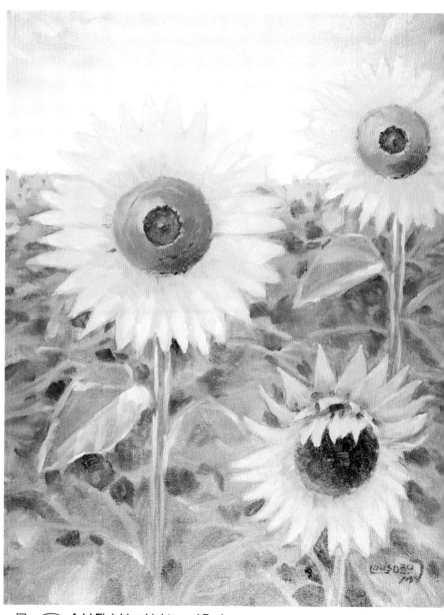

12 Add Finishing Lights and Darks

Using a no. 4 flat, make finishing adjustments of lights and darks. Add Cadmium Yellow Light to the outer parts of the petals, and Cadmium Yellow Hue to the inner petals. Let the painting dry, then sign and date it with a no. 4 rigger.

Field of Sunflowers
oil on stretched canvas
20" × 16" (51cm × 41cm)

Cloud Study

MINI-DEMONSTRATION

It's fun to try to capture clouds' ever-changing character. Keeping in mind the placement of the light source in the top right will help you create clouds with a three-dimensional quality. A photographed sky may look like a single flat color, but a painting expresses a sky best as an expanse of space that changes in both value and color. In this demonstration the sky is a midvalue French Ultramarine at the top graduating to light Cerulean Blue and Sap Green at the bottom.

Materials

Surface
8" × 10" (20cm × 25cm) canvas on board

Oil Paints
Cerulean Blue, French Ultramarine, Permanent Rose, Sap Green, Titanium White

Brushes
no. 12 or 1-inch (25mm) flat
no. 4 or ⁵/₁₆-inch (8mm) filbert

Other Supplies
brush wash with water, easel, palette, palette knife, rag or paper towel

Optional Supplies
mahlstick, medium, palette cups, smock or apron, thinner

1 Start Painting the Sky
With a mixture of Titanium White, Cerulean Blue and Sap Green, paint the sky using a no. 12 flat. Start at the bottom of the canvas and paint just past the middle. To mix the colors, start with Titanium White because the dominant blue and green will want to take over, making the sky color hard to tame. Add a drop or two of water or thinner to the paint to improve the flow. Create a thin application, but not as thin as a wash.

2 Add the Top of the Sky
With a mix of Titanium White and French Ultramarine, start painting from the top down, gradually adding Cerulean Blue as you work down to meet up with the bottom half of the sky. With a clean brush, work over the entire sky, top to bottom, to blend it more evenly.

LESSONS/TECHNIQUES

- Light Source (Chapter 10)
- Mixing Paint (Chapter 11)

3 Paint the Cloud Shapes

Using a no. 4 filbert, add the cloud shapes with a mixture of Titanium White, Cerulean Blue, French Ultramarine, Sap Green and a hint of Permanent Rose. As you apply the paint, it's OK if this mixes with the paint previously laid down for the sky.

4 Add Darker Values to the Clouds

Mix the step 3 colors using less white to create a darker bluish gray, then paint the shadowed areas of the clouds. The light source is coming from the upper right, so the clouds will be mostly dark in the lower left areas.

5 Add Lighter Areas to the Clouds

With Titanium White, mix in the lighter areas of the clouds. The brightest areas will be in the upper right of individual clouds. Clean your brush and replace the brush wash water for the best results.

6 Finish With Highlights

Apply thick Titanium White for highlights in the top right of the individual clouds. Do not mix the white highlight with the previously laid colors. The Titanium White should remain pure.

Landscape With Cottage

This landscape scene is from a photo I took of farmland not far from where we live. I added the cottage for interest and drew upon my experience painting plein air landscapes to create a sense of believ-ability even though the scene was painted indoors.

1 Start Drawing the Scene
Begin with a 2B pencil by drawing the horizon and the water's edge as the basis for the scene.

2 Draw the Trees and Path
Draw the trees and their reflections in the water. Add the path receding into the distance.

3 Add the Cottage
Draw the cottage along with the reflection in the water. Spray with fixative.

4 Apply Ground Color
Using a rag, smear Burnt Sienna thinned with water over the entire surface as the ground.

This demonstration continues after the Painting Trees Mini-Demonstration.

LESSONS/TECHNIQUES

- Linear Perspective (Chapter 10)
- Atmospheric Perspective (Chapter 10)
- Color Temperature (Chapter 10)
- Scumbling (Chapter 11)

Painting Trees

MINI-DEMONSTRATION

While you can just paint trees directly onto the painting surface without an underdrawing or underpainting, creating a detailed drawing first will help guide you as you paint.

Materials

Surface
5" × 3" (13cm × 8cm) canvas

Paints
Burnt Sienna, Cadmium Orange Hue, Cadmium Yellow Light, Phthalo Blue (Red Shade), Sap Green

Brushes
no. 2 or ¼-inch (6mm) filbert
no. 4 or 5/16-inch (8mm) filbert
no. 2 round

Other Supplies
2B pencil, spray fixative

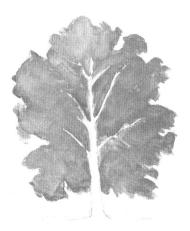

1 Paint the Leaves
After drawing the tree and branches and spraying the surface with fixative, paint the regions of the leaves with a mix of Cadmium Yellow Light and Sap Green, using a no. 4 filbert. Avoid painting over the trunk and branches.

2 Paint the Trunk and Branches
Paint over the trunk and branches with a mix of Burnt Sienna and Cadmium Orange Hue and a no. 2 filbert and a no. 2 round, improving and adding some branches as needed. Tree trunks and branches taper or become thinner as they grow outward.

3 Add More Leaves
Add leaves over the previous leaves and branches with the green mix of Cadmium Yellow Light and Sap Green, using a no. 2 filbert. If there are parts of the branches you don't like, try painting over them with leaves.

4 Paint Lights, Darks
Add more Cadmium Yellow Light to the green mix to create warm light areas and add Phthalo Blue (Red Shade) to the green and brown mixes to create cool dark areas, including leaves, trunk and branches with a no. 2 filbert.

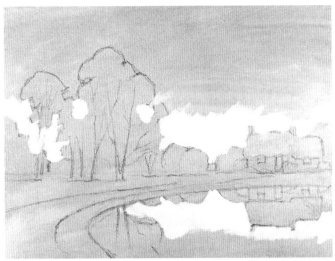

5 Start Painting the Sky and Water

Starting near the horizon, paint the sky using a no. 8 filbert with Titanium White and a touch of Permanent Rose. Start painting the water with the same paint mixture but with the addition of Cerulean Blue. The water is a little darker and bluer than the sky that it reflects.

6 Fill in the Sky and Water

Fill in the rest of the sky with a no. 8 filbert, adding more Cerulean Blue to the paint mixture as you paint upward. Add French Ultramarine at the top. Continuing with the no. 8 filbert, paint the water. Reflecting the sky, the water is lighter at the top and darker at the bottom.

7 Add the Clouds

Paint the clouds using a no. 8 filbert loaded with Titanium White. The light source is coming from the upper right, so the clouds are whitest in their top right areas.

8 Paint the Middle Value Colors

With a no. 8 filbert, paint different regions of the scene with a mixture of Yellow Ochre, Cadmium Yellow Hue, Cadmium Orange Hue, Cadmium Red Hue, Sap Green, Burnt Sienna and Titanium White.

Reflections

Though images and their reflections share similar values and colors, reflections don't need as much detail and precision as the images they reflect.

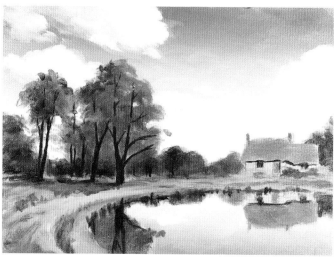

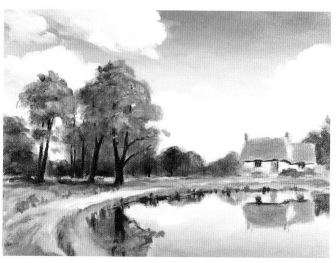

9 **Paint More Middle Values and Some of the Darker Values**
Using a no. 2 filbert, apply different combinations of the colors in the previous step plus Dioxazine Purple. For tree trunks and branches, mix Dioxazine Purple with Burnt Sienna and apply the mix with a no. 2 filbert and a no. 2 round. Scumble in places by lightly dragging the no. 2 filbert with undiluted paint.

10 **Add the Lighter Details**
Using a no. 2 filbert, paint lighter details such as parts of the cottage, some of the path and some of the leaves using various combinations of colors already used lightened with Titanium White. Apply a mixture of Titanium White and Permanent Rose around the cottage along the water's edge.

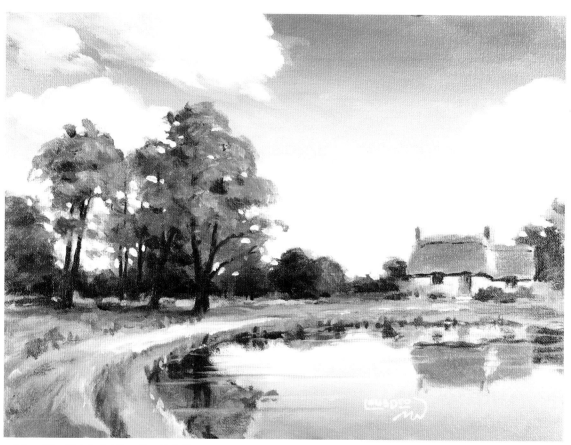

11 **Finish Adding the Details**
Darken and lighten areas around the trees and cottage, and make thin horizontal streaks on the water by dragging the no. 2 filbert through the wet paint. Let the painting dry, then sign and date it with a no. 4 rigger.

Patton's Puddle
oil on canvas on board
9" × 12" (23cm × 30cm)

Seascape With Boats

This is a simple composition, but it will make an impressive piece of artwork when you are finished. Notice the subtle transitions of colors and values from left to right in the sky, trees and water. Without these transitions, the painting might turn out flat, but, with them, you will create a beautiful, soothing water scene.

1 Start Drawing the Boat

With a 2B pencil, start drawing the boat with a horizontal line, going slightly up on the right for the hull. Two vertical lines, leaning at the top and slightly to the left will form the masts.

2 Form the Sails and Hull

Add lines to start forming the sails and hull. Measure the length of the hull and mark the height of the masts to approximately the same length.

Materials

Surface
9" × 12" (23cm × 30cm) canvas on board

Oil Paints
Cadmium Yellow Medium, Cerulean Blue, Dioxazine Purple, Magenta, Phthalo Green (Blue Shade), Prussian Blue, Titanium White, Yellow Ochre

Brushes
no. 2 or ¼-inch (6mm) filbert
no. 4 or ⁵/₁₆-inch (8mm) filbert
no. 4 rigger

Other Supplies
2B pencil, brush wash with water, easel, kneaded eraser, palette, palette knife, rag or paper towels, spray fixative

Optional Supplies
mahlstick, medium, palette cups, smock or apron, thinner

LESSONS/TECHNIQUES

- Value (Chapter 10)
- Color Temperature (Chapter 10)
- Composition (Chapter 10)
- Wet-Into-Wet (Chapter 11)
- Wet-Into-Dry (Chapter 11)

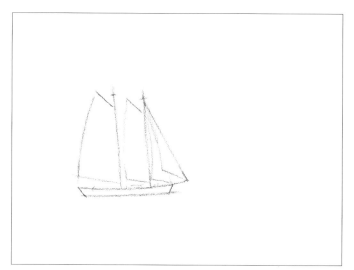

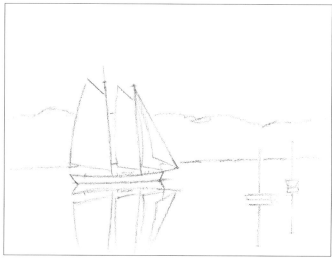

3 Add Features to the Boat
Start adding features to the boat, including the sails and the deck.

4 Add Background, Additional Boats and Reflections
Add the background trees and shoreline. Sketch in the smaller boats and add reflections to the boats. Erase any unwanted lines with the kneaded eraser and spray with fixative.

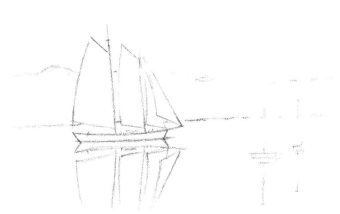

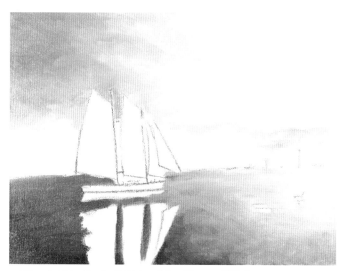

5 Start Painting the Sky and Water
With a mixture of Titanium White and Cerulean Blue, start painting the sky and water with a no. 4 filbert. The sky and water should be noticeably lighter on the right side.

6 Add to the Left Side of the Sky and Water
Develop the left side of the sky with a no. 4 filbert and a mix of Titanium White, Dioxazine Purple and Prussian Blue. Add to the left portion of the water with a mix of Titanium White, Dioxazine Purple, Prussian Blue and Phthalo Green (Blue Shade) and a trace of Cadmium Yellow Medium. The water should be darker than the sky above it.

7 Add White to the Right Side of the Sky and Water
With a clean brush and water, add Titanium White to the right portion of the sky and water.

8 Paint the Background Trees
Starting on the left, paint in the background trees with a mix of Phthalo Green (Blue Shade), Cerulean Blue and Dioxazine Purple using a no. 4 filbert. Work to the right, gradually adding Magenta and Titanium White to the mix so that the extreme right looks purple-gray.

9 Paint the Sails and Hull
With a mix of Yellow Ochre, Magenta, Cerulean Blue, Dioxazine Purple and Titanium White, paint the sails using a no. 2 filbert. Paint the hull with a mix of Dioxazine Purple, Phthalo Green (Blue Shade), Cerulean Blue, Magenta and Titanium White. The hull is darker and cooler on the left.

10 Add the Sails' and Hull's Reflections
With nos. 2 and 4 filberts, add the reflections of the sails and hull with the colors used for the sails and hull in step 9 along with the water colors. The reflections are similar to the color and value of the water, the difference between the two becoming almost indistinguishable toward the bottom.

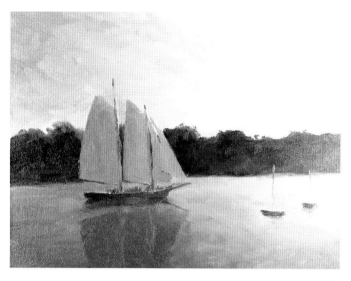

11 Paint the Smaller Boats and Masts

Paint the small boats, the masts of the large boat and some details with a mixture of Titanium White, Dioxazine Purple, Cerulean Blue and Prussian Blue. Use a no. 2 filbert and no. 4 rigger.

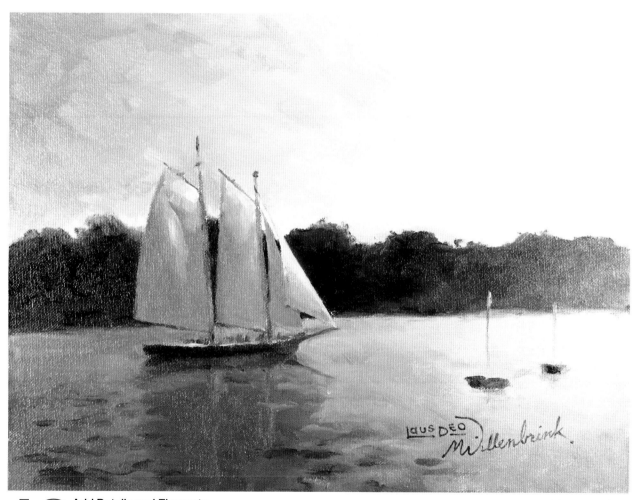

12 Add Details and Elements

Add final details and elements including the boat trim and waves at the bottom with mixture of Dioxazine Purple, Cerulean Blue and Prussian Blue, using a no. 4 rigger for the thin lines and a no. 2 filbert for the wider strokes. Use a mixture of Titanium White with Cadmium Yellow Medium for the highlights of the sails. Let the paint dry, then sign and date the painting with a no. 4 rigger.

Morning Sail
oil on canvas on board
9" × 12" (23cm × 30cm)

Springhouse in Summer

Working en plein air (outdoors), whether for sketches or finished paintings, is a great way to observe a subject and become more aware of subtle color variations that may be lost in a photograph. Consider making it a goal to observe the different hues of green in nature as the sun moves across the sky and also as the seasons change.

Two-Point Perspective

Use two-point perspective to construct the buildings. The vantage point is such that the buildings are above the horizon, giving the impression of looking up at them. The left vanishing point is within the picture area, while the right vanishing point rests on the horizon beyond the border of the picture area. Try drawing this on the painting surface with charcoal or pencil, then spray with a fixative so the drawing doesn't smear.

Alternative Approach

If painting the buildings in two-point perspective requires more effort than you want to exert and you feel as though your brain may explode, try repositioning the buildings to a straight-on view.

Materials

Surface
8" × 16" (20cm × 41cm) stretched canvas

Oil Paints
Burnt Sienna, Cadmium Orange Hue, Dioxazine Purple, Lemon Yellow, Permanent Rose, Phthalo Blue (Red Shade), Phthalo Green (Blue Shade), Titanium White, Yellow Ochre

Brushes
no. 4 or ⁵⁄₁₆-inch (8mm) filbert
no. 4 rigger
no. 12 or 1-inch (25mm) flat

Other Supplies
brush wash with water, easel, palette, palette knife, rag or paper towel

Optional Supplies
mahlstick, medium, palette cups, smock or apron, thinner

LESSONS/TECHNIQUES

- Linear Perspective (Chapter 10)
- Color Temperature (Chapter 10)
- Positive and Negative Painting (Chapter 11)

1 Add Ground to the Painting Surface

With a no. 12 flat, apply a thin wash of Burnt Sienna as a ground color. The reddishness of the Burnt Sienna will complement the greens.

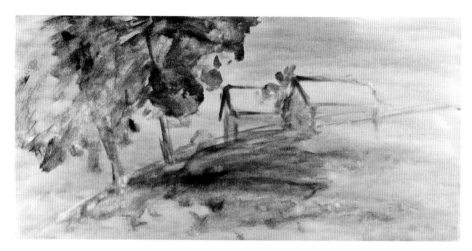

2 Sketch the Structures and Shadows

Using Phthalo Blue (Red Shade) and a no. 4 filbert, roughly sketch in the building shapes, trees and shadows. This will help you work out the placement of the elements if you haven't sketched them out ahead of time.

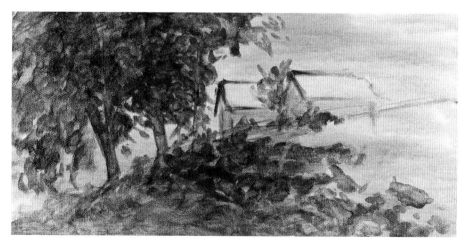

3 Add Darker Greens

Mix Phthalo Green (Blue Shade) and Yellow Ochre and use a no. 4 filbert to brush in the shadowed areas. You can add thinner to the paint to improve the flow. Gradually apply thicker paint.

Green Tips

To keep the greens looking fresh and pure, mix them with analogous colors (colors adjacent to green on the color wheel, blue and yellow in this case). To make green look natural and less garish, add a touch of its complement (red).

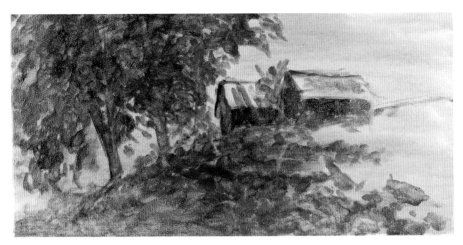

4 Add Browns

Mix Yellow Ochre with a little Permanent Rose and Phthalo Green (Blue Shade). Add paint to the building, trees and foreground grass with a no. 4 filbert.

5 Add Lighter Greens

With a mix of Lemon Yellow, Phthalo Green (Blue Shade), Titanium White and Cadmium Orange Hue, paint in the bright green areas with a no. 4 filbert. Develop the shadowed areas further with a mixture of Phthalo Green (Blue Shade) and some of the other colors.

6 Add Purples

Add the dark purples with a mixture of Dioxazine Purple with a little Phthalo Blue (Red Shade) and Phthalo Green (Blue Shade) to the shadowed areas with a no. 4 filbert. Apply some purple mixtures to the buildings. Add some greens and Burnt Sienna to the trees and foreground.

7 Add Sky Color

With a mix of Titanium White and a little Phthalo Blue (Red Shade), paint the sky using a no. 4 filbert. Create the small holes in the leaves of the trees by dabbing the paint onto the canvas with the edge of the brush.

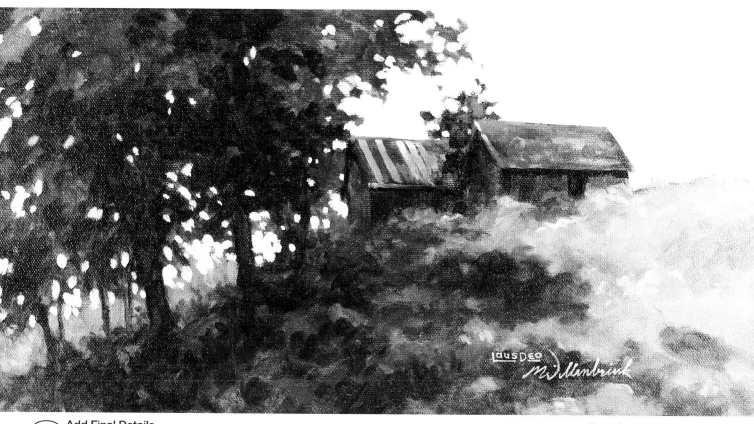

8 Add Final Details

Add final details and adjustments to the buildings and trees and add more blue in the upper sky. Write the date on the back of the painting. Let the paint dry, then sign the painting on the front with a no. 4 rigger.

Springhouse in Summer
oil on stretched canvas
8" × 16" (20cm × 41cm)

Twilight Gatehouse

The use of warm and cool colors gives this snow scene a cozy feeling. You can almost imagine people inside the building, sipping hot chocolate in front of a fire.

1 Draw the Basic Rectangles
Use a 2B pencil to draw the basic rectangular shapes of the structure, making sure the proportions are correct and the lines are perpendicular to one another.

2 Add to the Rectangles
Build on the basic rectangles, adding the window, the sides to the door and a triangle for the turret roof.

Materials

Surface
9" × 12" (23cm × 30cm) canvas on board

Oil Paints
Burnt Sienna, Cadmium Yellow Hue, French Ultramarine, Magenta, Titanium White

Brushes
no. 12 or 1-inch (25mm) flat

no. 2 or ¼-inch (6mm) filbert

no. 8 or ½-inch (12mm) filbert

no. 10 or ¾-inch (19mm) filbert

no. 2 round

no. 4 rigger

Other Supplies
2B or charcoal pencil, brush wash with water, easel, kneaded eraser, palette, palette knife, rag or paper towels, spray fixative

Optional Supplies
mahlstick, medium, palette cups, smock or apron, thinner

LESSONS/TECHNIQUES
- Structural Drawing (Chapter 10)
- Color Temperature (Chapter 10)
- Glowing Results (Chapter 10)
- Scumbling (Chapter 11)
- Using a Ground (Chapter 12)

3 Refine Shapes and Add Architectural Elements
Refine the shapes. Add curves to the roof ledges and finish the door, window, gate and other elements.

4 Add Trees and Shrubs and Erase Unwanted Lines
Sketch in the trees and shrubs and erase unwanted lines with a kneaded eraser. Spray with a fixative to prevent graphite from smearing as you paint over the drawing.

5 Add Ground Color
Smear diluted Magenta with a rag to form a ground. Create a transparent layer so that the pencil drawing shows through. Let the paint dry (a thin layer shouldn't take long).

6 Paint the Sky
Paint the sky with a no. 12 flat and a mix of Titanium White and French Ultramarine. Work from top to bottom so that there is more French Ultramarine at the top. Wipe down the French Ultramarine layer with a rag, smoothing and removing some of the paint so that the Magenta shows through. Go back over the entire sky with a clean, dry brush to add brushstrokes.

7 Paint the Stonework
Paint a basecoat on the stonework and chimney with a mixture of Burnt Sienna, Cadmium Yellow Hue, Magenta, French Ultramarine and Titanium White. Mix in more Cadmium Yellow Hue, Magenta and Titanium White to paint the warmer light areas. Mix in more Burnt Sienna and French Ultramarine for the cooler dark areas. Don't paint the individual stones yet.

8 Paint the Background Darks and Shrubs

Using a no. 8 filbert, scumble in a mixture of Burnt Sienna and French Ultramarine to add background darks of the tree shapes and shrubs. In some places the scumbling can be gently smoothed.

9 Add the Snow

Paint the snow with a mixture of Titanium White, French Ultramarine and Magenta. Use nos. 2, 8 and 10 filberts, depending on how broad or detailed the application. Use larger brushes for larger areas. Use a rag to wipe down the paint in places such as the lower foreground to expose the Magenta ground.

10 Paint the Stone Details

Paint the stone details with a no. 2 round and the stonework color from Step 7, making it darker in some places and lighter in others. The idea is to imply stones rather than paint every one.

11 Paint the Building Trim and Shadows

Using a no. 2 filbert and a no. 2 round, paint the gate, door and other trim work, including the shadows under the rooflines, with a mix of French Ultramarine and Burnt Sienna.

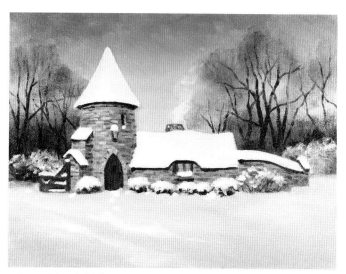

12 **Add Tree Branches and Vines**
Paint tree branches in the background and vines in the front of the building with French Ultramarine and a no. 2 round.

13 **Add Snow Details**
Using the snow color from Step 9, scumble smoke above the chimney and snow on the background bushes, building and vines using a no. 2 filbert. Use a no. 2 round for snow on the gate. Apply subtle highlights with pure Titanium White and a no. 2 filbert.

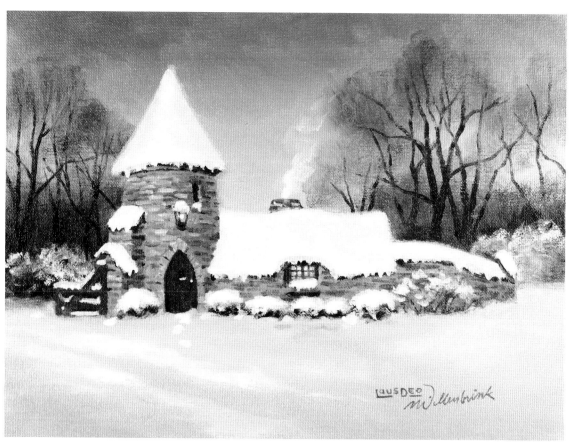

14 **Finish With Snow Details and Lights for the Lantern and Window**
Add snow details including icicles with Titanium White and French Ultramarine, using a no. 2 filbert and a no. 2 round. Using a no. 2 round, mix Cadmium Yellow Hue with Titanium White and paint in the lantern and window. Add some of the yellow around both the lantern and window for reflected light. Switch to Burnt Sienna to paint the mullion around the glass panes. Let the painting dry, then sign and date it with a no. 4 rigger.

Twilight Gatehouse
oil on canvas mounted on board
9" × 12" (23cm × 30cm)

Lion

When painting animals, it's fun to try to capture their attributes through their eyes or the tilt of the head or through the colors you chose to represent them. For this lion demonstration, I chose colors to show the authority and kingship that the lion symbolizes. Note that the light shining on the lion is coming from the upper right.

1 Sketch the Basic Profile
Using a 2B or charcoal pencil, sketch the basic shape of the profile along with a line to define the placement of the eye.

2 Add More Elements
Add the shape of the mane and the ear to the profile.

Materials

Surface
12" × 16" (30cm × 41cm) stretched canvas

Oil Paints
Burnt Sienna, Cadmium Orange Hue, Cadmium Red Hue, Cadmium Yellow Hue, Magenta, Permanent Rose, Phthalo Blue (Red Shade), Titanium White, Yellow Ochre

Brushes
no. 2 or ¼-inch (6mm) filbert
no. 4 or 5/16-inch (8mm) filbert
no. 8 or ½-inch (12mm) filbert
no. 4 rigger

Other Supplies
2B or charcoal pencil, brush wash with water, easel, kneaded eraser, palette, palette knife, rag or paper towels, spray fixative

Optional Supplies
mahlstick, medium, palette cups, smock or apron, thinner

LESSONS/TECHNIQUES

- Value (Chapter 10)
- Light Source (Chapter 10)
- Scumbling (Chapter 11)

3 **Start Adding Details**
Add details such as the nose and refine the form, erasing some of the linework with a kneaded eraser.

4 **Add More Details and Adjustments**
Add lines to indicate the shadows and fur along with other details including facial contours. Spray with fixative to prevent the graphite from smearing as you paint over your drawing.

5 **Add the Ground Color**
Use a rag to smear Burnt Sienna diluted with water as a ground. The paint should be transparent so that the pencil drawing is visible through the paint.

6 **Start Adding Paint Over the Ground**
With a no. 4 filbert, start adding mixes of Cadmium Yellow Hue, Titanium White and Cadmium Orange Hue over the face, mane and ear. To keep the underdrawing slightly visible, wipe down heavy areas of paint with a rag.

7 **Cover More of the Lion With Paint**
Continuing with the no. 4 filbert and the paint colors from Step 6, paint over more of the lion. For darker regions, add Magenta and Phthalo Blue (Red Shade). As you add more paint, it will become heavier and more opaque, eventually covering the pencil lines of the underdrawing.

8 Start Painting the Background

With a no. 8 filbert, start painting the background along the profile of the lion with a mix of Cadmium Yellow Hue, Phthalo Blue (Red Shade), Titanium White and Permanent Rose.

9 Fill in the Background

Fill in the remainder of the background by adding Titanium White at the upper right. Blend in Cadmium Orange Hue as you work down and to the left. Use a no. 4 filbert to make narrower brushstrokes for this step.

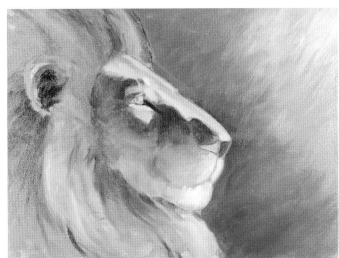

10 Develop the Colors of the Lion

Use a no. 4 filbert and mixtures of Cadmium Yellow Hue, Titanium White, Cadmium Orange Hue, Cadmium Red Hue, Permanent Rose, Magenta, Phthalo Blue (Red Shade), Burnt Sienna and Yellow Ochre to paint in the lion.

11 Continue Developing the Colors of the Lion

Continue building and developing the colors of the lion with a no. 4 filbert and the mixtures from Step 10. The paint can be mixed on the palette as well as mixed and moved on the canvas.

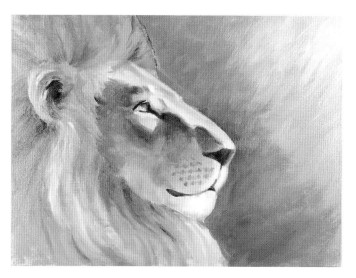

12 Start Adding Details and Adjustments

Using nos. 2 and 4 filberts, start adding details to the eye, nose and mouth, and darken the facial contours.

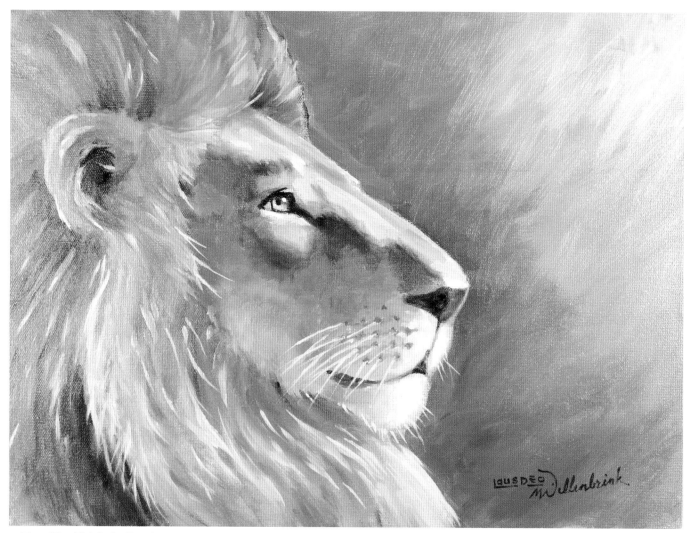

Regal
oil on stretched canvas
12" × 16" (30cm × 41cm)

13 Finish the Details and Adjustments

Add more details and subtle adjustments by lightening and darkening some of the fur and face. Add texture to the face by scumbling. Smooth the fur in some places with a rag. Paint over the darker paint of the whiskers, hairs and fur clumps with a lighter mix of Titanium White and Cadmium Orange Hue using a no. 4 rigger and a no. 2 filbert. Add thinner to the paint to improve the flow. Let the painting dry, then sign and date it with a no. 4 rigger.

Silhouettes

Adding people to a scene creates a sense of connection with the viewer. The figures don't need to be highly detailed, especially if the rest of the scene is painted loosely. The important part is to make sure they are proportionally accurate and easy to identify. The simplest way to achieve this is to place them in silhouette form.

1 Begin With Basic Structural Shapes
With a 2B pencil, sketch the basic shapes of the arch and building.

2 Add Structural Details
Add details to the basic building shapes. Erase unwanted lines throughout the process.

This demonstration continues after the Drawing People Mini-Demonstration.

Materials

Surface
9" × 12" (23cm × 30cm) canvas on board

Oil Paints
Burnt Sienna, Cadmium Orange Hue, Cadmium Red Hue, Cadmium Yellow Hue, Cadmium Yellow Light, Magenta, Phthalo Blue (Red Shade), Phthalo Green (Blue Shade), Sap Green, Titanium White

Brushes
no. 2 or ¼-inch (6mm) filbert
no. 8 or ½-inch (12mm) filbert
no. 2 round
no. 4 rigger

Other Supplies
2B or charcoal pencil, brush wash with water, easel, kneaded eraser, palette, palette knife, rag or paper towels, spray fixative

Optional Supplies
mahlstick, medium, palette cups, smock or apron, thinner

LESSONS/TECHNIQUES

- Linear Perspective (Chapter 10)
- Creating Brushstrokes (Chapter 11)

Drawing People
MINI-DEMONSTRATION

When drawing people, block in the basic features similar to a mannequin to develop the proportions and form.

Materials

Surface
drawing pad or sketchbook

Other Supplies
2B pencil, kneaded eraser

1 Draw Basic Proportions
Legs make up almost half the height of the average adult. Head size is a little more than one-eighth of the overall height.

2 Show Gender Differences
A major difference between men and women is the placement of the waist. Men have a lower waist, making for a larger torso. Women have a higher waist and fuller hips.

3 Add Movement
The appearance of movement, such as walking, can be added through subtle changes of the form. The straight legs are carrying the weight, and this affects the angles of the hips and shoulders, which are set at opposing angles.

4 Add Clothes and Hair
Add clothes, hair and costume elements to the blocked-in figures. The end result is two silhouetted figures that are easy to identify.

3 Sketch the Foliage
Add foliage shapes along with tree trunks and branches.

4 Add the People
Sketch the people shapes. Add minor details, including the foreground posts. Spray with fixative.

5 Apply the Ground
Using a rag, smear Burnt Sienna diluted with water as a light ground.

6 Add the Warm Underpainting Colors

With a no. 8 filbert, underpaint most of the foliage with mixtures of Cadmium Yellow Light, Cadmium Yellow Hue, Cadmium Orange Hue and Cadmium Red Hue. Apply paint thinly enough to allow the underdrawing to show through. These thin layers will be covered over with other paint layers.

7 Add the Light and Midtone Greens

With mixtures of Cadmium Yellow Hue, Sap Green and Phthalo Green (Blue Shade), add the light and midtone greens of the foliage with a no. 8 filbert. The paint consistency is slightly thicker than that of the previous layer.

8 Add the Shadows and People

Add shadows to the foreground, building and people with a mix of Magenta and Phthalo Blue (Red Shade). Add Cadmium Yellow Hue to the mix for warm shadow colors in places such as the outer arch. There hasn't been any need to use Titanium White yet, because thinning the colors with water makes them lighter. Use a no. 8 filbert along with a no. 2 filbert for painting more precise details.

9. Start Painting Over the Foliage

Using a no. 8 filbert, start painting over the foliage with a mix of Phthalo Green (Blue Shade), Sap Green and Cadmium Yellow Light. Add Phthalo Blue (Red Shade) to the mix for darker places. From this stage on, use thicker, more opaque paint.

10. Continue Painting the Foliage

Using a no. 8 filbert, paint more foliage with the green mixtures from Step 9 along with warm mixtures of Cadmium Yellow Hue, Cadmium Orange Hue, Cadmium Red Hue and Titanium White. Paint the tree branches with a mix of Burnt Sienna and Phthalo Blue (Red Shade) using a no. 2 round.

11. Add More Paint to the People

With a no. 2 filbert, place colors over the people shapes, keeping the image dark against the light background. For the shirt, use a mix of Titanium White and Phthalo Blue (Red Shade). For the dress, use a mix of Cadmium Red Hue, Magenta and Phthalo Blue (Red Shade). For the pants and hair, mix Cadmium Yellow Hue, Burnt Sienna and Phthalo Blue (Red Shade). Use a no. 2 round to add fine lines to the belt, purse and shoes with a mix of Burnt Sienna and Phthalo Blue (Red Shade).

12 Add Light to the Building, Foreground and Final Details

Using a no. 2 filbert, paint over much of the building with a mix of Titanium White and Burnt Sienna. Make adjustments and add details, including the foreground posts and sunlight on the path. Let the painting dry, then sign and date it with a no. 4 rigger.

Garden Stroll
oil on canvas mounted on board
9" × 12" (23cm × 30cm)

Portrait in Profile

Portraits are both fun and challenging. A good portrait painting starts with an interesting subject. Proper lighting will help you to observe lights and darks and the fine details of the face.

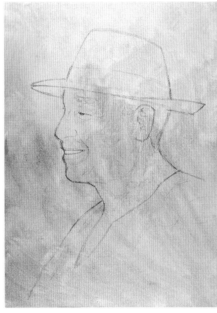

1 Draw the Profile

With a 2B pencil, draw the image directly onto the painting surface, following the mini-demonstration on the next page. Include lines indicating features and shadow transitions.

Another method is to draw the image on a separate piece of paper, then copy it to the size you want. After that, transfer the image onto the painting surface using graphite paper.

With either method, spray with fixative to prevent the paint from smearing the graphite.

2 Add the Ground

Use a rag to smear Burnt Sienna diluted with water over the painting surface. The ground should be transparent so that the pencil lines remain visible.

This demonstration continues after the Drawing Profiles Mini-Demonstration.

Materials

Surface
16" × 12" (41cm × 30cm) stretched canvas

Oil Paints
Burnt Sienna, Burnt Umber, Cadmium Red Hue, Cadmium Yellow Hue, Cerulean Blue, Magenta, Permanent Rose, Phthalo Blue (Red Shade), Titanium White, Yellow Ochre

Brushes
no. 4 or ⁵⁄₁₆-inch (8mm) flat
no. 8 or ½-inch (12mm) flat
no. 2 round
no. 4 rigger

Other Supplies
2B or charcoal pencil, brush wash with water, easel, kneaded eraser, palette, palette knife, rag or paper towels, spray fixative

Optional Supplies
graphite paper, mahlstick, medium, palette cups, smock or apron, thinner

LESSONS/TECHNIQUES

- Value (Chapter 10)
- Color Temperature (Chapter 10)
- Creating Brushstrokes (Chapter 11)

Drawing Profiles
MINI-DEMONSTRATION

Accurate proportions are essential to drawing and painting profiles. With subtle variations, this method can be used to draw almost any adult.

Materials

Surface
drawing pad or sketchbook

Other Supplies
2B pencil, kneaded eraser

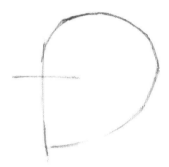

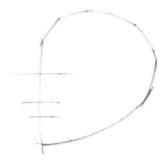

1 Draw the Basic Shape
Draw the basic profile shape slightly curved on the left side, then more curved on the top and right, then less curved at the bottom. A horizontal line halfway from the top and bottom indicates where the eye will be placed.

2 Add Lines for the Nose and Mouth
Add a horizontal line for the nose, placing it less than halfway down from the eye line to the chin. Add a line for the mouth, somewhat below the nose line.

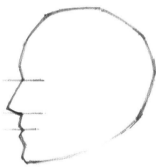

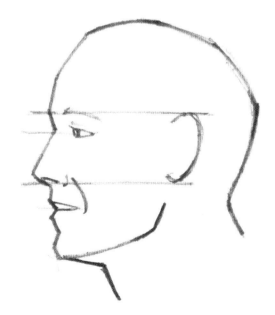

3 Form the Profile
Draw the form of the profile: Go in at the eye line, out for the shape of the nose and again in for the mouth.

4 Add More Features
Add the individual features including the eye, nostril and mouth. The ear lines up with the eyebrow and base of the nose. The jaw is defined along with the neck. Finally, add hair and costume features.

3 Add Washes of Burnt Umber to the Background

Using a no. 8 flat, add the values of the background with washes of Burnt Umber thinned with thinner or water. The background should be darkest on the left side to create contrast and emphasis on the face.

4 Add Washes to the Face and Clothes

Add values with washes of Burnt Umber to the face and clothes with a no. 8 flat. Use the tip for more detailed areas. Pull up excess paint with a dry no. 4 flat or wipe it away with a rag. The light source is in the upper left, so the left side of the subject will be lighter than the right.

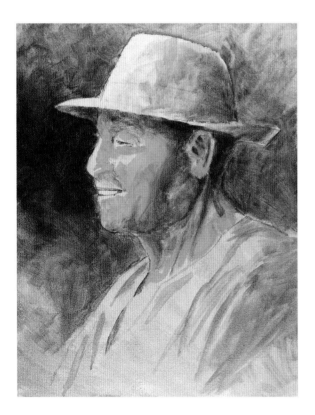

5 Add the Midtone Colors

Use a no. 8 flat and mixtures of Titanium White, Cadmium Yellow Hue, Cadmium Red Hue, Permanent Rose and Burnt Sienna to paint over the lighter areas of the face. Use paint that is thicker than the wash, but just thick enough to cover the previously applied paint.

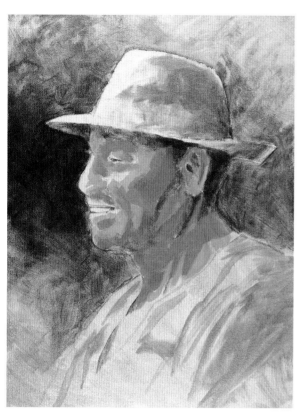

6 Add Slightly Darker Colors
Add more Burnt Sienna to darken the color mixtures from Step 5, then paint the hat and more of the face.

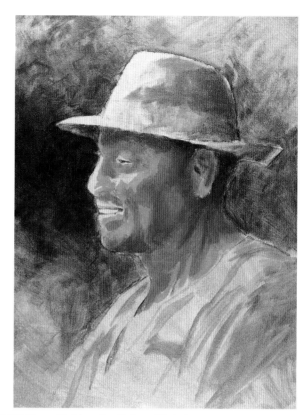

7 Keep Making the Colors Slightly Darker
Add more Burnt Sienna and some Cerulean Blue to the color mixtures from the previous steps and apply to the face and hat. The blue addition creates the cool color for the shadows.

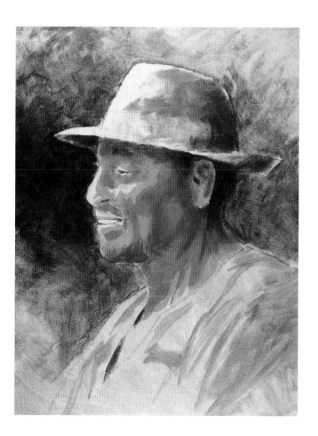

8 Continue Making the Colors Darker
Add more Burnt Sienna and Phthalo Blue (Red Shade) to make the color mixtures even darker. For the most part, blend the paints together as you place them on the canvas.

The Beauty of the Different Hues

Take a minute to look in the mirror at your own flesh coloring. There are subtle differences of color in your face. Now look at your friend's facial coloring. When painting portraits, it is both fun and a challenge to mix the right colors. Take a few minutes to practice mixing fleshtones on a scrap of heavy paper or canvas.

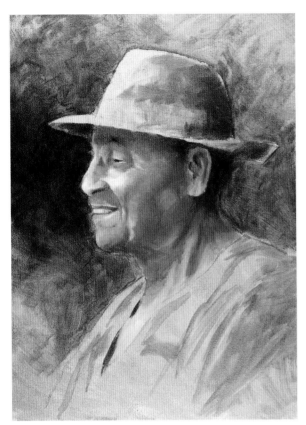

9 Add Lights and Darker Colors
Using a no. 4 flat, add lighter areas of Titanium White and Yellow Ochre to the subject, including the hat. Blend the wet paint, smoothing out the form.

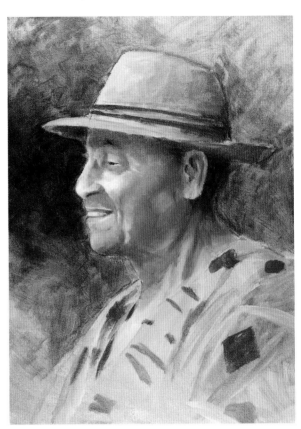

10 Add Warm Colors to the Hat and Shirt
Using a no. 8 flat, apply Titanium White and Yellow Ochre. Use Magenta for the reddish areas. Paint the hat and shirt looser and with less detail to draw the focus to the more detailed face.

11 Paint the Shirt and Background
Using a no. 8 flat, apply Phthalo Blue (Red Shade), Yellow Ochre and Titanium White to the shirt and background.

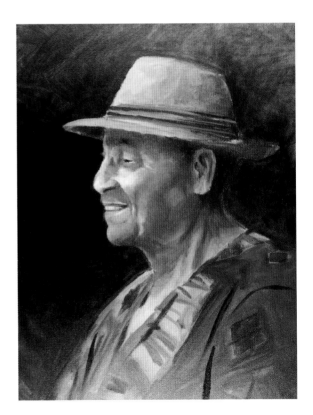

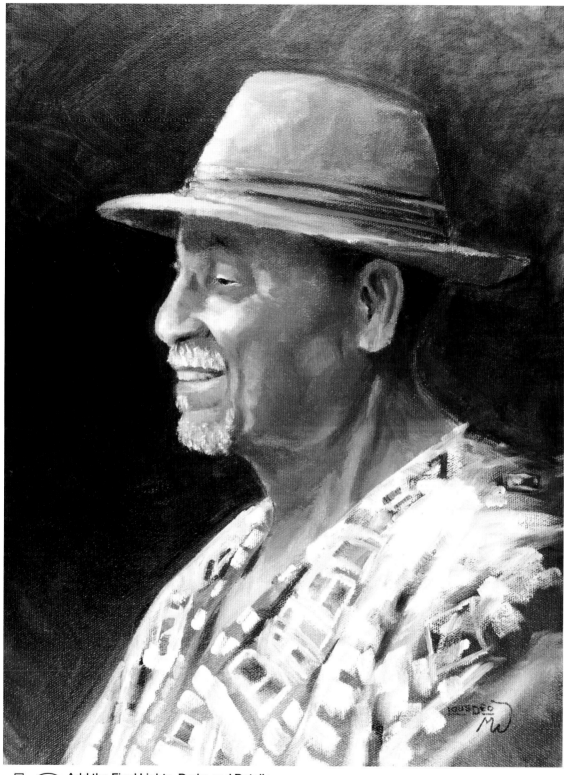

Mr. H
oil on stretched canvas
16" × 12" (41cm × 30cm)

12 Add the Final Lights, Darks and Details

Add and adjust the final lights, darks and details, including the hat, mustache, whiskers and shirt. Use nos. 4 and 8 flats and a no. 2 round for the details. Let the painting dry, then sign and date it with a no. 4 rigger.

A Mahlstick Makes It Easier

Try using a mahlstick to steady your hand while painting the details of this portrait.

Girl With Flowers

This demonstration captures the essence of childlike innocence. The warm colors in the foreground combined with the cool colors in the background emphasize depth.

1 Draw the Head and Shoulders
Draw the basic shape of the head and shoulders using a 2B pencil. A line for the center of the face indicates the tilt of the head.

2 Add Arms, Neck and Hands
Add linework for the arms and neck. Draw circles for the hands.

Materials

Surface
14" × 11" (36cm × 28cm) stretched canvas

Oil Paints
Burnt Sienna, Cadmium Yellow Medium, Cerulean Blue, Dioxazine Purple, Permanent Rose, Sap Green, Titanium White, Yellow Ochre

Brushes
no. 8 or ½-inch (12mm) flat
no. 2 or ¼-inch (6mm) filbert
no. 4 or 5/16-inch (8mm) filbert
no. 2 round
no. 4 round
no. 4 rigger

Other Supplies
2B or charcoal pencil, brush wash with water, easel, kneaded eraser, palette, palette knife, rags or paper towels, spray fixative

Optional Supplies
mahlstick, medium, palette cups, smock or apron, thinner

LESSONS/TECHNIQUES
- Color Temperature (Chapter 10)
- Wet-Into-Wet (Chapter 11)
- Wet-Into-Dry (Chapter 11)

3 Add Lines for the Face, Hair and Fingers
Add lines for the placement of the facial features, hair and fingers.

4 Add Details
Add overall details including the face, hair, dress and flowers. Erase unwanted lines. Spray with fixative.

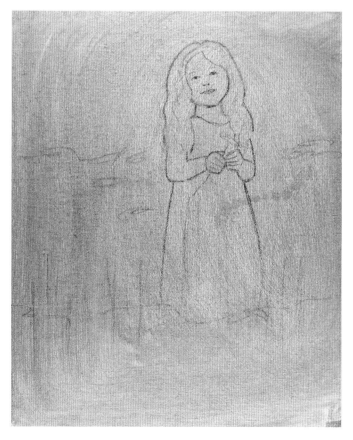

5 Add the Ground
For the ground, use a rag to smear Burnt Sienna diluted with water over the painting surface. The ground should be applied thinly enough to allow the pencil lines to remain visible.

6 Add the Skin Tone
Using a mix of Cadmium Yellow Medium, Permanent Rose and Titanium White and a no. 4 filbert, paint over the face, neck, arms and hands. The paint thickness should allow the pencil lines to show through slightly.

7 Paint the Hair
Using a mix of Titanium White, Burnt Sienna, Yellow Ochre and Cadmium Yellow Medium, paint the hair with a no. 4 filbert.

8 Paint the Dress
With a mix of Titanium White and Cadmium Yellow Medium, paint the dress using a no. 4 filbert. Use a no. 4 round or smaller brush for tight places. Some of this paint can be added to the hair.

9 Add the Foreground Color

Add warm foreground greens with a no. 8 flat and a mix of Sap Green, Cadmium Yellow Medium, Titanium White and Permanent Rose.

10 Add the Background Color

Add cool background greens with a no. 8 flat and a mix of Sap Green, Cerulean Blue, Yellow Ochre, Dioxazine Purple and Titanium White.

11 Add Darks to the Skin, Hair and Dress

Add darks to the skin with a mix of Permanent Rose, Cadmium Yellow Medium and Titanium White, using a no. 2 filbert and a no. 4 round for details.

Add darks to the hair with a mix of Burnt Sienna and Yellow Ochre using a no. 2 filbert and a no. 4 round for details.

Add subtle darks to the dress with a mix of Titanium White and Dioxazine Purple, using a no. 2 filbert and a no. 4 round for details.

12 Add Lights to the Skin, Hair and Dress

Add warm lights to the skin, hair and dress with a mix of Titanium White and Cadmium Yellow Medium, using a no. 2 filbert and a no. 4 round for details.

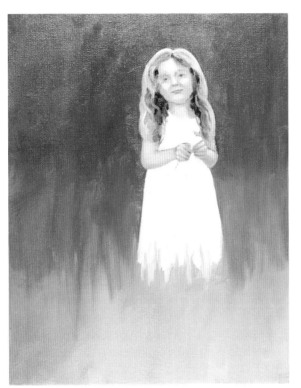
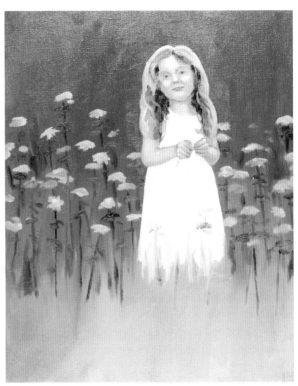

13 Add Details to the Face and Hands

With a mix of Permanent Rose, Cadmium Yellow Medium, Titanium White and Cerulean Blue, paint the details of the face and hands using nos. 2 and 4 rounds. Avoid overworking these areas. For the following steps, you may let the paint dry between steps, painting wet-on-dry instead of wet-into-wet. If you do, add a bit of medium to the paint.

14 Add Background, Flowers, Stems and Leaves

Paint the flower petals with a mix of Titanium White and Dioxazine Purple using a no. 4 filbert. Add the centers with a mix of Cadmium Yellow Medium and Titanium White using a no. 2 filbert. Paint stems and leaves with a mix of Sap Green, Cerulean Blue and Dioxazine Purple using nos. 2 and 4 filberts.

Keep It Steady

Consider using the mahlstick when working with this portrait. It will help keep your hand steady.

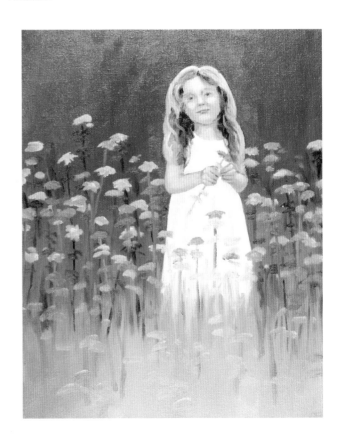

15 Add Foreground Flowers, Stems and Leaves

Paint the flower petals with a mix of Permanent Rose and Titanium White using a no. 4 filbert. Add the centers with a mix of Cadmium Yellow Medium and Titanium White using a no. 2 filbert. Paint the stems and leaves with a mix of Sap Green, Cadmium Yellow Medium and Titanium White using nos. 2 and 4 filberts.

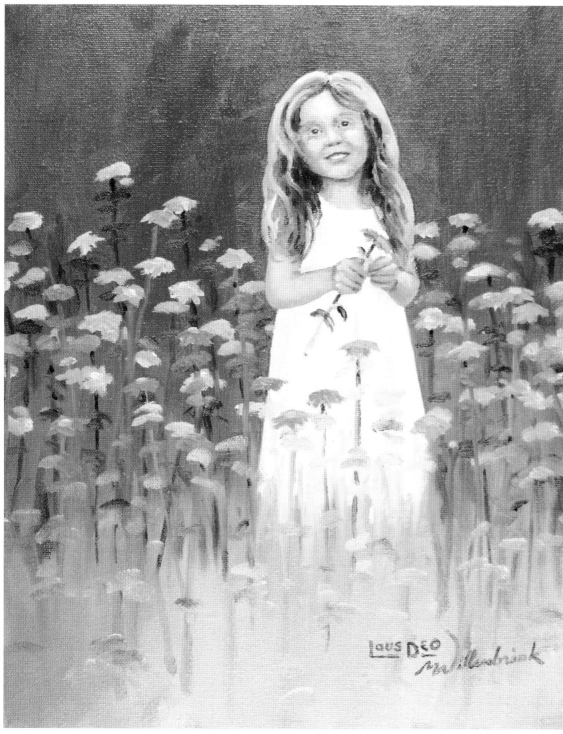

Girl With Flowers
oil on stretched canvas
14" × 11" (36cm × 28cm)

16 Add the Final Lights, Darks and Details

Add and adjust final lights, darks and details including face, hair, flowers and foreground using a variety of brushes and colors. Let the paint dry, then sign and date it with a no. 4 rigger.

Finishing Your Paintings

Once you have completed your fine art, you need to prepare your oil painting for display and longevity. Adding varnish and a frame may not seem important now, but, once you have completed these steps, you will see your painting in a whole new light. It will have a more finished, professional look that will make you proud of your masterpiece.

Drying and Storing Paintings

Before applying varnish, the painting surface must be free of dust and thoroughly dry. Drying requires six to twelve months or longer depending on the thickness of the paint. Store oil paintings vertically to prevent dust from collecting on them both before and after they've been varnished.

Applying Varnish

Varnish is a clear liquid available in both bottles and spray cans. Applied over oil paintings, varnish acts as a barrier from dust and grease and also provides a uniform finish to the painting surface. Some varnishes are removable, allowing for the option of cleaning the painting if it becomes dirty over time.

Varnish can be sprayed on or brushed on with the thin, even strokes of a wide brush. Whether spraying or brushing, always follow the manufacturer's recommendations and guidelines. If you brush on varnish, you'll need turpentine or mineral spirits to clean the application brush unless the varnish is water-soluble, in which case it will clean up with soap and water.

Framing Your Painting

Frames should complement the art and express the general theme without distracting from the art itself. Some artists include a nameplate on the front of the frame that states the title of the art piece as well as their name. The back may be covered with a sheet of craft paper, which acts as a dust cover. *Bumpers* keep the frame from resting directly against a wall and allow air to circulate around the painting to prevent mold. You may want to place a sticker stating the artist's information on the back.

Varnish Options
Varnish is available in bottles or spray cans. Spray cans are convenient. However, I prefer to apply water-soluble varnish with a brush because it makes cleanup easy. When using bottled varnish, designate a brush specifically for the application of the varnish so that you won't damage your good painting brushes.

The Right Match
Choosing the right frame will enhance your painting's appearance and give it a more professional, finished look.

Lookin' Good!
A painting that is framed well will look clean and professional, even from the back.

Glossary

A

Aggressive colors: warm colors that appear to come forward visually.

Alla prima: Italian for "at first," referring to an immediate application of paint.

Analogous colors: a range of colors adjacent to each other on the color wheel, such as blue-green, blue, blue-violet and violet.

Angle ruler: a small ruler that can fold in the middle and is used for measuring and transposing angles.

Art horse (or drawing horse, horse bench): a bench used for sketching and drawing with a prop for a drawing board.

Asymmetrical composition: a composition that has a balanced feel without having the elements placed equally on both sides.

Atmospheric perspective: also referred to as aerial perspective, this is depth implied through contrasts in value, definition and color temperature.

B

Back run: an instance in which paint at the edge of a freshly applied wash runs back into the wash area, which has begun to dry, creating a watermark; you can avoid back runs by pulling up any extra paint and water with a dry brush before it flows back into the wash.

Bamboo brush: a paintbrush with a round handle made from bamboo; when wet, the coarse hairs should taper to a point.

Bamboo brush holder: a bamboo mat used to store paint brushes.

Binder: a paint ingredient that binds the pigment particles. Oil is the binder in oil paint.

Blending stump: also referred to as a tortillion, this is a small roll of soft, tightly wound paper, about the size of a pencil, used for blending in drawing.

Block: a pad of watercolor paper in which the sheets are glued together on all four sides so the paper will wrinkle less when made wet; you can remove the top sheet after the painting has dried by inserting a knife between the top two sheets and running it around the four sides.

Blocking-in: the process of making a structural sketch of the basic overall shape and proportions of a subject.

Brush wash: a jar filled with water or solvent that is used to wash paint out of brushes.

C

Cake: a hard, dry version of watercolor pigment.

Canvas pad: sheets of primed canvas in pad form.

Carbon pencil: a pencil with a carbon core.

Cast shadow: a shadow that is cast from an object onto another surface.

Charcoal pencil: a pencil with a charcoal core.

Charcoal stick: a stick made of charcoal with no outer casing.

Chroma: color or color intensity.

Cold-pressed watercolor paper: paper that has a moderately rough surface texture.

Color intensity: the potency or strength of a color, also referred to as saturation.

Color mixing: mixing one or more paint colors with water to achieve the desired transparency, color and value.

Color palette: the colors used in a painting.

Color scheme: a family of colors used together in a painting, also referred to as a painting's palette.

Color sketch: a small, quick, preliminary painting used to plan the colors of a composition.

Color temperature: the differentiation between warm or cool colors.

Color theory: principles of how colors relate to one another.

Color wheel: a circular chart showing the primary, secondary and tertiary colors and how they relate to one another.

Colored pencil: a pencil with a colored core. These pencils are also available in black, white and grays.

Complementary colors: two colors that appear opposite each other on the color wheel, such as red and green.

Composition: the arrangement of elements involving structure, value and sometimes color, that provides a path for the eye to follow through a drawn or painted scene.

Continuous line sketch/drawing: see contour sketch/drawing.

Contour sketch/drawing: also referred to as a continuous line drawing, a sketch or drawing that is done by keeping the pencil in contact with the paper and moving the pencil along the surface, while studying the contours of the subject.

Contrast: the extreme differences between specific elements in a drawing or painting, most commonly used to discuss value.

Cool colors: colors that look cool, such as green, blue and violet, also referred to as recessive colors.

Copier paper: inexpensive paper used in copy machines or printers.

Craft knife: a small knife with a sharp, replaceable blade.

Cropping: to determine the perimeters of a scene or piece of artwork.

Crosshatching: groups of parallel lines overlapping in different directions.

D

Design elements: elements that are found in composition, including size, shape, line, value and color.

Design principles: the use of design elements, including balance, unity, dominance and rhythm.

Divider: a compass-like tool used for measuring and proportioning.

Drawing: a finished representation of a subject.

Drawing board: a smooth, sturdy board used as a support for sketching and drawing paper.

Drawing paper: heavyweight paper used for drawing, usually 80 to 90 lbs. (170gsm to 190gsm) or more.

Drybrush: a term to describe an application of paint to a dry surface using a brush loaded with paint and very little water.

E

Easel: a stand to prop artwork.

Ellipse: the shape of a circle when it is viewed from the side, as in perspective.

Eraser shield: a thin piece of metal used to mask areas of a drawing during erasing.

F

Fan brush: a brush with a fanlike shape to its bristles.

Fat over lean: a method of painting that involves layering more oily paint over less oily paint.

Filbert brush: a brush head with a flat shape and rounded tip that may come to a point.

Fixative: a spray applied to dry artwork to prevent smearing.

Flat brush: a brush head with a flat shape and squared tip.

Flat wash: a wash of paint and water that is even in value and color.

Focal point: the area or part of a painting to which the composition leads the eye, also referred to as the center of interest.

Foreshorten: to give the appearance of depth and projection by shortening the visible area of an element; imagine a door and doorway. When the door is closed, the door is the same width as the doorway. As you open the door, the apparent width of the door becomes less wide compared to the door frame.

Form shadow: a shadow on a subject that displays its form.

G

Gauging values: comparing the values of the lights and darks of a drawing or painting with its subject.

Gesso: a primer used to coat the painting surface before painting.

Glazing: to apply thin, transparent paint in layers.

Gradate: to create a transition from one value or color to another.

Gradated wash: a wash that changes value.

Grade: the quality of materials, such as professional grade or student grade.

Graduating lines: pencil lines that graduate light to dark or dark to light.

Graphite paper: thin paper covered with graphite on one side, used to transfer drawings or images.

Graphite pencil: a pencil with a graphite core.

Graphite stick: a stick made of graphite with no outer casing.

Ground: a layer of color applied to a canvas prior to the painting process.

H

Hake brush (pronounced "hockey"): a wide, flat paintbrush with coarse hairs and a paddle-shaped, wooden handle.

Hard edge: the sharply defined, unblended edge of a wash or stroke of paint.

Highlight: an area of reflected light on an object; the lightest, brightest areas of a subject.

Horizon: the line where land or water meets the sky, in reference to linear perspective.

Hot-pressed watercolor paper: paper that has a smooth surface texture.

I

Impasto: Italian for "paste" or "dough," refers to a thick application of paint.

Imprint: to create texture by pressing an item, such as a sponge, loaded with paint against a painting surface.

Intensity: the potency or strength of a color.

K

Kneaded eraser: a soft, pliable gray eraser that damages watercolor paper less than other erasers because it's less abrasive and doesn't crumble.

L

Lead: the graphite in a pencil and also the scale that rates the hardness or softness of the graphite: 6B, 5B, 4B, 3B, 2B, B, HB, H, 2H, 3H, 4H, 5H and 6H from soft to hard.

Lead holder: a type of mechanical pencil that can accommodate thicker graphite than other mechanical pencils.

Leading lines: a group of compositional elements used to form lines to direct the viewer's eye to points of interest.

Lightfastness: the degree to which a paint resists fading.

Light source: the origin of the light in a composition.

Lightbox: a shallow box with a light inside and a translucent surface that is used for tracing.

Line comparisons: comparing the placement of the elements of a subject with lines.

Linear perspective: depth implied through line and the relative size and placement of elements of a scene.

M

Mahlstick: a stick with a cork covered in leather on the end, used as a hand rest for steadier painting.

Masking tape: paper tape used to attach one piece of paper to another.

Measure: to determine specific proportions of elements in a scene.

Mechanical pencil: a pencil that allows for refillable graphite.

Medium: a liquid or gel paint additive that changes the characteristics of the paint.

Mineral spirits: a solvent used to thin and dilute traditional oil paints.

Mixture: a combination of watercolor paint and water.

Monochromatic: a painting done with different values of one color.

N

Natural hair brush: a paintbrush made of natural animal hairs.

Negative drawing: darkening around a subject so that the image is defined by the background.

Negative painting: painting around shapes or elements to imply their forms.

Neutral colors: browns and grays made from combinations of the three primary colors.

O

Oil paint: paint that uses oil as its binder.

One-point perspective: a type of linear perspective with one vanishing point.

P

Pad: a stack of sheets of paper that is attached at one side.

Painting surface: the paper, canvas, linen or panel that is painted on, also called a support.

Palette: a tray or disposable pad of paper for holding and mixing paints during a painting session.

Palette cups: small cups that clip onto the palette to hold thinner and medium.

Palette knife: a spatula-like knife used to mix paint on and clean paint off the palette and to add and remove paint from the painting surface.

Palette pad: a pad of disposable paper used as a palette for holding and mixing paint.

Paper weight: the thickness of a sheet of paper; common weights are the thin 90-lb. (190gsm), the moderate 140-lb. (300gsm) and the thick 300-lb. (640gsm).

Pastel pencil: a pencil with a pastel chalk core.

Pencil extender: a pencil handle with a sleeve used to hold shortened pencils.

Pencil sharpener: a device used to sharpen pencils.

Pigment: the ingredient that gives color to paint.

Plastic eraser: a soft nonabrasive eraser, usually either white or black.

Plein air: a French term meaning "open air," used to describe painting on site.

Positive drawing: drawing a subject on a background rather than around the subject like negative drawing.

Positive painting: painting an element on a background, as opposed to negative painting.

Primary colors: the three basic colors—red, yellow and blue—from which all other colors are derived.

Professional- (artist-) grade paint: high-quality paint.

Proportion lines: lines used to obtain the correct proportions when drawing.

Proportioning: comparing the dimensions of a subject.

Proportioning devices: tools that are used for proportioning such as dividers or a sewing gauge.

Q

Quill mop brush: a round paintbrush with soft hairs that form a point when wet, known for holding lots of fluid.

R

Recessive colors: cool colors that appear to recede visually.

Reference material: photos, sketches or drawings used to study a subject.

Reference photo: a photo used to study a subject.

Reflected light: light that is reflected from one surface onto another.

Rigger brush: also called a script or liner, a type of round brush with thin, long hairs.

Rotary lead pointer: a device used to sharpen the graphite of a lead holder.

Rough watercolor paper: paper that has a rough surface texture.

Round brush: a paintbrush with hairs that come to a point.

Rule of thirds: a composition that has the elements placed along a grid that is divided into thirds.

S

Sandpaper pad: a small pad of sandpaper used to sharpen the core of a pencil.

Scribbling: random, multidirectional pencil lines.

Scrub: to move a brush back and forth over a wash to remove some of the paint; this technique can damage both the brush and the paper's surface.

Scumbling: to apply undiluted paint over previously applied paint, allowing some of the previously applied paint to show through.

Secondary colors: the three colors—orange, green and violet—made from a combination of two of the three primary colors.

Sewing gauge: a tool with a movable guide that can be used for measuring and proportioning.

Shading: the lights and darks of a subject displayed through the pencil lines of a sketch or drawing or the darkened tones of a painting.

Sketch: a rough, unfinished art representation of a subject.

Sketch paper: lightweight paper used for sketching, commonly 50 to 70 lbs. (105gsm to 150gsm).

Slip sheet: a sheet of paper placed over a portion of a drawing so the hand can be placed on top without smearing the drawing.

Soft edge: a paint edge that smoothly blends into the surrounding paint.

Solubility: the degree to which paint dissolves and mixes with water.

Spatter: to create texture by applying random dots of paint.

Spray fixative: a spray coating applied to prevent graphite or charcoal from smearing.

Stretch: to attach wet paper to a board so it won't wrinkle as it dries.

Stretched canvas: a painting surface made from canvas stretched over a frame of stretcher bars.

Stretcher bars: the wood frame pieces of a stretched canvas.

Structural drawing: a drawing of the shapes and forms in a scene without value or color.

Structural sketch: a sketch of the structural form of a subject, absent of values.

Student-grade paint: usually less-expensive paint that is lower quality than professional- (artist-) grade paint.

Surface texture: the coarseness of the surface of the paper.

Symmetrical composition: a composition whose balanced look results from placing elements equally on both sides of the composition so the sides perfectly reflect each other.

Synthetic hair brush: a paintbrush made with artificial bristles.

T

Taboret: an artist supply cabinet.

Tangent: the point at which two compositional elements touch or intersect. Tangents usually detract from a composition.

Tertiary colors: the colors made from combinations of one primary color and one secondary color, such as blue-violet.

Thick over thin: the process of applying thicker paint over thin paint.

Thumbnail sketch: a small, quick sketch used to plan a composition.

Tooth: the roughness of a paper's surface.

Tracing paper: thin, translucent paper used for tracing.

Traditional oil paints: oil paints that usually require solvents, such as turpentine or mineral spirits, to thin and dissolve the paint.

Transfer paper: a sheet of paper covered with graphite on one side, used to transfer a structural sketch onto drawing paper or a drawing onto your painting surface.

Transposing angles: copying the angles of the subject when sketching or drawing.

Turpentine: a solvent used to thin and dilute traditional oil paints.

Two-point perspective: a type of linear perspective with two vanishing points.

U

Underdrawing: drawing directly onto the painting surface as a guide for the placement of the paint.

Underpainting: a monochromatic wash of paint on the painting surface used as a preliminary guide.

Unprimed canvas: canvas that does not have a layer of primer or gesso.

V

Values: the lights and darks of a subject.

Value scale (also referred to as a grayscale or value finder): a small piece of cardboard that has a range of lights and darks and is used for gauging values.

Value sketch: a sketch that displays the light and darks of a subject; used to plan the lights and darks of a painting.

Vanishing point: a point on the horizon line at which parallel lines seem to converge in the distance.

Vantage point: the point from which the viewer observes a scene.

Variegated wash: a wash that changes color.

Varnish: a clear liquid applied over a dry oil painting as a protective coating.

Viewfinder: a small piece of plastic or cardstock used as a handheld window to visually crop a scene.

W

Warm colors: colors that look warm, such as red, orange and yellow, also referred to as aggressive colors.

Wash: a transparent application of paint that has been diluted with water or thinner.

Water-soluble oil paint: oil paint that can be thinned and diluted with water.

Wet-into-wet: applying a layer of wet paint into a layer of wet paint.

Wet-on-dry: a term to describe an application of paint to a dry surface using a brush loaded with paint and a normal amount of water.

White vinyl eraser: a soft, nonabrasive eraser.

Woodless pencil: a pencil made of a cylinder of graphite coated with lacquer, with no outer wood casing.

Index

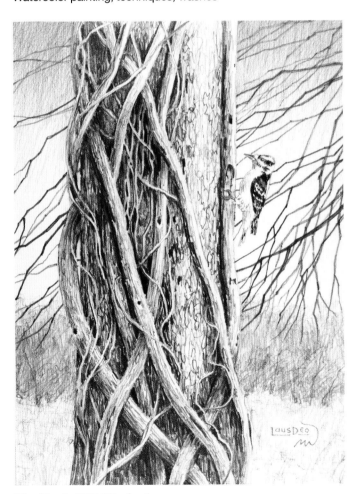

Vine Tangles With Woodpecker
graphite pencil on drawing paper
13" × 10" (33cm × 25cm)

About the Authors

Mark and Mary Willenbrink are the bestselling authors of the *Absolute Beginner* series. Mark is also a fine artist and teaches art classes and workshops. His website is shadowblaze.com and you can also find his fanpage on Facebook. Mark and Mary live in Cincinnati, Ohio.

Photo by Hannah Willenbrink

Other fine North Light Books are available from your favorite bookstore, art supply store or online supplier. Visit our website at fwmedia.com.

media

18 17 16 15 14 5 4 3 2 1

DISTRIBUTED IN CANADA BY FRASER DIRECT
100 Armstrong Avenue
Georgetown, ON, Canada L7G 5S4
Tel: (905) 877-4411

DISTRIBUTED IN THE U.K. AND EUROPE
BY F&W MEDIA INTERNATIONAL LTD
Brunel House, Forde Close, Newton Abbot, TQ12 4PU, UK
Tel: (+44) 1626 323200, Fax: (+44) 1626 323319
Email: enquiries@fwmedia.com

DISTRIBUTED IN AUSTRALIA BY CAPRICORN LINK
P.O. Box 704, S. Windsor NSW, 2756 Australia
Tel: (02) 4560-1600; Fax: (02) 4577 5288
Email: books@capricornlink.com.au

ISBN 13: 978-1-4403-3755-0

Edited by Stefanie Laufersweiler and Mary Burzlaff Bostic
Cover designed by Hannah Bailey
Production coordinated by Mark Griffin

Metric Conversion Chart

To convert	to	Multiply by
Inches	Centimeters	2.54
Centimeters	Inches	0.4
Feet	Centimeters	30.5
Centimeters	Feet	0.03
Yards	Meters	0.9
Meters	Yards	1.1

The material in this book appeared in the following previously published North Light Books:
Willenbrink, Mark and Mary. Watercolor for the Absolute Beginner © 2009.
Willenbrink, Mark and Mary. Oil Painting for the Absolute Beginner © 2010.
Willenbrink, Mark and Mary. Drawing Portraits for the Absolute Beginner © 2012.
Willenbrink, Mark and Mary. Drawing Nature for the Absolute Beginner © 2013.

Ideas. Instruction. Inspiration.

Receive FREE downloadable bonus materials when you sign up for our free newsletter at artistsnetwork.com/Newsletter_Thanks.

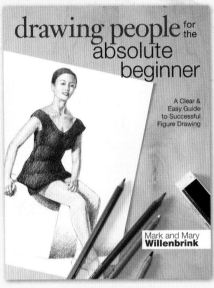

Find the latest issues of *Watercolor Artist* on newsstands, or visit artistsnetwork.com.

These and other fine North Light products are available at your favorite art & craft retailer, bookstore or online supplier. Visit our websites at artistsnetwork.com and artistsnetwork.tv.

Follow North Light Books for the latest news, free wallpapers, free demos and chances to win FREE BOOKS!

Visit artistsnetwork.com and get Jen's North Light Picks!

Get free step-by-step demonstrations along with reviews of the latest books, videos and downloads from Jennifer Lepore, Senior Editor and Online Education Manager at North Light Books.

Get involved

Learn from the experts. Join the conversation on